MAPPLETHORPE

ASSAULT WITH A DEADLY CAMERA

READER DISCRETION ADVISORY

This pop culture memoir contains sex, lies, greed,
perversion, murder, deceit, infidelity,
drugs, sex, immorality, scatology, ambition,
equivocation, character assassination, slander, blasphemy,
aspersion, betrayal, distortion, racism,
ungodliness, sodomy—
and that's just the critics
of Mapplethorpe.

A Pop Culture Memoir
An Outlaw Reminiscence

Jack Fritscher, Ph.D.

HASTINGS HOUSE
Book Publishers
141 Halstead Avenue
Mamaroneck, NY 10543

GEORGE DUREAU

MAPPLETHORPE

ASSAULT WITH A DEADLY CAMERA

ACKNOWLEDGMENTS

The author gratefully expresses his appreciation
to Elizabeth Gibson Gershman, Eddie Jaffe,
the American Popular Culture Association,
the Pontifical College Josephinum,
the Michigan Council for the Arts,
and the National Endowment for the Arts.

For Mark Hemry

CONTENTS

Illustrations appear between pages 130–131 and 226–227.

OTHER BOOKS BY THE AUTHOR

Popular Witchcraft: Straight from the Witch's Mouth

Television Today

Leather Blues

Corporal in Charge

Stand by Your Man

Some Dance to Remember

Jack Fritscher's American Men (Photographs)

MAPPLETHORPE

ASSAULT WITH A DEADLY CAMERA

PREFACE: *"MEIN CAMP"*

Mapplethorpe rhymes with *May Pole. Thorpe* means town.

"Our aim is . . . to reveal the cultural context . . . and to transform an individual story into a cultural narrative, and so to understand more fully what happened in the past."

—*Ronald Grele*

1
DANGEROUS LIAISONS

This is a memoir, not a biography, of photographer Robert Mapplethorpe. It's a detective story told in a confessional. For nearly twenty years, I have kept notes, letters, photographs, reviews, and journal entries about this most determined of artists. Robert and I lived parallel lives before we met. I helped him create himself. I first wrote about Robert in 1977, before the Art Reich could pronounce "Mapplethorpe" correctly.

Early on, in 1977, we collaborated on a cover for a magazine (his first), which I edited. In fact, I sketched for him the exact leathersex concept I wanted and selected the model to shoot. Robert brought his fresh eye to the assignment. After much objection from the publisher, the Mapplethorpe cover finally made it out on the Fall 1978 *Drummer*, number 24.★

We had once planned in 1978 to publish a book together. When he

★ The publisher, John Embry, hated the new rugged style of masculinity I was chronicling in *Drummer*, which I had dubbed on the masthead "The American Review of Gay Popular Culture." He was caught in a 1950s idea of leather and not very progressive: "It's the worst-selling issue we ever had."

Robert was angry with Embry's attitude, especially when Embry became

died, he left my name on his list of people who knew him in the 1970s. On that particular list, I believe, I am the last one alive. I was the first editor to publish his controversial leather photographs.★

Our work together matched our mutual interests and companionship.

Play "Moon River" or not, the fact is we were sweethearts. We were lovers. We were in love. Then we were close friends.

I found him models, dealers, and sex partners.

Robert made everyone an accomplice to his adventures.

He was a voyeur with a streak of exhibitionism.

He begged me point-blank to write about him.

"I want to be a story told around the world," he said.

At least, I knew, with him, what I was for.

I think Robert enlisted all his friends who were writers to play Boswell to his Johnson.

Robert never wrote. He gave interviews. Interviews were his forte.

Through the years, Robert's personal life, public career, and particularly his expression of civilized human values through photography have kept my interest.

My 1990 novel, *Some Dance to Remember*, which Robert read in draft, and to whom it is dedicated, is about the sex, drugs, and rock 'n' roll of the seventies and early eighties before AIDS. Within the story, a fictionalized defraction of Robert moves from our private relationship to world-class artist, with all the attendant joys and problems that happen to a friendship when one of the friends becomes a media sensation.

The demands of his professional work, his prolific output, his traveling to international shows, took a toll: the more famous he became, the lonelier his life.

His letters and late-night, long-distance telephone calls were confes-

obsessed with trying to recreate Robert's photograph of the cock and balls tied down on the bloody bondage board. Robert accused Embry of outright plagiarism.

The Mapplethorpe cover turned out to be, in fact, a classic. It was the first demimonde magazine ever to devote a complete issue to men into a cigar fetish.

Two subsequent cigar-themed issues have appeared, but none featured models with the same hypermasculine style as Mapplethorpe's.

Robert went on to do much work with the model, Elliot Siegal.

★ "Movement without Aim: Methodological and Theoretical Problems in Oral History," in *Envelopes of Sound: Six Practitioners Discuss the Method, Theory, and Practice of Oral History and Oral Testimony*, ed. Ronald J. Grele (Chicago: Precedent Publishing, 1975), 142.

sionals of anxiety. On the other side of celebrity, he felt isolated. He was always sure of himself aesthetically and professionally, but personally he felt invisible. That's why his series of self-portraits is important.

His autoshots show him revealing himself as a work in progress.

For all the art of his photography, Robert Mapplethorpe was his own best creation. He was, in Tom Wolfe's term in *Bonfire of the Vanities*, a social X ray of his times.

Mapplethorpe's best decade was 1975–1985.

He pursued art for art's sake. The fame and the money made up in quantity what his life lacked in longevity.

His AIDS was diagnosed in 1986 and he died in 1989.

Robert's work mirrored American society undergoing profound change in a tempestuous time in a specific place: the 1970s and 1980s in Manhattan.

To the degree that his art serves as a litmus test of the continuing American *fin de mille* debate between the just-say-no national character of denial and the individual right to choice, Robert, as a person and as an artist, has been misrepresented in the sound and fury.

Robert Mapplethorpe, the person, was swept away by political controversy about the arts, by critical articles about photographic technique, and by the epidemic of the millennium.

2
FAMOUS FOR 15 INCHES

This memoir intends to present some evidence that once there was a living, ambitious, sensually playful, scared, intelligent human being who, one day, finding a camera in his hand, looked through the viewfinder, like a gypsy with a first crystal ball, and saw the chance to focus his instamatic visions.

Robert was a sharpshooter.

He had an artist's eye.

Plus a contemporary pop culture concept of photographic art as immediate gratification in a society living in the fast lane. Sculpture, his major at Pratt, or painting, took too long.

With the camera, Robert mastered time itself in an art form not rooted in prehistoric ritual but invented by technology.

We both knew he would lead a fast, brief life.

Long before AIDS, I told him so in 1979, personally, and in print in the 1981 short story "Caro Ricardo." The plague had nothing to do with the romantic brevity in Robert's eyes. If AIDS hadn't got him, something else would have.

He was as fated as Byron, Shelley, and Keats to die prematurely, the same as James Byron Dean, Jimi Hendrix, Janis Joplin, and his famous look-alike, the poet-singer of the perverse, Jim Morrison of The Doors.

Death did not frighten him. He said so the way only the young can say so.

Death was an inevitability leading to suspected immortality.

"You can't cheat death," he said outside an antique shop on Greenwich Avenue in the Village, "but you can cheat life."

"How?" I asked.

"By not living."

Malcolm Forbes's epitaph fits Robert equally: "When alive, he lived."

Robert's posthumous notoriety typifies the "spin" he put on his life. Nothing was what it seemed to be. Robert was not a literal person.

Everything he saw was an ambiguous shade of something else.

He was a metaphorical person. The irony was he took photography, which is a literal person's perfect way to show life in snapshots, and raised the single frame to a metaphor.

A Mapplethorpe lily is not a lily is not a lily.

This is trick photography shot by a trickster.

Now you see it.

Now you don't.

Now, if you're lucky, you do.

Senator Jesse Helms never got it.

Helms probably thought that Robert's drop-dead flowers, always actually more explicit than his human nudes, were, uh, flowers.

And not the sex organs of plants or, omigod, phallic and vaginal symbols!

Metaphor is a problem for fundamentalists clamming up on the hard shell.

Robert captured the essence of flowers, figures, faces, and fetishes so resonantly on the literal level that the very perfection of the moment frozen in the single frame caused the very being of the object to suggest its own becoming . . . other.

That capturing of the suggestive instant of becoming ambiguous was his existential magic.

Elegant flowers become sexual organs.

The shadow of a flower becomes the horned god.

Sexuality becomes theology.

Face becomes mask.

The mirror becomes window.

Life becomes death.

The cross becomes the crown.

Light becomes dark.

The looking glass makes the way out become the way in: the anal insertions.

This spinning ambiguity causes fear in the literal-minded who look at his single-shot metaphors.

He intended his stills to be "moving" pictures, photographs that "moved" the viewer, through assault if necessary, for the viewer's own good, the way one slaps someone who is hysterical.

Every Mapplethorpe photograph is a single frame in a movie, which, if it existed, would be a series of dissolves:

> the lily dissolves to the genitalia,
> the face to the skull,
> the skull to the lily.

Although versed in film and video, Robert consciously kept with the discipline of the single-frame still camera.

Robert was a Platonist: he saw the real and he saw the ideal.

He saw the finite world in a classically time-bound way, and he wanted to show that way, that way of ambiguity that lies in all things, to those who thought what they saw was what they saw, what they believed was what they believed, and what they felt was what human feeling was.

The insistence on the "ambiguity of the human condition" was Robert's only social comment as he followed an almost pure aestheticism.

This means trouble in River City.

Robert's presentation of ambiguity, of course, is what slaps the authoritarian face.

Ambiguity pulls the prayer rug out from under orthodoxy, political, social, religious, and sexual.

Ambiguity, by its very presence, suggests that the observer may observe

the surface but may never read the essence; the way some people know the price of everything and the value of very little.

My brother, a career military sergeant, once, in desperation, said to Robert and me, when we had been verbally playing loop-the-loop around him, "I can't keep up with what you're saying. You both always say one thing and mean something else. I don't like being made fun of."

He said it precisely: in the presence of ambiguity, the uninitiated thinks maybe he might be the butt of a joke everyone but him gets.

American education hardly teaches literary interpretation or art appreciation.

Private interpretation of the Bible is perhaps the worst example of bad literary interpretation ever put into self-serving hands. The more a passage is stared at, the more it twists. From biblical "scholarship," it's an easy jump to righteous exegesis of art. The main criterion of judgment in America is a kind of moral theology that instantly jumps to classify something as sexual, and, therefore, threatening, sinful, venial, or mortal.

This mind-set comes perhaps from the only instance where most Americans can see something meaning two things: the dirty joke, wherein one thing is said and another meaning is meant.

Robert's ambiguity is sometimes sexual, but not always, and nowhere near the degree that his censors declare. His ambiguities lie more along the spine of chilling visions that humans refuse to acknowledge. The biggest denial, of course, is the denial of death. Robert worked thanatos the way he worked eros in ticks of clicked frames. He addressed the *vanitas* of fame and cash in the *morituri* portraits of Katherine Cebrian (1980), William Burroughs (1980), Louise Bourgeois (1982), Alice Neel (1984), Willem de Kooning (1986), Louise Nevelson (1986), and, finally, himself: *Self-Portrait with Death's Head Cane* (1988).

His politics embraces only the ambiguity that comes with change. Change is what conservative authoritarians cannot abide.

After avoiding the draft in the sixties, Robert, in the seventies' age of activism, made no public statements about the Vietnam War, about civil rights for minorities, about feminism, about sexual liberation, about the homeless. AIDS and his art, however, made him as eloquent as he could be. When sick with full-blown AIDS, he offered himself up for, or at least accepted as a pioneer volunteer, any treatment that might help. By establishing the Mapplethorpe Foundation, he achieved direction of his art and his estate to protect his photography while funding the arts, and

set his fortune on a course of endowing AIDS research and treatment facilities.★

Not particularly political while living, Robert postmortem has become symbol of the *garde assautif* whom religionists fear. Or at least his work has.

Robert was no free-thinking free spirit. Personally, he was rather direct about people liking what he liked. Or else.

He cared little really about sexual politics, racial equality, established religion, or government grants.

He would have liked the publicity the National Endowment for the Arts got him, but he had expressed to me as early as the summer of 1982 his contempt for any censor who got in his way. Robert was never government-dependent in his life. He never demanded grants or aid as his entitlement.

He received, instead, in the tradition of artists, the support of patrons; but he always gave his patrons, especially the beneficent Sam Wagstaff, as good as they gave.

He was a good arts hustler.

He recognized art as another form of business, the way that Hollywood talks not of the art of the motion picture but of the industry.

Robert was in business to make art and in art to make money. He could have been quite well off in his very successful career as a commercial fashion photographer. His first fine art exhibitions with Holly Solomon in 1977 received enthusiastic reviews and public acceptance.

Patronage may have opened doors, but once he walked through, he always had the talent to deliver the work.

He saw nothing wrong with making money while he made art.

He had no intention of living a bohemian life and dying young, poor, and uncelebrated in a Greenwich Village garret.

From the start, he ardently courted recognition and projected success ratios.

When he first mentioned his relationship with the poet-singer Patti Smith, he said, "Patti deserves to be a legend."

Deciphering Robert, I found that what he said of Patti, whom he regarded and photographed as his alter ego, he said about himself.

★ After his death, the Robert Mapplethorpe Foundation endowed an AIDS-care unit at Boston's New England Deaconess Hospital, where he died at 6 A.M. on March 9, 1989.

Robert prided himself on his intelligence.

He was not deluded.

He knew how to take care of himself.

Never did he think that the government has an obligation to support art. Never did he think that government has the right to censor art.

He believed in the separation of art and state.

He believed in free enterprise, so much so that he ensured the only kind of worldly immortality one can be sure of: before his death, he created the Robert Mapplethorpe Foundation, Inc.

Robert was more realistic about money than venal.

In America, cash is the main way people keep score.

Living well is the best revenge.

3
SEX, LIES, AND HASSELBLAD

Robert's cynical edge led him safely through three decades of American denial and deceit. He was a visionary, a seer who was a sayer of what he saw, coming up in the flower child sixties of the New York underground counterculture presided over by Warhol, who turned the Campbell soup can into proletarian pop art. He became a photographer of note in the seventies, the Decade of Liars, when lies about Vietnam turned to lies about Watergate and led to the lies of the eighties' Iran-Contra and savings-and-loan scandals.

Lying, the denial of truth, became the political art form with Nixon as its model at a formative point in Robert's life.

The cover-up of truth became the new fig leaf.

The *Esquire* cover of May 1968 showed Nixon in profile with four disembodied hands applying hair spray, blusher, powder, and lipstick to the mask of his face. The cover copy read, "Nixon's last chance. (This time he'd better look right!)"

Joe McGinniss, in *The Selling of the President 1968*, wrote, "Television seems particularly useful to the politician who can be charming but lacks ideas."

Nixon opened the masquerade that persisted through the media-manipulating Reagan regency that closed Robert's life.

The value of lying and the value of truth intrigued Robert, particularly as he moved through the *vanitas* of fashion advertising and the *bal masque* of society and personality portraits.

Face, the most intricate surface of the human body, became Robert's crucible of search.

In the end, he found every face a mask.

It was no accident that at the end of his life, Robert shot the face of Fawn Hall, Oliver North's complixative secretary, as well as U.S. surgeon general Koop, who, on the side of truth, tried to break a nation's denial and lies about AIDS.

Dealing with denial and lies, affirmation and truth, in the faces of others, Robert used his camera as a method of exploration.

Dealing with his own face, he used his photography as means of self-expression in a series of self-portraits that dramatizes the life-movie he led.

Toward others, he fixed his camera as a gun, focusing his sitters in the crosshairs of his site, shooting at that precise moment when the face and the mask of the face are either in harmony or at greatest conflict.

What is false and what is true are left to the jury of viewers.

Robert, ever the formalist, rarely pronounced judgment in photographs of others. In fact, women as well as men who sat for portraits recount his kindness.

In his portrait of infamous government secretary Fawn Hall, in fact, in any of his portraits of women, Robert explores the masks, the feminine mystique of personal, societal, moral, political, and gender otherness and leaves the conclusion to the viewer.

When Robert shot his mentor Holly Solomon in a portrait, Holly was grieving the loss of a friend and begged Robert not to shoot her. Robert, in a heat to shoot his 1978 book about dealers and art, insisted that he shoot Holly, who had been the first dealer to exhibit his work.

"So I went over to his studio at Bond Street," Holly Solomon said. "I could barely stop crying. I said to Robert, 'You know looking at me that it is not possible to take my photograph.' He said, 'Don't worry, Holly. I'll touch it up.' When he showed me the proof, I said, 'You can't print this.' I was overwrought with grief. So Robert retook my photograph. He understood that the photograph was too private; it never will be a public photograph."

The imprint of this nonverbal Mapplethorpe exists in an American tradition of artists who are writers. Their verbal images enrich the literature of the visual. Henry James in *The Portrait of a Lady* gets verbally behind the Mapplethorpe presentation of face with some explication of how a portrait of a face, masked or not, operates as a social X ray.

"By the shell," James wrote, "I mean the whole envelope of circumstances . . . we're each of us made up of some cluster of appurtenances. What shall we call our 'self'? Where does it begin? Where does it end? It overflows into everything that belongs to us—and then it flows back again. I know a large part of myself is the clothes I choose to wear. I've a great respect for *things*! One's self for other people—is one's expression of one's self; and one's house, one's furniture, one's garments, the books one reads, the company one keeps—these things are all expressive."

Robert's intellectual and aesthetic line of descent can be calculated historically from the Puritan and transcendentalist ethic of New England, from the first photographer depicted in American fiction, Hawthorne's Holgrave in the 1851 novel *House of Seven Gables*, through Emerson and Thoreau and Whitman, all of them impressed with Daguerre's all-seeing eye, which was no longer the Old Testament Eye of God as seen framed in the triangle on the dollar bill, but was the new eye, the technological eye of the camera.

So impressed was Emerson by the technology invented simultaneously and separately by both the British aristocrat William Talbot and the French stage designer Louis Daguerre (who filed his 1839 patent two weeks before Talbot) that Emerson added to his essays the metaphor that humankind's evolution would one day turn people into one organ, the eye.

The only real autobiography
Mapplethorpe created
to organize the world around himself
is his series of self-portraits.

Thoreau went to Walden to see the macrocosm the way Mapplethorpe left Queens to see Manhattan. Whitman, based in Camden, New Jersey, roamed American streets, and had filmmaking been available would have shot a composite montage of America. *Leaves of Grass* is a treatment of one photographic image after another.

Robert's progress can be calculated from the history of painting, which, even more than the sculpture he studied at New York's Pratt Institute (1963–1970), led him to a crisp style of perception and presenta-

tion. Robert, by the end of his life, when photography celebrated its 150th year, made the camera seem new again. He was a mirror to the world of the seventies and eighties. To some, he was a liberating window of insight. He provoked viewers to reevaluate the essence and form of what they saw.

Robert's impact can be calculated theologically on Catholicism's changing role as institutionalized keeper. Catholicism is the nuclear fusion of a broader Christianity. Often the two institutions are very much alike. Robert's personal exposure to Catholic ritual and icons gave him a classically confused approach to beauty, truth, sexuality, humanity, and spirituality. His art was one answer to the confusion.

Robert Mapplethorpe is not a Catholic photographer or an erotic photographer any more than he is a homosexual photographer. He is none and all of those. American religionists make comedy of themselves seeing sex in Mapplethorpe's photographs. Sex, like beauty, is in the eye of the beholder. The person reading Rorschach blots of light and shadow is the one who sees sex in ink stains.

Both art and morality change and evolve, especially in relation to one another. America has moved from a society that photographs its babies nude to a society that freaks out over simple nudity of children, males, and, in its latest twist, of women. The history of morality playing Pin the Fig Leaf on Art is a party game of some humor as the fig leaf seems to grow to a complete set of the emperor's new clothes.

4

IN THE HELIX BETWEEN ROBERT AND ME, NEARLY EVERYONE IS DEAD

If I dance to remember on Robert's grave, at least I dance by his invitation.

This memoir is a personal and collective journal of Robert Mapplethorpe remembered by some of those who knew him. The remembrance is factual and impressionistic. This is not a clinical biography of a famous photographer. The words, feelings, and memories are not the style of art critics talking of his technique and his place in the history of art.

My "take" on Robert is very personal, stylized, and as idiosyncratic as he was and we were together at a time when all the world was at play.

My collection of journal notes, tapes, letters, calendars, conversations, photographs, interviews, files, and phone bills recreate Robert in our shared *mise en scène*.

These recollections reflect the person who was Robert Mapplethorpe when he was abroad in the world. This is not a "take" of his childhood or of family relationships. Many of the memories and anecdotes are of famous people who in their own right have celebrity recall of their days and nights with Robert.

The dead Mapplethorpe was, unlike the living Mapplethorpe, a mass media sensation.

The personal Mapplethorpe had a Coca-Cola in one hand, a telephone tucked between his shoulder and his pale cheek, a Kool cigarette in his mouth smoking up at his squinted camera eye, while he chopped up MDA (a variation of speed) on a mirror to snort before heading out to plow the pertinent.

The private Mapplethorpe who played and laughed and learned and shared life was a man whose diversity of acquaintances was so broad that many of us were unaware of each other's separate bonds with Robert.

After all, he was just one of us: another artist.

I knew him intimately from 1977 to 1982, and then by telephone after 1982, when AIDS quickly emptied the jetliners of gay travelers tripping the Great Gay Bermuda Triangle from JFK to SFO to LAX.

This biomemoir is a survivor's document.

Nearly everyone hanging in the helix between Robert and me is prematurely dead. In my writer's conscience, I write nothing they would contradict were they alive.

None of them, Robert included, have any more memory than the remembrance we give them.

I bring my professional credentials, years of writing, teaching, working with artists, and persona to this pentimento the same way I gave them to Robert when he sought me out for help, friendship, love, and sex.

This outlaw reminiscence, beholden to no one, sponsored by no one, censored by no one, is a personally aesthetic, political, theological, and moral documentary.

This Mapplethorpe dossier is a detective story of people tracing Robert, the pop culture phantom, lost in controversy, technique, bequests, and franchise rights.

The person he was became a symbol.

His face was projected on the outside walls of the Corcoran Gallery, a block from the White House, during a rally by the Coalition of Washington Artists, the night before his canceled show "The Perfect Moment" was to have opened inside the Corcoran's walls.

His name became a sound bite, a buzzword: "MAPPLETHORPE!"

His name became an almost Mephistophelian adjective denoting both content and style: "Mapplethorpean!"

Ah! The complexity of Being Mapplethorpe!

Add the word *darling* to the next four lines.

How Mapplethorpe!

Hardly Mapplethorpe!

Too Mapplethorpe!

Very Mapplethorpe!

The Robert Mapplethorpe in these pages is many Roberts.

Everyone has his or her own Mapplethorpe.

As I have mine.

None detracts from the other. Relatively, Robert depends on all his survivors to complete his "portrait" in the manner of their own gifts.

Robert was living proof that moments may be perfect, but people are not.

Robert cut a romantic figure of an artist who lived fast and died young.

Of course, his photographs are all about terribly existential convergences of life, death, sexuality, beauty, and evil.

Of course, his art is a lightning rod for free speech, sexual politics, and academic papers.

As Ezra Pound said, "all artists are antennae of the human race."

I'm happy that once I sat at tables with him, slept in bed with him, fucked his face, published him, attended shows with him, rehung his photographs, buffed his nipples, argued and fought and made up with him, because on his rocket ride to his deliberate celebrity, he needed each and everyone he met.

He was brilliant.

He burned bright.

He was always so much alone.

Truth lies here.

In these pages lies the relative truth of memory.

It is unlike what anyone else can do.

And I'm writing it because Robert asked me to.

He more than once said, "I want to be a story told around the world."

In my novel, *Some Dance to Remember*, several scenes, discussions, and themes actually reflect what really happened to the relationship Robert and I shared. Robert had read, as early as 1979 and 1980, draft sections of the novel that was dedicated to him. We saw what was happening to us. We were very bright together in love in the downward vortex of his relentless ambition. We saw what was happening to him.

The demands of ambition and fame took him away from many intimate friends.

That hurt him.

That hurt me.

Fame hurt us all.

I took solace in Patti Smith's parallel-seeming entrances and exits. She had her career. I had mine. Robert had his. We all goddamn had careers.

One rarely loses a friend to anything but drugs, AIDS, or celebrity.

In 1979, Robert asked me to write a text for an avant-garde coffee-table book of his leathersex photographs. The title, a photoscatological pun, was *Rimshots: Inside the Fetish Factor*. I have the fifty-four copies of the photographs he sent me. He had my words in complete manuscript.

Then his fifteen minutes of fame suddenly began. . . .

Ciao, Roberto!

The rest is personal and public history.

And *Rimshots* awaits photographic authorization from the Mapplethorpe Foundation to be published.

Ironically, *Some Dance to Remember* was fiction, yet many readers think that novel is autobiography. On the other hand, this biomemoir, which is as true as the remembrance of anything past, may read like fiction to anyone in denial; but anyone who actually experienced the Golden Age of Liberation in the 1970s knows that even the far reaches of excess are true.

This is verbal photography. This is a portrait of the Mapplethorpe as a young artist.

"All photographs are true," Avedon wrote, "but none is accurate.*"

Ultimately, I can remember what everyone said or did only according to my own lights that were turned on when I was there. If what is

* Richard Avedon, *In the American West (Photographic Portraits 1979–1984)* (New York: Abrams, 1985.)

remembered is a spiritual confession, then it's a whisper through a grille on a wet afternoon about an accomplice in the High Crime of Art.

If I have misrepresented anyone in any way, forgive me stumbling like Geoffrey Chaucer telling tales on the way to Canterbury:

> *But natheless, whil I have tyme and space,*
> *Er that I ferther in this tale pace,*
> *Me thynketh it accordant to resoun*
> *To telle yow al the conicioun*
> *Of ech of hem, so as it semed me*
> *And whiche they weren, and of what degree,*
> *And eek in what array that they were inne.*

To the dead, I have tried to be true.

I am long past tears; so many are dead so young.

As for the living, I cannot begin to fathom how they remember the past imperfect of their changing minds.

For that reason, this which I write—all of which was somehow said or done—so as it seemed to me, I write ALLEGEDLY.

I may be dancing to remember.

I may be dancing in the dark.

I may be dancing on Robert's grave.

I'm dancing at his request.

PENTIMENTO FOR ROBERT MAPPLETHORPE: FETISHES, FACES, AND FLOWERS OF EVIL

"He wanted to see the devil in us all . . .
The man who liberated S&M Leather
into international glamor . . .
The man Jesse Helms hates . . .
The man whose epic movie-biography
only Ken Russell could re-create . . ."

Photographer Mapplethorpe:
The Whitney, the NEA and censorship,
Schwarzenegger, Richard Gere,
Susan Sarandon, Paloma Picasso,
Hockney, Warhol,
Patti Smith, Scavullo,
sex, drugs, rock 'n' roll,
S&M, flowers, black leather, fists,
Allen Ginsberg,
and, once-upon-a-time, me . . .

The pre-AIDS past of the 1970s has become a strange country. We lived life differently a dozen years ago. The High Time was in full upswing. Liberation was in the air, and so were we, performing nightly our high-wire sex acts in a circus without nets. If we fell, we fell with splendor in the grass. That carnival, ended now, has no more memory than the remembrance we give it, and we give remembrance here.

This article was originally published in *Drummer*, September 1989.

In 1977, Robert Mapplethorpe arrived unexpectedly in my life. I was editor of the San Francisco–based international leather magazine, *Drummer*, and Robert was a New York shock-and-fetish photographer on the way up. *Drummer* wanted good photos. Robert, already infamous for his leather S&M portraits, always seeking new models with outrageous trips, wanted more specific exposure within the leather community. Our mutual, professional want ignited almost instantly into mutual, personal passion. Movie scripts throw couples together this way. Life imitates art. We became, for over a year, a bicoastal Montague and Capulet.

Robert was a serious artist, disciplined enough to play by night and work by day. His "take" (one of his favorite words) on life pleased me: he was a grownup, obviously gifted with superb talent. That made him appealing. As an editor and a man, I had had enough of gayboy dilettantes who wanted to write but never wrote, who wanted to shoot photographs but spent their cash on coke, not cameras, who wanted to sing but never sang. Sex and drugs drained their discipline for creativity.

Robert Mapplethorpe's bawdy Baudelaire life was the inspiration of his art. "You live it up to write it down," he told me. "I expose my sexual kink on film. We both have the Catholic need to confess." Letters and notes sealed our east-west romance. "Jack, if you're not free for dinner tomorrow night, I'm going to beat you up. Love, Robert" (July 26, 1979). To Robert, S&M did not mean sadism and masochism so much as sex and magic.

Robert, by the mid-1970s, had become the Bad Boy of the New York art scene. Ironically iconoclastic, he became icon himself as artist and as model. He shot Warhol. Warhol shot him. Whenever I whizzed into Robert's 24 Bond Street loft, I faced him, hanging over the toilet, looking down, insouciant, from the framed portrait Scavullo had lensed of him. Francesco caught Robert, hands jammed into his leather jeans, Kool cigarette hanging from his mouth, torn T-shirt tight around his speed-lean torso, his Road Warrior hair tousled satyrlike. He confessed in his letters that his main enjoyment in sex was uncovering the devil in his partner. I should have been more careful with this photographer who worked with light and shadow. Lucifer, whose name translates as "Archangelic Light-Bearer," was, in Robert, a glorious angel flying always intensely too close to the edge.

Robert, innocent as any victim, died of AIDS on March 9, 1989, at the pinnacle of his international photographic success. He, with his early S&M

work published in *Drummer*, was the archetype of the "cross-over artist" who comes up from the gay subculture, same as Harvey Fierstein and Boy George, to acceptance by their own best creations.

At age sixteen, he made his first trip from Floral Park, Long Island, across the border from Queens, where he was born November 4, 1946, into Manhattan. He attended Pratt Institute in Brooklyn, sniffing around the edges of photography, making mixed-media collages from other people's photographs, until, in the early seventies, art historian John McKendry, curator of photography at the Metropolitan Museum of Art, brought Robert his first camera to take his own photographs. McKendry's wife, Maxime de la Falaise, provided Robert's entrée into high society, European and American.

Soon after, at a small gallery opening, a group show of young photographers, including Mapplethorpe, Robert told me his life abruptly changed. A man, admiring one of Robert's photos, turned to him and said, "I'm looking for someone to spoil."

"You've found him," Robert said.

The man was the charming, aristocratic millionaire Sam Wagstaff, the brother of Mrs. Thomas Jefferson IV. Sam was a great patron of the arts, who almost single-handedly, in the seventies, came from self-imposed reclusivity, with Robert in tow, to create the market for the new genre of fine-art photography. Robert became Sam's protégé and, for a time, lover. They were born on the same day, twenty-five years apart.

One splendid, sunny March afternoon in 1978, after Robert and I had disembarked from an SFO-to-JFK flight, we taxied directly to the restaurant at One Fifth, where Robert glided us into a green banquette. Several people nodded and waved. Robert's chiseled face, porcelain skin stretched tight over classic bone structure, broke into his easy grin. "I'm not into celebrities," he once told a *New York Times* reporter.

Nevertheless, celebrities came to his Bond Street loft to sit in the south light of the front room with its silver umbrellas and industrial piping. Everyone from Princess Margaret to Arnold Schwarzenegger wanted to be photographed by the fashionable Bad Boy with the Hasselblad.

"Arnold was cute," Robert said. "He sat with all his clothes on and we talked. He's nice. He's bright. He's straight. The gay bodybuilders I've been with are so 'roided out they're like fucks from outer space. I can't relate to all that mass. It overshadows personality. Arnold's soul is big enough to fill his muscle with his person."

Robert's relationship with bodybuilder Lisa Lyon was the best of muscle-and-photography. Lisa was the first of the new wave of female bodybuilders and Robert promoted her, because she was like him, reversing stereotypes, on the outrageous, androgynous cutting edge. Lisa's aura at supper on San Francisco's Castro, at a clone café appropriately named Without Reservation, was almost a psychic twin to Robert's. She is a beautiful woman of ebullient wit, so full of it that when one studies the non-Mapplethorpe photographs of her posing in *Playboy*, a feeling of Mapplethorpean sexual satire subtly torpedoes the Playmate image she projects sub rosa on Hefner's pages.

I drank in the atmosphere at the posh One Fifth. Robert lounged comfortably, waiting for Sam. "Did you ever go to Max's Kansas City?" Robert asked. "Did you ever *have* to go to Max's Kansas City? I went to Max's every night for a year. I had to. The people I needed to meet were there. I met them. They introduced me to their friends."

Robert delighted in acting out the tormented existentialist artist role even while toying with the celebrities and the editors of magazines. *Vogue* woke us up one morning—was it Diana Vreeland on the line?—begging Robert to shoot Faye or Fonda or Gere or Travolta or somebody hot they needed fast. I could hear only his side of the conversation, our bodies tucked together, my front to his back, a perfect physical fit, lying slugabed in his twisted sheets on his mattress on the floor.

"Ah, a *principessa*!" Robert said. *Vogue* wanted some princess, part of the stylish Eurotrash invading the New York postmodern club scene. Robert liked climbers. He had a soft spot for princesses and a hard-on for nasty sex.

Life with Robert was the cabaret of Dr. Caligari!

Still waiting excitedly to meet Sam at One Fifth, I realized what brash talent Robert had scandalizing his way into prominence as a "society" photographer, all the while assaulting mainstream conventions. Yesterday, John Paul Getty III; today, the toughest S&M hustler I'd ever hired for the cover of *Drummer*; tomorrow, the three-year-old daughter of Susan Sarandon. His acquired character was hybrid Manhattan society studded out from Times Square porn shops. His driving ambition was to combine the "forbidden" Forty-second Street gut-and-gonad feeling he experienced at sixteen seeing naked men in *Physique Pictorial*, to be the gut assault in his own elegantly erotic photography.

Across the crowded boîte, Sam Wagstaff made his entrance. Obviously

in love with Robert, he threaded his way through tables of wannabes, celebrities, and has-beens desperate to be recognized. Robert introduced us fast, taking Sam's hand, pulling back in surprise at the diamond ring Sam had slipped him. "Welcome back," Sam said.

Robert, swear to God, bit the diamond with his teeth. I nearly died. To Robert, who fancied himself devilish, nothing was sacred. Sam laughed and whisked us up, up, and away to his immense all-white penthouse atop One Fifth. His zillionaire digs were sparsely furnished, but what was there smelled of money and good taste. Art of all kinds lay splayed about in careful, careless piles. Robert's interest in photography had kindled Sam's. Together, they had accumulated the best of late-nineteenth- and early-twentieth-century photography, nearly all of it male nudes shot in the homoerotic covert style of the times.

The past in that present met the future. This planet's first fine art photographers, such as George Platt Lynes, saw the world through the lens for the first time. Sam and Robert bought up a first-rate collection of the earliest art photography. Robert referenced their primordial perspective, but stayed true to his earliest experimental Pratt Polaroids, to create images from his own Genet-icized world: sleazoid S&M, bondage, men encased in full-body black rubber suits, leather masters with slaves in chains in decorator apartments (Brian Ridley and Lyle Heeter), men with bodies erotically scarred with razor blades, men drinking through pissing jock-straps (his triptych, *Jim and Tom, Sausalito,* 1977), men with fists up their butts, a man with a satanic tattoo on his forehead who, when I met him, lived in an apartment decorated like a subway car from rubber mats to silver walls and lighting, and who, under the female nom de plume Judith Gould, wrote a sexy best-seller that became a sensational TV mini-series.

"You could do the same," Robert counseled me, "if you'd travel in the right circles."

"I won't suck high-society ass."

"Make them think they're sucking yours."

Robert was as well acquainted with the English and American smart set as he was with the after-hours fuck palaces of male erotic desire. In 1970, he had starred in Sandy Daley's film titled *Robert Having His Nipple Pierced.* He worshipped consensual, ritual, sexual "violence." He gloried in male flesh and advertised for bodybuilder models: his taste running from intense Caucasian perverts to streaming erotic blacks for his *Black Book.* In 1981, wanting my then lover Jim Enger, a championship bodybuilder, to be

captured in all his physical glory with Robert's creative glory, I set up a shoot all three found very satisfying. My bodybuilder lover, however, refused to sign a release; so Robert, demonically, cut off his head and turned his torso into a full-color greeting card.

Queens, I tell you, no matter how masculine, are queens!

In 1979, Robert gave me more than one hundred photographs of some of his most blatant work, so I might start paragraph one at the epicenter of his biography: his most personal photography. Some of these photos have yet to see the light of day. Later, in 1983, Robert sent me two original, single prints whose personal value far exceeds the extravagant price offered by galleries, having heard on the grapevine that I have three solo prints, the photocopies, and color proofs Robert gave me as lover, friend, and biographer. In death as in life, Robert is probably laughing at the cost of my sentiment; but some things, Roberto, have so much personal value they have no price.

One of Robert's photo series, illustrations for an edition of Rimbaud's *A Season in Hell*—a book whose words were lyrics to Robert's visual music—included one of the many self-portraits Robert shot, this one as a horned devil. My favorite of his self-portraits (1978) displays him in black leather chaps with a bullwhip handle, inserted in his ass, curling scatologically down its full leather length. Robert, as Pan, knew who he was and he was not shy to show it.

"This is," I told him, "your first reincarnation in three thousand years."

"How so?"

"I intuit it," I said. "I get reincarnational readings off some people."

"I'm one of them?"

"You're the most intense of them all."

The world and Robert Mapplethorpe were on no uncertain terms with each other. In this NYC incarnation, or in past goat-footed Dionysian lives, Robert demanded, managed, and delivered what he wanted from life. He lived on an ascending arc of creativity, notoriety, and success. He died with seven books in print: a bibliography of critics and social historians, not the least of which is Susan Sontag; a primo list of more than one hundred international gallery exhibitions, the triumphant epitome of which was the immensely successful showing at the Whitney Museum of American Art, from July 28 to October 23, 1988, which Robert gallantly attended in a wheelchair and an oxygen mask. He is one of a few photographers ever so recognized by that museum.

Robert Mapplethorpe knew how to do *Veni-Vidi-Vici*! He got from life all that he wanted of its quality, if not of its longevity; but then he purposely lived in the romantic tradition of Byron, Shelley, Keats, Janis Joplin, Hendrix, James Dean, and Jim Morrison, whom he most resembled in look and style. There are worse things than dying a success at an early age.

The most horrible photograph I've ever seen of anyone this side of Dachau is Jonathan Becker's photo of an emaciated Robert Mapplethorpe attending the Whitney opening. AIDS is a speed trip of the aging process. Robert looks a million years old in Becker's brilliantly revealing photograph, which, giving a famous face to AIDS, appears with Dominick Dunne's confessional essay, "Robert Mapplethorpe's Proud Finale," in the February 1989 issue of *Vanity Fair*.

I wrote about Robert in my 1978 story that was republished in a 1984 anthology, *Corporal in Charge of Taking Care of Captain O'Malley*, that Robert, Pan, ever-reincarnate, "will, when his next death-passage is appropriate, take his life with the same hands with which he has created and crafted it. He will neatly, stylishly even, finish it." Dominick Dunne's feature interview confirms that prediction right down to the death's-head cane in his benumbed hand that had been so adroit at making love and photos.

Robert's early work, sexually explicit leather images, many of them shot in the fishing-village-with-an-opera, San Francisco, shocked the New York art world in the seventies; but what succeeds better than shock? His reputation spread fast beyond the Manhattan novelty of a new talent in SoHo. The Bad Boy had tuxedo elegance and leather attitude. His devilish smile charmed the proverbial apples from the trees of patrons, grants boards, and gallery mavens. At $2,000 a shoot, the right people sat in Robert's studio. The right runs of platinum prints and lithographs, dispensed in wallet-whetting limited editions, found their way into the right galleries, the right magazines, the right addresses.

Robert was a shooting star, a lone rider, a nova-bright talent in the fast lane, careening with me, one April night, up the Avenue of the Americas, both of us loaded, but less loaded than the taxi driver who scared us both so much we sat cuddled on the floor of the backseat. Because I was a writer, he wanted me with him to chronicle (as he knew I already was) in my journal what his life, with all its notorious celebrity, was personally, sexually, and aesthetically.

He wanted not another professional critic, but a more intimate biogra-

pher. "You do write well," he wrote me on April 20, 1977, "I think we should go fast on the book."

He confessed, late one night, walking hand in hand from his favorite haunt, the Mine Shaft, that, as a starving brat fresh out of Pratt, he and Patti Smith had clerked at Brentano's, pilfering loose change. Patti wisely ended their clerking career. One afternoon at the cash register, another clerk was caught in a bad scene. Robert was shaken by the wild shouting and accusations of his co-worker's close call. "So," Patti said, "quit. We can manage."

They did. Robert's most-photographed model was himself. Next came Patti. She was a poet/singer/artist who in tandem with Robert set Manhattan on its ear. Leaving behind them the notorious Chelsea Hotel, where Robert kicked a hole through the wall dividing their rooms, together they took off: a famous couple, an androgynous Burton and Taylor. Within a short time, Robert was a staff photographer for Warhol's *Interview* magazine and Patti was a major recording star, the first of the female New Wave punk rockers whose chart-busting albums, like *Horses* and *Easter*, featured chiaroscuro cover shots of Patti by Robert Mapplethorpe. "Patti," Robert said, "deserves to be a legend."

Robert was a legend in this own time. MAPPLETHORPE! His name acquired elitist and popular mystique. Under Sam's guidance and through the astute management of the prestigious Robert Miller Gallery, limited prints of Mapplethorpe photographs zoomed up in price, a sure sign of success in America, where money is the main way of keeping score.

Robert's first exhibit at Miller, in 1978, coupled with a small show of Patti's graphic art, created a mob scene of white ties, pearls, black leather, and New Wave funk. In 1981, a Mapplethorpe print sold for $2,000; in 1984, $5,000; in 1987, $15,000. In 1986, Sam, whom Robert truly loved, died of AIDS, leaving Robert $5,000,000.

By 1988, Robert's name and face were so famous he posed, in an elegant full-page ad, for Rose's lime juice. What a send-up by a man whose favorite "cocktail" was poppers and MDA! His photographs graced the covers of dozens of magazines. In January 1988, amid rumors of terminal illness, *American Photographer* featured a Mapplethorpe cover photo and lead story, "Mapplethorpe: The Art of His Wicked, Wicked Ways." *Harper's*, in June 1988, availed itself of his excellent photos of blacks in Shelby Steele's lead essay, "I'm Black, You're White, Who's Innocent: Race and Power in an Era of Shame."

One afternoon, he sat me down in his Bond Street loft. The sun

slanted through the tall industrial windows and hurt my eyes. We had kept each other up for days.

"You okay?" He unscrewed the legs of his tripod.

"Yeah."

"Come on, Jack, you're lying."

"How embarrassed do you want me?" We had done everything in bed, but with his unfolding his equipment, I shied away and he noticed. The sonuvabitch always had to press the tender nerve.

"Why should you be embarrassed?"

"I don't know why."

But I knew why. Robert's eye was true. His camera eye—his all-seeing Third Eye—was truer. I finally understood why Native Americans feared the soul-revealing, soul-stealing devil lens. We both played at being cynics abroad in the world. Maybe he wasn't playing. Maybe I was only California attitude. Maybe he was Manhattan real.

So I sat, the West Coast writer stuck in front of the East Coast photographer's camera: like a "punk's viktim" about to be X-rayed like sushi at Hiroshima Ground Zero. His sight and insight cut through bullshit. In conversations, we threw snide asides to one another. His honeygreen eyes worked overtime.

I remembered the first night we ever made love, his tongue licked repeatedly across my eyeball. That was a probing first. No one had ever so directly fucked my vision. Sitting in his sunny studio, I feared his eye, *malocchio*, his evil eye, his wonderful eye that through the Third Eye of his lens might see me suddenly different, might pierce through my appearance to my reality.

I had seen others whose faces he had photographed. In real life, they seemed so different from the reality he froze into a single frame. I did not want to be victim of a single shot—not JFK in a frozen Zapruder 8-mm frame. I wanted to be Mapplethorpean-Mephistophelian transformed, if not into Schwarzenegger, then at least into the persona of a cult writer of black-leather things going bump in the night. And so my fear of his camera was primitive. He was a sorcerer. I felt in bondage to a process that tries to capture a whole person in a single frame. Yet, I wanted to give the devil his due. I wanted him to have his way with my face. Appearing nightly for two shows in his sexually shocking bed was not enough. Pillow talk was not enough. My own aesthetic required a Mapplethorpe Ultra-Fuck. I wanted what he wanted: to be the subject of his art so I could write biographically

for him what it felt like to be inside his art. Yet, for all my personal trust in him, making exotic U-turns under the sheets, I feared he might professionally expose the face I think I hid from the world.

In fact, he shot me effortlessly and quickly. He sealed the rolls of film and called in his assistant—the sorcerer's apprentice—working in the darkroom in the middle of his loft.

"The contact proofs will be ready tomorrow," he said. He hugged me.

I made us instant coffee in his small, jumbled kitchen. Under a silk-screened Warhol of Jackie Kennedy veiled in multiple-image mourning, an ashtray broke from smolder to blaze on the table littered with Con Edison receipts and please-please-please letters from galleries. Robert brushed the small fire to the floor and stomped the flames with his black pointy-toed snakeskin cowboy boots. Minor disasters stalked us: that insane Saturday-night kamikaze ride in the taxi up the Avenue of the Americas; a young gay man shot in the shin, before our eyes, by a mugger in the lobby of 2 Charlton; a naked man falling headfirst out of a piss-filled bathtub to the concrete floor of the Mine Shaft.

Robert laughed. "You're paranoid," he said.

"Signs and omens are everywhere."

"I read that homosexuality can cause paranoia."

"Homosexuals have reason to be paranoid," I replied. I thought of our friend and model, Larry Hunt, whom he had photographed sitting on a couch, feet and legs laced up tight to the knees in leather boots. Larry had disappeared from an LA leather bar; all that was found of him was his lower jaw and teeth in Griffith Park.

I remember Robert lowered his eyes. His mouth grew tighter. Robert resented resistance. Robert loved congenial compliance.

Shit happens, same as magic.

Wordlessly.

We walked to Jack McNenny's flower shop, Gifts of Nature, at Sixth and Houston. Robert was as famous for his genitalic flower photographs, especially calla lilies, as he was for his phallic fetish pictures, such as *Mr. 10½* and *Man in Polyester Suit*, wherein a King Kong black penis droops for days from the unzipped fly. Jack McNenny—the sweetest man, the talented floral designer with the drop-dead breath of an outhouse—always saved Robert his filthiest jockstraps and his best blooms for Robert's Baudelairean flowers-of-evil still lifes.

At Jack's shop, standing among the pure, white callas, Robert suddenly,

intuitively, knew I did not want to go to bed with him. Not that night. Not anymore.

He wanted to know why.

I didn't know why.

I think now it was because he had photographed me and I was afraid the devil had shot my less-than-lily-white soul, gaining power through some weird kind of photo-voodoo.

Robert was pissed, but in control. I wanted some neutral time together to sort things out. He needed time to work his seduction. He suggested supper at Duff's on Christopher Street. We lingered long. He plied beautifully subtle ways to untangle my mood. For some sexual-aesthetic reason, he wanted me, not in any way forever, just for that night of the afternoon he had shot me.

"There's been a madness on us all for some time," I said.

"You're afraid to go as far into nasty sex as I want to take you."

The hanging green glass lampshades in Duff's lit pools of light over separate tables.

"You want to be dirty." He spun his web.

"Let's pay the check."

At the door, the cold spring night chilled straight through our leather jackets. Robert headed out onto the crowded midnight sidewalk. A hundred guys cruised up and down Christopher from Ty's Bar to Boots-and-Saddles. Knowing full well we were headed toward disaster, I followed his fast pace up to Sheridan Square. The showdown was coming right on cue. We stood a long time in absolute silence, stoned on grass, still points in a rushing kaleidoscope of lights and traffic.

Finally, Robert said, "It's stupid."

"Everything is."

"It's stupid." He wasn't even holding one of his usual Kools to punctuate his gesture. "I'm not in love with you."

"I never thought you were."

"But when two intelligent people make excellent love, if they don't do it when they can, it's stupid."

"That's it?"

"That's that."

This sexual short circuit was about the fuck of intellect? He despised me, serpentinely, for refusing to eat the shit from his Eden's Big Apple Tree of Knowledge.

He hailed a taxi. No hands on each other's knees now. Where was that curious dyke photographer, Nita? Earlier that day, she had shot us together when she discovered us sitting in Stompers Gallery and Boot Shop. She was doing a book on gay couples, and she liked the way our arms and legs twined so well around each other. We gave her the poses she wanted.

She was right. Our bodies were a perfect fit. Our heads were another matter.

I ordered the cab to go to the Mine Shaft.

"You need fresh meat," the devil said.

When the cab stopped, I pushed some bucks between Robert's clenched fist and his leather-chapped thigh. I turned full face to his, and the perfect rhythm of my words spilled out: "What you said you're not, I think I partly am." I meant "in love." I climbed out, closed the door, and walked off without looking back.

Two mornings later, on the Sunday after Easter, repentant, lying with Robert in his loft, I felt his arm wrap around my neck.

"What I said the other night," he whispered, "I didn't mean."

I kissed his long artist's fingers. I said nothing. I didn't need to.

"I wanted to get really crazy. I wanted to go so far with you. Get so nasty."

"This is my farewell tour to New York," I said. "I'm joining a monastery. This is it for sex. I'm tired of life in the fast lane."

"Yeah. Sure." He pulled from his leather jeans pocket one of those little plastic MDA bags he was always dipping his finger into and shoving up my nose.

"No. I mean it, Robert. I'm tired of fistfuckers and dirty people. I'm tired of everybody always being sick with hepatitis and amebiasis and clap and crabs and you name it. You can glamorize it all you want with your photographs. I can glamorize it with my writing. But our lives are a constant search for new ways to be disgusting."

"You're dirty, Jack. You have a face that could have been drawn by Rex. You have dirty eyes."

"What I may want to do is not what I ought to do," I said. I felt like Eve being offered Eden's apple. "What about my eyes?"

"You've got dark circles."

"I won't after two weeks of rest. I'm not kidding. I'm heading back to California. I'm doing my own 1978 version of being born again. I don't want my face to look like a collapsed cake baked at high altitude."

"Dark circles are what I look for. Interesting people have dark circles."

"Robert Mapplethorpe's famous raccoon effect."

"Why don't you stay through tomorrow night? Warhol's giving an Academy Awards party at Studio Fifty-four."

"Don't tempt me."

"Mario Amaya will be there."

I hesitated. I liked Mario. He was an art critic and a friend. I had felt sorry for him when he had been shot, wounded, along with Warhol, when Valerie Solanas, the founder of SCUM (Society to Cut Up Men), had opened fire on Warhol for, she alleged, taking too much control of her life. Maybe Valerie felt about Andy the way I feared Robert's seductive acquisition of control.

"Hard sex," I said, "leads to hard times." None of us knew then that Gay Liberation would end up in an intensive care unit because of a virus.

That morning, I could have gone his way or mine. Had our night ships been in convoy for so long never to connect again? If so, then I knew that what-was must remain always so dear to my heart and my head. We rarely dared say "love." We had no need. Life is a series of Gatsby's beautiful gestures: a look, a lick across the eye, a touch, a word, sex verging on love—each and all again.

I fled New York, leaving on a jet. "I want, I need, I love, yes, love, with incredible respect, this man, Robert Mapplethorpe," I wrote at twenty-five thousand feet in my journal, "even though we may never really be together again."

When Robert sent me a package with a print of his photo of me, or perhaps not-me, or, more, what I was then, I hesitated. I wanted to see what this magnificent visionary photographer had found in me. I had to see if I looked dirty: not from the inside out—that id I had always known—but from the outside in. I had to know if I had a gay face: the haunted, hunted, distorted, stereotypical kind. I had to find out if my face had become like the Fellini faces in the bars and the baths: a dead giveaway of whatever night hunger it was that made us terminally different from other men. Had Robert exposed my soul? I thought back to the letters he wrote me.

His letters ached with the isolation of the gifted artist for whom life is never intense enough. In his left-handed slant, he wrote on April 20, 1977: "I think you're right about me needing a psychiatrist. I'm a male nymphomaniac. . . . Just can't get sex out of my head. I'm never satisfied. It

will drive me mad. But otherwise, life doesn't seem worth it. I'm probably going to have to find one person somehow that can keep me in. Otherwise my energy will just pick up and leave."

On May 21, 1978, he wrote: "It's midnight . . . I almost forgot to tell you. I let some creep stick his hand up my ass. I've been fisted—even came—but I think I prefer being the giver. I don't seem to have any great desire for it to happen again. In fact, I can't help but to give preferential treatment to the feeding process. I want to see the devil in us all. That's my real turn on. The MDA is coming on stronger. I have to take a dump but I'll save it. I'm sure somebody out there is hungry. It's time to get myself together, pack my skin in leather. The package is always important. Goodnight for now. I feel the pull to the West Side. The night is getting older. Love, Robert."

September 12, 1979: "The 'punk' leather boy from SF is getting more and more on my nerves. I hate naive people. He just left wearing his motorcycle jacket. I feel as though he shouldn't be allowed to wear it as he just doesn't have a sophisticated sense of sex. I hate happy naive people. I guess I believe in total dictatorship with someone who thinks exactly like I do in charge. How's that for ego? . . . I took pictures of Nick in color last week for a second possible [Drummer] cover . . . I met that publisher from Drummer a couple of times in the bar. Nothing much else to report. Blood is in the air. Love, Robert."

As he progressed into his Mandingo period of shooting glorious black men, he wrote: "I'm still somewhat into Niggers. [He used the word mostly with affection.] I even have a button that spells it out that I wear to the bars. It seems to attract the dirty jiggers. Sex Sex Sex Sex—that's all I think of. Let me out of this place. It's driving me crazy."

On April 10, 1978, on Hotel Boulderado letterhead, Robert, bored in Colorado, wrote: "Dear Jack—I just arrived here from New York. The London Times sent me to Boulder to take a picture of Allen Ginsberg. It sounds good, but I would prefer to be under the sheets in New York or even better in San Francisco. It makes me crazy when I travel, especially this sort of trip which is for less than 24 hours. . . . Thanks to you and your friends I've been spoiled. I haven't really been satisfied since I left San Francisco. I still miss you, Jack. I regret we never got into anything more while you were in New York. . . .

"It's 10 P.M. I'm in bed already. I checked out the 3 bars near the hotel

and nothing was happening on a Monday night in Boulder—at least I saw nothing. Besides, life has exhausted me.

"Ginsberg was a Jewish drag. He made me sit through his lecture on William Blake which was OK except that it reminded me of when I was in school as I had to make a great effort not to close my eyes and fall asleep.

"Then he complained about the *Times* spending the money to send a photographer out here as he's had so many pictures taken already."

(Ginsberg didn't seem to catch on that this wasn't just another motor-driven camera hack; this was to be a portrait by Robert Mapplethorpe.)

"Then he complained about having no time to make an effort. He finally decided to sit in the Lotus position barefoot. I quickly set up my lights which I had to drag out here and took 2 rolls (24) of film. I had wanted to do more than that as I came all the way and I do get nervous about the results.

"Somehow I brought up the subject of S&M and he did say (still in the Lotus position) that he was getting into it. No blood however. Anyhow, by the time I was through, he was apologizing and invited me to meet him later at some Rock 'n Roll club. I said I would, but I won't. His day is up. The time for chanting is over. As far as I'm concerned, it never existed.

"I'm going to turn out the lights and try to muster up enough energy to 'Jack' off. I'm going to think about having my fist up your clean asshole while you . . . Love, Robert."

Let the art critics recount the international art world's loss at the death of Robert Mapplethorpe. Let them explicate the wonders of his fourteen different printing processes, of his still-life studies of floral genitalia, marble sculptures, male and female nudes and fetishes and celebrity portraits, of his cool intellectualism smacking of neo-Marxism. Let them reprise his distinctive aesthetic edge in sinister pictures of a watermelon stuck in the middle with a butcher knife. Let them wax jealous over his rich patron who knew art when he saw it and who saw the genius in Robert's art. Let Paloma Picasso and Willem de Kooning and Louise Nevelson and Philip Glass and the punk princess Gloria von Thurn und Taxis be grateful Robert Mapplethorpe ever existed at all.

Let me sit on the ground and tell sad tales of the death of kings. Let me say I hate the portrait Robert shot of me. Let me distance myself from the truth he sucked from my face that is so different from the truth I think of my face. Perhaps he broke the mask. Perhaps Robert, the artist, forced me to look into my soul and change my ways. I wonder, do Richard Gere and

Princess Margaret and Arnold Schwarzenegger feel somehow changed? Robert's tongue never licked their eyeball. Robert's lean body never made love to them.

I confess now that in my May 10, 1978, letter I lied to him: "Caro Roberto, . . . the portrait you took of me arrived. You're good . . . I see the way you slanted me. I should be so kind to you in the slant of my written vision of you. Two pieces are completed in which you figure: the article, short, in *Drummer*, and another piece, barely fictionalized, in *Corporal in Charge*. . . . Take care, my good friend, I love you with all my head."

Let the critics assess the artist and his art. Leave the private man—what does not belong to Patti and to his lovers—to me. We were too hot not to cool down. As writer and photographer, as men, as fuckbuddies, something special passed between us. Revelation. Lust. Darkness and light. Good and evil. Understanding. Maybe even love.

We were what he said: intelligent people making excellent sex. That's the value of ships passing in the night: reassurance that in the dark sea-swells, with Robert gone, his art living on, other talented lights, rising and falling, will certainly loom closer out of the distance, learn from his brilliance, and, for brief passage, prove that none of us, as I learned from him, borne back against the current, is forever alone.

Centuries from now, people will look at Mapplethorpe's photographs, but what will they know of Robert, who has no more memory than the remembrance we give him?

Robert Mapplethorpe was a creature of the night. Take a walk down Greenwich after midnight. Peer in the windows of shops where we browsed for antiques. Robert was an offhand collector. He wrote impulsive, enormous checks for small bronze sculptures of the goat-footed devil. I think he will haunt those Village streets until his next incarnation. I think I am happy to be left with the memory of him and with the evil-smirking cover of *Drummer, Biker for Hire*, which is the best color portrait work he ever shot.

Robert came, saw, conquered. He became one of the premier photographers of the twentieth century. He got what he wanted, leaving me, Patti, and others with sweet memories of a private man who was also an artist from hell. He dared lay bare how vulnerable and strong we brazen homosexuals can be as seers and sayers exposing the truth of the underbelly of the human condition to a blind and deaf society.

Is this the reminiscence you wanted from me, Roberto?

Caro Roberto!

ADVENTURES WITH ROBERT MAPPLETHORPE (ADULT DISCRETION ADVISORY)
PERSONAL JOURNAL

Autumn in New York. Nineteen seventy-eight. At exactly 8:00 P.M., Thursday, October 12, Mr. Robert Mapplethorpe descended the stairs into the main salon of the supper club and walked into the bar.

He was elegant in his black leather jacket.

Leather seems to give substance to his slender body.

He wore black jeans and black cowboy boots with pointed toes. His black hair was tamed with water from the sink in his kitchen. He had practiced to perfection a certain Manhattan sophistication.

He made me, the Californian, marvel how New Yorkers who live in tiny apartments turn themselves out as if they owned the most stylish co-op. Robert is a better dresser than he is a housekeeper. I couldn't survive in his three rooms, well, four, if I count how he has divided the living room with a makeshift wall into two rooms to make his bedroom.

His bed is a mattress on the floor.

The whole place looks like a burglary scene, but I understand. My own apartment is strewn with papers and notes and photographs and super-8 movies. I call it "my intellectual mess." Creative types always have a dozen projects going at once. Every stack of paper means something when you're working hard at various projects. Robert's only room that's in order, because it's practically empty, is his studio, which is the front room, flooded

Drafted at 2 Charlton Street, #410, New York, and on United Flight JFK-SFO; edited in San Francisco.

with southern light. Arrayed under the bank of windows is a gray radiator running the length of the wall.

Jack McNenny, who had invited the two of us to the supper club, ordered Robert a beer.

"How are you?" Robert said. "Feeling better?"

I was grateful to him. I kissed him.

He smiled his wicked grin.

He had rescued me the afternoon before, Wednesday, when he had set me up to push my limits.

I had gotten into trouble.

Not so much sex-and-drugs trouble.

More like existential trouble.

I could see in his face a hint of satisfaction. Robert likes to fuck with people's heads. He likes to set them up to see where their flash points are.

"I'm still coming down," I said. "I'm still wired."

"I'm sorry." He laughed.

"Roberto," I said, "you're not sorry. You think freaking me out is funny."

"Actually, Jack, it is funny."

"You told me you knew those people," I said.

"I told you how they are, especially X. The more I told you about the party, the more turned on you got."

"Robert's right," McNenny said. "You always want more. Sometimes more can be too much."

Both, of course, knew the appetite of the tourist trip. I was spending ten days in New York. I was crashing two blocks south of Houston with George Agustinella at 2 Charlton at the corner of Sixth Avenue, but was spending most of my time with McNenny at his nearby flower shop, at 251 Avenue of the Americas (Sixth and Houston), and with Robert at 24 Bond Street, except when Robert was out doing business, which means art business or drug business. Besides visiting friends in Manhattan, I always need some time to myself, which means cruising out alone to hot spots like the Everhard Baths and the Mine Shaft.

"If you can't be with me," Robert said, "then you should be out with people who I know because they're the best people for sex."

"They were good sex," I said, "but with the acid something more than sex happened. The orgy was wild, but it was more than sex."

He laughed and lit a Kool. "With X, it always is."

I had told him I had only ten days and wanted to meet the hottest tricks he and McNenny knew—besides picking some strangers on my own.

The third night, Monday, two days before the Wednesday-afternoon orgy, he had set me up for a date with a doctor who was very handsome and very far out. I arrived at the door, and the doctor, I can't even remember his name, welcomed me in.

He is really good-looking.

His place looks like a sex pad. I figured, because he is a society doctor, he probably lives somewhere uptown and uses this East Village address for his tricks.

The place smelled with the usual telltale mix of Crisco, poppers, and smoke. The lights were low, throbbing disco pounded out from his large-reel tape deck. Candles, maybe a hundred of them, all different shapes and sizes, flickered around the room.

The doctor, except for a once-white Bike jockstrap, was naked, showered, and already stoned.

The thermostat was turned up high, really high, at least to me coming in fully dressed from the night chill.

He invited me to sit down, and we both pulled out our drug stashes.

He asked me if I was hot.

I looked at him and laughed.

We both laughed.

The evening was obviously going to be okay. Robert had primed us both with stories about the other, and the click was there.

Robert knows how to make good matches. Most of the time.

He's said for sure he gets some sort of kick setting me up with adventures he knows I'll write about in the book he wants to do together. He hates books. He hates the work involved in a book. I don't. He keeps asking me to write about him. Sometimes, I think that's the main thing he wants from me. (I could do worse. That's why I'm recording everything that happened of what I can remember, because the way gay relationships go, some day my words and his pictures will be all that remain. *Ars longa.*)

Robert said, "You're the most analytical person I've ever met."

"You should get out more."

Anyway, the doctor had lit his bed with spotlights on dimmers.

Robert, the sex-and-fashion photographer, had sort of cast us into our roles for the evening.

An open can of fresh Crisco sat on the bedside table.

We drank a glass of wine, shared our joints. The doctor took a hit of blotter acid. I took half a hit. He took my hand in his and clinically sized up my fist and checked out the smoothness of my fingernails.

We both smiled.

We were absolute strangers, but we were not anonymous.

"Robert scored some MDA for us," he said.

"He's great, for sure," I said.

We both snorted the white powder, hit the joints a few more shares, and sipped the white wine.

The doctor had a hunger for handballing and I liked topping guys, especially if the guy was into fantasy side trips that layered lust into the basic sensual fisting action.

"Why don't you strip off?" he said. He headed toward the bedroom, clearly visible from where we sat, and lay back on the sheets.

I piled my clothes on top of my boots, where I had stuck my keys and my wallet.

I always do that so when I'm leaving, I don't have to search for them. I'm also hick enough to think it's security, so the trick can't easily find my valuables. I mean, I saw *Midnight Cowboy*.

I walked naked toward him and knelt between his legs. "Robert said you were something special," I said. "You are."

He is, in fact, better-looking than Robert had indicated.

His body was very tan against the white sheets.

Towels and a brown bottle of poppers perched on the nightstand.

He reached under a pillow and pulled out two double-nostril silver inhalers, both hung on black leather thongs. He put one over his head and the other around my neck.

"They're loaded," he said.

Then the surprises began.

He grabbed me and pulled me down on top of him. We tussled for a few minutes, quite passionately actually, making general acquaintance of one another's moves. Suddenly, he asked me to kneel back between his legs.

Oh WOW . . .

He peeled his jockstrap slowly down his muscular legs. He flopped out half erect, but stiff enough to reveal his scrotum, which he covered with his hand.

"Wanna see?" he asked.

Hell, I thought, *this is the Big Apple. Sure.*

He removed his hand and revealed his balls.

I was amazed.

He was a medical professional with a fetish for surgical body enhancement. His scrotum was shaped like a doughnut. I mean, he had surgically had his sac sliced down the center, separating his nuts, and then had the center cut sewn shut on both sides. The operation was neither self-inflicted nor recent. The hair of his groin was fully grown.

I think I've seen everything in San Francisco. That's why I go to New York, like Holly Golightly: there's such a lot of world to see.

"How do you like that?"

He is quite proud of his handiwork.

"A lot," I said.

I really did. I spent the night with the bracelet of his nuts around my wrist, moving it up my forearm, fisting into him while he climbed the walls.

The fillip of his take on fisting was fresh.

I like guys who actuate their fantasies.

I slept at Robert's that night.

"Was that different enough?" Robert asked.

"For a pimp, you are so amused with yourself," I said. "Of course."

"Did he tell you his story?"

"I didn't ask."

"He has a friend who is a surgeon."

"I figured."

"He writes prescriptions for his friend in trade for minor surgery now and then."

If I want weird and fresh, Robert always knows the best.

"Did you really like it?" Robert said.

"It was far out," I said. "Just far enough. Yeah, I liked it. I don't think I'll ever forget it. The sensation was great. Besides, Monday nights it's hard to get laid."

"He likes to freak guys out. That's why I didn't tell you his whole trip."

"He's so good-looking, he hardly needs something extra."

"Everybody needs something extra," Robert said.

"You devil, you."

"You're the devil, Jack. I'm going to show you how nasty and dirty you can be."

"I'm never sure what you mean," I said, "but I dare you."

"Don't ever dare me." Robert is always intensely serious. "Let's go to sleep."

"Did you get laid tonight?" I asked.

We were lying on our sides with his back tucked into my belly.

"I saw this one nigger who interested me at first."

"Where?"

"At the Mine Shaft."

"So?"

"So I got his number."

"Then you didn't get laid."

"No."

"Do you want to cum so you can sleep?"

"I can sleep."

"So can I," I said. "I took two Valium."

"I've got Quaaludes if you need them."

"I always need Quaaludes," I said. "I'm fine. Save the Quaaludes."

Robert turned over under the sheet and took my face into his hands and kissed me. "You're too smart for your own good," he said.

"So are you," I said. "Thanks for the Doughnut Doctor."

"There's more where that came from," he said. "You get me models. The least I can do is get you the best tricks."

"Have you shot him?"

"He won't let me."

"Why? Because he's a perfect asshole?"

He sighed more than laughed. "You're never here enough."

"Geography is against us," I said.

We drifted off to sleep together, he dozing before me, I feeling his slender, tender body in my arms, loving him just because he is himself, a wild thing, seven years my junior. Bicoastal romances have a special glitter because time is at a premium.

That was Monday. Later, on Thursday, back at the supper club where Robert had made his entrance, he said, "X was a bit pissed about you freaking out at his orgy yesterday afternoon."

"I didn't freak out. I took too much acid. I mean, I didn't take more than I usually take. It's just that in New York I don't need as much. Those guys are so intense. This whole town is a speed trip. I hate speed."

Robert had given me an introduction to actor X's party on the Upper East Side. Its interior is too busy with Oriental art, Persian rugs, Warhol paintings, and photographs autographed to X, whose apartment it is, every nook and cranny of the posh place crammed with, I think, ridiculously expensive collectibles and antiques and draperies and upholstery without a plain and simple spot to quiet the eye, as if some dizzy decorator thinks interiors, unlike music, need no rest. The apartment is so fairy-dusted it should be in *Architectural Digest*. It's too ostentatiously busy for me. Robert touted the place as showy, the kind of place that looked like money. His own loft is a hovel; he couldn't care less about his own interior decor.

During the orgy, which was perversely outré, ten or twelve of us, minus Robert, who was spending Wednesday afternoon chatting up his work with some gallery owner or other, I felt, at first, a comfortable participant in male tribal rites.

I felt rather primal, but somehow not as Neanderthal as the other guests.

I was, and still am, at thirty thousand feet on this jetliner, in awe of the kind of decadence one can find in that part of Manhattan that Woody Allen in his films thinks is the whole world.

Robert wangled the invitation to see how committed I was to perversion. He likes to set people up to shock them into admitting to their own repressed desires. I try to bollix him with an unshockable, even bored, nonchalance.

(The invitation was easy to acquire: I was a new face in town, his friend, and writing was my credential.)

Homosexuality in itself is not perverse, but some homosexuals, the same as some heterosexuals, revel beyond the norms of the received taste of civilization.

Perhaps perversity, the last urban frontier, is avant-garde and retrogarde. No matter, the current norms must always be challenged. That's what artists are for: to poke Babbitts in the eye. If artists don't do that, they're not artists, they're entertainers.

Artists must always be open to witness everything.

Robert and I have that as common bond.

Besides, the guest list he named seduced me: several people I had only read about were to be participants.

Robert is quite frank about everything, even though he never really

has sex in groups. He stated explicitly that the orgy would be scatologically satanic sadomasochism.

How can I resist the opportunity to attend a secret party where the cool sexual politesse of "no pressure" allows me to be more solo observer of the local color than direct participant? Robert and I are both basically voyeurs.

I better rethink this quest for experience because my nature as a writer is to slip from voyeur to participant, so I can get inside the process. All writers have to experience everything: a writer writes best about what he knows. Robert scouts the partners for his shoots the same way, but he doesn't lay them unless he has to.

The afternoon's sensuality centered around artist Nancy Grossman's sculpture of a head wrapped in black leather bondage. A large leather dildo protruded from the head's mouth.

I don't know whether that was part of the original sculpture or something added to enhance its powers of conjuration.

I do recognize, from my experience interviewing witches for my book *Popular Witchcraft*, when demonic totems and rituals present themselves.

The group was terribly civilized and urbane, or at least most were. Some were out-and-out dirty-sex machines. Three young men, one of them what Robert would call a "nigger," had been hired in as feeders to insure the invited guests would have enough primary material.

I had given X my copy of *The Last Taboo*, whose scatology I had reviewed in a feature essay in *Drummer* magazine. I'm very curious about the escalating urban perversatility of liberated gay men.

Fisting, many think, is the last taboo to be incorporated into male sportfucking. They better think again. Scatology, from ritual anointing to communion, is the latest rage among sexual sophisticates who pay Robert court.

A writer, chronicling the popular culture of any subgroup within a subgroup, especially in the age of the New Journalism, must, in the best gonzo tradition of Hunter Thompson, who rode with the Hell's Angels to experience material for his book, and of George Plimpton, who played with a professional football team to write *Paper Tiger*, engage, even at a minimalist level, the group that he is chronicling.

But there are limits.

Pleasantly stoned, and in tony company, I watched, and, without

embarrassment, admit to being a minimalist supporting player in the revels.

Under the looming presence of the Grossman totem sculpture, the featured players moved to heights of ecstasy of flesh and blood and *merde* that surely equaled any theory of Freud or primal experience of Janov.

The men moved from incantatory words to grunts and growls, leaving civilization behind, devolving back to primitive communication of grunt and groan.

One particularly beautiful young man lay on the floor beneath the Grossman sculpture and became an altar around whom the assembled coven gathered to shoot their seed.

No matter how "sick" people may think this ritual, I can truthfully say I found them to have risen through the chosen medium to an ecstatic state.

I am somewhat of an empath, and their high energy was not lost on me. My spirit and my sense of aesthetics appreciated their dirty means to a spiritual end. Their transcendence is metaphor.

New York is a dirty city of a dirty present and a dirtier future.

My sense of well-being, and my perception of how sanity can be abandoned for either insanity or supersanity, caused me to flee to the shower, where I was followed by a man who had left twentieth-century language behind some hours before.

He was an aborigine.

He cornered me, grunting monosyllables, making his message quite clear.

On acid, everything seems quite clear to me.

Too clear.

I see the existential cosmic hopelessness of It All.

I don't know what drug cocktail he had swallowed. He was so in a trance state that he seemed not to understand plain English.

My only escape, because for me personally things had gone quite far enough, and professionally the writer in me had seen more than any anthropologist with a government grant would ever see, was to grunt back, offering to hose him off.

He took to the hot shower I sprayed on him and made a game of it.

I'll never forget how the water turned him from primordial ooze as his white skin began to wash through.

I confess I felt like God, an acid god, creating Adam, the human, from the mud of the earth.

It's all too much.

I quickly toweled off and pulled on my clothing, lacing my legs into my tall boots.

The colorful pleasures of the acid turned to fingernails of speed on a blackboard.

I clutched my throat, gasping for air in the steam-heated town house.

I was shocked, chagrined, ashamed, scared, full of guilt that I had waded out too far into the dirty heart of darkness.

Robert had pushed me in the game a little too far.

I was out of my league and I don't like that, especially here, in the close confines of this plane. The New York sexstyle is much nastier than San Francisco's.

I couldn't breathe.

I was terrified to leave the town house to go out into the Manhattan streets alone.

I was tripping my tits off.

X, the host, himself a television network name, came to see me out the door. I hesitated. This man who tried to be nice to everyone would think me a sexual hick who couldn't handle drugs.

I said, "I have to go, but I can't leave. If I step out on the sidewalk, I'll freak out. I'm already freaking out."

"You were splendid," he said. (*Splendid!* What a word! I think he was patronizing me out the door to get rid of me.) "You seemed to be having such a splendid time."

"I did. Thank you. Your party is great. I think it's because I didn't eat enough before I came. I've been out late ever since I arrived. I slept maybe four hours last night."

"Then please don't leave."

"Thank you."

As God is my splendid witness, I silently promised myself what everyone promises in that splendid state: "Just don't let me turn into Diane Linkletter. I promise I'll never take drugs again."

I started laughing. The whole scenario was so comic.

"You're okay," X said. "You can laugh."

"Crazy people laugh."

We both laughed.

He put his famous arms around me.

No one in those Upper East Side rooms seemed to notice or care. The

hired feeders had long before left. Only the noncelebs (except for one grade-B TV personality) and the sex fiends, the coldhearted crème de la crème of calloused Manhattan shits, remained, pigging out on their drug-induced appetites.

Why should they care?

I was one of Mapplethorpe's choice friends, after all.

I was his current squeeze.

Knowing him certified I wasn't a bimbo or a bozo.

What comfort could I possibly need?

I suppose they thought I was as jaded as Robert and as unfreakable.

X held me for a moment, but he did not know me; he could not soothe me.

I resisted him. I'm Irish and Austrian: that makes me independent and hopelessly romantic. I always resist depending on the kindness of strangers even when I should.

X took me upstairs to his living room, whose opulent busy decor made my eyes spin with architectural indigestion.

"I'll call Robert," he said.

"No."

I felt more dying than faint and careened from one wingback chair to another, bouncing off a suffocating sofa, hoping to outrun the speed and guilt and fear.

X grew impatient.

He wanted to return to his orgy.

He offered me some leftover in his refrigerator: cold consommé.

"Call Robert," I said.

Hours later, really only twenty minutes, Robert arrived, quite confused. "Oh, Jack," he said. "I keep telling you not to go out. I keep telling you to stay with me." He put his arms around me, trying tenderly to right my confusion, making light, reassuring talk, washing two Quaaludes down my throat. He finished dressing me, and took me out to a waiting taxi.

I said I was sorry about a hundred times.

"Don't apologize," he said. "I got what I wanted."

"I never thought I could be grossed out."

"Actually, you got what you wanted."

In the backseat of the taxi, I pushed on him very hard. I wanted to hit him, but I'm a lot bigger built than he is. "What the fuck do you mean you got what you wanted?"

(I still don't know what all he wanted.)

Slight as he is, he was able to maneuver me around to see the driver's rearview mirror. "Look at your face."

"I don't want to see my face. I can't see my face. We're in a cab, for godsake. I feel sick."

"We're almost to Bond Street."

No one I know in New York lives on the ground floor.

Everyone lives up several flights of very steep stairs.

When we reached the heavy industrial door on his flat, he guided me through and set me down on a chair in his studio.

"What are you doing?" I said.

"You've got what I want. You've got perfect dark circles under your eyes. You know that's what I look for."

"Robert Mapplethorpe's famous raccoon effect."

"Actually, right now, your soul is outside your skin where I can shoot it."

"Don't take my picture. Not now. I look like shit."

"Actually, you do." He smiled a grin at that moment that I didn't really like, but he had come and rescued me.

He had told me he loved me more than once and he had proven it, because Robert Mapplethorpe is not usually in the business of rescuing people he purposely tweaks. He despises innocence, which he says is another word for ignorance. (He's right.)

"I'll make it fast," he said.

"You'd better. I'm tripping on acid and dealing with Quaaludes and I think I need to eat something."

He quickly arranged his lights, adjusted his tripod, loaded his camera, bent over it to frame the viewfinder, and without coaching much more than asking me to look into the lens began clicking off his frames.

I tried to look normal. Big joke.

Finally, he was satisfied. "Gotcha," he said. He came to me, lifted me up, hugged me, and walked me to his bed where he lay tenderly, soothingly, beside me. After two hours, which on bad speed seem like two years, he said, "I'm calling McNenny."

"Why?"

"We'll go eat."

"I can't eat."

"You need to eat. Food will slow you down."

Robert and I had both known Jack McNenny before we met each other.

McNenny owns a flower shop called the Gifts of Nature at the northwest corner of Sixth and Houston and when Robert first started shooting flowers, McNenny found for him the best cut blooms in Manhattan.

McNenny and I are the typical story of tricks who become friends.

Robert called him and took no small pleasure in announcing I was a basket case in need of dinner.

"We'll be there in fifteen minutes."

McNenny stood waiting in his flower shop surrounded by roses and mums, piddling with vases, picking at arrangements bunched in his refrigerated display case.

There's something I've always found soothing in the shop McNenny converted from an old neighborhood pharmacy, keeping its dark wood shelves and counters intact, polished, and lit with track lights.

"Take a hit of some of your famous California vitamins," McNenny said.

"I look that bad?"

"You don't look bad."

"Actually, I told him the same thing," Robert said.

"He took my picture."

McNenny's comic Irish was up. "Good. You can decide if it's a 'Before' or 'After' picture later."

"Fuck you," I said.

"Let's feed him," McNenny said. "Take these." He handed me the vitamins and looked at Robert. "What happened to him?"

"I got him invited to X's afternoon soiree."

"I couldn't go," McNenny said. "I had to work."

"You're lucky you missed it," I said.

"Fuck no, man!" McNenny said. "You're talking to the scat king of Manhattan."

"I forgot," I said, "the reason you named your store 'Gifts of Nature.'"

Robert laughed.

McNenny closed up shop and led us around the corner to a small village diner.

The eggs, the muffins, the conversation the two of them engineered to distract me, on top of the Quaaludes, brought a first wave of calm.

Only once did I for no reason other than anxiety rise up suddenly from the booth and lurch toward the center of the floor.

The waitress looked at me like, well, oh yeah, another burnt-out case.

Robert pulled me back to the booth.

The instant we sat down—Robert and I opposite McNenny—in the intersection outside the corner diner, two cars collided.

One slammed the other across the cobbles. It came crashing through the plate glass window of the diner.

Ciao, Manhattan, I immediately thought.

Shards of glass showered the cash register.

The front grille of the car crushed halfway through the doughnut counter and dropped hoodfirst down to a weird tilt.

In a second, the accident had begun and ended.

Everyone froze in position.

Instantly, everyone calculated that no one was injured. They all began to laugh. Quietly at first, then louder.

The front wheel of the tilted car was still spinning in the doughnuts.

I stood bolt upright with a scream coming up from my freaked-out guts.

McNenny rose mirrorlike up opposite me. His face looked so weird. He was laughing.

Robert pulled me down next to him. He, too, was laughing.

Their laughing started the whole diner laughing louder.

Even the driver in the car was laughing.

I looked at Robert.

"This is very funny," he said.

The spinning tire shot one more doughnut across the floor and then it flattened with a final quick hiss.

"This is very funny," Robert repeated.

"This is funny?" I said.

"Welcome to New York," McNenny said.

We three looked at one another and laughed hysterically.

At least, I did.

They buoyed me up and led me to the door.

The proprietor was in the street screaming for the cops.

The waitress, still laughing, waved Robert away when he tried to pay.

They walked me back to the Gifts of Nature, once full of prescriptions,

now full of flowers. McNenny filled a small vase with water and handed me three blue Valium.

Robert said, "I think he should crash here. You'll be around, and I have to go out."

I hate feeling like an invalid, with people talking about me in the third person. I hate drugs. Why do I take them? I'm writing this on Valium because I'm afraid of flying, which I do only because airplanes extend the range of my sex life.

Robert said, "You're fine. Go upstairs and try to sleep. I've got appointments."

McNenny lives above his flower shop.

The Gifts of Nature is a triangular building because of the way Sixth and Houston intersect. The open space of the ground-floor corner shop with all its plate glass windows seems interesting, but McNenny's upstairs apartment with its little rooms seems like a small slice of pie.

The place smelled like an outhouse.

I was too zonked out to care. McNenny dropped me on his bed, and within five minutes, I passed over into a speedy, image-crazed sleep. Hours later, I didn't even feel him crawl in next to me when he came back from the Mine Shaft, which he says was around dawn. He says he passed out for an hour and got up and went to the flower mart.

When I woke, I showered and went downstairs. McNenny had a large Styrofoam cup of hot coffee waiting for me. "Robert called," he said. "He thinks you should stay here today."

"I can't go anywhere yet."

"You feel okay?"

"I'm fine. Wired, but fine."

"Robert wants you to stay here."

"Maybe I can help you or something."

"Drink your coffee and relax."

McNenny and Robert both existed without sleep.

He chattered for an hour about how one day four years earlier he had walked into Doc Siva's pharmacy and announced to the proprietor of thirty-eight years that his store ought to become a flower shop.

While Siva watched, stunned, McNenny removed the suppository display from the corner window and replaced it with a philodendron Doc had behind his counter. The Clairol Lady gave way to an overwatered Swedish ivy.

Doc watched the changes. He had been thinking a lot about the last thirty-eight years in the preceding months. McNenny was no stranger to him; he often stopped in for sundries and conversation.

"The doc was amazed," McNenny said. "He says, 'So you're in advertising. What do you know about plants?' 'Not plants,' I said. 'Flowers. Cut flowers. Arrangements.' And he says, 'Arrangements you can probably handle.' I got the shop on one condition. I promised to maintain the 1930s wooden cabinets, the frosted glass panels, and the marble floor. 'None of this plastic everything,' Doc said. So I got the shop. That's how I met Robert. He stopped in to check out the cut flowers."

"I need more coffee," I said.

McNenny offered to go down to the diner. "You stay and watch the shop. In fact, you can cut the ends off all those new day lilies. About three inches. Use the small hatchet and try to keep the mess way in the back. I like the customers seeing us working, but they don't have to see everything."

I spent the day coming around, chopping flowers. Robert called twice. I took a short nap in the afternoon. When I woke, he and McNenny were conspiring downstairs in the shop.

"You two are up to no good," I said.

Robert, the devil dancing in his eyes, said, "You'll like this. We're going out to dinner tonight."

"Not to the diner," I said.

"Better," McNenny said. "A supper club."

"I don't think I like supper clubs."

"This one's special," Robert said.

"I'm young, strung out, but I've only got so many days in Manhattan," I said. "Supper clubs suck. Let's eat at Mama Leone's. I want to go to the Mine Shaft."

"I'll take you to the Mine Shaft later," Robert said.

Someday I'll stand up and say no to that man. I should have last Wednesday. To him and McNenny both. Neither told me till it was too late why, just why, they were so intent on eating at an uptown supper club. I hate uptown. I only like Times Square, the Village, the plays and movies . . . the bars, the baths, the after-hours joints, and I much prefer to eat at the Sheridan Square deli that used to be the Stonewall Bar, where the riot against the police started gay liberation ten years ago in June 1969.

That night, Thursday, *after* we ate at the supper club, McNenny and Robert confessed the plot they had set up.

That Thursday afternoon, as I slept upstairs in McNenny's flat, a man had climbed out of a taxi outside Jack's Gift of Nature. Six months before, a supper club in which the man was a partner, had opened, McNenny (so unashamedly gay) had created an order for the man he knew to be secretly gay, an excessively beautiful arrangement. He even delivered the piece by taxi himself.

The man had said, "Thanks."

For six months, McNenny had billed the supper club for the flowers. For six months, he received nothing.

McNenny, the afternoon I was asleep, saw the man exiting the taxi and crossing Houston Street outside the shop. McNenny, angry, beside himself, the way only New Yorkers can get beside themselves, turned all mouth. He ran out of his shop and collared the man for payment.

"Butt off, fag," the man had said.

McNenny, president of the neighborhood small business association, loves any chance to make a scene.

"Everybody knows I'm a fag!" His Irish was up. "You fucking closet case. You think you're fooling anybody around here? This is the Village, for crissakes!"

The man climbed into a cab.

"You're as dishonest about your life," McNenny shouted, "as you are crooked about your bills."

"Don't talk to me that way," the man said. He ordered the taxi off into the stream of traffic speeding up the Avenue of the Americas.

Livid, McNenny returned to his shop and immediately called the restaurant. "What night does Joe Blow have off?" he asked. "My wife and I," McNenny said, "want to surprise him by coming up for dinner one night soon. We want to make sure he's there."

Wednesdays, he was told, and Thursdays, the man was off.

A few minutes after McNenny hung up, Robert came into the shop to check on me. McNenny, who has a mouth no one can shut up, told Robert what had happened.

"So tonight he's off?" Robert said.

"D day," McNenny said.

They both admitted later they had exchanged, probably in one fast beat, the knowing looks of conspirators.

They were laughing the same wild laugh they had laughed when the car landed in the doughnuts.

That's when I had come downstairs and said, "You two are up to no good."

That's when Robert, truly with the devil dancing in his eyes, had fed me all the shit, except the truth, about why we really had to go to the supper club.

They both laughed like hyenas, I figured, at me because I was more interested in sex than dining.

"I'll meet you both there," Robert said.

"Eight o'clock sharp," McNenny said.

"Where are you going, Robert?" I needed him then.

"I'm trying to hassle with a dealer on some Mission furniture," he said. "It's boring. You'll be better off staying here. Hang out. Go for a walk. I promise I'll get you to the Mine Shaft in plenty of time. Actually, I've got some business with Wally tonight."

(Wally Wallace is the founding owner of the Mine Shaft.)

Robert hugged me and left. He is so ambitious.

He's maybe got too many irons in the fire, but he handles everything okay, except then, when I really wanted him to stay with me, and one of his deals stood in the way.

That night, McNenny and I took a taxi to the Upper East Side club. Robert had not yet arrived, so we sat in the bar. At exactly 8:00 P.M., Mr. Robert Mapplethorpe descended the stairs into the main salon of the supper club and walked into the bar. He was, as I said, elegant in his black leather jacket, black jeans, and his black leather cowboy boots. His hair was wet with curls.

"Did you get the Mission furniture?" I asked.

"The price is too high," he said. "The secret of collecting anything is to get in before it gets popular."

"It's not taken off in California yet," I said.

(I should check into this as soon as I get back.)

McNenny ordered Robert a beer and another for himself. They always laugh when I order bottled water without a lime twist. Alcohol is not my drug of choice. It gives me a headache.

"How are you feeling?" Robert squeezed my knee.

"Fine. Still a little speedy. But fine."

"He took his vitamins," McNenny said.

"You Californians." Robert grinned and shook his head.

"I gave McNenny a double hit of niacin," I said. "It's good for cleaning the system."

"Usually, I drink Drano," McNenny said.

The maître d' escorted us to our table.

McNenny, suddenly the last of the big spenders, effusively insisted we order anything we wanted. "Price is no object," he said. "In fact, if you don't mind, I'll order for you."

Cocktails, appetizers, escargot, soups, lamb with mint and spring onions, sides of spaghetti, wines, and flan spun across the white linen tablecloth. They gorged with gusto. I picked at small amounts of what looked tasty mostly because I knew I should eat to make up for the last forty-eight hours and to prepare for the long, sleazy night at the Mine Shaft.

"Eat," McNenny said. "Eat."

"The more you eat, the more you'll dump," Robert said.

McNenny's scatological interests fascinated Robert.

"Is that what this is all about?" I said. I couldn't, and can't, handle McNenny's voracious appetite that way.

Halfway into the main course, McNenny grew flushed, red, agitated.

"What's the matter?" Robert said.

"It's the niacin," I said. "It causes your whole body to tingle."

McNenny clutched the tablecloth.

The waiter approached. "Is everything all right, gentlemen?"

"Yes," Robert said. "Our friend is having a vitamin rush."

The waiter raised a supercilious eyebrow. We were, after all, the only diners in leather, as sure a sign of deviancy as wearing a sweater or walking a poodle.

"Drink some water," I said. "It only lasts a few minutes."

"The fuck it does," McNenny said. "It's like red-hot needles all over my body."

"Come on, McNenny," Robert said. "You're overreacting."

"I overreacted yesterday," I said.

"No!" McNenny said through gritted teeth. "I took a hit of acid before we left."

Robert and I broke up in laughter.

"It's not funny," McNenny said.

"It won't last long." Robert took charge. He escorted McNenny to the john and administered one of the many substances he always carried in his pockets.

It was all madness.

A few minutes later, McNenny followed Robert to the table. He was okay.

Friends together, sharing a private joke, we thought we were hilarious.

"Everybody else must think," I said, "that we're either rude or having the best time here."

That made us all laugh even more.

We lingered so long over coffee and aperitifs that I was growing anxious about douching up for the Mine Shaft.

"No action starts before two A.M.," Robert said. "Relax."

When the waiter brought the check, Robert picked it up, very casually, took a look and laughed, and handed it to McNenny.

McNenny casually reached into his wallet and peeled out a fifty-dollar bill and laid the tip on the table.

He and Robert exchanged glances and laughed.

McNenny then placed an envelope under the check. "Come on," he said. He stood up, followed by Robert, and both turned to me and said, "Hurry up."

"What's the rush?" I said.

Robert took my elbow and steered me halfway through the crowded tables of the supper club.

We were passing the maître d's station when the waiter at our table starting shouting.

McNenny grabbed Robert, who dragged me by the elbow, and we all broke into a fast gallop toward the door, scattering incoming patrons to the side.

"What's going on?" I yelled.

"Shut up," McNenny said.

"Pretend you're in a movie," Robert said.

McNenny pushed the two of us into a Yellow Cab and climbed in after us. "Sixth and Houston," he yelled, "and step on it."

The taxi's takeoff threw us all together in a pile in the backseat.

I looked back through the rear window and saw three shark-suited goons come running down the sidewalk after us, and stop.

With relief, I watched them growing smaller in the distance.

The florist bill, of course, was in the envelope McNenny had left on the table.

"That," Robert said, "was perfect."

McNenny couldn't stop telling and retelling the story of how the supper club faggot manager had stiffed him. He was beside himself with glee. "Welcome to the Big Apple," he said to me.

The goons' look had scared me, really still scares me.

"I don't think I'm ready for this."

"Sure you are," Robert said. "You just need more drugs."

That night, while we three were at the Mine Shaft, each trailing off separately through the maze of rooms and corridors and stairwells, cruising for sex with the two or three hundred other male patrons, someone smashed the largest plate glass window of the Gifts of Nature.

McNenny had already had it boarded up when I arrived at eleven the next morning.

Robert and I had met up at the main bar in the Mine Shaft after our separate late-night adventures and taxied together back to his Bond Street studio to sleep.

An early phone call from a *Vogue* editor had awakened us shortly after nine. Robert, very sleepy, talked softly, hung up, and turned to me.

"I have to shoot some *principessa* this afternoon."

Too tired to move, we lay in each other's arms for a long while. When finally Robert had to get up, I had already decided to stop by Gifts of Nature, have coffee with McNenny, and maybe help him in his shop to kill time and rest up for that night's return to the Mine Shaft.

"You don't want to go there again," Robert said.

"I like anonymous sex," I said.

"I think you should stay here with me."

"You always say that. I can't stay."

"Why not?"

"Because you'll get bored with me." I really meant I needed fresh meat. I mean, I like him. I even love him. But he has all of New York every night; I had only ten days. I made polite excuses. "I am a guest, and you know what they say about guests."

"Don't jack me around, Jack."

"I'm serious."

"So," Robert continued relentlessly insinuating himself into my plans,

"if you're going to McNenny's, I'll either call you there from Sam's when I'm finished at *Vogue*, or should I just come by the shop?"

"Either," I said. "I'll be there. I owe him for being so nice to me yesterday."

"What about me?"

"I owe you, too, except that you took advantage of me and shot my picture."

"It wasn't exactly rape."

"When I write about this, and I will write about this . . ."

"That's what you're for."

"I wasn't ready for my close-up. Can't you just hire a press agent?"

He changed the topic. "Wasn't last night something?"

"It was too much. You can use my photograph for the obituary we all almost deserved."

"Actually, I should have contact proofs later today," he said.

"I can hardly wait."

In fact, I was genuinely curious to see how Robert had Mapplethorped me. I'd seen his interpretations of other people I knew and how their real faces were transformed into Mapplethorpe masks.

I feigned indignation.

He never fawns over my writing.

I never fawn over his photography.

We take each other's skills for granted.

It's enough tacit, mutual endorsement that we're making conceptual progress on the book he wants to do in tandem: his photographs, my text.

All that morning, I worked with McNenny, sweeping the glass and broken flowers from the marble floor of the shop.

McNenny was never quiet. His Irish mouth never stopped. He complained to every neighbor who wandered in to cluck about the damage. They all agreed the neighborhood isn't what it used to be.

Doc Siva's daughter stopped in, because "I had to see whatever happened. I'm so glad Daddy retired to Florida."

"We should all retire to Florida," McNenny said.

Shortly after four o'clock, Robert breezed in. The *Vogue* shoot had been rescheduled for next week.

"The cunt is not ready"—he shot a very Mapplethorpe look at me—"for her close-up. She feels, she says, like one big zit. I told her to lay off the

drugs. Sam is at some fucking board meeting. I wanted to see him. I miss him when I don't see him."

Robert's tenderness is always so sweetly offhand.

"So you're turning into a fucking florist," he said.

"And you take pictures of pansies," I said.

"You need a spanking."

"So do you." I sat among a dozen boxes of cut roses on a stool at a high table in the back of the shop.

McNenny stood at a counter in the middle of the store next to a large red-rose funeral arrangement he had worked on all morning.

I was scissoring bunches of tight-packed daisies into shape.

McNenny, short against the towering funeral arrangement, was jabbing at his next creation, sticking cockscomb into a Styrofoam frog, surrounding it with daisies, carnations, and baby's breath, throwing comments to Robert and me, saying how much he hated FTD's precise designer arrangements, fielding chatter with customers about the unseasonable weather, their health, the broken window, the high price of good roses, and how much Doc Siva liked Miami.

The human flow of the shop warmed me.

With Robert returned early, the world seemed to flow at a pleasant pace, a pace my self was homing into as the overkill of the acid from the orgy the Wednesday before this Friday was out of my system.

Robert handed me a flat brown envelope. "Here's your photograph," he said.

"Oh, God!" I opened the clasp and pulled out the portrait. I must have frowned.

"Let me see," McNenny said.

I showed him.

"Not bad," he said.

"Don't you like it?" Robert asked.

"It's very good work," I said. "But I don't think I look like that."

They both groaned.

"Shit, yes, Jack," Robert said.

"That's not my face."

"Of course, it's not your face. It's your look. I shoot through faces. You're dirty."

"Oh, God!" McNenny said. He ran toward the front of the small shop.

Robert and I looked up.

"What?" I said.

Robert, street-smart, bodily pushed me behind the high counter and joined me.

A strange man had entered the store.

I always like New York's colorful characters.

This guy was straight from Central Casting, a Mediterranean type: floral print shirt with the collar flared out over the lapels of his dark blue double-knit leisure suit, shirt unbuttoned down over his hairy chest, a gold chain around his neck. Three blocks away, Robert had said, Francis Ford Coppola had filmed the street festival sequences for *The Godfather*.

"What are you doing?" I said to Robert. "This guy's here for the funeral arrangement."

"Funeral?" Robert whispered. "Shut up. Don't move." He deftly, this photographer of flowers, ever so slowly, seeming not to move, piled up bundles of daisies to obscure our faces.

McNenny is always so tough-mouthed. "You here for a pickup?" he asked. "You the party who ordered the funeral arrangement?"

"Yeah," the man said.

"So here it is," McNenny said. "My Gifts of Nature specialty. I call it 'The Last Rosary.' Fifty rose buds, only the best, stuck into five decades of silver-aluminum holders."

"Nice," the man said. "Very cute."

Two more men, startling after an afternoon of gossipy old women, entered the side door of the shop from Sixth Avenue.

They stood eyeing several Madonna vases.

One touched an arrangement.

The three seemed unaware of each other, yet somehow they seemed together.

Suddenly, all their attention focused on McNenny.

"I want my money," the man at the front said.

Robert pulled me down lower. He reached for the small hatchet that lay in the tool drawer. We crouched our butts into a bunch of American Beauty roses, waiting for McNenny to talk his way out of this.

"What money?" McNenny acted like this was a musical comedy.

The man looked out at the driver in his car parked illegally on the Avenue.

"From your little party last night at my restaurant."

"Oh, that," McNenny said coolly. "You'll get it." His hands never

missed a beat working the arrangement in front of him. "Your partner ordered a display from me. I made it special. Hey, I'm a little guy, you know? Hand to mouth. I waited six months for my money."

The man slammed the counter with his fist. "I don't give a shit about your money. He ain't my partner. He's a manager. And he ain't too good a manager."

McNenny backed away from the counter.

The man leaned across the Styrofoam and stems. He palmed a gun in his hand.

The other two closed in.

One of them kept his eye on us.

"Omigod! Omigod!" I whispered to Robert. "Omigod!"

Robert kicked my leg.

The man at the counter turned sharply toward us. "You two girls, shut up."

"Yeah," the man with his eye on us said, "maybe we want witnesses, maybe we don't."

"I'll put the check in the mail," McNenny said.

"Not good enough." The first man nodded to the other two. "Take care of this fern," he said.

He exited to his waiting car.

The two hoods picked McNenny up bodily, slamming him into his refrigerated case full of roses.

His head hit the door, shattering the glass, spilling daisies and baby's breath to the floor.

They kicked him around in the flowers.

The side of his head opened up. Blood, redder than the roses, covered his face.

One kicked McNenny's kidneys and smashed a praying ceramic Madonna vase into his groin.

The other rang open the heavy brass cash register, scooped out a handful of bills, looked around, and tipped the cash register up on edge, pushing it deliberately off the counter. It crashed to the floor next to McNenny's chest. A threat, a warning, it could easily have been aimed to land on his head.

They left him lying on the marble floor, moaning in the roses and blood.

The one who always kept his eye on us walked toward us and with his

gun barrel knocked the flowery hedge of camouflage away from us. "Fags!" he said.

"Your partner's a fag," McNenny shouted. "And so are you!"

Robert shouted, "Shut the fuck up!"

"Yeah," the man said, "shut the fuck up."

He backed out the door.

The car drove off. Slowly.

The confrontation had lasted only seconds.

Four days ago, that afternoon, that Friday, the florist, the writer, and the photographer could have been murdered.

At St. Vincent's emergency room, the black doctor took eighteen stitches to close McNenny's head, which a nurse wrapped in gauze.

"John McNenny," the secretary at the emergency desk addressed him.

"No," he said. "My name is not John. My name is Jack."

"Jack is the same as John," she insisted. "Jack is the nickname for John. I must use your legal name."

"My legal name is Jack," he said.

"You've heard of Jack Kennedy and John Kennedy?" This fish would not stop. "They were the same person."

McNenny looked her straight in the face. "Pound cake, cunt!"

At least his mouth still worked.

I know in reverse the fight he was going through. His legal name is really Jack. My birth-and-baptismal name is really John, but I've never, ever in my life been called anything but Jack by anyone other than bureaucrats filling out forms.

Robert complains about people who say the word *apple* in Mapplethorpe; he hates worse when I call him "Nipplethorpe," because of that movie he made getting his tit pierced. (I love teasing him; no one much does, he's so serious.) What really pisses him off is the confusion people have between him and Robert Opel, the performance artist who streaked the Academy Awards. Opel runs the Fey Way Gallery in San Francisco and featured several Mapplethorpe photographs in a show. Somehow, the Roberts Opel and Mapplethorpe have fused and people think there is one artist, Robert Oplethorpe.

They hate each other but they have not yet met.

Later, the three of us returned to Gifts of Nature.

"Where's your camera now that we need it, Robert?"

McNenny is always so nasty.

"Come on, McNenny," Robert said.

The neighbors came to look at the broken refrigerator door and to console McNenny's mummified head. "What next?" they all said.

The police arrived.

Robert said, "It was punks."

"Yeah," McNenny said, "punks."

The cops sized up the scene, and they called us "boys," but that wasn't what they meant.

"So what can you say?" one of the neighbors said. "What can you do?"

"At least you tried," Robert said, "to skin the cat."

"It's all a crock," McNenny said. "It's all a big crock of shit."

"Life's a big crock of shit," Robert said.

McNenny was a mess.

Robert and I took matters in hand. We closed the shop and taxied McNenny back to Robert's. He called the doctor with the doughnut scrotum, who came to Bond Street and shot McNenny up with something to ease the pain.

"Give us all something for the pain, Doc," Robert said.

"I'm fine," I lied. "My Quaaludes are settling me down fine."

Robert led the doctor into the kitchen for medication.

"I want to go out," McNenny yelled.

"Where?" Robert said.

"Anywhere. Just out."

"As long as he stays with you," the doctor said.

Robert looked put upon.

"Never sleep after a blow to the head," I said.

"Right." He gave me the evil eye. "Right," he repeated, very flat. "I thought you and I could finally be alone."

"Don't mind me," McNenny said.

"You almost got us killed," Robert said.

"You don't like situations you can't control," McNenny said.

"No one does," I said.

Telling Robert the truth about Robert is a sure way to piss him off, especially when he's not getting what he wants.

But that's true of everybody.

"The sooner we leave," I said, "the sooner we'll be back."

We tramped down the stairs to Bond Street. The night air cooled the tension.

The doctor took one taxi. We three took another.

"Where we going?" McNenny said.

Robert directed the cabbie north to the tramway car that goes up and over the East River alongside the Fifty-ninth Street Bridge to Roosevelt Island.

The tramcar was a good idea. We rose smoothly up and out over the dark water. Behind us, Manhattan spread out, classic as a movie shot, as we gained altitude in the car.

"Roosevelt's all mental hospitals." McNenny paced a short circuit back and forth in the small room of the lift. "All along the west side of the East River are hospitals."

The other passengers, silent, watched him like some idiot savant, finding some, maybe, authority in his bandaged skull.

Robert and I stood apart from him and very close together.

"That hospital over there is where Dr. Tom Dooley died." McNenny walked to us. "You remember him."

Manhattan was reflected below, distorted, in the strong East River currents.

"He was gay, too, you know."

A woman seated at the front window glared at the three of us. "Isn't anybody straight anymore?" she said.

Robert smiled at her and she smiled back.

"We ought," she said, "to deport all you boys."

"Yeah," McNenny said, "but who'd do your hair?"

"Come on," Robert said. "We had enough trouble tonight."

The tramcar descended to Roosevelt Island.

Together we exited down the promenade to the water's edge. Manhattan stretched clear in the late autumn air as far as we could see. The city lights reached up into the muffled hum of the night air.

McNenny wobbled off to sit on a bench.

The lights wobbled on the water.

The Atlantic wind rustled the island trees.

Traffic cruised overhead on the Queensboro Bridge.

"This is sort of romantic," I said.

"We could run at each other in slow motion," Robert said.

"We're not lovers," I said.

"But we fuck good."

The lights and the bridge and the water, everything that had

happened, made me want to be romantic, but Robert is always so analytical.

I was stuck between McNenny zoning out on the bench and Robert staring down into the obsidian mirror of the East River.

New York is fun, but it's not like San Francisco.

I felt, and I feel, distant from New Yorkers no matter how much I like them.

I shouldn't have said it, when I said, looking at the city over Robert's warm shoulder, "I love you."

But I did and I'm glad I did, because he turned his face to me and said, "I love you, too," so coolly, so really real, I truly believe him, not as lovers, but as friends.

He put his right hand in the left back pocket of my jeans. The wind caused him to shiver. I put my arm around his thin shoulders.

Robert is so urbane and cool and classic.

I'm too romantic not to sense how isolated he is.

We kind of just stood there watching Manhattan show off.

I remembered how Francie in *A Tree Grows in Brooklyn* had looked at the same flickering skyline and had said it was important to look at everything as if it were the last time you'd see it, because the last time of anything has the poignancy of death itself.

God, I really do love him, in the gay way, to be sure, but more, in the human way, because he's so fragile, so thin, so likely to disappear. There are so many miles between us and so many dangers in the heart of the darkness he courts that so scares me.

McNenny walked up behind us. He put a hand on Robert's left shoulder and on my right and stuck his bandaged head between ours. Then he shouted, "Thank you, New York, for letting me live here!"

Robert and I laughed out the tension of the day. We all three got really quite hysterical.

We took the tramcar back, put McNenny in a cab, and wandered along Fifth Avenue.

I saw a window full of silver unicorns at Tiffany's.

Robert laughed. He thinks I'm so funny, I think sometimes he means funny-peculiar, but he says we make intelligent sex, which is a new take for me.

Later that night, that was three nights ago, we slept together after we made "intelligent sex," which was when he again licked my left eyeball

with his tongue, and I made him stop because it's like too personal and freaks me out.

He keeps insisting I'm dirty.

I keep telling him I'm not.

I think I'll not frame or hang his photograph of me.

If truth is in it, it's his truth, and if it's mine, I won't ever admit it.

McNenny's head was still bandaged this morning when I left.

In 1980, Jack McNenny became the New York distributor for my quarterly magazine called *MAN2MAN*. Robert offered one of his photographs for the premiere issue, but he never got around to sending it.

The international art world was calling him everywhere, and he hadn't the time even to continue with the book we had been planning since 1978 titled *Rimshots: Inside the Fetish Factor*, even though he had selected and sent all the photographs.

In 1981, Jack McNenny fell sick; his spleen had to be removed. In 1982, he sold Gifts of Nature and moved for health reasons to San Diego, where, "unrepentant," he started publishing the underground magazine *Jack's Shit List*. McNenny died in 1983 at thirty-eight.

The last model and shoot I arranged for Robert took place, with me and my then lover, Jim Enger, in San Francisco in 1981. Robert sent, via Edward De Celle, autographed photographs from the shoot in 1983.

By 1982, I had completed an almost final draft of a novel written during the 1970s. Robert had read many passages in progress and was very supportive of the project.

When the story's two main characters discuss their relationship and the impact of the celebrity coming to one of them, the relationship *à clef*, of course, is ours.

Robert walks, fictitiously, by name through *Some Dance to Remember*, which, when published in 1990, because of his creative input and personal encouragement, was dedicated to his memory.

One critic said the novel does with words what Mapplethorpe did with the camera.

I should be so lucky.

In the novel, the character on the cusp of fame says, "I want us to be a story told in beds at night around the world."

That fictional line came from a true statement Robert once confided. He told me, the writer he had long before sought out, "Don't laugh. But I

want to be known, I want my work to be known, around the whole world."

I didn't laugh.

Robert Mapplethorpe was, for all his canny ambition, a real person of sensitive feeling and transcendent talent.

He was a seer unafraid to exhibit what he saw.

It is an American scandal that Robert's sweet person was lost in the cause célèbre avalanche of sympathetic essays about his technique and place in history, because his art was trashed by politicians in search of a controversial issue and by ignorant religionists terrified of their own bodies.

His photographs are mirrors.

He mirrored me to me and frightened me.

I had warned him to clean up his act.

His photographs of me warned me to clean up mine.

I couldn't save his life.

But he saved mine.

Once he was flesh and blood.

Once, faced with his own death in an epic plague, he intensified the quantity and quality of his visionary art.

His growth as a person shows in his uncompromising series of revealing self-portraits that show him ageing fast, from youth to old age, in the terrifying speed trip that is AIDS.

Human life was not lost on him.

Always he was a good man worth loving.

MAPPLETHORPE AS CULTURAL TERRORIST
PLAYING "CHICKEN" WITH THE AVANT-GARDE

New York is a tough town, But the devil's advocate whom
Mapplethorpe feared lives in London.

Edward Lucie-Smith is more British than the queen, more amusing, and
better dressed. He is a much-published author of fiction, history,
and art.

Robert never liked Edward, because Edward, meeting Robert Map-
plethorpe, long before he became "The Mapplethorpe," diagnosed Rob-
ert's social climbing as a one-trick pony.

Robert, who rarely received a bad review, feared the power of critic
Edward Lucie-Smith, whom he called "that nasty, English faggot critic."

Edward is hardly nasty. He lives in London in a flat in Avonmore Road,
next to the Great Olympia Exhibition Halls: computers one week, travel
fairs the next. At his home, he cooked up a Moroccan supper for me while
we tattled on, wedged in among his substantial collection of paintings,
photographs, sculpture, and books. He is a brilliant scholar whose sense of
art history and contemporary society gives a touchingly real sense of
Robert hustling the New York art world. Two stacks of book manuscripts
he is writing sit neatly on his desk. Among more than a hundred titles, he is
the author of *Eroticism in Western Art*, published by Oxford University
Press.

The hour was late. We had attended a gallery opening for David
Pearce, who paints leather more classically than Mapplethorpe shot it, and
then a late screening of Derek Jarman's extraordinary film *Edward II*.
Jarman was Mapplethorpe's bête noire. And, now, we were both slightly
giddy with the kind of after-midnight chat that loosens inhibition.

Lucie-Smith's view from abroad offers insightful perspective on the young photographer lately sprung up in America. "Robert Mapplethorpe was an extremely interesting American phenomenon," he said. "Robert was not a great artist, he was a great salesman."

Such judgment by the much-published art historian and critic flashed a fresh, provocative perspective on Mapplethorpe, whose later fame as a household word was owed more to political controversy than a national debate on aesthetics.

During the U.S. censorship battles, art, as expression of free speech, had been defended in principle much more than the work of Mapplethorpe in particular.

Robert was simply the legal scoop *du jour*. His surname became an answer on the TV game show *Jeopardy* in September 1990.

He was an artist certified by galleries, museums, critics, celebrities, and indirectly by the National Endowment for the Arts, which funded galleries showing Mapplethorpe, who himself never received NEA grants.

The courts judged not at all if he were a great artist. Somehow, the media and the public presumed posthumously that Mapplethorpe's work must be great art because the great furor it caused made it famous for being infamous.

Edward Lucie-Smith is a scholar whose vision eschews instant media bites for the larger scope of art history.

"To understand Robert, one must understand that the New York art scene is extremely closed. I've always functioned as a well-informed outsider. Manhattan has its own social dynamic. A kind of incestuous interplay of money, fame, and art. Robert learned the game early on. He wanted in and he would do anything to enter the in-crowd. He parlayed a virtual hostage situation. He played 'chicken' with the avant-garde."

"To gain what approval?"

"Imagine the young Robert in the late sixties, early seventies, deliberately setting up avant-garde savants by showing them his fresh, shocking images. They had to like his work, because if they blinked in shock, they immediately lost their avant-garde status. His assault on them was an 'invitation to a mugging' he could not lose. Robert wanted status and he achieved it by threatening their status. If they thought themselves far out, he presented himself as farther out. He was very clever."

"Robert must have found it difficult to manipulate you."

"My God! The poor lad hardly had the chance. A psychoanalyst, who

is married to my best friend, engineered my meeting Mapplethorpe. He introduced Robert with the immortal phrase: 'I want you to meet the most polymorphously perverse person I have ever met in my life.' What a come-on!"

Robert's boyish charm failed to work to his advantage. Edward Lucie-Smith presented a formidable hurdle that Robert, even with a running start, could not clear. His practiced ingenuousness fell flat.

"Robert, at that early stage," Lucie-Smith said, "was still on the outside looking in. He was a greyhound on a leash. He foamed with ambition. He had various friends plugging his reputation. Gert Schiff, a professor at NYU, was one such person, more than the psychoanalyst, who fostered my brief first acquaintance with Robert."

"What was Schiff's interest in Robert?"

"Gert was two people in one body. He was a respected art historian, a full professor at NYU, author of the Fuseli Catalog *raisonné*, later the creator of the wildly successful Late Picasso show at the Guggenheim. A meticulous Swiss. He was also a prime case of gay satyriasis. He fucked anything that moved—if it was reasonably pretty and of the masculine gender. He performed a balancing act between these two selves by being a resident for many years at the Chelsea Hotel."

"The Chelsea Hotel?"

"Gert got me a room there, and that's how I continued my ongoing acquaintance with Robert."

"What year was this?"

"The New York underground cinema was in full swing. Warhol. The Kuchar brothers. Kenneth Anger. Warhol had just made *The Chelsea Girls*. He made *Blow Job* in 1963. He made *Chelsea* in 1966. So it was 1966.

"Robert at first was too poor to live at the Chelsea Hotel, so he lived down the street, but he hung out in the Chelsea, cruising its corridors, picking up on the art-sex-and-drugs cachet of the address, trying to meet people who knew people."

Robert at the time was twenty years old and had been hustling Manhattan for four years. He was six years away from meeting art historian John McKendry, curator of photography at the Metropolitan Museum of Art, who bought Robert his first serious camera.

Robert worked the Chelsea Hotel and the galleries by day the way, in the later, more successful, period in the late seventies, he worked clubs like Max's Kansas City, The Saint, and the Mine Shaft by night. Those early

days, he once told me, were hard and dark. Sometimes, he was able to afford the tab on a small room at the Chelsea Hotel on West Twenty-third Street. Sometimes, he retired to a dingy walk-up just down the street. In New York, one's address is everything, and crashing the Chelsea, the notorious avant-garde enclave, gave Robert his first tangible sense of arrival.

At the Chelsea, Robert claimed (in his version), he met Patti Smith, who appeared in his open doorway looking for someone else, not Robert, whom she had never met. "I woke up," Robert said, "and there was Patti. We recognized each other's souls instantly. We had matching bodies. I had never met her, but I knew her."

The androgynous bodies took, according to Robert's take, to a kind of Chelsea heterosexual bonding. They became a couple on the art-and-party circuit. They pooled their money to afford their nightly visits to Mickey Ruskin's bistro at Park Avenue and Sixteenth Street, Max's Kansas City, where sixties pop celebrated itself nightly. "I hated going there," Robert said, "but I had to."

At dawn, the young couple returned to the Chelsea. Robert supposedly had kicked a hole in the wall between his room and Patti's. This instant suite was his first attempt at interior design.

Robert needed Patti. He was alone. She was there. She nurtured him for several years. She was a writer and he was mad for the company of writers. She was a singer and he loved rock 'n' roll. *The Chelsea Girls* film had lasted three hours and fifteen minutes. Robert and Patti lasted longer. For a while, as a couple, they were chronologically correct, until they weren't. Patti graduated to her own stardom, travels, and odalisques. One pop culture urban tale has Patti running off with playwright Sam Shepard, leaving Shepard's writer/film actress wife, O-lan Jones (O-lan later became a theater legend, directing her experimental music and theater company, Overtone Industries). Another urban pop tale, told by porn star J. D. Slater, pairs Patti with the lead guitarist of MC-5, Fred Sonic Smith.

Patti Smith herself can be the only one to tell the tales of her heart. Whatever her real private history, the true romance pop culture story is she never really left Robert, not for men, not for women, not for music, not for long, because she was more than his muse; she was his twin, his divine androgyne, and he was her photographer, the artist whose camera, with her, became positively Kirlian, capturing her spirit, her aura, her being.

His camera became their bond.

"Patti is a genius." Robert said that so often I began to understand that what he said about Patti he was projecting about himself as modestly as he could. His style was to reveal his personal self by indirection. (His professional self he revealed by edict.) Consequently, I never knew much about Patti, to whom I sometimes spoke on Robert's phone calls from my home, because Robert used her as an emblem to talk about himself.

When Edward Lucie-Smith met Robert and Patti, they were inmates at the Chelsea: spiritually, but not physically. "When I met him," Edward said, "Robert was in one of his 'broke' phases, and the walk-up a few doors down the street was the place where he slept, if he ever did sleep, while he hung out at the Chelsea." But Robert and Patti seemed avantly certifiable "Chelsea Girls." Signs and omens were everywhere. Warhol's film was banned in Boston and Chicago. The "Chelsea Robert," so enthralled by Warhol, was already on the trendy trajectory toward censorship.

"When I stayed at the Chelsea Hotel," Edward Lucie-Smith said, "there was a girl named Sandy Daley who had made the underground film *Robert Having His Nipple Pierced*. The scene was pure Warhol. Miss Daley's screening of her film took place in the very room where it had been shot. Some of the silver plastic pillows, their helium depleted, flitted through the film. Robert was there with Patti. The relationship was starting to turn to a pair-bonding friendship.

"But there he was. He had never yet picked up a camera in a serious way. He was still on the other side of the lens. He was the star of this . . . movie."

"What was he like that night?"

"He was pretty. He was uncertain. He knew who I was."

"That's Robert. It was the same when we met. He knew who I was. I had never heard of him."

"That night, he fairly dripped with ambition for one so obviously not tremendously talented."

"Was he playing underground film star?"

"He was beyond that conceit. The next day, he insisted I come up to his dingy walk-up so he could show me his rather creepy collages, pictures of naked young men cut from magazines. He had covered them with a kind of rubbery spiderweb so they seemed to be flies caught in a death trap."

"What was your reaction to the film?"

"I thought the evening odd. In the film, Robert and Patti were very

like each other, outsiders, pretty, but hungry and skinny, and deathly intense. Patti had a slightly hysterical edge, which I think probably has to do with something in her childhood. She did the soundtrack of the movie. She spoke live; it was an improvised poem. Patti worked then, the way a good rap artist works now. Patti watches while Robert, having his nipple pierced, lies in the arms of a male lover."

"Home movies in the cinema of the damned."

"I think the film was supposed to be about the tensions in Robert's nature, about his attraction to Patti and his attraction to men. They seemed to have come to some terms with the ambiguity, perhaps through the film. It encapsulated the moment from which they were all moving away."

Edward Lucie-Smith's assessment is as poetic as Fitzgerald's closing lines of *The Great Gatsby*, and as existentially insightful: "the moment from which they were all moving away."

That crucial "moment," not yet a "perfect moment," was that nano-second when Robert Mapplethorpe "came out" from heterosexuality into the chic homosexuality that would certify him as genuinely avant-garde.

Robert's experience with Sandy Daley's movie, in this charmed Chelsea circle, showed him the power of film that freezes time into moments perfect and past imperfect.

Never underestimate the power of women in art.

Patti, as poet and singer, jumped way ahead of Robert. Before her celebrity as an early punk-rock pioneer at the music club CBGB, she was an eager performance artist of her own poetry in SoHo clubs. Robert himself made it into the avant-garde Holly Solomon Gallery, where Holly was about to change his life.

"Holly," Edward said, "is a formidable woman. She was then the Mother Superior of a certain kind of avant-garde scene. She advanced in a serious way. Soon Holly sent him to the Robert Miller Gallery."

"Holly claims," I told Edward, "Robert walked out on her, politely enough, right during her exhibition of his work. He simply wanted to trade up and out of SoHo because art patrons then didn't like to go south of Fifty-seventh Street."

"Everyone remembers everything differently," said Edward. "I do think it was another way round. I don't wish to contradict anyone, most of all Holly, whom I revere, but Robert was doing images Holly couldn't handle."

I said, "Robert took Holly around to porn shops and they both had a good laugh about the sex magazines and the marital plastique."

"Still, Holly is not gay. She's straight. Avant-garde, yes. But heterosexual. And Robert had become overtly homosexual. Robert Samuels was an openly gay gallery hardly abashed by Mapplethorpe's early work, even though I don't think Robert Samuels ever did a show of the later, real S&M material. They used to show his *X Portfolio* to potentially sympathetic clients in the back room. All this pop culture history depends on one's knowledge of the inner workings of the New York art scene, on one's memory, and one's attitude toward the truth."

Truth is not chronology.

Truth is not biography.

Truth is something one distills from impressions.

Truth is *Rashomon*.

"Robert, I must say," Edward mused, very like the analytical historian he is, "was very lucky to meet and cohabit with Sam Wagstaff, who was a real, old-fashioned easterner and one of the first pioneers in the collection of photography. My friend, Helene, the psychoanalyst's wife, had known Sam since they were teenagers. They used to go to upper-crust teen dances together. She said Sam danced divinely. So you very well see that Robert married better than he first realized. Wagstaff was pedigreed and had a generation's head start on Robert. Wagstaff was a collector. He had little creativity himself, but he had great taste.

"Very little, even by the mid-seventies, was known about photography as fine art.

"Wagstaff was collecting great photographic images before the hierarchy of photographers was settled."

"Robert shocked Sam's perceptions about sex," I said.

"Sam shocked Robert about photography," Edward said. "With Sam as his mentor in the vast unstudied sea of photographic images, Robert was a most privileged student. Sam gave Robert access to an art form, and genres within that art form, which was then completely unfashionable, particularly Edwardian pictorialist photography.

"Robert absorbed every image he ever saw. The Baron de Meyer's famous image of the flower became Robert's flower. Robert also nicked something from de Meyer's sequence of photographs showing Nijinsky in *L'Après-midi d'un Faune*."

In several of his self-portraits Robert referenced himself as faun, satyr, Pan.

"The Diaghilev milieu," Edward said, "would have suited Robert very well. And then, when the money started coming in, he began collecting. He absorbed anything that could be useful. He picked up on the incoming Deco craze."

I told Edward that sometimes while shopping with him, I was amazed. He was buying up Arts and Crafts, Mission furniture, before anyone else in the seventies caught the rage.

"Robert was lucky with Sam that he caught the wave of photography, the same wave that benefits Cindy Sherman, Bruce Weber, Herb Ritts, Helmut Newton, and Annie Leibovitz." Edward gestured to a shelf of recent photography books. "Back in the sixties," he said, "New York collectors were frightfully arrogant, frightfully specialized, and, therefore, frightfully provincial. They were frightened that images of flowers might be kitsch. Could they dare have photographs of flowers on their chic walls? But secretly they all had a sweet tooth for Robert's kind of candy.

"Robert charged into the scene and opened it up. He was young, fresh, and coyly abrasive. His bold condescension, his icy coldness to anyone who challenged him, was excitingly assaultive in a decade when theater loved cruelty. He broke the perceived taste of the avant-garde obeying Warhol's pontifications.

"Robert gave people permission to be avant-gardists with photographs of lilies in the dining room, because, as soon as everyone knew about his fisting photographs, his lilies gained an edge. The flowers opened up whispered avant conversations about his forbidden photographs, which, at first, not too many had been granted favor to see."

Edward Steichen said in 1963 that the custom in New York since the 1920s was to hang nude art, especially photographs, discreetly away in the bedroom.

"So the subtext of the flower photographs' popularity is the existence of the nude and leathersex photographs?"

"The forbidden photographs," Edward replied, "made the flowers desirable, salable."

"Did that same sexual subtext cause his celebrity portraits to succeed?"

"He definitely benefited from his private history. Of course, it was sexy to be shot by such a naughty boy."

"But are the portraits good?"

"He was a great photographer of celebrities. That doesn't make him a great photographer historically, but he had a knack for bringing out an essential beauty in faces from the most ordinary to the most extraordinary.

"His subject whom I knew best was Bruce Chatwin. Robert and Bruce were the same kind of person. Ambitious, charming—if they wished to be. Bruce was a writer, the author of *Songlines*, a novel about Australian aborigines. In England, he cut a brilliant, legendary, seductive figure. Robert, very keenly, cut straight to the element of danger in Bruce's personality, just that risky trait which was to bring Bruce to an early end from AIDS."

Bruce Chatwin, the distinguished travel writer best known for his 1977 *In Patagonia*, died at age forty-eight on January 17, 1989, seven weeks before Robert died.

"Robert superficially posed Bruce as an pretty, blond English boy with blazing blue eyes," said Edward. "He posed him as some wild creature caught in the glare of the spotlight.

"Robert stripped Bruce's mask of ambiguity. Bruce had always been running away to the ends of the earth to deny he was gay. But Robert, who was so commercially out sexually, knew what Bruce was about and his photograph tells all.

"Robert often bragged that he knew what people were for, what they were really like, even if they didn't know themselves, or wouldn't admit it. He liked to upset people by showing them his truth of what their faces hid. I know he upset me when I saw my portrait. Eventually, he upset everybody."

Robert certainly knew what Chatwin's literary reputation was for. He engaged Bruce to write the introduction to Robert's *Lady Lisa Lyon* (Munich: Schirmer/Mosel, 1983).

"Bruce was exposed on film," Edward said, "but Robert kept him conventionally pretty enough to keep Bruce happy, even though the photograph virtually exudes his deepest, darkest secret."

"Robert often X-rayed subjects who interested him," I said. "The portraits he shot by personal choice are a different take from the commercial portraits he did for cash."

"Let's say Robert was good at perfecting people in the way that a good courtier perfects his patron, all the while keeping his cynicism cleverly coded even within the art piece."

Edward opened the photography book *In the American West*, and read a quotation from Richard Avedon:

" 'A portrait is not a likeness. The moment an emotion or fact is transformed into a photograph it is no longer a fact but an opinion. There is no such thing as inaccuracy in a photograph. All photographs are accurate. None of them is the truth.' "

"At least Avedon speaks like Steichen," I said. "I find it sad, as does Joel-Peter Witkin, that Robert never wrote about his work. He said writing took too much time, so he preferred to hang out with writers. His literary talent was to give absolutely charming interviews to reporters."

"Robert stole that gimmick from Andy Warhol," Edward said.

"But Warhol wrote, sort of the book *Popism*. And Robert wrote only letters. Maybe he hadn't enough intellectual mass to write. He wasn't well educated. He was great at small talk: deflecting, derailing, trivializing, humoring. I remember him saying that primitive tribes who believed the camera sees the soul were right. Maybe that says everything he had to say about his photography."

"He *was* iconic," Edward said. "It was his Catholicism. Women, madonnas, virgins. Celebrities of the Jungian anima. Robert seemed to venerate women as much as he did males. You once wrote, I remember, that Robert was partial to princesses."

"Yes. Of both sexes."

"Robert was very like Boldini, who is the Italian Sargent, much shallower than Sargent, who exaggerated the same elements which Robert was able to put into the camera. Especially with princesses. There is as much exaggeration in the celebrity portraits as there is in the genital photographs. I suppose there's a certain chic in that.

"One could line the better Mapplethorpe portraits up against some drawings by David Hockney, who is so very good. Where the nudes are concerned, Robert, unlike Hockney, treated his subjects not as personalities, but simply as objects. Human sculpture. He studied sculpture first. There's a big gulf between Robert's black nude sex objects, shot by the gay Robert, and the nude celebrity portraits, shot by the homosexual Robert. Hockney's nude drawings are always naked portraits: real personalities with cocks attached.

"So many gay photographers don't take portraits of nude men. They just shoot pictures of a cock which happens to have an appendage, a person attached to it."

"I often do that myself, for magazines and videos," I said. "That's what sells. That's entertainment."

"Exactly," Edward said. "One must really consider so much in any assessment of Mapplethorpe."

"Where do you place Patti Smith in all of this?"

"I wish I knew Patti better. She came to see me in England. She rang me up, which I never thought she would. She was photographing rock stars. I think she was trying to compete with Robert's act. I remember how incredibly naïve she was, yet she struck me as very sensitive. She's a good person, but somehow damaged. Robert's work gives some internal evidence that he clung to her as symbolic of some possibility he had lost."

"That possibility was his heterosexuality, which reared its latent head once in a convenient while."

"You don't say."

"I do. And what you say touches me, because when I look at the last photographs of Patti, she seems like the grieving, about-to-be-widowed Mrs. Robert Mapplethorpe. I think she's the wife he would have had."

"I'm sure of that. Women in men's lives create more mysteries than mistakes," Edward said. "I simply didn't understand her need to photograph rock stars."

"It could be she wanted to emulate Robert with her own camera. She is a woman of a certain vision in her writing."

"But she was unable to do photography. And then going back to Detroit, of all places, with the baby. I can't remember if the baby's father was ever announced."

"Perhaps Robert was the father."

"God save us. Another Mapplethorpe."

"He has a younger brother, also a photographer, to whom he left his cameras. He has exhibitions under the name Ed Maxey."

"I am well aware of that young man. He just had a show in London. Robert—and, I suspect, other Mapplethorpes as well—regarded me as a hostile power."

"He probably feared your critical analysis," I said.

"I hope Patti doesn't share that fear," Edward said. "She was his alter ego. She was the light to his dark. Perhaps she sees the other side of me. I suspect his photographs of her are his best work."

"Women responded exceptionally well to Robert," I said. "He was one of those men who genuinely like women. Brutus, a straight male

model Robert and I both shot, traveled to Japan with Lisa Lyon. Brutus swears that Robert had a hot affair with Lisa."

Women, from college girls to socialites, love to dally with artists. Women were the first to promote Robert, who knew how to promote them. He shot film of Patti and video of Lisa and stills of them both. . . .

"I must say," Edward said, "that the women in his photographs, whether demure or daring, seem genuinely self-assured and comfortable, as if they trusted him implicitly behind the camera."

"His mother died shortly after Robert," I said. Her name was Joan Maxey Mapplethorpe.

"At least she missed the scandal," Edward said.

"His father, Harry Mapplethorpe, told the press that he wouldn't have any one of his own son's photographs hanging in his house."

"So where does that leave the younger brother?"

"My guess is," I said, "somewhere in the Mapplethorpe firmament. Immediately after Robert's death, he showed up in Los Angeles photographing women, celebrities, nothing sexy or controversial I know of. He seems to be straight. His girl friend, when he was in LA, was said to be one of Robert's female models. If he's not gay, in an age of AIDS paranoia, he's a safe, nonembarrassing reincarnation of Robert, who loved confrontation. He's culturally a half-generation younger than Robert. He's mid-thirties, probably wanting, justifiably, what everyone wants: fifteen minutes of fame. At thirty-two, Robert had been famous for years. A certain San Francisco photographer, who was jealous of Robert alive, said, 'Ed's photographs in *Details* magazine seemed cloned from Robert. If Robert was an X ray, Ed is a Xerox copy.' How tacky these queens can be about innocent straight survivors."

"I was worried," Edward said, "that *I* might be negative about the Mapplethorpe clan."

"Don't look at me," I said. "I'm just a pop culture journalist talking to people."

Anyone who puts his art out for exhibit hangs it for criticism as well. My limited experience with Ed Maxey Mapplethorpe, his reputation, and his work has run from enthusiasm to wait-and-see if he finds his own voice or his own eye. Time will tell if he's his own artist or just numero uno of all the Mapplethorpe impersonators. It would be wonderful if Ed could have his own career. He seemed personable when we spoke. Robert bequeathed Ed his cameras, and told Ed not to use the Mapplethorpe

surname, because Ed would do better on his own. Was that fraternal sentiment or commercial endorsement? Or was it that there was only one MAPPLETHORPE! Knowing Robert's knack for control and controversy, one thinks, well, this may be drama from beyond the grave. The dead Lord Mapplethorpe spins the archetype: Cain dies; Abel lives; Cain keeps Abel under control. Ed Maxey Mapplethorpe actually has some hands-on arts credential besides a share in the sibling gene pool.

"Ed worked with Robert," I said, "as an assistant from about 1982 to his death in 1989."

"God knows, someone should have," Edward said. "We were looking at some of Robert's later work at the last art fair in London and were rather shocked by the poor quality of the prints. They hadn't been properly spotted. They were dirtily printed. When you inspected them, the immaculate quality he had always been so famous for didn't stand up at all."

"At the last," I said, "he seemed to shoot faster. As he became ill, he had less time to pay attention to the editing, let alone to the printing. I don't know. I can only conjecture. Like Warhol, who let other people do his work, Robert sometimes seemed to me more into product than art. I've talked to several photographers who have AIDS and they all said they'd speeded up their production."

"Well, anybody would. But these were rather inexcusably grungy, even in an unfortunate age of grunge as style, especially when his reputation relied on one's perception that his work was immaculate."

"AIDS takes its toll in many ways."

"I have a theory about extremely modern art," Edward said, "which is that the person is more important than the product."

"Thank Warhol and his fifteen-minute cult of personality. I think people are more important than art. But I understand what you mean as a critic."

"What I mean to say is that Robert finished up in a situation where his presence was everything. What was left were relics. Robert, in effect, made himself, St. Robert Mapplethorpe, commodity and martyr."

"To die for art ranks somewhere near dying for love," I said.

"May I tell you a parable? Joan of Arc was a girl from a remote country, the daughter of a prosperous peasant. By strength of will and personal conviction, and some mad mysticism, she became an androgynous warrior. She took a gigantic risk, and, of course, she paid for it. Jump from Joan to Robert. Give a little. Take a little. Robert performed the same sort

of self-transformation. He was a middle-class boy run away from a Catholic family. He transformed himself into a mover and shaker in the most insular and snobbish art world of them all. He did it by personal conviction. That's why, in a sense, I don't hold his careerism against him. He assaulted the New York avant-garde with his camera, and won." Edward Lucie-Smith smiled. "Robert Mapplethorpe was a cultural terrorist."

"What of his reputation twenty years from now? Will he be revered or just a footnote because of the censorship battles?"

"Robert Mapplethorpe will always be a figure of bizarre fascination. He's no Oscar Wilde. Robert never produced in photography, no matter how much his 'perfect moments' are touted, anything as good as *The Importance of Being Earnest*, which is the perfect symbol of comedy."

"I think he is as talented, genre for genre, as Wilde," I said. "He's virtually a retroversion of *The Picture of Dorian Gray*. Certainly, in court and controversy, Mapplethorpe is this *fin de siècle*'s Wilde with a Hasselblad."

"One should also consider Duchamp and Dürer. Duchamp invented the 'found object': art that isn't art. Dürer portrayed himself as the Christus."

"Robert often fantasized and photographed himself as the Christus," I said.

"Actually, the most revealing Mapplethorpe book is Christie's catalog of the auction of Robert's estate. It may be Robert's greatest joke."

"No," I said. "His greatest joke was his BBC interview."

"Well," Edward said, "he wasn't a great collector and his wasn't a great collection. Christie's catalog was extremely skillfully hyped to legitimize all the kitsch, and anyone wanting to know Robert would benefit from studying it.

"The catalog has four or five sections. First, all the glass, which was Robert's real specialty; then a mix of Mission and fifties furniture; followed by rather leading-edge decorative specialties of his time. Next was Robert's so-called photographic collection—the vintage material, which I suspect consisted mainly of gifts from Wagstaff. Also, I recall a pile of minimalist artwork, which no doubt came from Sam, because it had nothing to do with Robert's tastes or interests. Finally, there is this accumulation of diabolist kitsch: devil's heads, skulls with crossbones, satanic candlesticks. You name it. He had it."

"I often shopped with him. He bought by whimsy. Price was no object."

"I'm sure you thought it a joke."

Robert was a dealer. The Christie's auction catalog is a beautiful piece of work published for moving "The Collection of Robert Mapplethorpe, Sold for the Benefit of the Robert Mapplethorpe Foundation, Inc." Actually, the catalog is Robert's Wish Book come true, a sumptuous garage sale, as has become custom among *haute* homosexuals, selling off grand-to-the-valiant-end in an age of AIDS, "by appointment only."

Robert secures the last laugh, the biggest sale of all.

Loot.

The proof of his social and aesthetic acceptance.

He was an aerobic shopper.

He was good.

He learned from Sam to hit on a genre before it became chic. He collected 1950s glass, Mission furniture, African and Native American folk art, Old Masters and new from Europe and America. He had a good eye, but he often paid too much. Dealers knew he had money. He cursed when he was overcharged, but his lust for the object held him. I'd advise him to walk, think, have coffee, return, negotiate. That took time. He rarely bargained. He knew he had reached the fulcrum where he had more money than time.

Robert recouped the excessive prices he all too often was charged. He "worked" his collection. He photographed his American and European glass vases with flowers. He shot his collection of folk art and European sculpture: a small Farnese Hercules, Pan, Satyr, Mephistopheles. He used the objects in his studio work, because he loved them, but, as a sharp trader, wanting to recoup his investment, everything of value had a price. He lovingly photographed his things in the glamorous, pricey style suited for beautiful commercial print ads for magazines to up their resale value.

When finally his precious objects were auctioned, he had, in addition, his beautiful photographs of them: sale objects selling themselves. The physical collectible might be sold, but he maintained ownership of the negatives of their photographs. Because he photographed the objects, they were worth more, endorsed by his selection and enhanced by his take.

Every perfect object served double duty.

Through his camera, he multiplied his loot.

He not only sold the stuff.

He sold photographs of the stuff.

The Christie's auction was a collection of relics of St. Mapplethorpe.

He endorsed his collection the way athletes endorse Wheaties. He upped the value. A George Sakier glass vase became even more important when collected, photographed, and signed by Mapplethorpe.

At least to those collectors, mistrustful of their own personal instinct for style, who follow formidable tastemakers like Robert.

No wonder George Dureau said, "Robert ran himself like a department store."

Robert's collection of photography was far-ranging: antique to contemporary. He bought and sold and kept the best, at least, of the work he personally preferred, especially respected friends Lynn Davis, Joel-Peter Witkin, George Dureau, and Annie Leibovitz.

In his personal photography collection, kept till death, his private, delicious delight in the art is distinctly profiled.

Robert's final photo-sort profiles the homage he paid to photographers, historical or personal friends, who influenced him or whom he admired: F. Holland Day (*Orpheus Series, Return to Earth*), Adolph de Meyer (*The Opium Smoker* and *Portrait of Robert Stowitz in a Diaghilev Ballet*), Harold Edgerton (*30 Cal. Bullet through an Apple*), George Dureau (assorted male nude studies), Peter Hujar (selected images), Clarence Kennedy (fashion and society sculpture studies), Angus McBean (male face portrait and reclining male nude), George Platt Lynes, Julia Margaret Cameron (*The Shadow of the Cross*), Edward Curtis (Native American portraits: *Crow—Chief White Swan* and *The Potter, Hopi*), Edward Steichen (*Fashion Portrait*), Alfred Stieglitz (*Portrait of Marie Rapp*), three from Diane Arbus, two from Bruce Weber, seven from Joel-Peter Witkin (*Lisa Lyon as Hercules*, bearded, and *Mandan*, depicting the sun dance ritual enacted by my friend, mystic performance artist, Fakir Musafar), five from longtime friend and Mapplethorpe Foundation board member Lynn Davis (*Iceberg* and *Selected Images*), and two from Annie Leibovitz (one, the sublime photograph, *John Lennon and Yoko Ono*, 1980: Lennon nude, curled fetally across the reclining Ono whose hair flows across the floor; this photograph was taken the afternoon of the evening Lennon was shot).

Robert, ever in search of the other's interpretations of his persona, enjoyed the tribute of other artists who created superlative portraits of "The Mapplethorpe." At Bond Street, early on, he cherished his image as shot by Scavullo.

Drawings, photographs, and screens of Robert, sold on the auction block, represent the best of what he liked about himself interpreted by

sibling artists: Patti Smith, *Robert Mapplethorpe and Patti Smith Go to Coney Island Together*, graphite and crayons, $400; David Hockney, *Portrait of Robert Mapplethorpe*, pen and black ink on paper, New York, June 1, 1971, $75,000; Francesco Clemente, *Untitled* (Robert Mapplethorpe), water-color on paper, March 1976, $15,000; Don Bacardy, *Portrait of Robert Mapplethorpe*, pen and black ink wash on paper, February 2, 1979, $1,500; Tom of Finland, *Portrait of Robert Mapplethorpe*, 1979, $600; Andy Warhol, *Portrait of Robert Mapplethorpe*, synthetic polymer silkscreen on canvas—unframed, 1983, $120,000.

These works give perspective on the photographer who was absolutely enamored of self-portraiture.

We once discussed gaining the whole world and losing one's soul.

Robert kissed the concept off.

Robert was a material boy.

He joked about his pact with the devil. Lapsed Catholics do that as shtick. He invited me along. I had other things to do. I preferred sex to money. At least then, when the world was safer. In that take, somewhere, is the difference between the erotic seventies and the greedy eighties, and the nineties' attitude about both decades.

Nothing in the Christie's auction was more personal than Robert's jewelry. Anita Loos and Marilyn knew diamonds were a girl's best investment. Elizabeth Taylor appreciates diamonds as tokens of romance. Robert liked jewelry. Andy worshipped jewelry. Of course, not after the gauche style of Liberace. But they often compared treasures. Andy's taste ran to the fashionable. Robert tilted more toward the arcane.

I witnessed more than one purchase.

In complement to his occult sculptures of Mephistopheles, Satan, satyrs, death skulls, snakes, and ritual knives, his jewelry related to necromancy: silver crucifixes worn pendent from neck chains; devil-faced cuff links; coiled serpent pins; gold bracelets worked with astrological symbols; brooches with pentacle, or lucky horseshoe charms engraved with the number 13, and Samboesque faces of black men; rings of magical design; and Third Reich "jewelry," particularly rich metal insignia of military rank. Robert's choice in his night-life jewelry fit the leathersex style of *faux* Nazi set by the Hell's Angels and ritualized in Kenneth Anger's underground movie, *Scorpio Rising*, a favorite in the sixties in museum film-art programs and a classic in the seventies in leather bars that showed movies over the heads of the crowd.

Was the Christie's auction slated for a "designer" date? The Robert Mapplethorpe Collection sale was held on Tuesday, October 31, 1989, the Highest of all Homosexual Holidays, Halloween, the first All Hallows' Eve after Robert's death, and four days before his forty-third birthday.

"Robert wasn't amoral," Edward said.

"I thought his whimsy revealed his character," I said. "It was shocking fun. All the satanic buys reinforced my own interest in the occult, which was very important to Robert. He played at it. We all did then. For outrageous symbolism. The Age of Aquarius and all that."

"I think, *hmmm*, more than that." Edward sounded suspiciously British. "Robert was immoral in the sense that he wanted to parade as the devil. He photographed himself wearing horns."

"Satanism was his affectation," I said. "He used the occult like he used homosexuality: hot topics to distract and scare people so they couldn't get too close and find out he was terribly insecure and not very well educated."

"You don't think he meant it?"

"I spent more than ten years, from age fourteen to twenty-four, in a Catholic seminary. Once a Catholic, always a Catholic. No matter how lapsed."

"Perhaps he *was* in some passing phase."

"Robert had as many phases as faces and postures and attitudes," I said. "What I'd like to know is, historically, will Sam Wagstaff as collector and arbiter of taste exceed Robert's reputation as a photographer?"

"I think anyone who cares to analyze the phases of Robert's work will have to go through the Wagstaff collection in minute detail."

"The Wagstaff collection was bought by the Getty Museum."

"Yes," Edward said. "It's presently squirreled away for cataloging."

"That should take some time."

"I recently thought of the most wonderful story," Edward said. "Robert and Sam were already lovers, still in the first flush of love, and Sam had brought his little sweetheart to England on one of his photograph-buying trips. There they were, visiting an extremely nice flat in the best part of London: wonderful Old Master drawings, nice Dutch pictures, the flowers, the antique furniture. That was Sam's milieu from birth; Robert's only recently by marriage.

"What a show these two Americans put on! Cloying as two lovers, they sat side by side on a huge sofa holding in their laps a large album of

Polaroids they had brought to show my friends, and Sam's friends, Helene and Werner.

"These Polaroids! My God! They were shots of their personal sex life! The pictures were of genitals tied up into exotic knots and presented on little wooden plaques. I suspect the genitals were Sam's. But, there they were, this honeymoon couple sharing their wedding photographs with sophisticated friends."

"Those Polaroids were his first explicit leathersex pictures," I said.

"I believe that Robert's photography, as photography became the obvious vehicle for his ambition, was an offspring of their erotic games. He progressed from Polaroids to the very formal photographs which appeared in the Robert Samuels album. The fisting photograph appeared about this time: a pair of buttocks with an arm inserted. A very abstract form."

"Actually, it's one of my favorite Mapplethorpes," I said. "The lines are sculptural, stoned, somewhat as abstract as Henry Moore sculpture. As I did a dozen years ago, writing meditations on Arthur Tress's photographs, I've even written a Zen meditation piece on that photograph, because, in its penetration, its formal repose, it is a bouquet of flesh, exhibiting that 'the way out' can also be 'the way in' to the chakras of ecstasy. Male homosexuality is a problem to many heterosexual art critics, and to many businesses, whose overweening gay intolerance is not acceptable.★"

Reading the literature on Mapplethorpe written by straight heterosexuals is rather amusing as they twist in the wind trying to legitimize the leathersex photographs or the black nudes.

If Robert Frost's critique was good enough for poetry, in adaptation it's good enough for Robert Mapplethorpe's photography: "A poem need not mean, but be."

A photograph need not mean anything; it needs maybe just to be, to exist.

Gay photography of gay subjects does not really require interpolation by gay-friendly straight people, no matter how critically endowed.

No offense, but straight people don't really understand homosexual people the way white people don't really understand blacks; but, out of self-defense, gays

★ When Arthur C. Danto's overwhelming *Mapplethorpe*, created with the cooperation of Robert's estate, appeared with 280 duotones, London's Harrods, one of the world's largest department stores, declared the book pornographic. The same week in November 1992, Harrods sold out, in one hour, their entire allotment of Madonna's book, *Sex*, with heterosexual and lesbian photographs by Steven Meisel.

understand straights, and blacks understand whites, because gays and blacks are raised in dominantly straight and white societies respectively.

"The step," I said, "from the honeymoon Polaroids to the three separate categories of leather, fisting, and S&M is, in fact, not very long. Robert's photographs—faces, flowers, figures, fetishes, fashions—however much distinguished, are all of a piece."

"Robert," Edward said, "even though he was far from that horrible introduction, 'the most polymorphously perverse person,' was uniquely perverse in absorbing from Sam's collection the totally unfashionable style and content just so he could beat the avant-garde into submission to what he wished to declare far out. Robert would stamp his foot to get people to pay attention. I know the syndrome. I have it myself."

"We all do," I said. "Speaking of stamping one's foot, I wonder if you have any opinion on the rumor that Robert committed suicide?"

"There are many kinds of suicide."

"AIDS is some people's suicide."

"Sylvia Plath committed the most famous revenge-suicide in recorded history," Edward said. "When I knew Sylvia, not well, but well enough to dislike her, I knew Ted. Also I knew Ted's mistress, Assia Wevill, very well. Assia was the woman for whom he left Sylvia. I shared an office with Assia when I worked in advertising and we were close friends. Assia, too, later committed suicide."

"Maybe there is no Mapplethorpe curse. Maybe artists are simply more volatile and honest in acting out what other people refuse to even consider."

"Curses, truth, legends," Edward said. "History, my little flower, is simply an agreed-upon lie. Everything is true, isn't it? *Hmmm*? When Ann Stevenson's biography on Sylvia appeared, it was the first detailed and truthful biography of Sylvia, although certainly not the whole truth. When Mapplethorpe's literal biography comes out, I suspect the situation will be the same. Your work is the first insider's cut at his persona in the popular culture milieu you experienced. Actually, the Mapplethorpe Truth is not going to match the Mapplethorpe Legend. *Hmmm*? And people will always prefer the legend.

"How can a biographer build up Robert as a modern hero and then tell the world that one of his turn-ons was to force his black sex partners to say, 'I'm your nigger'! After all, every authorized biography

will have to address itself to the liberal white audience. That's where the buyers are.

"The whole truth about Robert Mapplethorpe, as you and I know, won't take easy or convenient form."

Actually, because Patricia Morrisroe, a free-lance journalist researching Robert Mapplethorpe, entered my life, she became a player. She's one more writer who missed the seventies and is trying to backfill Robert's life from the outside in instead of the inside out. The questions Morrisroe asked me were rather more chronologically based than psychologically penetrating. She was full of questions of *when* and *where?* "For five hours, I answered literally the literal questions she asked about a most metaphorical life."

"I hope you taped that interview," Edward said.

"Oh, yes. She even asked me what books she could read to learn about the seventies milieu. I could refer her only to *Some Dance to Remember*. She seemed very sincere—fragile, even—but I have this personal feeling, shared by many in the masculine-identified gay subculture, about all these straight women in the nineties trying to handle the postmortem lives and affairs of gay males in the seventies. I mean, even young twenty-something gay males in the nineties have more than their own share of difficulties understanding the *Zeitgeist* of the seventies."

"What is the truth about someone, anyway?" Edward asked. "There are as many Roberts as there are people who knew him. As a straight white woman, Patricia Morrisroe has as valid a right as anyone to document what she can of Robert Mapplethorpe. I have a special view of him myself, because of my odd angle of having known Wagstaff so well. So, I hope I haven't sounded too harsh."

"I hope the same," I said, "because of my odd angle of having known Robert so well, and because so many men have died so young and . . . All I can say is that Robert actually, specifically, asked me to write about him."

"Mapplethorpe would love the contretemps of corporate biography competing with personal reminiscence," Edward said.

"I'm neither mean nor competitive," I said. "Writers other than myself are writing different genres. Their styles of lackluster questions and their innocence, when they telephone me, spurred me on to pull together my notes, letters, journals, interviews, and memories to counterbalance the direction they were taking. I hadn't planned to write about Robert until I was eighty, which is twenty-five years from now."

"But with AIDS," Edward said, "gay men can't chance waiting until they are old."

"That is cold truth, but it is not the essence of my motivation, because I do not have HIV, nor do I intend to get it. I am HIV negative.

"Robert's death is one of three hundred dead men I've known. They're all becoming a blur. I want only to capture Robert's person, as he was, and as he reflected it in me and in some of the many people we all knew in common during one of this century's most exciting decades.

"I'm not interested in tracts about chronological biography and photographic technique.

"What interests me is the personal reminiscence of the living, breathing Robert, the way Lillian Hellman—with whom I share a common birthday—remembered Julia in *Pentimento* . . . and you know how they dared to dish Lillian!"

"Who can say what's better?" Edward Lucie-Smith said.

"Memory," I said, "is all *Rashomon* anyway."

POPPING CULTURE, DRUGS, AND SEX
THE LEATHERSEX YEARS

R obert Mapplethorpe's cultural biography I know by heart because his profile in American popular culture mirrored my own. We led parallel lives up to the time we met: we knew the same people, places, events, and shared the same interests. My life contained itself in university teaching, writing, photography, the sexual liberation front, and the study of American popular culture.

I participated in the founding of the American Popular Culture Association at Bowling Green University in 1967. In his *Journal of Popular Culture*, Ray Browne published my pop-critical articles on *2001: A Space Odyssey*, and *Hair*, the musical written by then idols Gerome Ragni and James Rado, who also appeared naked with superstar Viva on the very first cover of Warhol's *Interview* magazine.

In 1969, the Popular Culture Press contracted me to write the nonfiction book *Popular Witchcraft: Straight from the Witch's Mouth*, which included the Mapplethorpe icon, Jim Morrison. To Mapplethorpe's undying wonder, I shared with Jim Morrison the "gentleman's grace" of the same Sausalito tailor for black leather trousers. The tailor, a high school classmate of Morrison's, broke in his leather by wearing it first.

Mapplethorpe was about five feet ten inches and 150 pounds, hung about six inches, virtually without body hair, so he was not threatening to women or gay men in a decade in which "threat" meant "sexy." In quite a calculating manner, Robert used the sugar of the camera (to lure gay white boys) and the sound of money (to lure straight black men) to compensate for his venial sex appeal.

Transcribed edit of paper prepared for San Francisco Outwrite Convention, April 1990: "Censorship and Art in the Age of Helms and Mapplethorpe."

Robert's wafer-thin, drug-waif body, adroitly abstracted by black leather, was unimportant, really, compared with his head. More specifically, his face, especially his eyes, and, despite his androgynous inability to grow a real beard, his triumph of black faun-hair and aggressive Pan-teeth captured people's attention.

He knew in a world of great male and female beauties that if anything good was ever to happen to him, he had to conjure it up himself. Actually, when we met, he was quite good-looking. "You knew Robert at his most attractive," Edward Lucie-Smith told me. By 1982, his recreational drugs had taken their toll. HIV destroyed what remained of his physical appeal.

If God had shorted him on drop-dead looks, he would play the sexy devil to seduce the black-and-white beauties after whom he lusted, knowing money would level the playing field.

Popular Witchcraft also contained a very progressive interview with the neopop High Priest of the Church of Satan, Anton LaVey, who, at the time, was disconcerted because the Manson Family killing of actress Sharon Tate and coffee heiress Abigail Folger had confused the public about his Church of Satan. LaVey was a West Coast pop icon, in many ways similar to Warhol, except he was sexually straight, genuinely intellectual, and interested not in pop art so much as in pop religion.

At the time, LaVey had been rather connected to appropriate blonde Hollywood superstars, all women, some of whom he honored in his dedication to *The Satanic Bible*: Tuesday Weld, Jayne Mansfield ("I told her to stop seeing that man who was driving her car").

Because he needed to make his position clear, LaVey gave me, at least, according to *Fate* magazine, one of the best interviews of his life. It was midnight, August 16, 1970.

In 1979, Robert Mapplethorpe asked me if I would introduce him to LaVey, because as a former carnival pitchman, lion tamer, and topless bar promoter, LaVey fascinated Robert with his mix of Satanism, celebrity, and self-promotion.

I told Robert that I didn't think he and LaVey would hit it off, as LaVey, a very cultivated and educated man, was not seeking the kind of notoriety Robert was calculating for him by grabbing his image. (Let's say I've always believed in the Devil as much as I believe in God. Theology is reciprocity. Like Robert, I was raised Catholic. When I finished my New Journalism participatory adventure into the occult, I was very careful to steer wannabe

amateurs away from the real auteurs. People raised to be Christian are not equipped to play with pagans.)

In 1965, I met up with Warhol's touring Velvet Underground and Ingrid Superstar, who was dancing to the Mamas and Papas' "California Dreamin" on the tables in the cafeteria of Loyola University's downtown Chicago campus. At the time I was a teaching assistant, fresh out of ten years in a Catholic seminary—the Pontifical College Josephinum, which is directly subject to the pope and not to any American bishops who might have controlled its excesses in the fifties and sixties.

Ingrid Superstar pushed me directly toward the Illinois Institute of Technology. Because of *Esquire* magazine's coverage of underground films, I was screening the early 16-mm works of Kenneth Anger, whose *Scorpio Rising* images (1966) were projections of a life I had only lived in secret fantasy and never knew existed outside my head.

In that IIT hall, I came out into the leathersex images. They were the exact same outlaw images that, in the parallel universes we inhabited, kick-started Robert Mapplethorpe, who adored the tough leather-blasphemy work of Kenneth Anger.

By 1973 I had met the Godfather of Gay Writing, Sam Steward, who, in the sixties, had secreted away for Anger all his unreleased footage, because the cops (and a certain family) wanted his underground films. In 1974, I received a State of Michigan Grant for the Arts to tape-record interviews with Steward about his life in art from his days with Gertrude Stein and Alice B. Toklas, Thornton Wilder and James Purdy, Kenneth Anger, and James Dean.

My first major interview came in 1966. Tennessee Williams took me, a tender twenty-six (looking sixteen), under his wing during his stay in Chicago for the premiere of his rewrite of *Eccentricities of a Nightingale*. Chicago had been good luck for Williams when *The Glass Menagerie* had premiered.

Eccentricities at the Goodman Theater fared less well, but, in between anxiety attacks (mine) and drunken languors (his), I was able to write down the first of my popular culture interviews, in Chicago, while Mapplethorpe was working New York.

Robert was a photographer in search of money.

I was a writer in search of experience.

My fifteen-minute Williams "affair" lasted until the opening-night curtain fell on *Eccentricities* and, literally, on Williams himself, who was so

drunk that the proscenium curtain, sweeping out from the wings, knocked him down flat on his butt while the audience turned from yelling "Author! Author!" to simple laughing at the fallen hero. The cast members, groping through the "drape," finally pulled him, still seated, back under the curtain. What comedy! That pop culture night has marked my take on "Fame" ever since. Life is not a cabaret. Life is a slip on a banana peel.

While I was pressing popular flesh from a university base as graduate student and then as associate professor of writing, film, and American culture, I virtually lived in New York, where Robert, himself a tyro, was busy creating his power base.

We both arrived in Manhattan at about the same time, with a seven-year age difference. He was student. I was professor. I slept in Village hotels, saw movies in the morning, crashed galleries and bought Broadway tickets in the evening, spent the nights at the bars (The Anvil, The Eagle, The Ramrod) and baths (The Everhard and The St. Mark's), and generally cruised as I imagined Thomas Wolfe would have, careening around New York meeting Lindsay Kemp, Derek Jarman, and a few other artists who would eventually become mortal enemies of Mapplethorpe because he cast them as antagonists in the game of cash-and-carry.

British film director Derek Jarman remembered that one night in the 1980s, at a party at Heaven, the disco, he was going down one stairway as Robert Mapplethorpe was climbing up another, and Robert shouted out, "I have everything I want, Derek. Have you got everything you want?"

Whenever I was around Robert Mapplethorpe, I dimmed my own headlights, so I could be the observer and he could be the actor.

After all, in 1970, I wrote in my journals that on a cultural level, what was happening to gays in the streets by day and in the baths by night was going to be one of the most important convergences in urban sexual history. I talked enough in the classroom, on the university lecture circuit, on the radio, and in print. I delighted in explaining popular culture to artists who needed explanation, explication, or introduction.

Tennessee Williams was the pop culture past.

Anyone in my generation was now and happening.

Had I known a plague was going to kill everybody, I'd have shot more super-8 film, more photographs, recorded more interviews, and written even more often in my journals.

This is one of the wonders of the Mapplethorpe leathersex photo-

graphs from the seventies: he was able to shoot them, develop them, and print them.

Even if he hadn't been any good as a photographer, what a documentary feat!

Sex in the seventies still suffered from its criminal status in the sixties, so most sexual people were very afraid of cameras and tape recorders, thanks to the CIA and the U.S. military, which figured all gay people were ripe targets for blackmail.

Technology in the seventies was strictly Dark Ages. Everything was clunky and that dismayed me, creating great technophobia. In 1970, the press said the VCR was to debut in 1971. Because of format wars, the VCR and video camera penetrated to the consumer level at about the very same speed as HIV: 1981–1982.

Happening together, video and AIDS changed American popular culture forever!

Before the high-tech revolution, back during the Sex Wars, while I watched for fun and scholarly review New York underground films like *The Chelsea Girls*, and stood in front of the Chelsea Hotel until I gathered up enough courage to wander through its halls looking for sex and drugs, Robert was actually living at the Chelsea.

I cavorted in 1967 with art critic Mario Amaya, who was shot on June 3, 1968, when Valerie Solanas shot Andy Warhol. Robert and I were standing around Warhol's Factory, but on different afternoons; or, if we were there the same afternoon (as we often laughed later, because we probably were), we never spoke. We both presumed the possibility that we had even had sex together, anonymously, at the Mine Shaft (before we met formally in San Francisco in my office at *International Drummer* magazine, where Robert, an ambitious young photographer, sucked up to my role as editor).

While Mario Amaya was my sporting buddy, he was also director of the Chrysler Museum in Norfolk, and one of the first critical professionals to take an early interest in Robert.

As is often the case with museum directors, Mario's real popular culture influence has too often been overlooked. Mario sent Robert to me.

Also, without Mario's urging, Robert may never have attempted his first leathersex photographs that he had tentatively begun when he showed me his portfolio in 1977. I said, "These are great, but they're not strong enough."

I decided to put Robert on the cover of the premier leather magazine of the decade, *Drummer*.

That Amaya-encouraged, Fritscher-designed, Mapplethorpe-shot 1978 *Drummer* cover pioneered "Middle Mapplethorpe: The Leather Years."

Internationally.

In color.

Without the leathersex of "Middle Mapplethorpe," ultimately, Robert Mapplethorpe would never have been able to get arrested.

MAPPLETHORPE'S EVOLUTION

Early Mapplethorpe
1970–1977:
BRASH ARTIST AS YOUNG FAUN

Self-portraits ▪ Manhattan ▪ SoHo ▪ Polaroids
▪ Collage ▪ Frames ▪ Patti Smith ▪ Sam Wagstaff
▪ First exhibition ▪ Drugs and music

Middle Mapplethorpe
1977–1981:
BRIGHT ARTIST IN SEARCH OF PERVERSATILITY

Self-portraits ▪ The Village and San Francisco ▪ Leather
▪ Blacks ▪ Bodybuilders ▪ Lisa Lyon
▪ First book publication ▪ Drugs, S&M, and scatology

Late Mapplethorpe
1982–1989:
BRILLIANT ARTIST WITH AIDS

Self-portraits ▪ New York, Europe, Japan ▪ Blacks
▪ Fashion ▪ Celebrity portraits ▪ Flowers
▪ Critical recognition ▪ Drugs and AIDS.

As late as 1982, photography books and gay photography books mention Peter Hujar, Arthur Tress, and George Dureau, but hardly anyone outside the Art Reich and Warhol's *Interview* put the yet-to-be-famous star name *Mapplethorpe* in their pages.

So, in the seventies, I was going out on a limb giving rave reviews to Robert's work, which served my publishing purposes of trying to levitate gay liberation by paying attention to people who were having sex and still functioning as artists and writers.

1978
FRITSCHER INTRODUCTION OF MAPPLETHORPE TO LEATHER ART SOCIETY

The Robert Mapplethorpe Gallery

By Jack Fritscher, *Son of Drummer*, originally published January 1978

He likes Cameras, Coke, Kools, and Crisco. He is, in fact, his Hasselblad. His Camera eye peels faces, bodies, and trips. He rearranges reality in his SoHo loft in Manhattan. His studio is his space for living, balling, and shooting. He lunches afternoons at One Fifth Avenue. He maneuvers after midnight at the Mineshaft. He photographs princesses like Margaret, bodybuilders like Arnold, rockstars like his best friend Patti Smith, and night trippers nameless in leather, rubber, and ropes. He's famous for his photographs of faces, flowers, and fetishes.

His name is Robert Mapplethorpe.

Mapplethorpe is no "concerned" photographer smug with social significance. He shoots portraits only of people he likes. He chronicles SM fetishism from the inside out. He's a man who knows night territory. He likes guys with strong trips and stronger raps on their trips. His take on life and people is open, very sensual, and totally upfront. His frank honesty matches his camera work.

Mapplethorpe sees.

"You can tell," he says, "who's interesting, who's sick by the way they say *uh huh*. You can tell who's dirty by their eyes. I look for dark circles. Interesting people have dark circles."

Mapplethorpe provides the lights and the camera. His subjects are the action: sniffing jocks, piercing cocks, wearing locks. Without exploitation of his subject, Mapplethorpe manages to capture essential passion of both a beautifully bored society woman and a two-hundred-pound Village man in baby drag. He can explain to guests at his international gallery openings what they need to know when they ask, "I like your photo of the man in full rubber, but what does it have to do with sex?"

Mapplethorpe knows.

He is a collector of satanic bronzes, Mission furniture, 19th century photography, and 20th century foxes. His latest favorite book is *End Product: The First Taboo.* His latest project, in addition to a show with Patti Smith, is an authentic SM fetish photography book. Any men with suitable trip and heavy enough rap should contact Robert Mapplethorpe through *Drummer.*

Auditions, held nightly, are something else!

Mapplethorpe himself is a transmorph. This is his first reincarnation in 3,000 years. His satyr's honey-gold eye knows pleasure and excellence as ends in and of themselves.*

I had a large monthly magazine to fill in a sexy decade when notoriously few people wrote, drew, or did photographs.

The difference between the seventies and the AIDS eighties and nineties is in the seventies, most people were too busy having sex to create art about sex.

The AIDS mortality rate has turned every survivor into an historian, and that's just the women, lesbians mostly, galloping in like thieves on horseback to write and lecture and publish about White Male Sex in the Gay Seventies.

* Mapplethorpe articles that appeared in the gay press, like Mapplethorpe exhibitions at gay galleries, such as San Francisco's Fey Way Gallery, have never to this date been included in published Mapplethorpe bibliographies and lists of shows. The not-so-perfect "gay" moments documenting realpolitik Mapplethorpe have been left invisible. He was gay, and if the gay leather world had not welcomed him, there would be no Middle Mapplethorpe of the Leathersex Period—which may reveal a motive for the denial by omission.

The Halloween 1989 writing on the wall of the toilet at the café Without Reservation, on Castro Street in San Francisco, read, "O, please, God, make the dykes shut up!"

The gay-male graffiti implied that the exploiting dykes should be shut up the way some dykes would make some men shut up who tried to exploit women.

Actually, I know no one, at least in California, who thought that Robert would be any more talented, famous, or controversial than the thousand other gay photographers.

San Francisco documentary photographer Rink met Warhol at the Factory in 1969, and Robert in the late seventies. Rink said that Robert was always disappointed with the early Mapplethorpe photography books.

"I told Robert," Rink said, "when you publish a book, you can have three things: schedule, time, and quality. You can't have all three. Even with all his money, he couldn't get what he wanted."

When, at New York's famous sex club the Mine Shaft, I met John Boundy, Manhattan director of the National Film Board of Canada, Robert was working the Mine Shaft, Studio 54, and The Saint.

My tryst with Boundy led to booking Academy Award—winning filmmakers, like Grant Monroe, into the Kalamazoo, Michigan, Institute of the Arts, where as board member in 1968, I created and directed the film program that screened underground and serious films through May 1975. For a week, the National Film Board was the toast of Upper Midwest high society.

This pop culture background sketches out the sexual incest of art, intellect, and influence in the intense Golden Age of Art and Sex Liberation in the 1970s.

Literally, as well as metaphorically, pop culture success depends on who fucks whom.

Period.

Art patronage, reviews, and show bookings can be traced on the same grid as sexual contacts at a VD clinic.

In the seventies, Patty Hearst, everybody's Pop Debutante of the Decade, was Robert's favorite society child.

Deconstructed as a debutante and reconstructed as a revolutionary, Patty Hearst switched identities with an ease Robert envied. He referenced Hearst as Tonya, Queen of the SLA, in his photograph of himself with a machine gun. (The pentacle behind him excused anything he did, because, in the pop phrase of the period, "The devil made me do it.")

Robert loved the pop culture concept of Patty the Deb having her consciousness raised when kidnapped by the Big Black Buck, Cinque, leader of the Symbionese Liberation Army.

Robert, in his sexual encounters with black men, hoped one of them might be his Cinque.

He thought that his interest in satanism, pumped up by sexy black voodoo, might offer him opportunity, when playing with black conjure men, to get everything he wanted by selling his soul to the devil.

He figured the devil, like Robert himself, was always shopping.

Late in Robert's life, Warhol died, as reported by Bob Colacello, in *Holy Terror*, possibly in a voodoo-related death.

Robert was not alone in his magical mystery tour.

He courted my familiarity with the satanic LaVey and the voodoo botanicas as much as my immersion in and my exit from Deep Catholicism.

I was the only truly and actually ordained exorcist he knew. I was a writer, an art critic, a pop culture professor, a magazine editor, and a publisher.

He wanted my voodoo, my sex, my writing, my influence, my body, mind, and soul.

Robert was expert in sucking up other people's lives.

But he was different from those who in the seventies' gaystream were commonly called "Energy Vampires."

He lived through intimates and friends.

He wanted everything a person could give him.

That's one reason we liked each other immediately.

He wanted all my life, art, and analytical experience.

We didn't sideswipe.

We collided head-on.

I wanted to mentor the boy and watch what happened.

I wanted to corrupt him as much as he wanted to corrupt me.

We fucked and mindfucked until "mutual murder" between us made us more dangerous to each other than Robert, who was never very analytical, would believe.

Finally, his drugs and dirty sex outdistanced me.

We stayed good friends at long-distance.

Robert was killing himself.

If Robert had lived, he might have suffered the same final pop culture

spin on fame as Patty Hearst, who became a camp icon in Baltimore director John Waters's film canon. Patty Hearst was Robert Mapplethorpe's dream girl: the rich bitch who is kidnapped and through force becomes the white sex slave of a dangerous black revolutionary who makes her betray her family and rob banks.

He wanted Patty to be his wild WASP heiress the way the doomed superstar Edie Sedgwick was Warhol's, so he could shoot his own underground movie, which I dubbed *Citizen Kane II.*

In his black-and-white dreams of race, gender, and money, Robert's fantasy, because of Patty Hearst's mythic pop culture past, was to photograph the rescued heiress as a lacquered Bay Area society matron who had been forced into romance-novel adventures beyond her will to resist.

For instance, the morning after our late-night *pas de* Pan, John Boundy and I exchanged credentials: his job was to book the Canadian Film Board across the United States. I was founding director of the Genevieve and Donald Gilmore Art Center's film program and a member of its board of directors. Through man-to-man sex, art zeroed in on the heartland of the Midwest and presented a graceful week of seminars, screenings, and parties at the four local colleges. Such is the pattern of pop culture. At least in the seventies, before white men became everybody's whipping boys.

Robert's own messy life and formal art, enhanced by drugs and the rags-to-riches mystique of Andy Warhol, defined itself by seesawing, through fashion and society, and from art to commerce. Mapplethorpe threw himself headfirst into this trendy world for his rites of passage.

Fine art and commercial art merged with Warhol's soup can. Artists from Andy to Annie have done "windows." Warhol and Jasper Johns and Robert Rauschenberg showed work in Bonwit Teller windows; Mapplethorpe did shoes and shilled lime juice; Annie Leibovitz does *Vanity Fair* magazine, blurring the lines between art and commerce so shrewdly, shooting editorial photographs and commercial advertisements so seamlessly, that her one voice enunciates the whole issue.

Thoroughly postmodern Mapplethorpe constructed and deconstructed himself and his art, waltzing through the history of art like a pickpocket.

Robert set his goal to make money by selling shoes and perfume to women through the photography of fashion, which is the world's second oldest profession.

Mapplethorpe loved the surfaceness of haute couture.

Women are, in a sense, anesthetized through the lacquer of glamor.

The "feminine" qualities Mapplethorpe shot exist only in magazines and calendars.

His women, except for Patti, reflect little but glitz about the essence of being female. His idea of a princess, such as Gloria von Thurn und Taxis, known on the circuit as "Princess TNT," is a sleeping princess. His actresses fare better, especially Susan Sarandon, who seems to have awakened in the sheets, startled, but fully aware. Sarandon and Kathleen Turner rallied together with Christopher Reeve, Stephen Collins, and Ron Silver to defend Mapplethorpe from Senator Jesse Helms on Phil Donahue's television talk show, September 17, 1990.

Liberals loved the Helms-Mapplethorpe brawl. The subtext of defending Robert was a defense of their own art. Few of these people realized that Mapplethorpe was, in his bigotry, more like Senator Helms than anyone realized. Robert's personal take on gender and race was strictly out of the antebellum South of North Carolina.

Helms and Mapplethorpe seem traditional and tame compared with the politically correct hordes who emerged while Congress did battle with the National Endowment for the Arts.

Robert Mapplethorpe was never ever politically correct.

He was never a "folk" hero, never a name brand, except posthumously.

He was shy, retiring, nice, sexual, cash-driven, obsessive, and HIV-positive until he was capped by a posthumous last tangle in Ohio.

Cincinnati gave *The Mapplethorpe Story* a great third act.

Mapplethorpe achieved more fame dead than alive when he died at forty-two, the same age as Elvis.

Avowed heterosexual Senator Jesse Helms, who never literally destroyed a Mapplethorpe photograph, was preceded by other famous temperaments. Rudolf Nureyev actually tore up Robert's work. Film director John Duffy, better known as porn star J. D. Slater, destroyed Robert's photographs of Slater's then lover, Frank Diaz.

When Slater asked Mapplethorpe to replace the photographs, Robert insisted that J. D. sit for him. Slater refused, saying, "I don't do black-and-white." Mapplethorpe pronounced Slater a philistine. He never spoke to him again, primarily because Slater refused to have sex with Robert to obtain another set of the photographs.

Several gay photographers, angrily reacting to Mapplethorpe's marrying a millionaire, plied the livid slander of queens. There were rumors in

the early eighties that Mapplethorpe was a federal agent in the seventies, before and during his relationship with Sam Wagstaff. Sam allegedly provided a convenient cover while Robert was supplying information on artists and gay activists to the government in return for spending money and travel chits.

If this mix of art and state was true, the NEA debacle was small potatoes.

Imagine! Robert Mapplethorpe as a spy!

Robert was capable of almost anything. He worked at being that ambiguous Wolfeian (Tom, not Thomas) social X ray of his times burning in the *bon vanitas*, a decadent sybarite, a follower of Fellini, whose *la dolce vita* camera made urban perversity chic. Robert found the camera an easy power tool in the incestuous air-kiss kiss-ass world of art, publishing, and fashion.

Unlike Warhol, who distanced himself from his work, Mapplethorpe was his own best creation. His self-portraits are always the most dramatic of his work.

Robert was his own greatest object.

His classic narcissism was perfect for the seventies, when disco dictated people dance alone.

Outside his cultural reaction to his Catholicism, using Catholic symbology, and running off to shoot the Episcopal ("Episcopal" meaning a kind of High Camp Roman Catholicism) archbishop of Canterbury, when he would have preferred to shoot the pope, Robert Mapplethorpe had no spiritual life.

Except as satanic posturing, he never played at direct religiosity as Warhol had in his silly 1966 movie *Imitation of Christ*.

He remained first, last, and always a self-absorbed object of his own desire, lust, and ambition. On the cover of *Creatis*,★ which he autographed for me, his right arm extends across the field of the photograph. Robert looks to be his usual self, mocking the central art object found throughout Western culture, the crucifix with the magnificent, nearly naked, crucified man.

★ *Creatis, La Photographie au Present, No 7, 1978*, was *"un magazine bimestrial, vendu dans les galeries, les librairies specialisées,"* published in Paris by Albert Champeau, publisher, and Mona Rouzies, art director. *Creatis*, No 7 contained, in addition to the playful cover self-portrait (1975) of Robert, smiling, with his arm extended across the frame, twelve 12.5 × 12.5-inch Mapplethorpe photographs running first to last, as an an-

Robert's sole soul-image was his dramatized body.

That's not a condemnation of a soul in the seventies and eighties, when "greed was good."

Actually, if any self-indulgent person had a self worth indulging in ego-driven photographs, no matter how superficial, it was Robert Mapplethorpe.

If Robert objectified himself, imagine how distant in focus he was from the gay men and straight women who populated his life.

The gay men he treated as documentary curios.★

The women, excluding the separate category of Patti Smith, he treated in two distinct ways: the society photograph and the fashion photograph.

He liked dropping the names of Tom Wolfe and Joan Didion before he knew them. He posed himself in the late seventies as a New Journalism art photographer who was participant in the story of the leather-art photograph as much as reporter of the leather-art photograph.

Robert flowed with the changing autobiographical opportunities of his voyeuristic life.

nouncement of his complete early accomplishment: *Nick/New York 1977* (tattooed forehead and extended tongue); *Cedric/New York 1977* (shaved head and shoulders as sculpture; an early use of ethic abstraction); *Marc/New York* (leather chaps and penis composed sideways as still life); *Jimmy Douglas/New York 1976* (portrait of male holding face masklike in hands); *Patrice/New York* (close on hand and jockstrap over thigh) and *Patrice* again (close on penis with foreskin next to jockstrap and star tattoo on thigh); *Iris 1977* (three iris with three shadows, all entering frame from left); *Lucinda Childs/New York 1978* (portrait with profile facing frame right); *Bob Wilson/Phil Glass* (two-shot on two chairs); *Amarillys/1977* (three amarillys leaves "interrupt" through left frame); *Jim/Sausalito 1977* (that first famous leather photograph with hood and ladder in the World War II bunkers); *Feet/New York 1976* (shrouded feet wrapped in sheet take foreground; face above them, distant and blurred). In *Creatis*, 1978, the whole future sweep of the Mapplethorpe career is in place, technically, esthetically, and in content featuring leather, flowers, portraits, and blacks. Basically, by the time of the American Bicentennial in July, 1976, Robert Mapplethorpe was working at the full height of his powers that time would only enhance.

★ The AIDS Holocaust has turned Mapplethorpe's photographs of leathermen into documentation of unsuspecting victims. Plague has made Mapplethorpe a gay redaction of Russian photographer Roman Vishniac, who photographed from 1935 to 1939 the Jewish life that was about to become extinct in Eastern Europe. *To Give Them Light* (New York: Simon & Schuster, 1993).

MAPPLETHORPE'S SUBJECT THEMES

1. Mapplethorpe's early, hungry, implied "sex-drugs-music" photographs of his punk-art time-share with Patti Smith on the town.
2. His Ripley-Believe-It-or-Not leathersex photographs documenting erotic male rituals where women were conspicuously absent.
3. His African-American males as meaty objects of desire.
4. His celebrity and fashion photographs of various women summed up in his 1980s female assemblagist work with Lisa Lyon; his virtual deathbed photographs of a "widowed" Patti Smith.
5. His classic, materialist, still-life photographs of flowers and everything in his collection that, in light of AIDS and his inevitable estate sale at Christie's, could be made more valuable through canonization in his photography.

In every photograph, Robert created a palpable sense of style that always referenced his "self" in terms of the values of his twenty-year career.

He worshipped Warhol, who, Robert said, was not above stealing ideas—the very same accusation painter-photographer George Dureau made about Mapplethorpe stealing Dureau's ideas.

Patti Smith may have been his Mona Lisa odalisque, but San Franciscan Isadora Duncan, who set the Western art world on a classical retrieval, is the woman most inherently the presage of Mapplethorpe.

As Duncan arrived at art by elimination, finally simply standing, rather than dancing, on the stage, Robert did the same: eventually, he eliminated everyone, except Patti and himself, as he, dying of AIDS, photographed the "stuff" he'd leave behind . . . and flowers, *flores para los muertos*.

Isadora, who was immensely revivified in 1968, in Karel Reisz's film *Isadora*, starring Vanessa Redgrave, anticipated Mapplethorpe's legal troubles in the Midwest. For instance, Janet Flanner wrote, "At the Indianapolis Opera House, the Chief of Police watched for sedition in the movement of Isadora's knees."

Robert's self-explanation, which began about the time he first hit San Francisco, was an uphill hike from Manhattan, which hadn't as many whole-grain reference points as California.

West Coast popular culture has a tradition as strong as East Coast.

San Francisco was a whole new game for Robert, and all the New

York emigrants who tried to Manhattanize San Francisco in the late seventies.

Homosexual love, all the rage, had become to Robert a distinctive expression of art. He had come a long way from the young man he was in his underground film debut.

He left heterosex behind.

Like Walt Whitman, that other artist from the Manhattan "suburbs," Mapplethorpe's homosex puts a spin on women that few people care to address.

Art and sex in the seventies are inextricably linked.

Masculinity, surfacing in the ritualized Mishima-like *Nipple Pierced* movie, was no Mapplethorpe identity issue. Whatever his genetic sexuality, he presumed his definite masculinity. Robert never doubted he was a masculine-identified homosexual from the first erotic experimental movie to last skull-cane "still life" of Lord Mapplethorpe's self-portrait collection.

Robert investigated the commercial possibilities of femininity and its cultural archetypes and stereotypes; but the answers to the female are not readily present in Robert Mapplethorpe.

If Mapplethorpe addressed androgyny, he looked to see not how men could be like women, but how a woman could be more like a man.

Because of Mapplethorpe, the gender wars have escalated. In March 1994, Yoko Ono's play, *New York Rock*, opened off Broadway and called for an end to the bashing of males by females. The *Michigan Quarterly Review*, in the fall of 1993, presented a special issue on the male body, featuring a John Updike essay, "The Disposable Rocket."

"Any accounting of male-female differences must include the male's superior recklessness, a drive not, I think, toward death, as the darker feminist cosmogonies would have it, but to test the limits, to see what the traffic will bear—a kind of mechanic's curiosity. The number of men who do lasting damage to their young bodies is striking. . . . Take your body to the edge and see if it flies."

Robert practiced unsafe sex.

He challenged high-risk behavior and lost.

Even before AIDS, I set him down and told him, in terms of health and hygiene, to clean up his act. Perhaps I was too corny, too Midwest, too "feminine" trying to nurture him in this way. (He had seen what my administration of niacin had done to our friend Jack McNenny the night of our adventure into Sicilian cuisine.)

Finally, when we talked on the phone, and he knew that I knew the gay jungle drums had told everyone he was HIV positive, he was the one who said, "Don't you say one word to me."

I bit my tongue.

We rarely spoke after early 1984, because, after Robert's shoot of my bodybuilder lover, Jim Enger, whose head Robert cut off to merchandise Enger's body on a greeting card, all our telephone calls had been initiated by him.

Enger had left San Francisco angry after I had set up the shoot.

Superstar Jim Enger, "The Most Desired Man in America," as the seventies turned into the eighties, had thought it was to be a celebrity shoot.

Mapplethorpe thought the bodybuilding champion was just another gay man.

I was caught in the middle and left holding the photographs from the socially disastrous shoot that Edward De Celle two years later hand-carried from Robert in New York to me in San Francisco.

Thanks to Robert Mapplethorpe, thanks to steroids, thanks to AIDS, I never saw Jim Enger again.

Not pretty.

But this is a survivor's story.

Help! I'm trapped by AIDS and I can't get out!

I told the Chaucerian tale of the seventies once in fiction in my novel *Some Dance to Remember.*

Everyone thought it was fact.

In this memoir, again I fold time back, but through fact, which, no doubt, the truly perverse, especially those with a vested interest, will say is fiction.

Actually, I found I could have sold space to real people who wanted their names to appear, like Robert Mapplethorpe's, in an introductory clause to any sentence in *Some Dance.* In this memoir, even more people, sucked into that Mapplethorpe voodoo no one can resist, want to be included.

Memories of sex, drugs, and the real way we were make some people head straight into the alternative truth of denial.

Robert Mapplethorpe engaged the HIV virus.

Purposely, the twenty-something boys, who have never known a sex life without AIDS, fatalistically expose themselves to HIV as a test of ritual manhood.

In the second decade of the virus, the gay erotic industry still asks gay directors to film actors having unprotected sex for the home video audience.

It's the logic of totally absurdist theater.

It's perfect finale to *The Mapplethorpe Story*.

Actually, each and every time Robert's brilliance attracted me, I flinched from what his New York art life had done to him.

I felt salvation was in California, in San Francisco, where Robert said, quite emphatically, he'd prefer to live.

His predictable disdain of every topic marked him a provincial New York denizen in a New York minute.

Manhattan is a province all to itself. The New York art scene, defined as an island of insecurity by British art critic Edward Lucie-Smith, can be regarded one way as Susan Sontag's High Camp.

Like fashion and bodybuilding, art world bitchiness compares only to backstage at the opera.

Some stereotypes are archetypes, but who dares catch the stereotypes like deer in the headlights?

When New York journalists writing biographies of famous dead people call my number to request biographical information, copies of letters, memorabilia, the best answer, once their story has been heard, is to be "Ver-r-r-r-y Robert Mapplethorpe" and charge them for what they want for free.

Of course, art and commerce require strategy. However, as a veteran of two worlds (straight and gay), and of five arenas (publishing, university, corporate, museum, and municipal government), I find the political intrigue, which is the same in all of them, to be the very reason I refused Robert's invitation to travel parallel to him when he began to rocket off into celebrity.

The arrival of some women in these arenas was heralded as a way to break the "vicious masculine cycle of power."

Instead, some women have ended up aping the worst things men ever did. Instead, some women in the covens of the art world, who would make Anton LaVey's covens blush, have begun to look an awful lot like Valerie Solanas, the assassin from SCUM (Society to Cut Up Men), who shot Andy Warhol with a gun to control him, because she said he controlled women with his camera.

Of course, Robert's elegance of upward social mobility earned him

$230,000,000 and that made the Mapplethorpe name a signature with power in art and business.

So what about Robert's mortal enemy, Derek Jarman? The progressive Jarman was the most underestimated British film director of the seventies, eighties, and nineties. His talent/time span paralleled Mapplethorpe's. But unlike the nonpolitical Robert, the HIV Jarman was also an upstart AIDS activist purposely tweaking the conscience of the government by design. Robert was far more conservative, because he ran himself like a department store, and worried about impact on his sales. While Robert shot film and video of Patti and Lisa, he confined himself to controlled studio still photography and he never directed a play or wrote a monograph about his work. Robert purposely kept his private self an enigma.

Derek purposely revealed his self and his art life.

Jarman was the British Mapplethorpe, and then some.

Derek cut a wider swath in the arts than Robert.

His career trajectory and accomplishment when examined will throw light on the terribly reclusive Mapplethorpe. Jarman died of AIDS on February 19, 1994.

However, in the way society abruptly judges some homosexuals ART SAINTS and others AIDS QUEERS, Mapplethorpe became Lucie-Smith's sex-transcendent St. Joan of Arc and Jarman became the plague-society's leper artist.

Fine art and pop culture are degrees of perception achieved through media management.

Mapplethorpe milked the cash-cow artstream.

Jarman demanded the social justice of health care.

The cash-cow straightstream never really saluted the theater, film, photography, and diaries of Jarman, who always had something to say on his prolific mind.

Jarman, another gay artist rising in transit with his female muse, had his own Patti Smith, the actress Tilda Swinton, star of his 1991 masterfilm, *Edward II*, and of director Sally Potter's 1993 adaptation of Virginia Woolf's androgynous hero/ine *Orlando*.

In the battle of Jarman v. Mapplethorpe, was it better to be "cult" than to indulge world-class opportunism?

Director Gus Van Sant shed light on the kind of decisions Robert and Derek made. "It's not about selling out. It's about buying in."

It's about buying in and maintaining personal dignity and artistic integrity.

In the Art World.

"Actually, Jack," Robert once said to straighten me out. "It's not about liking these people."

It was the usual argument between Early Integrity and Late Capitalism.

It was our major debate in the 1970s and early 1980s about straight-streaming gay politics and gay art into the American popular culture.

Then the nightmare.

AIDS re-ghettoized homosexuality.

Everyone straight and gay ran for cover.

AIDS made heterosexuals afraid of homosexuals, AIDS made homo-sexuals terrified of heterosexuals, because AIDS has long been perceived by homosexuals as a Viral Concentration Camp invented by a heterosex-ually driven government that cannot afford to set up concentration camps for those who are different by skin color, by sexuality, or by et cetera.

Actually, the scary lesson of the "Bashing of Mapplethorpe" by preda-tory, redneck government officials who took art to trial, precisely because it was gay, is a study in the national exclusionist psychology that tolerates definition of identity of its self in terms of who and what it defines as the enemy.

Communism collapsed only seven months after Mapplethorpe died. Robert died March 9, 1989; the Berlin Wall came down November 1989. Without the external enemy of Communists to fight, demagogues, seek-ing hot reelection issues in autumn 1989, needed a fresh, credible foe, because their political campaigns and political identities had always been based on not what they were "for," but on what and whom they opposed or excluded.

Who's the villain this time?

This Identity-by-Enemy paradigm has been the xenophobic American psychology since the War of 1812.

Suddenly, in 1989, Communism was no longer the industrial-strength foreign enemy. U.S. politicians lost their defense-budget identity and urgency. So the house-to-house search for enemies turned internal, do-mestic.

Home-grown homosexuals, especially homosexual artists, were easy targets for demagoguery.

Senator Jesse Helms, Republican of North Carolina, lacking an issue

for a reelection campaign, knew what badly translated Old Testament pages he was fanning to flame.

Senator Alfonse D'Amato, Republican of New York, who went on Fag Art Alert, ironically cut his own federally funded throat when he seemed to forget that forty-two cents of every NEA-dollar actually went to a New York resident because the resident was an artist.

Hello?

Mapplethorpe became Public Enemy Number One.

Dead fags are even easier to bash than live fags who snap back.

On the floor of the U.S. Senate, Helms denounced the two men kissing in Mapplethorpe's *Larry and Bobby Kissing, 1979*.

There's the bottom line.

Man-to-man affection and bonding are perceived as homosex by well-known art critic Helms.

If Mapplethorpe hadn't been a fag, his work would never have gotten busted.

Homosexuals in terms of that evolving social experiment, the fabulous U.S. military, are subject to the exact same kind of prejudicial rhetoric that was used fifty years previously against Negroes in the military.

Predictably, within several years, the fags-as-niggers rhetoric will evaporate under the hot light of social inevitability that homosexuality is not only valid, but even of particular merit, because homosexuals do not breed in an overpopulated world whose very overpopulation causes violence and pollution. Actually, for not breeding, homosexuals should be paid subsidies the same as farmers who are subsidized for not farming.

Once queers become homosexuals the way niggers became African-Americans, who will be next on the home front victim hit list of prejudice?

American Muslims, who are the fastest-growing religion in the continental United States, had better join the ACLU now.

Before they get Mapplethorped!

POP CULTURE BABIES AND THE WOMEN WHO LOVE THEM

A CHRONOLOGY OF CENSORSHIP

"Women . . . beautiful creatures of grace . . ."
—*Stephen Sondheim,* A Little Night Music

Women introduced, created, mentored, nurtured, and maintained Robert Mapplethorpe in life and in death. Singer-poet Patti Smith accompanied him rhythmically and faithfully from start to finish. Manhattan gallery owner Holly Solomon launched his career with his first two exhibitions in 1977. Lynn Davis, Lisa Lyon, Susan Sontag, Sigourney Weaver, Tina Summerlin, and other women touched his life.

Janet Kardon, once director of the University of Pennsylvania's Institute of Contemporary Art, was a longtime enthusiast of the Mapplethorpe work. It was Kardon who inspired the quintessentially named exhibition, "Robert Mapplethorpe: The Perfect Moment."

Those drop-dead beautiful photographs played, without incident, in the last ninety days of Robert's life, at the University of Pennsylvania (December 1988) and the Chicago Museum of Contemporary Art (February 1989).

On March 9, 1989, Robert died.

Mid-March 1989, the Reverend Donald Wildmon saw a museum catalog featuring Andrès Serrano's *Piss Christ.*

In April, conservative Republicans discovered that the NEA had funded $15,000, through the Southeastern Center for Contemporary Art

in Winston-Salem, North Carolina, to the hugely overrated Andrés Serrano for an installation that included *Piss Christ*.★

In May 1989, Republicans in the U.S. Senate denounced federally subsidized art-filth. Immediately, both political and fundamentalist crusaders licked their chops and their stamps to solicit money through the mail to fight the NEA's "spending taxpayers' money on perverted, deviant art."

In June 1989, Christina Orr-Cahill, director of the Corcoran Gallery of Art, claimed the Serrano case had made the $30,000 NEA funding of the posthumous Mapplethorpe show a political issue.

She did not defend art; she surrendered to pressure and canceled "The Perfect Moment" exhibition. She lost a three-month battle, a strategic first battle, in an art-religion war that would rage for years.

Christina Orr-Cahill failed the principles of freedom of expression and the separation of church and state. She let a knee-jerk issue, incited by avowed heterosexuals, trample the constitutionally perfect moments of principles that override the money-driven, hissy-fits of some preachers.

Worse, some women say, Christina Orr-Cahill may have hyphenated her surname, and she may have been favored to direct the Corcoran because of her gender, but she was no feminist hero. She caved in.

Once again, the serpent entered Eden.

Orr-Cahill bit the apple.

Republican politicians began the heaviest assault on art and artists in America since the McCarthy-Nixon witch-hunt of the early 1950s.

Mapplethorpe's mother, Joan, died two months after Robert.

All these women, and all these men, all have their own Mapplethorpe, as do all his friends and surviving father and siblings.

One person's fact is another's unknown.★★

What really happened in the gay pop seventies has the best objective correlative in mainstream popular culture. Robert, seven years younger than I, had basically the same cultural experiences growing up, especially as regards

★ In 1987 Serrano had submerged a photograph of a crucifix into a twelve-by-eighteen-inch Plexiglas tank filled with more than three gallons of what Serrano said was urine. He was like a man crying "Fire" in a crowded theater. Serrano's urine looked red as blood: he was making sacrilege of the major icon of fundamentalist Christianity and flaunting body fluids at a society obsessed with the AIDS peril of bodily fluids.

★★ Something, however, separates biography from fiction, or else my *à clef* novel of the Dream Time of the Seventies, before AIDS, would have been definition enough of that time.

Some Dance to Remember, completed in January 1989, appeared February 14, 1990,

women. The perception of women by young white males in the fifties and sixties was created significantly by the still camera and motion pictures.

In 1966, when Robert was twenty, NOW, the National Organization for Women, was founded. Betty Friedan's *The Feminine Mystique* was in its third year as best-seller. And *Newsweek* declared, "In five years, Pop has grown like The Blob, from a label for what appeared to be a minor phase of art history to a mass psyche."

Robert and Patti, clerking at Brentano's bookstore, were aware of every fad and personality in the escalating pop world of women, drag queens, and gays as interpreted by trend-setting artists like Warhol, the Pope of Pop.

Five years earlier, in 1961, JFK had founded the President's Commission on the Status of Women to study formally the social and economic condition of women. What JFK, himself an instant 11/22/63 Pop Icon, intended to study formally, pop culture, scaring the horses, ran away with.

For instance, Mapplethorpe's eventual Saint Joan of Didion wrote in *Mademoiselle* in February 1961 an insightful process analysis that enabled young women of the sixties to live the kind of life Patti Smith dared to live around Robert.

"Girls who come to New York are, above all, uncommitted. They seem to be girls who want to prolong the period when they can experiment, mess around, make mistakes. In New York there is no gentle pressure for them to marry, to go two by two, to take any indelible step; no need, as one girl put it, 'to parry silky questions about what everyone at home refers to as my *plans*.' New York is full of people on this kind of leave of absence, of people with a feeling for the tangential adventure, the risk adventure, the interlude that's not likely to end in any double-ring ceremony."

The great women's director, George Cukor, who happened to be a Hollywood homosexual, floated in and out of the New York crowd who adored him as inspirational camp. The Warhol women, and the drag

cued by no more than coincidence into publication by Tom Wolfe's searching request for nonfiction novels in *Harper's* magazine, September 1989: "Stalking the Billion-Footed Beast: A Literary Manifesto for the New Social Novel." Tom Wolfe called for the involvement of the New Journalism, wherein the writer becomes part of the story and the story flows through the writer, and the writer jams all of a story between two covers. "Who needs more books by the Absurdists, the Neo-Fabulists, the K-Mart Realists? What we need is a novel about Jim and Tammy Bakker." *Some Dance* was a work of fiction that pressed the essence of gay popular culture of the seventies, without tears, between the covers.

queens, all Warhol superstars, descended from Cukor's larger-than-life presentation of Hollywood actresses.

Tennyson said, "I am a part of all that I have met."

Cukor said, acknowledging the pastiche of pop eclecticism that would become Mapplethorpe's, "All these things accumulate and other people's visions become a part of you."

A perfect definition of the genesis of pop.

You're a strange new mutant. . . . A scholar of American Popular Culture. You're a vulture feeding on your contemporaries. It used to be, when things were what they used to be, that scholars would wait a decent fifty years at least before daring to dissect people and their behavior. . . . Do you know the difference between a vulture and a pop culture scholar? . . . A vulture waits till you're dead to pick on you.

Actually, if I could write the things I wrote in my 1967 Ph.D. dissertation about the greatest women's dramatist in American history, Tennessee Williams, if I could write about his psychology and theology, about his exploration and application of life and death and women in American culture, to earn that Ph.D., perhaps I am qualified to make similar esoteric and curiously interesting pop observations about Robert Mapplethorpe, whom I knew personally and intimately far better than I knew Tennessee Williams.

I make no apology for my vocation. I make my living as a dispassionate observer. I believe one must study culture quickly before it melts. Memory and memoirs only make the past glow. I love the firsthand immediacy of another of my interviews, Sam Steward, the Father of Gay Erotic Writing. He was a joy telling his merry tales of Gertrude and Alice and Thornton and the rest of the Charmed Circle. Who but the living, breathing Sam, the last survivor, could tell the intimacies of Bilignin, how he, one night, stumbling into the bathroom, caught sight of Gertrude, one hand trying to cover her mastectomy that only Alice had ever seen. No one had even known that Gertrude had cancer. But Sam knew. That's the kind of firsthand reportage that is the essence of pop culture: get it while the source is alive and kicking; poke at it while it's fading; perform an autopsy while it's still warm; keep to the immediate evanescent facts and feelings that will evaporate before

they can be recorded; leave the eulogies to historians studying the world through the rearview mirror. . . . Writing history is dead and distinctly different from the vicarious adventure of witnessing a whole people being carried away by history.

I admit I'm a fame-and-failure junkie. Not mine. Others. I entertain an almost perverse curiosity about the ironies of American culture. I want to know why the postmodern craze for derivative pastiche, quotation, and appropriation succeeds seamlessly. . . . Especially, I want to know in all their infinite variety all about American women and American men. America . . . is a wonderful country that has yet to be discovered.★

In 1967, against the roar of the Vietnam War, I finished graduate school and began university teaching, which allowed me five months a year in New York.

Robert was twenty-one and I was twenty-eight in 1967, the year of *The Graduate, Sergeant Pepper's Lonely Hearts Club Band*, and the Summer of Love celebrated in the Haight-Ashbury and Berkeley as well as the East Village and Columbia.

By 1969, the year of Kenneth Anger's underground *Scorpio Rising* going Hollywood in *Easy Rider* (the trip), *Medium Cool* (the camera), *Midnight Cowboy* (the hustler in New York), *Hair* (the communal youth rebellion), and *Interview* (the self-conscious magazine of pop), Robert finished his matriculation in the graduate school of NY Pop Art.

The sixties ended August 9, 1969, when the Manson Family entered, of all places, the home of Doris Day's son, and murdered the pregnant actress Sharon Tate and five others, including coffee heiress Abigail Folger and hairstylist Jay Sebring, whose car trunk, in cruel irony, contained whips and leather.

Robert hated murder of the rich and famous, because it cut into his model and client list.

He was not being cynical.

Warhol's spinning *Interview* had memorialized Sharon Tate. Edward Brooks De Celle, owner of the Lawson De Celle Gallery in San Francisco, showed Mapplethorpe early on and recalls a luncheon at which Mrs. Folger discussed quite movingly the murder of her daughter.

★ From *Some Dance to Remember*, Stamford, CT: (Knights Press, 1990), pp. 19, 20, 21.

Everything is connected to everyone by smoke and mirrors, beauty and privilege, drugs and money, sex and death.

In 1967, I met Mario Amaya, who towed me along one afternoon to Warhol's Factory, where everyone seemed to wear black so they didn't clash with the art. I had seen Gerard Malanga and Nico appearing with the Velvet Underground in Warhol's *Exploding Plastic Inevitable*, but I was not ready for Warhol, under his wacko shock of albino wig.

I had come out sexually on May 15, 1967, and was pleasantly impressed how having sex with people opened doors one could otherwise never walk through without all kinds of introductions and appointments.

Gayness was, back then, endorsement, not issue. It was instant entrée and credential for me, for Robert, for any aspirant willing to come out.

Later came the question: "What are you besides gay?"

Mario Amaya was a one-man tutorial in dealing with film folk whose underground movies were as meaningful to me as Hollywood once had been.

The only person I spoke to that afternoon at the Factory was a woman, Brigid Polk, who was heavier than Mama Cass, but I had admired her zaniness of running around to Laundromats and appliance stores to shoot multiple images of the washing machine, *Speed Queen*, which was the title of her only work known to me outside of her starring roles in Warhol's movies.

By 1969, the Village was my home away from home. For ten years, from fourteen to twenty-four, I had been the toy of "sadistic" priests, one of whom wrote a letter saying I was not a homosexual. By twenty-nine, the other end of the whip came to hand. Circles other than Warhol's opened up after gay liberation raised its hand at the June 1969 Stonewall Rebellion in the Village.

Gay photography studios legitimized themselves out of the sexual underground after the 1969 rulings regarding adult materials handled by that arbiter of taste, the U.S. Postal Service.

The age of legit leathersex photography was born. New York photographers Lou Thomas and Jim French founded Colt Studios.

In 1970, Lou Thomas hired me as a photo model for a leather shoot with a Forty-second Street hustler. That year, Warhol's *Trash* appeared and *Myra Breckinridge* rode slap-saddle across screens double-billed with the British hit *Performance*, in which rock star/pop icon Mick Jagger plays an Anger/Brando leather boy with sexual ambiguity: a perfect model for Mapplethorpe emerging in black leather.

That autumn, after shooting many "underground films," I shot my first leather film on super-8 starring the particular New York star X, whose premiere in underground screenings in Manhattan and San Francisco was a success. Were it to be rereleased on video, the title might be: *X Having His Buttocks Whipped*.

We are all the sum total of popular culture.

Pop culture has invaded the national bloodstream.

The Pop Couple, Robert Pop and Patti Pop, moved through their Pop Adolescence in the Pop Art World, influenced by the invasion of British Pop.

In the Pop Speak of the sixties and seventies, Pop People often played, "What movie am I now?"

Pop Urchins living at the Popularly Priced Chelsea Hotel, Robert Pop and Patti Pop (not their real names) Popped Pills and listened to Pop Music (to make Pop Music) and watched Pop Movies (to make Pop Movies).

Imagine Robert Pop and Patti Pop at a rocky horror triple-feature picture show.

Consider that the Pops are tropes turning in tandem periodicity to the light of the movie screen.

Robert Pop and Patti Pop appear first in Shelagh Delaney's 1961 movie, *A Taste of Honey*: relationship of homosexual who lives with pregnant girl.

They pop up again in 1965's *The Leather Boys*: leather-jacketed Rockers versus mod East End Teddy boys, while "hero" takes in gay boarder and "heroine" tries to win the "hero" back.

A Taste of Honey and *The Leather Boys*, both as female-focused as was Mapplethorpe, feature, as *Time* called her, " 'that unblushing ham,' Rita Tushingham."

Finally, with the female predominant, Robert Pop and Patti Pop thrill the Paparazzi in 1965's very uptown *Darling*: Julie Christie won the Oscar portraying an empty fashion model whose plea for a relationship to the homosexual photographer, finally, is, "We could do without sex. I don't really like it that much."

Was this a "high concept" or what?★

★ In 1961, long before Mapplethorpe, one of my first pop culture articles appeared in print, sorting out the persona of the late James Dean, who then was not that late and not yet really a candidate for pop sainthood. In 1965, another pop culture film essay examined the moral relativism and social meaning of John Schlesinger's classic *Darling*. Not in the pop pages of *Interview*, which hadn't been created yet, but in the theopop of *Catholic Preview of the Arts* magazine.

Turn the pop trilogy of *Honey/Leather/Darling* into a quartet with that quintessential photographer's movie, *Blow-Up*, (1966). Michelangelo Antonioni's *Blow-Up* plays like a Warhol *Polaroid noir*, spinning as it does, as Mapplethorpe finally did, on the blow-up of a single frame.

The physically enlarging blow-up of a photograph matches pop culture's blow-up of traditional art, of men's idea of blow-up women, of the emotional blow-ups in the human condition, of the overblown egos that control images.

Blow-Up, not to be confused with Warhol's portraiture-film *Blow Job*, is either objective correlative or coincidence the way that John Lennon and Yoko Ono, posing naked in bed for photographs, are correlative or coincidental to the Famous Pop Couple of Mapplethorpe and Smith.

In Alvin Toffler's *Future Shock*, sociologist Orrin Klapp said, "One of the functions of popular favorites is to make types visible, which in turn make new life styles and new tastes visible."

In 1965, British artist Gerald Scarfe penned a caricature of Lord Snowdon, nude, with the camera hanging in his groin pointing out long, hard, and quite phallic.

Blow-Up, shot in London, was part of the pop British invasion of the United States led by the Beatles in 1964.

Michelangelo Antonioni's *Blow-Up* was a brisk, dark, pop culture mystery about sex, death, and the all-important presence of the camera. Antonioni's spiritually empty hero anticipates every wannabe with a Hasselblad.

Fashion photographer David Hemmings shoots the London world of fashion models, using his camera as phallus, substituting f-stops for the F Stop, virtually cam-fucking supermodels, until he is confounded by the mystery of Vanessa Redgrave's aristocratic silent self-identity.

Nothing happens.

Everything happens.

And then you die.

Patti Pop had to become a writer and singer.

Robert Pop had to become a photographer.

What duet else could they do?

Pop!

MAPPLETHORPE'S SEXUAL AMBIGUITY

MAPPLETHORPE: If I were a woman, I'd be a whore.
FRITSCHER: You are a whore.

Our lives in the 1970s were steamy underground movies. The young Robert shot multiple frames.

In 1973, Robert shot Warhol superstar Candy Darling talking on the phone in a quartet of shots.

The same year, he shot: (1) a Polaroid quintet of *Patti Smith (Don't Touch Here)*; and (2) a quartet of self-portraits, with two shots of a statue, in which he lies nude on black leather, folded knees up, almost fetal, spinning a take on Marilyn Monroe's iconic calendar.

By the end of 1973, his autopic *Self Portrait, 1973* dramatizes him, a very up-against-the-wall motherfucker in a black leather vest, with his face a Kirlian blur.

By 1974, in his *Self Portrait*, shirtless, with leather wristband on rampant right wrist, and left hand tucked in the rear waist of his leather belt, he presents himself in full focus as a kind of standing *Le Penseur*.

Mapplethorpe had started out as a sculptor.

Robert's sexual ambiguity escalated after he died.

Confusion.

He was gay.

He was straight.

He was bisexual.

He was polymorphously perverse.

Actually, he was all things to all men and women.

The straight press profiled Mapplethorpe as an aristocratic artist, a peculiar lord of leather homosex, who shot pretty pictures of faces and flowers when he wasn't being a bad boy shooting fetishes.

The gay press ignored him in death as it had in life.

Finally, shamed by the notoriety paid Mapplethorpe by the clamoring straight press, the gay newsmagazine the *Advocate*, according to then editor Mark Thompson, had an internal fight about putting Mapplethorpe on the cover as Man, er, Person, of the Year. Actually, Robert appeared on half the cover, because the *Advocate*, perhaps tired of the beating from the P.C. crowd, was obliged to put a female on the cover.

As if the "politically correct" time-share of the December 18, 1990, cover wasn't enough indignity, some queens decided, because they themselves were female-identified homosexuals who were left in power when Bette Davis died, that the Mapplethorpe half-cover would be, of course, darlings, the self-portrait with lipstick.★ As if Robert were a drag queen!

Robert was a male-identified man.

He enjoyed an artist's ambiguities.

If the viewer needs to think Robert was investigating his female side, how Jungian!

If the viewer needs to think Robert painted himself up, clowning around, to examine, maybe, expose, the masks women are forced to smear on their faces, how Freudian!

If the viewer needs to think Robert was a commercial photographer glomming on to a new angle to sell high-fashion cosmetics *à la* Joe Namath's famous seventies TV and print commercial wearing pantyhose, which gained from his uncompromised male identity, how clever!

The *Advocate*'s needs are different from that autopix's autobiography. Actually, only a small percentage of gay men are so confused about gender that they think all gay men want to be women; unfortunately, those few long ago took over most of gay publishing to perpetuate their particular mythology.

What was not ambiguous was Mapplethorpe hated the *Advocate*.

That mag was not his advocate advocating anything of his advocacy if he had ever bothered to advocate anything in his apolitical life.

The *Advocate* queenstream has never understood the leatherstream of

★ *Quel* success! Twenty-one months after he died, Robert appeared looking like a topless drag queen in a mental institution. Third World lesbian Urvashi Vaid appeared looking very mannish in a lifeless wannabe-Mapplethorpe "portrait" by Timothy Francisco.

masculine-identified men, or gay artists who are in the straight main-stream.

Robert was in aggressive competition with everyone. He achieved fame in the seventies. He achieved power in the eighties.

Michael Douglas, in the Manhattan madcap movie *Wall Street*, said, "Greed is good."

In 1988, the dying Robert photographed himself as Death Warmed Over, holding his cane-with-skull. Edward Lucie-Smith thinks that in this photograph, Robert looks like a handsomer Dr. Joseph Goebbels.

He who dies with the most toys wins.

Actually, time flies when you're dead.

Robert never knew how the eighties ended.

Or that he became more famous dead than alive in Cincinnati.

Or that Communism collapsed.

He wouldn't have cared. He was so apolitical he wasn't even sure Communism wasn't just another style.

Actually, Mapplethorpe was a crypto-Republican exclusionist who believed in the traditional places for women, blacks, and gays.

How doubly ironic!

In life, he closeted his sexism and racism to fit into pop art. Warhol's need for everyone's talent made pop art an essentially inclusive movement.

In death, Republican southern religionists, unaware of his attitude toward women, blacks, and gays, attacked him.

Senator Jesse Helms picked on Mapplethorpe because he needed to get reelected and had no hot burning issue to address, until he demonized Robert Mapplethorpe as a smut peddler.

What a waste! Robert was dead and unavailable for comment. Just as well. He would have been terrible in court.

In death, Mapplethorpe and Warhol are no longer persons. They are incorporated foundations creating arts and charity grants. Their competition continues. Money, worth, has always been the way of keeping score. At the beginning of 1994, Warhol's estate was block-priced at $220,000,000, and Mapplethorpe's estate was un-block-priced at $228,000,000. What a row in the courts and in the press that caused! Especially to the executors who were to receive a percentage of the value. Critics thought it strange that Warhol was valued as if all his works were sold in one day in a block package. Mapplethorpe's "remains" were valued on separate pricing sold over the years, if not the ages.

Andy and Robert may be the Abbott and Costello of pop art, but who's on first?

Robert Mapplethorpe's sexual turn-on was all-American dollars. Lots of them. In large denominations. And diamond rings he could bite. Mapplethorpe was Marilynesque marrying a millionaire.

Sam Wagstaff had all the sex appeal in the world.

Question: What if Sam Wagstaff had been Pam Wagstaff?

Whatever the answer, it's Robert's truth about women, about sex, about men, about money. . . .

In the artpolitik, women legitimize gay artists. Gay artists know the role of women: to make the gay artist escort-friendly to other women and nonpredatory to threatened husbands.

Robert and Patti played Romeo and Juliet with homosexuality as the puzzling problem between Montague and Capulet. Patti never was a fag hag. Patti Smith actually connected him to Ms. Sandy Daley, who shot *Robert Having His Nipple Pierced*.

Patti Smith, if the truth be known, is the soundtrack, words and music, of the moving image of Robert Mapplethorpe's life.

In Daley's film, as Robert lies stoned in the arms of some male *amour du jour*, Patti keens over his rite of passage from personal experimentation with heterosexuality to professional homosexuality. There's a story.

What secrets does the erstwhile "Mrs. Mapplethorpe," the First Lady of the Faces and Flowers, the "Female Widow Mapplethorpe," recall from those steamy early days of the mister's polymorphous proclivities?

What promises were made?

What silences purchased?

None?

None.

In the gay seventies, women who were poets, singers, and performance artists were considered chic ornaments for gay men. They were not unlike straight men's trophy wives.

Masculine-identified gay men, particularly, matched up with female partners who were not like female-identified gay men's "sisters."

The women, in turn, for spinning the gay man's image, gained access to clubs, bars, discos, galleries, and audiences they would never otherwise have had.

It was not lost on career-minded women in the seventies that pop diva Bette Midler had conquered New York performing down in the depths

of the notorious Continental Baths of the Ansonia Hotel—where she sang.

In November 1976, the night the infamous Mine Shaft opened in New York, a woman in full leather stood on the stairs rising up from the street to the second-floor entrance. Wally Wallace, the founding genius of the Mine Shaft, watched the woman move in her place in line to the door where he was selling admission.

"I knew," Wally Wallace said, "when I opened a leather sex club for men that women would want in. Women's liberation and all that. But I wasn't prepared for it the very first night. So I told this very beautiful woman that this was a sex club for men. I was polite and she was nice. I mean, she was great-looking. I told her maybe some other night. She said okay and walked down the stairs and out the door. As soon as she did, about twenty hot guys, and I mean hot-looking leather guys, followed her. She had an entourage. I invited her in after that. She was Camille O'Grady."

In the late seventies, Camille moved to San Francisco. She was a punk poet, a rocker, a singer, a leather player, a beauty. She partnered up with the leatherman who had streaked the Academy Awards, Robert Opel. He had moved in The Great Sex Migration to San Francisco, where he opened the Fey Way Gallery.

Opel exhibited Mapplethorpe.

Impresario Opel's identity confused with photographer Mapplethorpe's.

Naturally, Camille O'Grady was confused with Patti Smith.

Camille O'Grady objected vehemently to being the West Coast Patti Smith. "I opened CBGB's," Camille told me in 1979, "before Patti Smith ever entered the door."

My! My! My! Sorry I asked.

That's the way the women were before so many men died leaving the archetypal widows alone: Jackie Bouvier (gun), Yoko Ono (gun), Camille O'Grady (gun), Patti Smith (camera). . . .

In the seventies, certain people seemed bohemian except when they seemed like white trash, which became a "style" in the leather scene and the drag scene of the seventies.

Robert, however, in those days, seemed poor to me the way New Yorkers escaping from apartments to San Francisco looked dirty from drugs and after-hours clubs. Maybe we all looked that way. I hated the

Mapplethorpe look he shot of me back then. That Mapplethorpe photo was my wake-up call. Coming to terms with the generic *bohemian* and the specific *hippie*, one branches out to *naif*, which becomes *waif*, which begets *trash*, which becomes *punk*.

The labels and the "Look" from NYC to LAX to SFO were mutating fast in the sexual underground.

New Yorkers, like Michael Maletta, hit San Francisco announcing they intended to teach the West Coast how to party.

They kept their promise.

The Manhattanization of San Francisco was considered a bad trip.

Mapplethorpe arrived in the wake of rip-offs like Maletta's Creative Power Foundation, which had funded major parties like "Night Flight," hung with panels from Cristo's curtain, and "Stars," which took over the entire dock of Pier 26 on the San Francisco waterfront almost under the Bay Bridge.

STARS!

Thousands partied under one roof for one night only.

STARS!

Thousands of dollars went up noses so the fists fit up asses.

STARS!

Leather and Levi scenes of water sports, scatology, and S&M beatings and torture wilder than any Mapplethorpe photograph. The men were dancing stripped to the waist in the huge center of the pier, where the disco beat on under trapezes of the flying acrobats and the go-go platforms of the posing bodybuilders. Unscrewed bottles of popper drove the dazzling light show spinning through movies from a dozen projectors.

"Stars" was a pop culture event that went positively tribal.

New Yorkers had upped the ante when San Franciscans needed it most.

The San Francisco that Mapplethorpe knew was better than Sodom and Gomorrah.

Actually, San Francisco in the seventies has been best remembered by religious fundamentalists. Everything they say is true; but we weren't guilty, because it wasn't sin. It was liberation after years of oppression.

The San Francisco that Mapplethorpe knew was a city made paranoid and operatic in the wake of the November 1978 assassination of straight mayor George Moscone and gay supervisor Harvey Milk by confused supervisor Dan White, the immediate and scary ascension of Mayor

Dianne Feinstein, the White Night Riot, and the city's very direct connection to the mass Kool-Aid suicide in Jonestown in the same traumatic November 1978.

What a libretto for *Mapplethorpe! The Musical!*

New Yorker men and their women working San Francisco's distractions were not overly popular.

Robert Mapplethorpe had to override the prejudice, not the expected prejudice of being gay or male, but simply of being from New York City. Talk about provincial!

Robert needed new labels.

He needed *leather* and *S&M.*

He needed new ladies.

In later days, Lisa Lyon, traveling as Robert's sidekick, stood in for Patti Smith, who was appearing on Saturday-morning kid shows, bumping around with Soupy Sales. ·

Lisa was like Robert's Amazon Protectress. Not at all playing Patti's Madonna. Patti had seemed poor as punk. Lisa seemed hard as trash. Robert Mapplethorpe and Robert Opel actually argued about the value of the women they had in tow!

Robert's view of women was no more opportunistic than his view of everyone else.

He needed them.

And, for a while, he needed me.

Robert was straight the way that straight women figure that gay men are, under it all, really straight. That Straight-Woman Fantasy, that she can cure a queer if only he has sex with her because she has the female power to straighten him out, was an Urban Folk Myth Robert loved to exploit. He added to his commercial mystery adroitly hinting, neither affirming nor denying, that he had sex with women. How could his perversity be *poly* if he didn't?

He anguished continually over sex in letters and conversations.

"Robert Mapplethorpe once told me he was straight," I told director J. D. Slater, who laughed for two minutes and said, "Gee, Jack, if Robert had lived, he might have turned into Betty Boop."

Robert was perverse enough to say to me in one of our enhanced seances, "What if I'd been a straight asshole, and had turned Sam down?"

Nice touch of sexual ambiguity.

Go down to the crypt immediately, poke the ashes, sample the DNA

and see if Robert was a genetic homosexual or simply an opportunistic heterosexual scared of sex with women.

Actually, if science articulated the difference between genetic homosexuals and *faux* homosexuals, who are really genetic heterosexuals afraid of heterosex, the perceived gay population would instantly drop by 25 percent.

Strident feminism causes men who would otherwise be some women's husbands to head for the cover of gay bars. They'd rather be fags than married.

These failed heteros, posing as homos, often disguise themselves as the straight (not gay) stereotype of the "Effeminate Homosexual."

Women know that the more traditionally masculine a man is, the more likely it is he's gay. (Rock Hudson was one of the greatest actors in the world: he made heterosexuality believable.) Taught Straight Stereotypes of Gays by military pop culture, these don't-wannabe-straight guys become at worst sissy-wimps and at best screaming drag queens. Desperate and confused, they ape the women of their attraction-repulsion. To the degree he is effeminate, the more genetically straight is the *faux* queer, who hides from women, and who reinforces the sissy-queen stereotype against otherwise masculine-identified genetic queers.

In 1989, I wrote for publication again what I had written in 1980, that masculine-identified homosexuals have more in common with masculine-identified heterosexual men than men who are female-identified homosexuals.

Camille Paglia basically repeated the same concept in the October 1991 issue of *Esquire* (p. 138).

That drive-by shouting needed saying in terms of the Mapplethorpe universe staked out by men in the hypermasculine ritual and *Zeitgeist* that has nothing to do with women. Robert tumbled into this leather-driven male world and had to make his way almost against type.

Robert romanced society.

He was bisocial.

When he wasn't romancing men, he romanced women.

Robert was emotionally connected to some women, but always conditionally.

Whereas Robert's men were mostly gay, Robert's women were mostly straight.

Robert Mapplethorpe was to society women and media women what most gay men are: *entertainment.*

Where rich women gather, men sing for their supper.

And sometimes they cook it.

In the seventies, I shot leathersex movies of, among other men, Robert Walker, the extraordinarily handsome blond society portrait painter/ bodybuilder/chef, who was sent smiling back to cook for his patron, one of the world's richest women . . . after Mapplethorpe had his infamous way with him. A week later, Robert Mapplethorpe was guest of honor at Madame Swank's table, where he adroitly peddled his photographs, to her and her husband and their friends, thanks to the chef, for whom Robert in turn found painting commissions.

Whatever Robert's sexual identity was, deep inside, he had to be the archetypal gay man as bad-boy artist, because rich and famous women and the art establishment would not have taken to him if he were straight or female or bourgeois.

Robert was not popular those days for his intellect or his private personality; he was known for his snide you–don't–dare–not–love–me attitude.

He glossed Diana Vreeland cynically and said, "I love the rich. They're so clean."

His smirk-faced autopic with the leather whip tailing from his buttocks is Essential Signature Rorschach: "Kiss My Ass and Eat My Shit."

That's the self-portrait *Advocate* editor Mark Thompson wanted on the cover. He may have been overruled by queens, but his instinct was absolutely correct.

Madonna, sort of the world-stage media child of her ambitious predecessor Mapplethorpe, knew the value of Being a Gay Male. Shadow-dancing, Madonna claimed to be "a gay man trapped inside a woman's body."

It had to happen to somebody sooner or later.★

What is this Gay Man Identity Factor doing to women's identity?

What did Robert's Gay Man Identity do to the women in his life?

According to the pop culture gossip, Lisa Lyon retired to Los Angeles to live with *Center of the Cyclone* author John Lilly; and Patti Smith

★ *Women's Wear Daily* praised fashion photographer Steven Meisel, who, once considered too risqué for the fashion mainstream, eventually crashed his shocking art into magazines such as *Vogue* and into advertisements for pricey Gap spots. Meisel worked closely with Madonna on the concept of her book, *Sex*. Meisel, who shot the photographs for *Sex*, enjoys in his mid-thirties a kind of pop para-Mapplethorpe commercial career.

married, moved to a Detroit suburb, had a child, and wrote some articles about gay men in pop culture magazines.

"*Details* magazine features a reminiscence by singer Patti Smith on her relationship with Robert Mapplethorpe, accompanied by pictures from *Mapplethorpe*, a new book of his work. 'I'm not after beauty,' Mapplethorpe told Smith, 'I'm after perfection, and they're not always the same.' "[*]

Patti Smith, Camille Paglia, Joan Didion, Susan Sontag, and some other women excepted, it is interesting that, in the sea change from the chic seventies to the AIDS nineties, a coup of some women has barged in for a hostile takeover of the life histories, art, and politics of some gay men who lived during the seventies and died in the eighties.

Such co-opting of gay men on the lecture and publishing circuit is another exploitative hit at the current pop target of choice, white males.

In the sixties, Valerie Solanas of SCUM shot Warhol, and no one cheered. In the nineties, the onomatopoetically surnamed Mrs. John Wayne Bobbitt, Lorena Bobbitt, the New Improved Valerie Solanas, cut off her husband's Bobbitt, and some women cheered. The allegedly heterosexual Bobbitts, momentary dick-less wonder couple, entered history like the Irish Squire Boycott as their typically nineties' story entered folklore and their name entered the English language.

If anybody's going to cut up white guys, remember: Mapplethorpe, a white guy, did it first. His famous black-and-white photograph of the male privates, bloody in bondage, preceded his portrait of the seated, naked leatherman whose body was a mass of scarification from razor cuts.

The black-and-white "still life" of the bound, bloody privates was derived from Mapplethorpe's early Polaroids he and Sam Wagstaff showed around London on their English honeymoon.

Robert's literal prime cuts read symbolically.

His primal castration references exhibit his garden-variety fear of the vagina dentata as well as his respect of other men who are quite willing, really, not in fantasy, but really, to torture other men to the extreme they want. Robert liked the concept of torture. Consensual or not. He was raised a Roman Catholic. He was Irish. In his mind, he placed the whole being of the sadist and masochist on the playing field of love and death and all the reciprocal terms between those extremes: pain and pleasure, passive

[*] Orland Outland, "Out There: The Annals of Queerdom," *Bay Area Reporter*, November 12, 1992

and aggressive, soul and body, beauty and terror, animus and anima, the cross and the crown.

The leather photographs are all of white males. Robert attempted to stake out a fetish franchise of white leather and black men.

But if he had done to women with knives and guns and penetration what he did to white men, no liberals would have defended him from Senator Helms, who probably would have ignored Mapplethorpe's presentation of black men.

And black women, who remain invisible except for a dancer or model or two, such as Anna Waddell, and Dolphina "Dolcie" Neil-Jones, she of the handbag and hat, in *Some Women*.

Robert's views of women and blacks, his views of gender and race, were not those of a saint. In fact, the only candidate for sainthood in this story is Patti Smith.

She ran her own life, sometimes part of Robert's, sometimes pulling back, taking care of her own self, her business, her career, her life, to be apparently alienated, reconciled, and to return again.

Patti was Robert's Muse, Eve, Madonna, Poet, Twin, and Widow.

No wonder Robert always spoke reverently of her.

"Patti's a genius," he said.

Repeatedly.

Robert should have written about his own life.

But he didn't.

Patti is a much published writer.

Nobody owes anybody anything.

I can write a certain gay "Take" on Robert.

But Patti is the writer, friend, and confidante of Mapplethorpe who can write the best "Take" on Robert as perceived with the straight insight of a woman.

Patti is a pop goddess.

She appeared as "January" on *Annie Leibovitz' 1994 Calendar of Portraits*.

SOME WOMEN

obert Mapplethorpe easily disarmed people. He knew how to charm the defensive, relax the uptight, and direct the independent to an obedience.

He was the man who removed Yoko Ono's shades and presented her eyes to the world.

Some women interested Robert. Not women in general, but some women in particular, and not even all the women in *Some Women*.

Robert, essentially, was a one-woman man, and that woman was his mirror, Patti Smith, whose very existence fueled Robert's introspection.

Patti and Robert were old souls destined to meet again and again.

Lisa Lyon, Robert's "other woman," who appears twice in *Some Women*, was never soulfully connected to Robert as was Patti, who appears four times at the climactic close of that book.

Lisa was a dynamic model, a worldly woman whose surfaces interested him. Lisa was, at least when we dined together, a double stun gun of sexy beauty and dishy wit. Lisa is one of those straight women with the talent to be one of the guys, a prankster, earthy, with a humor so self-effacing that she actually joked that she had built her body on MDA.

Robert and Lisa traveled well together as a famous couple.

Lisa helped Robert escape the confines of his studio. She brought Robert out to shoot the world. She opened him up. She made it possible for him to create in less controlled situations. She widened his scope and his out-of-studio *oeuvre*.

Their work together, *Lady Lisa*, is Robert investigating the anatomy and role-playing of an assertive feminine personality, who, in the feminist seventies, was the first famous female bodybuilder. Lisa, as bodybuilder, developed herself as a muscular female. She avoided the mistake later women bodybuilders made in designing their muscles, using freak-out anabolics—male steroids—to build men's musculature on women's bodies.

To Robert, Lisa was a new icon, a new image.

Robert eroticized Lisa at the beginning.

At the end, Robert hung up on Lisa, who called him repeatedly from California with strange cures for AIDS.

Before their falling out, Robert posed Lisa, virtually phallically, in blue swimsuit and red rubber cap standing barefoot over the black model, Jack, lying on the floor. Terrific ambiguity: Lady Lisa Lifeguard is either seductive Siren or Botticelli's *Birth of Venus* on the half shell. In other poses, she is the Society Woman in hat, veil, gloves. She can pose in changed gender.

Lisa and Patti represent in body type the Mapplethorpe female who is not in the tradition of the fecund female figure. Mapplethorpe's women straddle androgyny by their very slender builds.★

Click! Click!

Robert liked the anomaly of an athletically feminine woman in the sport of bodybuilding, which traditionally worshipped the male body.

Early on, before he met black bodybuilders, Robert protested too much when he said he cared little for straight, white male bodybuilders. "You can't work out that much and have a brain," he told me.

In 1976, he had shot Arnold Schwarzenegger, who was, Robert said, "straight and very pleasant."

His photograph of Herr Schwarzenegger is simple as a declarative sentence.

Robert was indifferent to it, but he published it, because der Herr was famous, and clever, taking bodybuilding out of its sideshow status. Actually, Holly Solomon said, "the photograph of Arnold was the first photograph Robert sold to private Manhattan collectors."

Der Herr appeared posing, live and in person, in a kind of performance art show at the Whitney Museum, Wednesday, February 25, 1976. The 8:00 P.M. program was titled, "Tissue Issue. Articulate Muscle: The Male Body in Art."

Candice Bergen's photographs of der Herr are as declarative as Robert's.

Maybe "straight and pleasant" doesn't show up on film.

Robert, recognizing my then obsessive attraction to bodybuilders, felt

★ Robert directed a 1978 black-and-white film of Patti titled *Still Moving/Patti Smith* which, he wrote me in a letter, he shot on $2,000 of his own money and worried he'd never earn back. In 1984, Robert directed Lisa Lyon in a color film.

obliged to explain that he simply didn't get what male bodybuilders are all about.

That's practically heresy for a gay man to say, because, if physique contest auditoriums were emptied of homosexuals, most of the audience and numerous contestants would disappear.

Robert may not have "gotten" white male bodybuilders, whom he called "fucks from outer space," because he had bedded more than a few bodybuilders and found their narcissism impenetrable.

He couldn't get into another man's narcissism.

He hadn't the power to disarm bodybuilders, shielded psychologically in Jungian terms by the muscle of their body armor, the way he could disarm, in Freudian terms, normally built men or women.

He was human.

Robert genuinely liked women, the mystique of women, the company of women, and women seemed to like him.

He was one of those attractive men who make some women dislike homosexuality because, unlike sexual competition from other women, sexual competition with other men is a fight for love and glory they rarely win.

Robert was a typical masculine-identified homosexual whose concern for women was limited by his homosexuality. But he was not one of those male artists whose fear of women translates to sadism toward women. He reserved his sadomasochistic investigations to men.

Luckily, Robert lived in Manhattan among women sophisticated enough to enjoy the plenty of him that was available to them.

He eschewed the feminist movement the way he avoided gay politics.

A classicist, a formalist, he was a humanist evolved beyond gender squabbles.

When faced with emotional political issues, he simply cut through the issue and went for the principle.

He refused to deal with abortion, sex, and drugs because, to him, they were nonissues. He felt that people should simply take a cue from the women, and allow free choice on everything.

He was very permissive, because free choice had led him to such great personal freedom.

One cannot escape, perforce, when discussing Mapplethorpe's women, to address the androgyny that had, at least, a kind of Jungian interest for Robert, always in his connection to Symbolic Patti, and particularly in his 1980 self-portrait wearing cosmetics.

His "androgyny" was essentially pop cultural and commercial. He never gave evidence of wanting to be a woman. He was no closet transvestite and certainly no drag queen.

Mapplethorpe was a fashion photographer.

He was also his own least expensive and most cooperative model.

He began his career shooting himself and displaying other of his photographs in frames he designed with mirrors. He actually appears more "effeminate" in his autopix from the early 1970s.

Touching up himself with cosmetics associated with women, Robert experimented with putting on one of the masks women often wear to see if he could work the sex and magic of his camera to break through to the other side of gender.

He wasn't trying to look like a woman. He was like the straight men, and gay men, who like to wear women's panties while they smoke cigars for exhibition sex. These men say they don't want to be women. They want to be seen as men red-blooded enough to fill out women's panties. Witness his high-heel and mesh-stocking photographs of the hypermasculine Roger Koch. In 1983, Roger, billed as "Frank Vickers," was the number-one throb in gay films. Robert did not want to shoot Roger in drag; Robert wanted to display soft female apparel in contrast to the hard male physique. Roger was not too happy. Actually, Roger failed to understand that Robert was dramatizing his strength even in parody. Robert would have killed to possess Roger Koch.

Robert, in the erotic-court Manhattan style of the genderfuck times, was actually trying to look like a contemporary rock star.

He was secure enough in his personal masculinity to mask himself with mascara to see what feeling he might evoke in himself. The artist was attempting to increase empathy with women at a time when androgyny was an issue dramatized in the nightlife of the clubs and the world of rock 'n' roll: Mick Jagger, David Bowie, et al.

Androgyny is a ritual act that states the person is not male or female, but flesh, not man or woman, but human.

"Mapplethorpe," Edward Lucie-Smith said, "was typical of those deliberately artificial artists, somewhat like Gustave Moreau, who helped begat Art Nouveau. Moreau and that group admired in Michelangelo what they took to be the 'ideal somnambulism' of Michelangelo's figures."

Robert, one of the world's great leather and kink fetishists, experimented, but couldn't penetrate the incredible essence of being female.

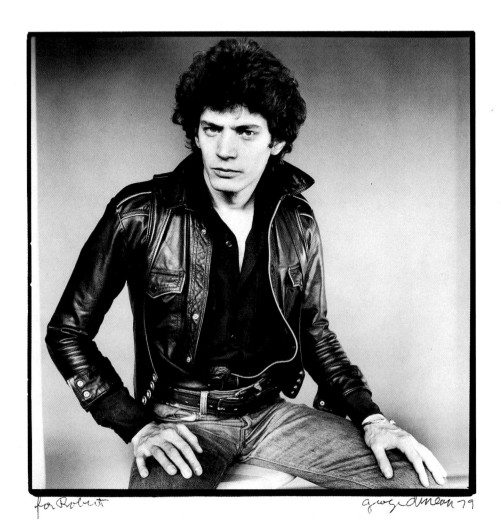

for Robert

george dureau 79

A 1979 portrait of Robert Mapplethorpe by acclaimed New Orleans photographer George Dureau, long acknowledged as Mapplethorpe's mentor. Like Mapplethorpe, Dureau is an artist and photographer.

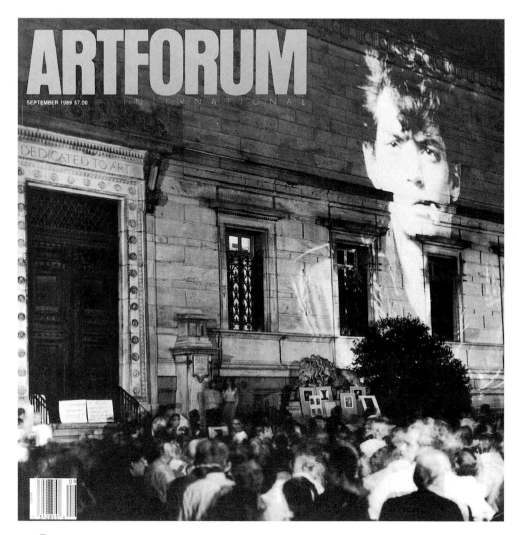

The cover of ARTFORUM magazine, showing protestors projecting Mapplethorpe photo onto the wall of the Corcoran Gallery, Washington, D.C., after Senator Jesse Helms' (R.–North Carolina) attack had closed the exhibit.

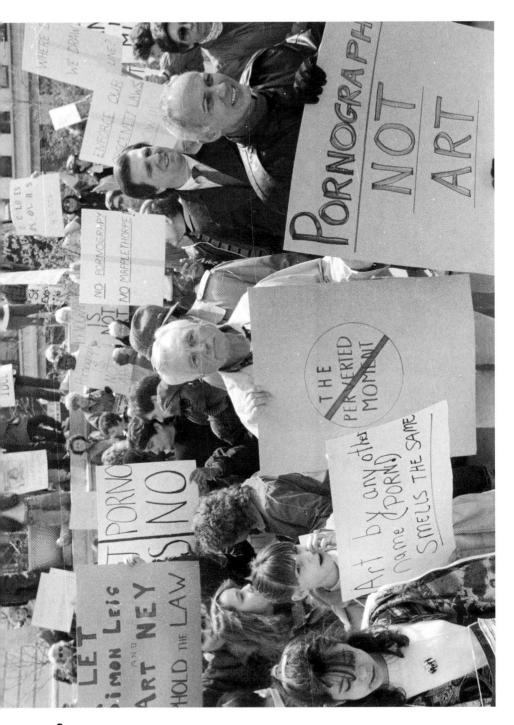

On April 6, 1990, hundreds of people protested against the scheduled Mapplethorpe exhibit at the Contemporary Arts Museum in Cincinnati, Ohio, where the celebrated censorship trial was convened. (AP/Wide World Photo).

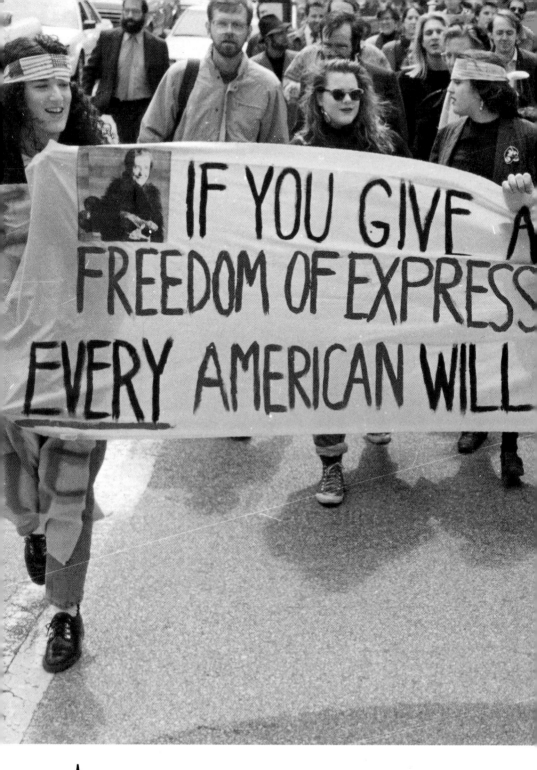

IF YOU GIVE A
FREEDOM OF EXPRESS
EVERY AMERICAN WILL

A march by counter-demonstrators in Cincinnati—who favored opening the Mapplethorpe exhibit—demanding freedom of expression for artists. The museum won the censorship trial and the exhibit was opened. (AP/Wide World Photo).

(FACING PAGE) Exhibition staff workers Scott Blum (l.) and Vincent
Marasa (r.) hang Mapplethorpe photos on the walls of the Cincinnati
museum after the biggest censorship trial in recent history. (AP/Wide
World Photo).

(THIS PAGE) Other staff workers prepare to hang additional
Mapplethorpe photos on the Cincinnati museum walls. Senator Helm's
denouncement of Mapplethorpe created a chain reaction of fear.
(AP/Wide World Photo).

Quentin Crisp Dishes With Miss Manners

THE ADVOCATE

$2.95
$3.95 CAN.
£2.95 U.K.
/ 8.90 NETH.

DECEMBER 18, 1990 • THE NATIONAL GAY AND LESBIAN NEWSMAGAZINE • ISSUE 566

WOMAN MAN

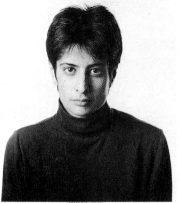

URVASHI VAID

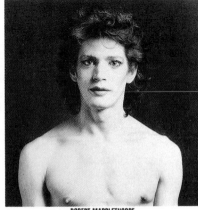

ROBERT MAPPLETHORPE

OF THE YEAR

▼ Vito Russo Remembered
▼ Moscow Activists on Gay *Glasnost*
▼ ACT UP Split Up

Fab Fashion Supplement

The *Advocate,* the national gay and lesbian magazine, proclaimed Mapplethorpe "The Man of the Year" in its December 18, 1990 issue, despite the fact that Mapplethorpe had died eighteen months earlier.

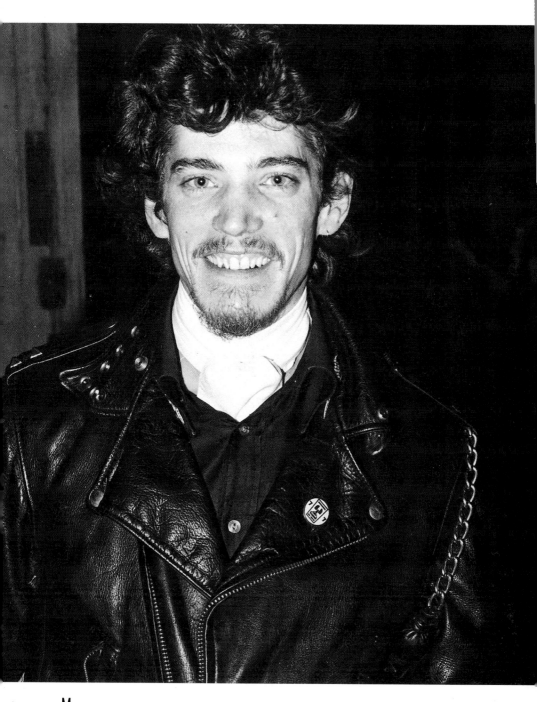

Mapplethorpe's self-portraits were a fiction. In this 1979 candid photograph by Rink, Mapplethorpe drops his mask to reveal the *joie de vivre* that made him so charming and engaging to his friends.

(L-R), British poet Thom Gunn, winner of numerous awards, including the MacArthur Foundation "genius" grant, standing with Mapplethorpe, center, and photographer Crawford Barton. (©1990, Robert Puzan).

Crawford Barton's famous photograph *The Kiss on Castro* caught *the perfect moment* in 1975, when gay and straight cultures co-existed. Barton, 50, died of AIDS on June 12, 1993.

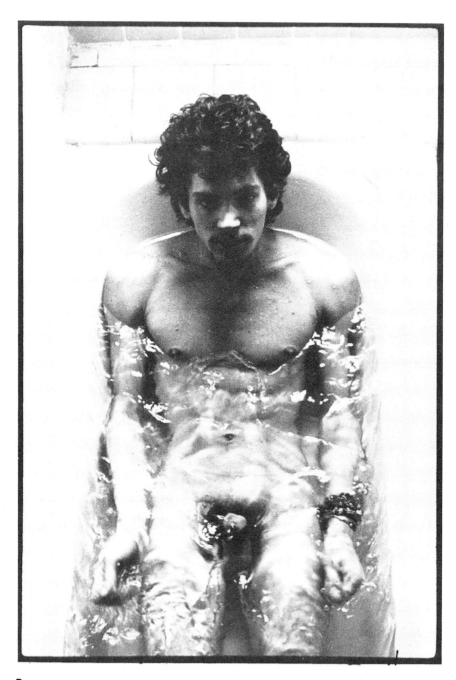

Photographer Don Herron created his *Bath Series* in the '70s to relax celebrities. It was Herron's symbolic homage to rock star Jim Morrison, who died in a bathtub in Paris. Here is Mapplethorpe in tub.

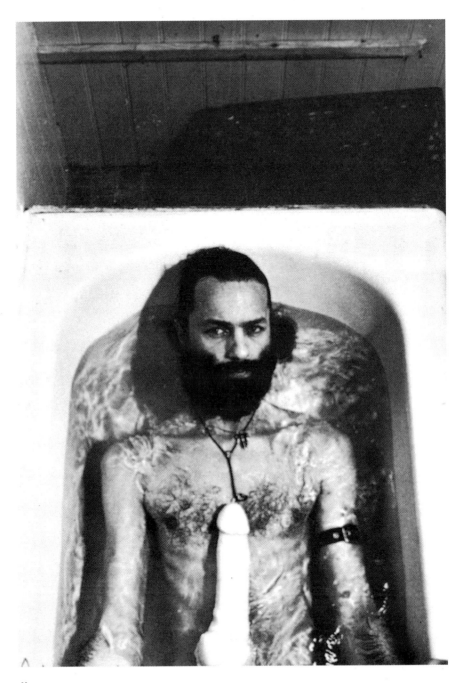

Herron photographed Robert Opel in 1979 behind Opel's Fey Way Gallery in San Francisco. Opel is the man who streaked at the Academy Awards in 1974. He was gunned down in the gallery in 1979.

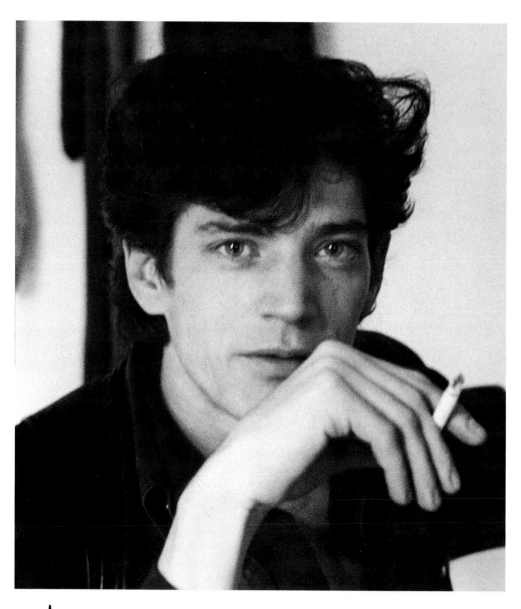

Always ready for a close-up, Mapplethorpe relished how the camera created instant entree into history. He was conscious of the genre of the *celebrity photograph*. (Photo by then *Advocate* editor Mark Thompson).

The 1983 portrait is Warhol's image of Mapplethorpe that was auctioned at Christie's. It could easily illustrate Mapplethorpe's panel in the AIDS Quilt in The Names Project, Block #1233. (AP/Wide World Photos).

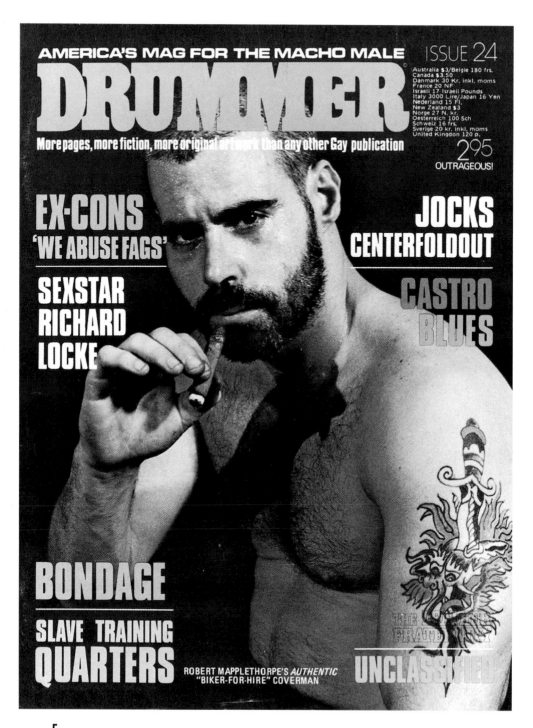

Fritscher commissioned Mapplethorpe's first magazine cover in color, which Fritscher designed with a high-concept sketch for the artist to follow. It appeared September 1978 in *Drummer* magazine, Issue 24.

Perhaps that super-facies self-portrait, which the gaystream wrongly embraces as a drag shot, is actually satire of cosmeticized women, and, always in the spinning Mapplethorpe, of drag queens who figured so prominently in the wares of his mentor/tormentor, Andy Warhol. A satiric gloss fits with his constant mythological gloss in his other self-portraits.

The Mapplethorpe autopix are not true confessionals; they are sold for amusement purposes only.

Robert's nearest autobiographical record of androgyny looks so masklike that its very failure to penetrate the secrets of the female gives clue to why his photographs of women, other than Patti, seem rarely to penetrate the surface of their feminine mystique. When it came to the real sexuality of women, Robert really hadn't a clue beyond the takes of fashion or the iconography of religion or art history.

He was typically gay. Gay men, despite popular folklore, know no more about women than do straight men. If women disappeared, gay men would never notice. Gay men, who aren't interested in pussy, only pretend to bond with straight women through fashion and sensitivity. It's a clever way to be available when the women's husbands inevitably want to take a walk on the wild side.

Yet Mapplethorpe could catch beauty, in his style, in his take, within his capacity, like no one else. In his photographs of women, he tenders his females with the same narcissism he offers in his self-portraits. Narcissism, after all, knows no gender. Narcissism is the main theme of pop culture, capitalism's consumerism, and advertising.

His photographs in *Some Women* are studies in the control of the beautiful surface.

How civilized!

Some issue-driven women don't like his photographs of women. That's a measure of something and, though it may say more about the fad of "correct politics" than it does about Robert, they think real attention must be paid them.

Go figure!

The photographs are a male's interpretation, and most of the women seem ornamental, if not downright vulnerable, except for that sexuous Sarah Bernhardt, the lippy Sandra Bernhard.

Some Women, after all, is carefully titled.

Robert knew the limitations of what he was doing.

These photographs are not the enigma of Everywoman.

These are some women, not all women, certainly, not even particularly representative women. They are mostly famous women, many of them performers. They know how to give face to a camera, how to interact with a lens.

Robert did not create photographs of women for men to consume. Mapplethorpe shot women for an audience of women. And gay men. His fine art photographs and his celebrity portraits grow out of his seminal interest in fashion photography, whose audience is women and gay men. The photographs are technically exquisite, but strangely aloof, some kinky but not sadomasochistic, and a bit off-center: women are arranged, perhaps like flowers, sectioned off in body parts, framed by the lens, passive, pensive, eyes very often closed. Others are reacting rather than acting, some are, by their choice, vulnerably nude, some wearing jewelry or restrictive clothing that carries a bondage subtext.

The *Some Women* cover shot of Lucy Ferry at first looks like Lucy Ferry resting her head in her hands, which seem like flowers. Studying the portrait, one sees the trickster photographer at work. The image reads as if a pair of hands, Lucy's, or other than Lucy's, cuffed with bracelets, are holding up a disembodied head, the face and hair perfectly groomed, not a death mask, but a mask to be worn in life.

A cover shot is always a signature shot.

A book can be read by its cover.

If so, then masks, not faces, are the subject matter of *Some Women*, even in the unmasked Yoko Ono.

Pop art faces are generally blank.

Pain, Emily Dickinson diagnosed, has an element of blank.

Some of his women seem to exhibit suffering.

A kind of suffering different from the self-conscious suffering of the men in the leather S&M photographs. Robert examines this quality of female blankness.

Aloof women do not promise sexuality.

Jacqueline Bouvier's father took one look at her college graduation photographs and told her to schedule a second sitting. He reportedly told her, "You look too available."

As late as the sixties, middle-class Americans did not show their teeth in formal photographs.

Yoko, years before, had been photographed nude with Lennon, to much controversy. In Mapplethorpe's photograph, she appears stylishly

dressed and coiffed, but an ineffable look of can't-get-no-satisfaction reminds the viewer that she was the most controversial woman in rock 'n' roll, a nowhere-man artiste, who looks up, with inscrutable privacy, at Robert.

Like Mapplethorpe, Yoko Ono has been accused of social climbing. What Asian mask does she present to Mapplethorpe? It's more than the continuing grief of the second most famous widow in the world.

Something there is about some women's eyes, those windows of the soul, that imprint the presence of Mapplethorpe's camera.

His studio lights reflected in the pupils of most close-ups are so distractingly apparent, the photographer, who was an expert technician, must be telling the viewer something about the complicity of the subject with the photographer in the high crime of art.

Is Robert himself reflected in those pupils the way Hitchcock walked through his own films?

Is it simply studio lighting, because it appears only in the studio shots?

Robert liked speedy drugs. Robert liked speedy shoots. He had little time for most people. He had a little spiel about his edgy attitude about shooting portraits on assignment:

"Just climb into the automatic photo booth, darling. Pull the curtain closed. Sit on the bench. Deposit your quarters in the slot. The machine will flash four times and you'll have your poses on one strip, they'll come out that dispenser there, in three minutes flat, be careful, they'll still be slightly wet, and you and all your girlfriends can stand around and giggle."

Some things, when heard, are remembered virtually intact.

Robert's celebrity photographs of some women, excepting Susan Sarandon and several others, seem distant, disconnected, even cynical. Sarandon, rising *déshabillé*, clutches the bed sheets, and casts a powerful look.

His work with Lisa Lyon, however, connects on the level of two artists working professionally at creating content and form, working at creating commercial art.

His work with children is simply portraiture.

However, the shot of the little girl with genitals exposed as she lifts her little dress seems to reference, not pornography, but a little Cupid by Leonardo.

His photographs of Patti are excruciatingly personal studies, from the early drug-waif portraits to the wraithly romantic 1988 portraits in *Some Women*.

At the end of Robert's life, Patti becomes the Madonna, the Pietà, matured in Robert's Roman Catholic vision, the woman, the survivor, the lover, the might-have-been wife, the soon-to-be widow, his suffering mirrored in her sorrowful mature face.

By 1988, nearing the end, both of them knowing that any shoot could be his last, Robert captured the face of the woman he loved as if she were Mrs. Robert Mapplethorpe: woman, artist, artist's wife.

Her face in those final photographs matches Robert's final signature self-portrait, his *éminence grise*, holding the staff of life capped with Death's skull. These very personal photographs offer two more faces of AIDS— the person with AIDS and the grief of the survivor.

When a second Robert Mapplethorpe panel for the AIDS quilt is sewn, it should exhibit, side by side, with no more words than MAPPLETHORPE-SMITH, the last photographs of these two people, man and woman, who had so long been friends together.

His women, his portraits of women, represent women as seen by a male, as seen by a New Yorker, as seen by Mapplethorpe.

Basically, the Mapplethorpe women are to womanhood what New York City is to America in the famous *New Yorker* cartoon by Saul Steinberg, in which the nation outside of New York shrinks away inconsequentially from the self-pumped Manhattan perspective.

GAY ARTISTS AND THE STRAIGHT WOMEN WHO LOVE THEM

Women, not their husbands, whom they tow through galleries, are the true patrons of art. In American popular culture, one proto-typical mixed-gender couple is the straight woman and the gay male artist. Has anyone yet sighted a straight man and a lesbian artist? For the women, the gay male artist often serves as surrogate partner who may also be a walker or a sitter. Walkers are men who accompany women to events requiring an escort. Sitters are men who literally sit with women who are broken-hearted or ailing or elderly. Ideally, neither exploits the other in the symbiosis.

The gay artist with his female patron, the gay photographer with his female model, the gay film star actor with his contracted wife, the gay bodybuilder with his blonde bimbette, the gay pro athlete with his perpetual fiancée, the gay Hell's Angel with his old lady, the gay business broker with his debutante, all kneel to the significance of the appearance, not the reality, of seeming to be a heterosexual couple. In the agreed-upon mendacity of American culture, the appearance of heterosexuality is good for business and keeps the tabloids at bay.

Does that say everything one needs to know about Mr. X and his fabulous wife, Charade X?

No matter what Patti Smith's real relationship was to Robert Mapplethorpe, some people would wish her to be at least symbol, if not fact, of his "latent heterosexuality."

Heterosexuals commonly entertain the illusion that homosexuals given world enough and time will eventually turn to heterosexuality.

In actual fact, the reverse is true. As I stated quite clearly as a guest on *The Oprah Winfrey Show*, on January 28, 1993, it is heterosexuals,

particularly women's husbands, who turn to homosexuality for recreational sex. "I like having sex with you," a husband told me, "because you're a man. If I had sex with a woman, that'd be unfaithful to my wife. I love my wife and my kids. And I know I can't fall in love with another man."

Yeah.

Right.

Straight people want to believe the utterly wild scenario that if Robert Mapplethorpe had lived longer, he would have come to his senses after his misspent youth, married Patti (thus redeeming them both from sex, drugs, and rock 'n' roll), and fathered a bevy of little Mapplethorpes.

AMERICAN FACT: No matter what you are in reality, give the public what they want in appearance. Convicted criminals appear to find Jesus. Murderous wives appear to be victims. Gays appear to be straight. What happens in reality in private no one cares about. What happens in appearance in public matters. The dysfunctional family must appear religious at church.

Some straight people want the gay Mapplethorpe to appear to be at least a closet heterosexual.

It would be so much better for business if his life and his work were, uh, acceptably straightened out.

In the public hetero imagination, Robert Mapplethorpe is fantasized to be secretly in love with Patti Smith.

Patti, likewise, in the hetero Hollywood version, becomes the romantic chanteuse manufactured as the artist's love interest to cancel out his homosexuality by intimating that his tortured creativity was fueled by heterosex longing.

The plot thickens when Mapplethorpe model Lisa Lyon is cast as "the other woman" who comes between Mapplethorpe and Smith.

The American pop culture of sex often grasps at straws with disastrously destructive results to sexuality.

If the appearance can be created that Mapplethorpe was straight, then his homosexuality (meaning, all homosexuality) stays as invisible as Ralph Ellison's invisible blacks in *Invisible Man*.

Actually, Robert Mapplethorpe never ever indicated to me in any way that his relationship with Patti Smith was anything but platonic friends who respected one another as persons and artists sometimes working together. Period.

Nevertheless, because Robert's homosexuality is central to his art and to his controversy, people always ask, "What about Patti?"

Only Patti Smith, the private person, can answer that question about Patti Smith, the public person. No matter the heterosexual speculation, and no matter what some women eventually confess about their relationship to Robert Mapplethorpe, the bottom line was, and is, and will never change: Robert Mapplethorpe was a man's man.

He was shy, he was sensitive, he was an artist; but so were we all. He was afraid of us, afraid of sexual-outlaw men; but he was terminally fascinated. He took drugs to get up the courage of his perversion, because he wanted to enter our sexual, rugged, dark fraternity. He saw in our wild leather style of domination and submission the classic Greco-Roman masculinity he so wanted to infuse in his life and work. His first collage work featured muscular hustlers. Then he met those of us who could give him the rites and rituals for which he so hungrily lusted.

That's truth.

I had love and sex and relations with Robert Mapplethorpe, whose death made me a kind of unclassifiable widower.

But that's not Hollywood.

That won't play in Peoria. My hometown.

So, driven by the hetero needs of hetero pop culture, and because of the psychological drama of the made-for-TV movie, *The Perfect Moment: The Robert Mapplethorpe Story*, I have always deduced a role for Patti Smith in which I cast her as Robert Mapplethorpe's Symbolic Significant Other.

Robert Mapplethorpe loved women with the purity, the courtly love, that only a masculine-identified gay man can bring to the feminine mystique, which he so honored in his resplendent photographs of women.

FIRST BLUSH: HOLLY SOLOMON DISCOVERS ROBERT MAPPLETHORPE

olly Solomon is the person who shifted Robert Mapplethorpe's world on its axis.

In 1977, the Holly Solomon Gallery launched Robert Mapplethorpe in his first two distinguishing solo shows: "Flowers" and "Portraits." Within months, Holly Solomon presented Robert in the group exhibit "Surrogates/Self-portraits." In 1978, the Holly Solomon Gallery presented Robert in "The New York Boat Show." That same year, 1978, Robert's work, christened by Holly Solomon, first appeared in the Corcoran Gallery of Art, Washington, D.C. This was also the first gallery to cancel his work, in July 1989, due to the pressures of some U.S. senators and some religionists. In 1978, Robert was among ninety-five photographers invited to show his work in the landmark exhibition "Mirrors and Windows: Photography 1960 to the Present," at the Museum of Modern Art. "Mirrors and Windows" was conceptualized by John Szarkowski, director of the MOMA's Department of Photography. Holly Solomon had accomplished the prestigious launch on the course she set for Robert Mapplethorpe.

JACK FRITSCHER: In the beginning, at the creation of Mapplethorpe, you were there, as was I, silent witnesses, unknown to each other and kept separate by Robert, who excelled at keeping his various friends apart. Now that he's dead, my task is to restore the person who was Robert Mapplethorpe. It is very much a detective story, as all of us who knew him come out of our sadness to memorialize the living, breathing Robert, who could fuck you over or not with his shy smile that made him an expert at always getting what he wanted.

HOLLY SOLOMON: I met him about the same time you met him. Suddenly, he was in my life. Just as suddenly he was gone. Ours was one of those 1970s art encounters. I was showing the photographs of Eddie Shoustek, who recommended that I meet Robert and see his work. Immediately, when I looked at his portfolio, I had two major responses. First, I was absolutely convinced that Robert was an artist. Second, and this is a very important distinction, I understood that Robert was not only a photographer; Robert was an artist who was a photographer.

I studied his other work. His collages. His frames. He had the passion of a daring young man. Also, I was taken by, and felt very deeply about, that very young Robert's conviction that photography should be taken seriously as a fine art. He was as eager as an evangelist about this new way to consider photography.

Remember, that as late as the mid-seventies, photographs as an art form were collected by enthusiasts who put them in little plastic envelopes and stashed them away in drawers.

Before 1980, photography was considered a dubious art. Photography was hardly felt to deserve the full power of exhibition reserved for art.

JACK: And there stood Robert Mapplethorpe at the Gates of Art.

HOLLY: Precisely. I felt Robert's evangelism was his very clever presentation of photographs in elegant, even over-elegant, frames that positioned the photographic work with aesthetic power.

Other photographers, of course, had presented their work as art, but Robert was determined to legitimize the camera through a kind of aesthetic assault on the art establishment.

Robert thought gallery owners, critics, collectors, were not as avant-garde as they thought, precisely because they had overlooked photography as a legitimate art form. I appreciated his evangelism. And, oh, he was charming, warm and gentle. He was a very nice companion. I enjoyed my relationship with Robert. It was a short and very happy collaboration.

JACK: Weren't you the first art professional to promote him?

HOLLY: Yes. I believe we met in 1976.

JACK: That year, Robert appeared at your gallery in a group show titled, "Animals." He so wanted in that exhibition that he photographed a dog, *Dalmatian*.

HOLLY: After that group show, I did two solo shows of Robert. Both were distinctly one-artist exhibitions in 1977. One was called "Flowers." The other was "Portraits." I remember those two shows were really tough going.

JACK: Why? The critics? The public? Robert?

HOLLY: Listen, in the mid-seventies, to get any kind of uptown audience downtown to SoHo was extremely difficult.

JACK: SoHo, I remember from my experience, was first pioneered by gay guys who found they could rent a loft more cheaply than a Village apartment. That kind of gentrification by gays, some of whom were artists, opened the door to other artists and the first galleries.

HOLLY: First galleries. Yes. Remember when most people wouldn't cross Fifty-seventh Street to come downtown? I was downtown by 1976, and established by 1977. I had been showing Bill Wegman. Billy was at the gallery. I had other artists who, like Robert, were artists working with photographs. So as people came to look at their work, I'd say to them about Robert, "I've got this other young artist. You have to see his work."

In that way, I was instrumental in getting Robert into "Documenta 6" at the Museum Firdericianum in 1977. I remember flying over to West Germany to personally help the curator hang the goddamned show. I thought: *I'm not going to go all the way to Kassel, West Germany, and not see Robert hung*. "Documenta 6" was Robert's first kind of real breakthrough. He was very happy. He was in Europe and his photographs were on exhibition.

Then we all went to Basel, Switzerland. I remember we had William Wegman, his wife, and the dog, and Robert. We were quite an entourage arriving in Basel. The artist, his wife, their dog, and the photographer. So that was my objective in 1977. I was trying to introduce Robert as an artist, and not just a photographer.

JACK: Your concept clarifies quite a bit. In order to explain an artist working with photography, you had to educate people that photography was not the bastard child of painting.

HOLLY: Well, we really tried. All of us together. I had known Sam Wagstaff before either of us knew Robert, and Sam had met Robert before I did.

JACK: Sam had met Robert very early in the 1970s. Actually, film footage exists, much like the footage of the very young Bill Clinton meeting President Kennedy in the Rose Garden, of Sam Wagstaff introducing Robert as a rising star to the collector Robert Scull in 1973.

HOLLY: Sam was the great curatorial person who helped photography achieve its identity as art. Sam really loved Robert. He adored Robert's work, and he adored Robert. He helped Robert wherever possible, but he was sophisticated enough to Robert's career needs to take a backseat role once I began dealing with Robert in the gallery.

JACK: What was Robert like when you were with him on his first trip to Basel? Now that he's dead, people want to know what he was like behind the face he shows in his self-portraits.

HOLLY: He already had many European friends, people he had met in New York. Sam was very connected. And Robert was so charming. He really was an extremely sweet human being. Everyone liked him. I remember once we went out to dinner. I'll never forget that he was trying to convince me that I had to wear leather.

"Holly," Robert said, "you've got to try leather."

"Robert, I hate leather. It's cold in the winter, and hot in the summer. Forget it!"

"Oh, no!" Robert said. "You'll look perfectly beautiful in leather."

JACK: He liked his women in leather.

HOLLY: Oh yes. Really, I admired him very much for adoring Patti. I'll never forget how he once dragged me to this concert somewhere the hell

outside of New York. He was very proud of her. He cared very much for her. I was very proud in retrospect because I thought that we were two people whom he really loved, and who really meant something to him. The way he took Patti's photograph and mine was just different than anybody else.

JACK: I love the photos of you. The triptych Robert shot in 1976. Each of the three frames reveals more of you. Like time lapse of a flower.

HOLLY: I treasure it.

JACK: It's wonderful.

HOLLY: That portrait series was pivotal. He wanted to join my gallery. I wanted to see him work, not an audition of his talent so much as of that charismatic ingredient very necessary to a photographer: how the photographer deals with people. How he can manipulate the poser. So, I said to Robert, "Okay, kid, I'm going to try you out. Before I take you on in my gallery, you can do my portrait, and I'm going to pay you."

I didn't tell him why I particularly wanted to see him work shooting my portrait. I really wanted to know how he dealt with people he was photographing, because the one thing that I thought I could do was get him commissions for portraits.

So I sat for him. He worked so easy, and he made you feel so comfortable.

JACK: When I sat for him, he worked effortlessly; he seemed to do nothing while creating everything.

HOLLY: He had an extraordinary gift for working with people. I was an actress in earlier years. Andy wanted me to play the part in *Lonesome Cowboys* that he finally gave to Viva. I told Andy, "I'm not going to Phoenix with Joe Dallesandro and your group, dear." If he had shot it in New York, I might have done the movie. I was just taking care of myself. As an actress, I had worked with absolutely horrible photographers who were not artists. Every job was "dear," "honey," "babe." They made you feel lower than a prostitute. Robert was the soul of respect and charm—

and not above using cunning when it was for someone's own good. I think Robert never abused the trust of anyone whom he photographed.

JACK: Thank you. I've spent a lot of years on the West Coast defending Robert's personality. He was no saint, but he was no villain either. He was as charming as he was cunning, and he was very good at dismissing people who became tedious.

HOLLY: Robert and I always had so much patience with each other. And sometimes I needed it. Especially early on. Right at the first, right in the middle of the first show I gave for him, he came into my gallery, polite, friendly, businesslike, but very sweet, like a real mensch, which I've always respected. And he said he wanted to move his show away from my gallery up to the Robert Miller Gallery.

That was very tragic for me. An artistic loss. My mother had just died. A personal loss. It was a trying time. Anyway, I said to him, "Robert, I respect your decision. I wish you had waited till after the show to leave." I told him frankly it was quite rash to leave in the middle of a show. But, and this was my advice to him, I said, "It's your career. I think it's a stupid move, because you could have asked for and gotten the best of both worlds."

JACK: Which was Holly Solomon downtown, and Robert Miller uptown.

HOLLY: Yes. I tried to tell him about gathering power to himself.

JACK: Maybe he felt more comfortable uptown.

HOLLY: I think he felt more at home and at ease in the Robert Miller Gallery—for reasons I don't wish to be quoted.

JACK: Ambitions, rivalries, sexual preference. Anyone can fill in the blanks after the fact without incriminating anyone.

HOLLY: Nevertheless, I continued to support his work, even though neither Robert nor the subsequent galleries ever gave me any credit for showing him first.

JACK: Art politics is like politics in every area. The San Francisco gallery

owner Robert Opel, who showed Mapplethorpe in 1979, was also over-looked. His Fey Way Gallery exhibitions of Mapplethorpe I've never seen listed anywhere. In fact, none of my published writing on Robert has been noted in any of the bibliographies. At least, you were finally mentioned in the acknowledgments in the Whitney book, *Robert Mapplethorpe*. The critic Edward Lucie-Smith, who was also around Robert from the first, has always said that in England, you are known as the woman who was so very important to Mapplethorpe's early career.

HOLLY: Well, I had hoped to be.

JACK: But after the first burst of Mapplethorpe, after you had given him confidence and credibility . . .

HOLLY: He bid me farewell, and he presented me with his self-portrait with the whip up his rectum. To put it mildly, I kind of gasped.

JACK: This was his parting gift?

HOLLY: Let's say I knew there was a message.

JACK: Maybe about him acting like an asshole.

HOLLY: But I understood that he meant me no insult. My former husband took one look at it and said, "Tear it up." I said, "No, no. Someday I'll sell it for an awful lot."

JACK: Robert was very clever about giving photographs to special friends. Sort of repaying people for their help. He was generous to me, but I know he was generally most stingy at giving out prints of his pictures.

HOLLY: After he left my gallery in 1977, Robert really never talked to me.

JACK: Don't feel bad. Around 1983, Robert started dropping lots of people. By 1984, he was not remembered fondly in San Francisco. People resented being dropped. By 1985, he had closed his circle down to a Manhattan few. My relationship to him by that time was only by telephone and usually he made the calls when he was traveling and lonely. He had

suspected for at least three years that he had HIV. He didn't see how he could have been anything but infected. By 1986, when his diagnosis was rather public knowledge, he had retreated into himself and his work in the way so typical of artists with AIDS. Our mutual friend, the San Francisco photographer Crawford Barton, who died in 1993, had told me that his diagnosis had pushed him into a veritable orgy of productive work.

HOLLY: When Robert became extremely ill, I wrote him a letter. Robert sent word back indirectly through a mutual friend in San Francisco who said, "Holly, please, Robert would like to meet you for dinner." I said, "Of course." So after all those years, I had dinner with Robert. It was very sad. Actually, it was quite appalling.

JACK: Was that in 1989, before his last illness?

HOLLY: I forget the actual date. It was before his Retrospective. Maybe 1987. At dinner, he made me promise I would go to the Retrospective. He looked so sick. But we just giggled and laughed as if we'd been in constant touch for the last ten years. That night, I think, Robert thought I was terribly funny. Few people understand that an elongated death by AIDS is stressful. We laughed and giggled, but, of course, my heart was heavy. That's how we made up, and, after that dinner, every time we saw each other, it was "Hello" with big hugs and kisses.

Of course, I did go to his Whitney Retrospective in 1988. Dear Robert! He was so sick. When I went over to congratulate and kiss him, he said to me, "Holly, this is my retribution for leaving you." He was seated in a wheelchair. "This is my retribution," he said, "to be sitting here looking at your portrait all night."

Robert had actually stationed himself in his chair in front of the portrait of me. It was the one I had hired him to shoot, so I could see how he worked before I knew what he could do.

With that, I really wanted to cry.

I said, "No, Robert, there's no need for retribution. I'm so proud of you."

And that was the last time I saw him.

JACK: What a scene that opening at the Whitney was! And what a tableau. You with the honored, dying artist staring at your portrait.

HOLLY: Of course, I'm still very proud of him. And protective of his work. I am instrumental in correcting the marketplace about his work. I do have a gallery. I do promote art. After Robert died, I called up a particular auction house that had advertised an original Mapplethorpe in a beautiful original Mapplethorpe frame. The price quoted to me was two thousand dollars.

I said, "You really have got to be joking."

They said, "No, no. Two thousand dollars. That's what they sell for. Not a penny less."

So I bought it, and in three days I called the manager at the auction house and said, "You really should get your figures and facts straight." I took pains to explain that a Mapplethorpe was not just a photograph, that they were not estimating the value of a photograph, that it was one of a kind. Done in the original frame.

"Oh yes, yes," I was told.

"Oh, my yes," I said. "You guys made quite a big mistake. I just sold your not-a-penny-less photograph for forty thousand dollars."

JACK: I'm not surprised. Nobody knew that Robert would get his fifteen minutes of fame after he died. Immediately after Robert died, when I first approached magazines with my "Pentimento" feature article, even Manhattan magazines didn't know who he was, or didn't think he was important enough to memorialize. You understood him. I understood him. But so many people just didn't get it.

HOLLY: Robert was very ambitious, and he loved money more than anything. I once said to him, when we were talking about his health, "Robert, you're not going to die. You love money too much."

JACK: Money can keep you young. It can keep you alive. It can keep you moist.

HOLLY: We joked about money a lot. But money was no joke to Robert. Not really. Money was his way up and out of the working class.

JACK: At the beginning, did you meet his family?

HOLLY: I met his mom and dad. He was very gracious and courtly to his mother and father.

JACK: He sometimes spoke to me about his younger brother, Ed, because my only sister, whom Robert had met, was about the same age.

HOLLY: His parents were working class, and that was good because most artists come from the working class. Great artists rarely come from the upper classes. His folks were very Irish-looking to me. Robert and I both tried to make them feel at ease.

JACK: It's not easy for parents when a child turns out to be an artist.

HOLLY: They were so very proud of their son.

JACK: That was then—at Robert's first show. After the Helms and NEA scandal, Robert's father was quoted in *Newsweek* saying he wouldn't want any of those photographs hanging around his living room.

HOLLY: I realized from the start that Robert considered it very important to be extremely social. More so than most people.

JACK: Art let him move in a richer crowd.

HOLLY: He was suddenly with the class he aspired to become.

JACK: Art and money gave him social mobility out of his blue-collar Irish background.

HOLLY: Exactly. I understood immediately why he loved all these social beings. He did. He loved royalty.

JACK: One morning, his phone woke us up in bed. He rolled over and said, "Ah, *principessa!*" I said, "Robert, stop it!" He could be so vulgar about royalty. He was in his glory.

HOLLY: I actually told him once, "Robert we are a democracy." I really did. But beyond the patronage of royalty, it's very important for artists to support each other's work. In Robert's case, when I took him into my gallery, everyone in my gallery helped to support his work.

JACK: What made him attractive to them at the start? Was it just because he was good-looking? Or was it that he was doing his Liza Minnelli number from *Cabaret*: "Divine decadence, darling!"

HOLLY: Robert worked all those angles, but my artists simply thought he was a good photographer. Plus, he was this photoevangelist daring people to pay serious attention to photographs as art objects. Also, and I don't blush to say it, I showed his work to every single curator I knew.

JACK: And weren't you also responsible for guiding Robert into fashion photography?

HOLLY: I had a few friends who were fashion designers. I said to Robert, "Come on, try this too. Try every venue you can." He did. He was very open and cooperative. He had his own mind but he took suggestion well.

JACK: So you truly introduced him to the genre of fashion photography.

HOLLY: Yes, I did. I worked very hard for Robert. And I continue to do so.

JACK: He was so personal with me that I wonder, was he very personal with you?

HOLLY: I can remember we went to Broadway once. To go to the movies. And we found ourselves standing outside a dirty-book store.

JACK: Of course! One of those Forty-second Street "libraries" where he got that exhilarated feeling of looking at forbidden sex!

HOLLY: I knew he'd gotten his collage materials there.

JACK: That's where he first read my work and decided we had to meet.

HOLLY: We stood outside the adult bookstore. He kind of looked at me funny.

I said, "Robert, what the hell's wrong with you?"

He laughed. "Oh, come on, Holly," he said. "You don't want to go in there."

"Yes, Robert, I do. I want to go inside and see for myself."

He turned beet red. He thought I was kind of a dummy, but his protectiveness was kind of sweet, you know, because I'm old enough to be his mother.

JACK: Were there magazines or sex objects in the store?

HOLLY: Objects and magazines. We walked around looking at everything. He was a little embarrassed. I wasn't at all. I was genuinely interested in how people used that stuff. It was like a scientific/anthropological expedition. I laugh when I remember how Robert turned beet red.

JACK: Call the *National Enquirer*. "Mapplethorpe Blushes in Dildo Store."

HOLLY: Robert so enjoyed shock value.

JACK: I recently showed a woman friend Robert's photographs. I asked her if she found his work shocking, and she said, "No. The only thing I find shocking about these photographs is that I've never seen them before."

HOLLY: So true. Censorship is shocking. Robert showed me everything. I respected him the more for that. And, to tell the truth, during the trial in Ohio, I hung one of his accused "dirty" photographs in my gallery when I was having a summer group show.

Bill Wegman was about to open a show at the Taft Museum, and the curator asked me about the wisdom of opening Bill's show in such a censorious climate. I felt it very important to open Bill's show. I am against that kind of censorship. I was very instrumental in getting the American

Dealers Association to write a letter publicly in support of Robert's show. I called up the ADA and insisted that a letter be written right away against any kind of censorship. I will always defend Robert's work. Even past his death.

And, oh, it's so very sad to think that he's gone.

JACK: I know. The work lives, but he's gone. We can celebrate the work. That's why I appreciate your telling me that Robert blushed. It's like a nuclear flash. Most people don't think that Robert Mapplethorpe would blush at anything.

HOLLY: Robert blushed quite often. Actually, I must say, my humor with him often made him blush.

JACK: You were close to Andy Warhol as well as to Robert.

HOLLY: Andy was always very instrumental in my professional life. But both men, Andy and Robert, kept me out of the personal part of their lives. Of course, I kept them out of mine. One should. Andy and Robert treated me like some madonna. I was never expected to participate in their sex lives or drug lives. They both gave me the highest respect.

JACK: Do you find that's basically a statement about Robert's relationship to women?

HOLLY: Yes. I think so. Robert was keen about people and quite sensitive about women.

JACK: And Patti?

HOLLY: I must say, I felt Robert really loved Patti. I mean *really*. Robert and Patti were both tolerant of my way of life as I was of theirs. But I don't presume to know what their relationship actually was. He really loved her. I don't know if they had sex or not, nor do I care, but he loved her.

JACK: Patti was his constant subject from his first photographs to the last.

HOLLY: I feel every person's sexuality is personal to them. Everyone

should have freedom of action as long as they don't hurt anyone. What Robert enjoyed sexually, you may know, but I don't. He liked leather. That means something. And he had declared himself a homosexual. That's such a big relief. The worst are the closet people. Robert, I will attest from the very personal way he treated me with respect, was always most gracious to women. Women loved him.

JACK: If the women got a fair shake, then what about the men in the leather photographs?

HOLLY: I admired Robert's amazing talent in trying to make everyone as beautiful as they possibly could be. He never put a back-handed spin on his subjects the way some photographers really try to make people look as ugly as possible. He wasn't mean or nasty in that way at all.

JACK: For history's sake, to whom did you make Robert's first significant sale?

HOLLY: Barbara and Eugene Schwarz were the first people to buy one of Robert's photographs. They bought his 1976 portrait of Arnold Schwarzenegger. Eugene had thought to put together a photography collection in the face of the great dichotomy: either a person collected photography or collected art.

JACK: Enter Holly Solomon.

HOLLY: Indeed. I carried his work into the gallery and hung it on the wall. I wanted to create a market for the concept Robert Mapplethorpe brought to me in his evangelical zeal to canonize photographs as art.

ROBERT OPLETHORPE: STREAKING THE ACADEMY AWARDS

Robert Mapplethorpe
+ Robert Opel
=Robert Oplethorpe

In the Sodom–Oz mecca of San Francisco, the Fey Way Gallery, invented by Robert Opel, opened its arty-party doors in March 1979, at 1287 Howard Street to an SRO crowd. Leather and art combusted in the high-octane vapor of the seventies. Owner Robert Opel had a knack: right person, right place, right time. Five years before opening Fey Way, Robert Opel created a standard for performance art that in the extremis of the 1970s was rarely equaled. He was the man who streaked the 1974 Academy Awards. A billion people, live, around the globe, were shocked by the most naked man in the whole wide world.

Opel's timing was perfect. He hid inside the Oscar scenery until two absolutely quintessential movie stars stood at the podium waiting for the envelope, please.

Elizabeth Taylor and David Niven were about to be telecast in an Oscar Moment that will be replayed forever in the history of Hollywood.

Opel burst naked from the scenery.

Elizabeth Taylor turned with a look strictly from *Suddenly Last Summer*.

David Niven arched his best British eyebrow.

The audience went silent, then howled, applauded, roared, fell back to stunned yammer.

Security police grabbed Opel and hustled him away.

Taylor put her hand to her elegant bosom.

The quick-witted Niven leaned into the microphone and said, "There's a young man who will long be famous for his shortcomings."

Opel's appearance shock-locked into the collective media consciousness: the comic equivalent to the tragic live shooting of Lee Harvey Oswald. If you saw it, the scene was etched. Sort of. The Global Village, sour on Vietnam and the 1972 break-in at the Watergate, had a big laugh.

"That night was such a rush," Robert Opel told me. "I remember climbing inside the scenery and taking my clothes off. There were so many thick electric cables under me I was afraid I'd be electrocuted. But I stuck to my plan to wait for Taylor and Niven, because they were so perfect. When I jumped out and started running, I don't remember anything until the cops grabbed me. It was so fast it was a blur."

"You made headlines," I said.

Opel laughed. "No one even remembers who won the Oscar that year!"

Robert Opel used up sixty seconds of his fifteen minutes of fame. He didn't know he was on a countdown to his murder.

Robert Mapplethorpe, of course, had to meet Robert Opel.

In several ways, they were Doppelgängers inevitably meant for each other.

Opel had fled from Los Angeles, where in one of his famous run-ins with then notorious police chief, Ed Davis, he had been arrested for appearing naked at a Los Angeles City Council meeting debating the closing of nude beaches.

He sought refuge in more liberal San Francisco, where he began to create his niche in the leather and art crowd. He drew attention to his work as performance artist, writer, and photographer.

Robert Mapplethorpe was simultaneously on a quieter, more refined trajectory of fame.

Andy's dictum, everyone will be famous for fifteen minutes, was a standard to live by in the seventies, when huge sex parties, hosting thousands, declared on the invitations, "Everyone is a star."

The only thing more dangerous and life-threatening than being homosexual is being a Kennedy. Actually, no state of being in America is more genuinely terrifying than being a homosexual or a lesbian.

On the way to stardom in the liberated seventies, few ever considered

the party couldn't last forever. My instinct was that nothing lasts forever. So I wrote copious journals and magazine articles, took photographs, shot super-8 movie epics, saved pertinent news clippings and gallery and party invitations, and made audio recordings of interesting people. Video, unfortunately, made its consumer debut too late for the seventies. Had video been readily available before 1981, the nineties might not have so misunderstood the seventies.

The seventies were a different world, and should be judged by the standards of no other decade than the seventies.

It was *carpe diem* from A.M. to P.M.

In all of liberated sexual history, there has probably never been—and this is a seriously considered notion—a decade like it. The Roaring Twenties were a tea party by comparison.

Robert Mapplethorpe insisted he had to meet Robert Opel.

Robert Opel felt the same about Robert Mapplethorpe.

Neither was sure he'd like the other.

Both of them, snatching at celebrity, noticed that people were confused about who was who. There seemed to be one too many Roberts. Working their way up separately, Mapplethorpe and Opel both were outraged that each was getting lost in a third person everyone was talking about.

That person, getting all the credit, did not even exist.

His name was Robert Oplethorpe.

Blame it on drugs, gossip, and loud rock 'n' roll.

Everyone in the seventies was who they were unless they weren't. When individuals are creating a new liberated identity for themselves individually and as a group, confusion is inevitable.

The meeting of the two Roberts occurred, by appointment, in Summer 1978 at my home, which was then 4436 Twenty-fifth Street in San Francisco. Mapplethorpe was out on a visit. Opel was bouncing around the city pumping support for two projects: one a magazine he would publish, the other, an alternative gallery space that he was pulling together quickly.

Mapplethorpe arrived first and was making one of his many telephone calls from 415/285-5329 when Opel rang my doorbell. We were three men and a multiple agenda. They wanted to lay eyes on each other. Mapplethorpe was interested in Opel's gallery as yet another venue. Opel was interested in Mapplethorpe's joining a group exhibition. As editor of

Drummer magazine, I had journalistic interest in witnessing a possible clash of titans. In art and publishing, sooner or later everybody pimps for everybody else.

The two Roberts stood in my kitchen. Mapplethorpe paced nervously, filling the air with secondhand cigarette smoke. Opel sat at the table, sprawled in a chair. A joint was based around. Some beer was popped. Mapplethorpe offered whiffs of MDA. Such amenities loosened the tension. Each Robert finally saw the other. The sizing up was a sight.

"So," Opel said to me, "do you have the story for me?"

"What story?" Mapplethorpe asked.

"Robert's starting a new magazine."

"I'm calling it *Cocksucker*," Robert said. "It's a monthly."

With both Roberts talking, and neither willing to be called "Bob," "Robert Oplethorpe" was materializing in my kitchen. Their age, build, body movements, and accomplishments began to meld like a trickster created by smoke and mirrors.

Always thinking of the sale, Mapplethorpe told Opel, "You won't be able to sell it on newsstands calling it *Cocksucker*."

"Watch me," Opel said.

I handed Opel my double-spaced story manuscript in a manila folder. He looked at me quizzically. "What's the matter?" I asked.

"I came over so you could read it to me."

I was taken aback. "I don't do auditions," I said.

Mapplethorpe laughed.

"Really," Opel said. "I want you to read it to me."

I looked at Mapplethorpe. I was a bit embarrassed about what he might think. "Erotica is best read privately, alone," I said.

"Come on, Jack," Mapplethorpe said. "You're talking to a performance artist."

"Right," Opel said.

I sensed an alliance forming between the Roberts. That was good. I wanted them to like one another.

"Okay." I gave in. I began to read the seven-page short story, watching Opel across the table sitting in the chair, and Mapplethorpe leaning against the refrigerator. By page two, Opel unbuckled his belt, popped the buttons on his Levi's, lifted his butt, and pulled out his flaccid critic's ruler.

Mapplethorpe grinned his Mapplethorpe grin.

By page four, the critic's ruler was hard; by page five, the pumping

picked up, faster on page six, and then, near the end of the last page, seven, shot its judgment in an arc that splattered on the kitchen floor.

Mapplethorpe and I stared, silent. Opel came down from his rush, tucking his professional judgment back in his shorts.

"Does that mean you like it?" I said.

Opel reached into his leather jacket, pulled out his checkbook, and wrote while he said, "Will a hundred and twenty-five dollars do?"

We all laughed.

Mapplethorpe said, "I thought I was the master of the quick-buck sale."

"Let's you and I talk," Opel said to Mapplethorpe.

The group show at Fey Way was a hit. In fall 1978, Opel's gallery was the first to open in the light-industrial area south of Market near the Miracle Mile on Folsom, where the leather bars and baths ruled the night. By the eighties, South of Market gained the sobriquet SoMa, in imitation of New York's SoHo.

The Roberts, appearing together at openings and swell parties, together stamped out the identity of the mythical "Robert Oplethorpe." They enjoyed a utilitarian, nonsexual, slightly competitive relationship that was profitable to both.

Life is stranger than fiction, especially when women enter stage left. Mapplethorpe had his singer/poet/muse, Patti Smith. Opel lived in quarters behind Fey Way with his singer/poet/muse, Camille O'Grady. Maybe no one's noticed, but homosexual men compete for women as much, maybe more, than heterosexual men compete for their ladies.

With Robert Mapplethorpe off somewhere in the world, I drove to Fey Way to interview Camille O'Grady, who was making quite a splash of her own, on Opel's arm, in the leather set. I planned to interview Patti Smith as well. I had been faculty adviser to the first Women's Awareness Week at Western Michigan University in 1970. All the liberation movements of blacks, women, and gays fit together before they didn't.

Armed with my audio recorder, I dragged along my companion, David Sparrow, who was to shoot 35-mm black-and-white of the interview. (David and I frequently collaborated on photographs for magazines, using the one name "Sparrow Photography." My byline was on so many stories and articles in the seventies it was too much to have my name on the photographs as well. The collaboration worked until 1981, when Sparrow could no longer be nudged into commercial shooting. He died of AIDS in 1992.)

Camille O'Grady was a raven-haired beauty, fair skin, great bone structure. She was a poet, singer, painter, and performance artist. Opel adored her. Mapplethorpe called her "a second-rate Patti Smith." There was a certain ambitious, creative tension, but all very subliminal, among the four people in the two famous art couples—depending on who was talking.

RECORDED LIVE
JUNE 1979

CAMILLE O'GRADY: When I was seventeen, I was all over Manhattan. I knew Robert Mapplethorpe very well. We went to school together. I went to Pratt Institute for eighteen months. We were running around in motorcycle jackets doing art things. I used to make huge drawings and then burn them in public. People would ask, "Are you a witch?"

JACK FRITSCHER: You do dabble in the occult.

CAMILLE: I wasn't occult, exactly. Actually, I was so psychic as a child, I had no idea other people weren't. So I had trouble communicating. Like, I'd sit with someone and I'd say, "I know all this about you. Why don't you know this about me?" My parents were very careful not to let me know I was bizarre. I went to Catholic school and freaked out the nuns.

JACK: I know that experience.

ROBERT OPEL: You're a Catholic?

JACK: Once upon a time.

CAMILLE: Almost everybody I know who is a lapsed Catholic is really interesting. Robert Mapplethorpe was raised Catholic.

JACK: I did a survey on people selling drugs in San Francisco, and almost

every dealer was, or is, a priest or was in the seminary. Amazing what religion does to people.

CAMILLE: It's the ritual. Catholics used to have fabulous ritual, but they've blown it. Robert [Opel] and I went to Mass just to see what a mess they made of it. When I was a kid, I used to sit in the library and get off reading about the martyrs. This one was burned at the stake. This one had her teeth pulled out by Roman soldiers. I used to play games with other kids. We would play "Martyr." We would tie some kid up to a tree and pretend we were burning him up.

JACK: *The Roman Martyrology* was my introduction to S&M. I was in the seminary for ten years. I went in when I was fourteen.

OPEL: Oh, my God! We should sue the Catholic Church in a class-action suit for what they did to you all.

JACK: Scratch a faggot these days and get a Catholic.

CAMILLE: Well, the more esoteric ones, people like you and Mapplethorpe and me who are into more exotic trips.

JACK: I think of myself as a progressive Catholic, not lapsed. Modernized. Catholicism actually taught reincarnation until the fourth century, when Rome decided it was too complicated for people to understand.

CAMILLE: The Church used sex as a handle. By taking sex away from people, they gained power over them.

OPEL: Control freaks.

JACK: What I find ironic is that the Church suddenly jumped ahead four or five centuries from the past and tried to contemporize itself in 1962. Here it's 1979, and they're still stuck in 1962 singing "Michael, Row Your Boat Ashore," which isn't contemporary anymore.

OPEL: Like the pope should have Camille come in and perform during High Mass.

JACK: What kind of poetry are you writing these days?

CAMILLE: I have a musical background. I do poetry readings. I write poetry with melody, with structure.

OPEL: She writes lyrics.

CAMILLE: I have a tape you should probably hear. (*Inaudible aside to photographer*) My hair looks hideous today.

OPEL: You know how weird you are about pictures.

JACK: David, get some shots from the other side.

CAMILLE: Some people photograph fabulously. I have a traveling eye.

OPEL: You have a roving eye.

CAMILLE: Ha! I work my eyes during a shoot. I wrote a poem about being photographed. It's called "A Moment Embodied." I have a friend in New York who used to take pictures of me when I was doing drawings and he got fabulous stills out of it because I was moving.

JACK: Jim Stewart has taken great photos of you. We knew each other in the Midwest and then moved out here. Not together, though he lived with me. He's really bloomed in San Francisco.

CAMILLE: He's good to work with. I can't believe how many gay photographers there are now.

OPEL: My God, we're all sitting in the middle of a happening.

JACK: Revolution. Liberation.

OPEL: Celebration.

CAMILLE: Sex in the sheets. Sex in the streets. All photographers have to

do is aim and focus, there's so much happening that's never been seen before.

JACK: Fill me in some on your career as a woman performing for gay men.

OPEL: Fags and fag hags.

CAMILLE: Shut up, Robert. I liked Jim Morrison a lot. My attitude on stage has been compared to him. Gay men are fabulous audiences. Bette Midler and Liza Minnelli both had great success singing at the Continental Baths in some hotel. In New York. Where was it?

JACK: The Ansonia Hotel. Midler's piano man was Barry Manilow.

CAMILLE: The first band I played in was at St. Mark's Church, Folk City. We were prepunk. Because we wore leather jackets, they billed us as a fifties revival group. I'm not punk. Punk is done by kids. I try to take a point of view of someone who knows something instead of all that posturing kind of shit. I played at the Bottom Line, and also at the Mine Shaft.

OPEL: Everyone's "played" at the Mine Shaft.

CAMILLE: I was way ahead of everybody. That's why gay men like me. They're very progressive. In New York, I wasn't making much money, but I was like the pioneer. I broke ground for other performers. I opened CBGB's. Patti Smith had never set foot in there. She's very big now. Hit records.

JACK: Perhaps Patti is more mainstream, like Mapplethorpe, while you and Opel here are performing within the gay subculture.

OPEL: We're going commercial, too.

CAMILLE: Robert is the gentleman who's now managing my career. I've got a new single due out and I've also published a book with my drawing and writing.

JACK: You're being managed by the guy whose dick has been seen by more people . . .

OPEL: Isn't that a strange compliment to pay, a very interesting comment about our society, where a man can become a celebrity by taking off his clothes.

CAMILLE: Everyone has a funny story about their reaction that night.

OPEL: It's like a Möbius. I'm destined to be always running nude past the TV screen forever and ever and ever.

JACK: You're being beamed, all scrambled, out into space, right behind *I Love Lucy* reruns. No wonder other planets won't contact us when we keep sending them signals like this.

OPEL: You're very good.

CAMILLE: I've read other interviews you've done. That's why I'm letting you do this.

OPEL: I'm convinced all this is going to have a space ending. That spacemen are going to land. I get this way when I get dusted.

CAMILLE: Anyone want some more wine? Some more grass? I probably never will be mainstream. People are not ready for me. Well, gay men are. As a matter of fact, a lot of straight guys are more uptight sexually than gay guys, because there are more taboos and shit that to them threatens their "masculinity."

OPEL: We're just more open to outrageous stuff, and we always want more.

JACK: Right here in Fey Way you give everybody more than they bargain for. Drawings, paintings, photographs, performance art. I thought display-ing Larry Hunt in a cage as a living sculpture was a nice touch.

OPEL: As long as it's erotic.

CAMILLE: That's the thing about gayness. It's like part of a super ability to be open and receptive. The ability to go beyond what you're told. That's why I can communicate with gay men. With straight people, it's like I pick up the phone and there's nobody to talk to. It's very definitely the actual sexuality that makes gay people more open about their feelings than straights.

OPEL: You can fuck your way to a higher consciousness.

JACK: Do you get much flak from women about your behavior?

CAMILLE: You mean because I have sex with gay men in places like the Mine Shaft? (*Laughs.*) It's a very odd thing about me, my personality, and my work. I'm surprised I have so much backing from women who see me perform. They seem to understand what I'm doing. I think women who are running around being "liberated" are going about freedom in a dumb way, with no sense of humor about it. Those women's groups are sooo deadly serious. They're missing the party. I like to share things with people. Artistic interaction is very important. I like Paris in the twenties, when people inspired one another the way Robert and I inspire each other.

JACK: The way Mapplethorpe and Patti inspire each other, and Opel and Mapplethorpe inspire each other.

CAMILLE: Symbiosis. We inspire each other. Then writers and critics come along and mix it all up some more.

OPEL: What Camille is singing about is the celebration, which is now, not about the revolution, which would be political rhetoric, but about the celebration which is, in fact, sexual and very innocent, so gay people—gay men, particularly—relate right away to that kind of celebratory art. They are fans, because they understand the message right away.

JACK: So all the gay art that is happening now really has a lot of support

from within the community that sees itself in art, out of the closet, legitimized by art, finally, at long last?

OPEL: Exactly. And once gays get it, then it can go out to the straight mainstream culture.

JACK: Like disco.

EVERYBODY: *Uughh!*

OPEL: Camille's message is it's okay to sing and talk about men fucking in celebration of themselves.

CAMILLE: Right. Actually, the sex I sing about is sex mostly men do now, but anybody could do that kind of sex. Here I am, a woman, a case in point. I can do anything a man can do, except get a blowjob in the john.

JACK: And I thought a kiss on the hand was quite continental.

CAMILLE: Very good.

JACK: So you don't get much feminist flak?

CAMILLE: No. They seem to like the way I swing free. A couple of women did fabulous interviews with me. They also saw me perform. They understood exactly what I was doing. I said on the radio the other day, some straight guys get real upset, other straight guys get real turned on. A lot of gay women really like my stuff.

JACK: David, can you get a couple more shots?

CAMILLE: My hair looks awful. No one in New York understands San Francisco. They know something is happening out here. They think I came out West to become an Earth Mother and wear granny gowns and flowers in my hair.

OPEL: There's so many New Yorkers migrating out here.

JACK: That's causing a problem.

CAMILLE: What's that?

JACK: The Manhattanization of San Francisco. New Yorkers are not popular here. Mapplethorpe runs up against that a lot.

OPEL: Because he's so New York. His work is more approachable than he is.

JACK: He's shy.

CAMILLE: I'm not. What I should do now is play my new single for you.

Robert Opel's openings at Fey Way, displaying new Mapplethorpes, drew ever larger crowds. To this date, in all the listings of Mapplethorpe's shows, the very important Fey Way exhibitions are omitted, most likely by oversight.

Mapplethorpe made sales through Opel.

Edward De Celle, one of Robert Mapplethorpe's main gallery representatives in San Francisco, attended all the shows at Fey Way. "I can't fathom," De Celle said, "why the Fey Way shows were not listed. The shows in Chicago, at about the same time, at the gallery called In a Plain Brown Wrapper, which was avant as Fey Way, are listed. Opel's was a legitimate, alternative gallery."

And ultimately a killing ground.

As a performance artist, Robert Opel "did" San Francisco the way he had "done" Los Angeles. He appeared outrageously costumed controversially whenever and wherever he might make a social comment. When former supervisor Dan White was tried and found guilty of manslaughter in the assassination of San Francisco's mayor George Moscone and gay supervisor Harvey Milk, the city erupted, on the evening of May 21, 1979, into the White Night Riot. Thousands of gays, angered by the light sentence given to Dan White, a job jumper who had been both a fireman and a cop, stormed City Hall and burned several police cars in a battle that ran till dawn.

White's defense was that he was high on junk food and was not fully

responsible for shooting the mayor and the supervisor, both of whom were shot, sources say, deliberately in the crotch as well as the body. White's "Twinkie Defense" earned him a slight prison sentence. In October 1985, Dan White committed suicide sitting in his car in his closed garage.

Or was it suicide?

Robert Opel, while the White trial was front-page news, costumed himself as a character called "Gay Justice." In front of City Hall, Opel performed a mock trial with another performance actor garbed as an undercover cop. Opel called the piece, "The Trial of Dan White."

The meter was running down on Opel's fifteen minutes of fame.

On Sunday evening, July 8, 1979, three weeks after the audio recording, two white gunmen walked into the Fey Way Gallery, 1287 Howard Street, SoMa, and demanded money from Robert Opel, Camille O'Grady, Anthony Rogers, and a fourth, unidentified person. The gunmen carried a sawed-off shotgun and an automatic weapon. Opel said none of them had any money. The man with the shotgun pointed it at Camille's head and said, "Give us the money or I'll kill her."

Opel, the man who had streaked the 1974 Oscars said, "Fine. Kill us all."

The guy with the automatic fired a shot into a painting.

Opel yelled, "Get out of my space!"

They dragged him to his apartment behind the gallery.

Camille heard the shouting.

Opel, always fast of tongue, argued with them.

"We'll blow your head off."

"You'll have to. There's no money here."

Camille heard the shots.

She heard Opel's body hit the floor.

The gunmen fled.

The robbery began around 9:00 P.M. Opel was pronounced dead at San Francisco General at 10:40 P.M.

Round up the usual suspects.

Speculation has never stopped.

Were the murderers really robbers? Were they after money? Did they think Opel sold drugs out of Fey Way? Were they undercover cops fed up with Opel's constant performance assault? When everybody's fucking everybody, who knows exactly who's getting fucked?

"I think," Robert Mapplethorpe later said, "Opel was shot by critics disguised as gunmen."

"That's not funny."

At least it put an end to Robert Oplethorpe.

Look at Robert Mapplethorpe's startling 1985 photograph, *Der Schuss*, a close-up of a hand firing a Smith and Wesson revolver.

The photographer shot at the same instant the finger pulled the trigger.

Gunfire spews like ejaculation.

The moment is so perfect that the viewer's senses short-circuit.

The eye can hear the gunshot.

Mapplethorpe, ever obsessed with guns, banging for bucks, regarded Opel's exit, in a mix of awe and envy, as a hard act to follow.

At the height of AIDS terror, when a New York couple tied themselves together, naked, and jumped from their high-rise apartment, gay men thought uncivilized thoughts and played out alternatives nice safe people keep to themselves.

If the public watches public dying then why not public sex?

SCENARIO: Interior. Night. Establishing shot. Two men, naked, kneel kneecaps to kneecaps. Mirror images. Bodies oiled. Erect. Grunting noises. One hands the other a pistol and then picks up a pistol himself. They grunt and mirror. The camera moves in slowly, as slowly as the two men, each stroking the other's body, moving the pistols up between them, intertwining arms the way a bride and groom intertwine arms to drink their wedding champagne, gun barrels provoking grunts, huffs of breath, eyes wide open, cold steel barrels, each equally parting the other's lips, parting the other's bared teeth, looking down the barrels at the other's hand, into the other's eyes, biting down, sucking the barrel, fingers on the triggers, hands on rampant cocks, eyeball to eyeball countdown, the click-click of the unloaded pistols metallic under the animal roar as both shoot their loads up the belly and chest of the other.

Sex.

Death.

Art.

"Never let's become ordinary to each other."

"THIEVES KILL GALLERY OWNER, GET $5."

—*San Francisco Chronicle*, Tuesday, July 10, 1979

THE MUSE IS A BITCH

P hotographers, a breed of artist only 150 years old, now throw their shadows on paper that fixes images, unlike the protophotographers whose shadows could appear only ever so briefly in the firelight on the wall of Plato's cave.

Robert Mapplethorpe was a night shooter.

He shot the dark night of the soul. He risked the dark truth of the human condition. He conjured the dark side of religion, culture, and sex.

He was an iconoclast who became an icon.

He never stripped a model more than he stripped himself in his self-portraits that are the narrative of his life.

Robert had not a vanity, but a vivid self-esteem, as he raged to the edge of the uncharted *terra incognita* of the human psyche. Art, as a vocation, can be a risky dance on the killing ground. That artist is best who dares reveal his or her particular soul.

Robert stripped himself one night, playing the lapsed Catholic for me, his bicoastal lover, the former seminarian and prolapsed Catholic. We were ex-altarboys working hard at upping the ante on his shock factor. He wanted feedback.

He was passionately afire with autophotography, the completely perfect loop of aesthetic control: the photographer as his own model, the subject as object, every nuance behind and before the camera controlled, the songwriter who sings his own songs, the shaman–priest as his own offering.

Robert got naked, his own personal-best model, vested in leather, spinning spiderlike from within, some fantasy of blasphemy that he wanted me as writer-partner to critique with both erotic and esthetic response.

He was a *Kama Sutra* kamikaze.

That night's role-playing, the masks, the costumes, the conjurations were purposely seductive scenarios of primal lust, blasphemous satire, and

sophisticated art. He became the Archangel Lucifer, whose name means "bearer of light." Lucifer, theology's riskiest rebel, was Robert's patron of photographers to whom light and darkness are the essence of the art.

"I'll show you something I'm working on," Robert said.

Robert, committed body and soul to the fame track of notorious icon bashing, always had a purpose, even in the sack.

Recall Robert's quintessential self-photograph with a whip up his ass: Lucifer/Pan tailed as demon, snake—evocative of the serpent in Eden—leading us into temptation; his graphic homage to the lyrics of the poet/singer he adored, Jim Morrison, "riding the King Snake" in the song "This Is the End, My Friend."

Assume what memory must recall when a notorious photographer into ritual enactment vests himself in leather, stands over his lover's face, penetrates himself with a braided leather whip handle, and undulates multiple poses with all the liveliness, voice, and erotic moves that no single still frame can deliver—and calls it foreplay.

That night in the Bond Street studio, Robert transformed himself, rehearsing the stance, the posture, the penetration, the turn of the head, the sneering face looking back, all of which he created, alone with his camera, into the 1978 autophotograph that exhibited his "response to a society of assholes" that he felt had abused him with its pushy notions of theology, sex, and politics.

Robert mooned the world with contempt.

His only real pleasure was making that world pay big hard cash for his sassy images.

The cost to him, as seer and sayer, was enormous: his photographs are not erotic; they are not emotional; they are cold. Probably no one has ever masturbated to a Mapplethorpe.

At the 1980 Castro Street Fair in San Francisco, Robert Mapplethorpe, rich and famous, sat vomiting on the curb near the marquee of the Castro Theater. He was alone when I found him, lost in the press of muscular flesh. We walked to the Eureka Valley School playground and lay together in the grass.

He was very depressed, alienated from the gorgeous bodybuilders partying nearly naked, unthinking, in the sunny street. His "take" on life was cold as art for art's sake. His "take" froze his emotions into the formalism of his classic photographs. He was pure crystalline intellect. He was suffering existential isolation.

"I can't always be the famous photographer," he said. "They'll never understand me. Not the straight ones. Not the gay ones. What I'm saying, really saying, they refuse to hear."

Photography, or fame, or maybe the exhaustion of always having to be "The Mapplethorpe" had stressed Robert. Talent, to the disciplined artist, is a relentless mistress. The talented ones are often slaves to their talent; they achieve art, beauty, and glory at an exhausting personal price, if they are to remain true to their art.

"What does it take?" he asked.

"Everything you have."

That afternoon, lying in the grass, Robert Mapplethorpe cried.

PORTRAIT OF THE ARTIST AS A YOUNG SUICIDE

Robert Mapplethorpe was born a suicide. I told him flat out in 1978 that in many previous lives, he had killed himself and would do so again. He smiled, feigning no denial, so in tune were our spiritual lives during the three years we were bicoastal lovers, chronologically correct for one another.

Empathic friends by instinct know the other's destiny. For *In Touch* magazine, in 1979, I wrote an *à clef* short story about Robert, "Caro Ricardo." It was published a second time in the 1984 anthology, *Corporal in Charge of Taking Care of Captain O'Malley and Other Stories.* On his deathbed, Robert handed my book of short stories to a freelance journalist and said, "This is about me."

The key passage, written from my actual conversation with Robert, reads:

> "This is," I told Ricardo, "your first incarnation in three thousand years."
>
> "How so?"
>
> "I intuit it," I said. "I get reincarnational readings off some people."
>
> "I'm one of them?"
>
> "My wonder is why you waited so long between incarnations."
>
> The world and Ricardo were on no uncertain terms with each other. In this incarnation, or in past goatfooted Dionysian lives, Ricardo demanded, managed, and delivered what he wanted. Ricardo will, when his next death-passage is appropriate, take his life with the same hands with which he has created and crafted it. He will neatly, stylishly even, finish it. Ricardo is as close a mirror

to my Gemini psyche as I have ever recognized. Fucking with him was very much fucking with his total being.

Robert idolized the famous who died young. Half in love with mournful death, Robert particularly worshipped rock star Jim Morrison, the pouty Botticelli lead singer of The Doors. Robert physically resembled Morrison and, after the singer's mysterious death in Paris, in July 1971, Robert, three years younger than Morrison, began to assume the dead singer's look, attitude, and doomed-angel leather-style straight out of auto-cide James Dean.

In 1978, Robert begged me to give him my silver-on-black print of Morrison. Before Robert collected *objets* that Christie's would auction after his death, he collected identities.

At the start, he was very much the collage artist who cared nothing about the illegalities of co-opting copyrighted photographs, so why not borrow great bits of the Morrison persona? Later, when successful, as British art historian and critic Edward Lucie-Smith pointed out, Robert was not above shoplifting design and content from the work of New Orleans painter and photographer George Dureau, with whom we all were friends. Dureau's longtime assistant, Jonathan Webb, often hid George's work from Robert, because, Jonathan said, if Robert saw it, six weeks later he'd be showing his Manhattanization of the Dureau concepts.

Robert depended on other artists and benefactors, as he had on his family and then on punk singer Patti Smith, with her network of female gallery owners.

Ernest Becker, whose superb *Denial of Death* we were all reading in the 1970s, says that such dependency "for a strong person . . . may become intolerable, and he may try to break out of it, sometimes by suicide, sometimes by drowning himself desperately in the world and in the rush of experience. . . . He will plunge into life. . . ." Becker quotes Kierkegaard, who says about the defiantly self-created man, "into the distraction of great undertakings . . . he will become a restless spirit . . . which . . . will seek forgetfulness [of his dependency on others] in sensuality, perhaps in debauchery." Just the ticket for the 1970s, the decade starring the American Pop Culture of Sensuality.

The nineties' dazed and confused interest in the current hip revival of seventies' redux fads and fashions, for those who did inhale, means a new

reconstruction of Robert Mapplethorpe so soundly deconstructed by Senator Helms in the NEA fiasco in the 1980s.

As Robert's letters to me affirm, I had told him to seek psychiatric help against his self-destructive excesses of sex and drugs. "I think you were right," he wrote, "about me needing a psychiatrist. I'm a male nympho-maniac, . . . Just can't get sex out of my head. . . ."

Sex was the vehicle for Robert's fascination to break out of it, some-times by suicide, sometimes by drowning himself in scatology and African-American males. He destroyed his photographs of the one and merchan-dised his photographs of the other.

No one fools around with the often satanic ritual of gay scatology without invoking the dark powers of death, as Mapplethorpe did in his collection of devil sculpture and his romancing the demonic in his photo imagery. He took pride that his birth was four days after Halloween. When I asked him about the prudence of his twin obsessions, he said, "With scat, I make myself invulnerable. I build up my resistance to everything." That was before 1981 and the announcement of AIDS's presence. By 1983, he said, "I know that all the first to die had a lot of sex with niggers."

Yet, he continued his racist pursuit: to be killed by a powerful "nigger." (His word.) He played the racial stereotypes of sexually dangerous African-American males to shock the rich elite with whom he played his game of "chicken": "If you don't buy this, then you're not cool or chic enough to hang out at this gallery." Besides, Robert preferred models, both leather and black, who posed for little or nothing. His favorite film, expressed in Boyd MacDonald's interview in *Straight to Hell* magazine, was the race-erotic mid-seventies pot-boiler *Mandingo*.

Perhaps the reason so many "dinge queens," as white men who indulge in collecting darker races are called, died first of AIDS was caused by the African-American socioeconomic structure that almost ensures that intra-venous drug use, and, therefore, HIV, will be more prevalent than in the Caucasian overculture. Gay folk statistics casually suggest something that may say nothing more than reveal the racism of gay culture, whose received taste is set by middle-class white males who control much of the gay media.

All intelligent people consider suicide, at least intellectually. Life, like the concepts *mother* and *child*, is a reciprocal term that cannot be under-stood fully without the concept of death. Artists are particularly sensitive to existential considerations. In America, artists have a tradition of suicide, either with startling violence (Hemingway and a gun), or with an eroding

habit such as alcohol or drugs. Add the seventies' punk rocker style, which was sanctified by the deaths of musicians white-male Jim Morrison, white-female Janis Joplin, and African-American male Jimi Hendrix, to arrive at Mapplethorpe's preoccupation with his primal flower, the lily, the very symbol of death and ironic resurrection.

Robert Mapplethorpe killed himself, intentionally, despite warnings, with unsafe sex and drugs.

Even without the specter of AIDS, Robert Mapplethorpe would have been dead before the 1980s ended.

AIDS was simply a convenience: fashionable, marketable; a public display of dying, which Robert—like so many gay men—opportunistically seized, that was not like a quick, hidden suicide that would be over before he could enjoy the media attention.

Robert had a Grand Guignol sense of humor exceeded only by his acquaintance, photographer Joel-Peter Witken, who once sawed a cadaver's head in half so that the halves could face each other for his famous "mirror" photograph which Robert owned until his death.

The polarities of love and death, both twisted in the American psyche of denial, infused Robert's artistic and emotional persona already tweaked by the Roman Catholic tradition in which he was reared. He photographed Patti Smith, his lifelong alter ego androgyne, as both Death Warmed-Over in his early photographs and as his Widowed Survivor in his final work as he was dying. The love-and-death theme in the American consciousness is a constant in both the pop culture of song and the aesthetic culture of literature and art. Critic Leslie Fiedler opened this cultural debate on eros and thanatos in his landmark book, *Love and Death in the American Novel*.

Robert exercised control over every aspect of his life. His control of his death did not require the "suicide doctor," Jack Kevorkian. He quietly endured the death of his benefactor and one-time lover, Sam Wagstaff, who left him a fortune. Robert, in turn, solidified through his well-thought-through Mapplethorpe Foundation, which was to administer his will after his death, funding museums and hospitals to keep his work collected and his name in print. He orchestrated everything in his images, in his life, and in his death to fit into his constant Catholic subtext of *The Roman Martyrology*, the lives and deaths of the saints.

He knew his only canonization would be, not by fickle critics, but by himself.

Robert spent his life first running after the critics, from whom he was proud, he said, to have never gotten a bad review (not true), until he began to run from critics. He feared the day that the world would turn on him, as it does on every fashionable artist. He asked me to defend in print the San Francisco photographer Jim Wigler, when Wigler was censored and censured in 1981 for his images of terminal leathersex, and death by gun, knife, and rope.

Robert, unfortunately, was already dead when Senator Jesse Helms, in the National Endowment for the Arts scandal, attacked his work and that of Andrès Serrano. He was long dead when he became so infamous that his self-portrait was projected as a veritable icon by anticensorship protesters on the outside of the Corcoran Gallery. He had already self-immolated when he stopped, as no artist of his politically active generation has, the United States government in its tracks.

MERCHANDISING THE MAGICAL, MYSTICAL MAPPLETHORPE TOUR THAT'S COMING TO TAKE YOU AWAY

"Robert ran himself like a department store."
—*George Dureau*

1
I AM A CAMERA

Robert Mapplethorpe's Bond Street studio in Greenwich Village was a one-man-band cottage industry.

He was a hardworking photographer. His photographs, as much as he cherished their reputation as art, were pure product—a beautiful means to an end.

Basically a commercial photographer with fine art aspirations, Robert, when he is good, is magnificent. Only history, after the brevity of his life and the media blip of controversy, can sort out the lasting importance of his total work.

Robert had great instincts, was a good shooter, and was more surprised than anyone else that he was better than even he imagined.

The camera, in the right hands, sucks up an incredible amount of information in one click. In addition, Robert had an aesthetic and analytic IQ to match.

He had the touch for the schmooze, the take, the shoot, the edit, the print, the presentation, and the sale.

Born with an artist's temperament into a middle-class Catholic family, he saw no conflict between art and commerce. One, in fact, supported the other. H. L. Mencken said, "Virtue equals money." Cynical by birth or baptism, Robert's spin on commerce was cynical commercialism. He gave good product. He loathed the public taste. He openly "fleeced" the well bred, the well known, and the well heeled. He believed in his talent, which was real, but he was amazed, until he wasn't, that critics and clients paid him so quickly and so easily so much notice and cash.

He was a cynical innocent. For all his ambition, he was a true artist, sometimes overwhelmed by what he caught on film, by what the camera and the gods gave him at the moment when everything that rises converges.

"Look at this. Look at this!" he would say in amazement.

"From his work," photographer Joel-Peter Witkin said, "Robert must have felt, if I die now, I'd be happy. Robert must have felt that. Every artist does when he stands back and looks at something he's made, and on the most honest, no-bullshit level, realizes he's transcended his own physicality, and has tapped into something of the spirit, and he looks at it, and thinks, 'My God! How did I do that?' "

Robert's first work was impotent collage. No fusion took place. Fusion, that blinding integration of everything the artist is, intuits, and knows, is transcendently important if art is to move from personal to universal planes. When I first met him at the Chelsea, the very young Mapplethorpe's creativity was in bud, not in bloom. He was just another demimondaine in search of his talent. The early Picasso and the early Hockney both had a certain buoyant fizzing talent from the start. The early Mapplethorpe did not fizz. Robert, however, had Acquired Creativity Syndrome. He studied, absorbed, and pushed himself to bloom. As a formalist, he finally experienced artistic, transcending fusion. His fisting photograph is a fusion remake of Weston's palm tree. Because they are beholden only to Robert's internal vision, and not to any fashion account or celebrity, his penis-crucifixion [Number 14, *Untitled, 1978*, in *Ten by Ten*, titled *Richard, 1978*, in the Whitney's *Robert Mapplethorpe*] and his *X Portfolio* are really his best work.

 —Edward Lucie-Smith conversation with Fritscher, December
 20, 1993

Robert, as much as his determined model, Arnold Schwarzenegger, willed his destiny.

Leni Riefenstahl, Hitler's photographer of preference, was a Manhattan personality at the time of the Herr Schwarzenegger shoot. The beauty of her approach to the human body was not lost on those two Aryans. Robert always spoke highly of Arnold.

From childhood, Robert felt stardom in his guts. As an adult, he paid the dues required to achieve media recognition that he was a star artist. He was as bright and intelligent as he was industrious and genuinely "nice." He worked; he studied; he schmoozed; he plotted; then he worked some more. He designed his cool formalist art and networked his ambitious life the way rock stars and politicians work a room selling their personality. He pursued fine art goals to achieve his fiscal mission of invading and conquering the rich and famous. With exact deliberation, he chose for friends people who could be useful to him. To his credit, for every door opened to him, he rose to the occasion with grace and talent, delivering the goods with the petulant upper-lip smirk of a Presley.

Robert understood the X ray of his time. The seventies were the golden age of fast food, fast talk, fast drugs, fast friends, and faster sex.

Click! Click!

Photography is the fast-take scion of art.

Never ambition's self-defeating fool, Robert hit the on-ramp to the fast lane with a pocket full of skill, timing, persistence, and luck.

Intent on immediate gratification, he exchanged the slow process of sculpture he had studied at Pratt for the faster expression of photographic collage. Immediately, he felt limited by pictures clipped from the male skin magazines he bought in Times Square.

Subsequently, he decided to shoot his own images.

Robert's first photographic power tool of choice was the Polaroid Instant Land Camera. When he and Sam Wagstaff wed, he took quite a few choice honeymoon pictures. In fact, his interest in photography began with shooting their sex life: Polaroids of genitalia, most likely Sam's, tied up to small boards. Sam, who was no fool, encouraged the photography to increase the frequency of lovemaking and prolong his affair with the much younger, ambitious *artiste*. "No sex tonight? Then how about some photographs?" Which was the same thing. Others, less clever than Sam Wagstaff, have used the same ruse to keep the kick in a declining sexual relationship.

The early instant portraits of Patti Smith, and his own first self-

portraits, often incorporate the Polaroid commercial film-packaging as part of the image. Robert, adopting such a pop art trick from Warhol, announced instantly that he was a mixed-media pop artist presenting his photographic concept from subject to framing.

"Did you ever go to Max's Kansas City?" he asked me. "Did you ever *have* to go to Max's Kansas City?" Night after night, out he trekked, buoyed by drugs, supported financially by Patti, hoping the doorman would judge them cool enough to enter and mingle among the other wannabes rubbing tushes with the celebrities: Mick, Bianca, Liza, Halston, and Warhol.

Robert, educated in the rigorous morality of *The Baltimore Catechism*★, hoped to God his nude work was obscene and blasphemous. He worried his early portfolio was not erotic enough to sell. He asked the famous homoerotic artist Rex, who draws with a Rapidograph pen while listening to tapes of the Third Reich, "How do you do it? How do you make your drawings so erotic?"

In 1980, I interviewed Rex on Mapplethorpe's exact question.

1980
ART AND PORN AT THE END OF THE 1970S

REX: By the term "gay artist," I don't mean the window dresser at Macy's creating flower pastels on weekends, or the tidy lesbian making abstract sculpture in her garage. I mean people who have directly undertaken the terribly difficult chore of portraying the human form engaged exclusively in homosexual acts or the homosexual lifestyle. These are the artists to whom I direct my criticism.

JACK: The marketplace here in New York, San Francisco, Los Angeles, Europe, seems suddenly flooded with these "gay artists" of whom you speak. Nude and copulating forms seem everywhere.

★ *The Baltimore Catechism* is the Torah of Catholicism. Every Catholic child must memorize its questions and answers in order to receive First Communion. *The Baltimore Catechism* has become a camp reference.

REX: Yes. And I find most of them have everything going for them but one vital ingredient: no real sense of real male sexuality! Much of their work is heavy in technique and low on originality, content, and realism. Erotic art without sex is like light without heat! Porn needs sex! If an artist lacks the facility to communicate real sexuality, then he should go into interior decorating, or portrait work, where his skills—and feeling—can be put to better use.

JACK: You use the terms *erotic art* and *porn* interchangeably.

REX: I prefer *porn*. There are no doubts about its intention. It's like coining a four-letter Anglo-Saxon word from the Greek. . . . *Porn* makes you stand up and be counted! Also, fanatics don't attack *erotic art* with the same verve they'll censor *porn*. Of course, the word *art* intimidates most Americans. We all know we're supposed to "revere art" and "hate porn." Aren't labels convenient? People naturally get confused when one is the other, so I like to interchange them frequently when discussing my professional work. Ambiguity keeps people guessing, and, hopefully, open-minded.

JACK: As an artist, are you a pornographer?

REX: I certainly hope so! Otherwise, I've got a lot of explaining to do where the 1970s went. Still, porn—like beauty—is in the eyes of the beholder. In reality, much of the sex in my drawings is more ritually suggested than actually portrayed. But the end result should cause a hard-on. For men who like men. Really like men.

JACK: You very often load whole feature-length movies into the content of your single-frame drawings. Your realism, intensity, content—all these turn some guys on and others off.

REX: Yeah. Just like real life.

JACK: But for some guys aren't you possibly too rough . . . too masculine?

REX: One can never be too masculine in my book. But make sure you have the right definition for real masculinity.

JACK: Why have you so defiantly devoted your considerable talent to porn as opposed to art?

REX: I wanted to contribute something I felt men needed. To me, the world doesn't need more portraits, still lifes, automobile ads, or clown faces. It seems to me there's never enough porn. Then, too, I like to think that porn separates the homosexual adult men from the gay boys. Art for me is more than entertainment, which merely intends to amuse—not change—you. Art, even when it's porn, can shake you up, by attracting or repelling you. True art has the ability to move you, to change you; but, on the whole, I think people dislike art because in reality they fear being changed.

Porn, on the other hand, asks nothing other than that you enjoy yourself, so powerfully that it actually changes a physical portion of your body from soft to hard. Perhaps porn is a kind of Super-Art.

Robert knew—he always knew—his nudes were not erotic except by intellectual classification. The blistering, raw eroticism he hungered for, he never achieved.

Except for my take on Robert for *Drummer*, the gay press never sought him out to illustrate their masturbatory pages with his photographs. As George Dureau commented, "Even the book *Uncommon Heroes*, purporting to represent gay legends, ignored Mapplethorpe."

His work has the trappings of erotica, but he was too cerebral for passion, which he envied in others, especially in blacks. He never evolved beyond the anthropology of erotica into the action-heat of porn.

Robert's own sexual psyche was cold. Intellectual.

Few admit bedding him. Some who do, say it didn't work, usually because of the drugs. He was very affectionate, but he wasn't emotional sex; he was intellectual sex. Accepted for that novelty, he was a stimulating partner, if one likes to have rational sex, which to some is not as torrid as passionate sex. Robert used every sexual fetish and gimmick he could find to try to ignite real heat and passion in himself and his work. That's why he turned to leather, and that's why he turned to black men, in his quest of passion's soul.

Leather fetishists found his documentation fresh because he brought the leather world out of the closet. While S&M leathermen lionized his work for a time, they did not buy it. They themselves took hotter

pictures of their own sex style. Perhaps his inability to achieve real eros, personally or on film, was the price fate charged Robert for his careerism.

Ironically, he used eros as a tyro when he needed a gimmick to knock on the doors of patronage. To get the attention of gallery owners, he affected a black leather jacket and black clothing. Black was de rigueur at Warhol's Factory. Black does not clash with displayed artwork. He calculated his presence. He knew he bore a striking resemblance to Eric Roberts in *King of the Gypsies* (1978). He had the satyric face of a falling angel. He smiled and introduced himself as "Robert Mapplethorpe, the pornographic photographer."

He wanted to be perceived as provocative.

In his jokey bullwhip-up-the-butt *Self Portrait*, Robert wore the popular leather chaps favored by Harley-Davidson owners. Robert's art history reference may be lost on the chic, but Robert, who dressed like everyone else in the leather bars, was sculptor enough to know he evoked Donatello's bronze sculpture *Attis-Amor*.

Most leather fetishists have no clue as to the roots of the leather-bar costume of chaps and vest. Donatello's bronze "biker" has the leatherstream's requisite mustache, long hair, and shirtless torso. His leathery chaps tighten around his legs and scoop open to emphasize his crotch. His wings even prefigure the biker wings in the trademarked Harley-Davidson motorcycle logo.

"Attis" has strutted around leather bars from the mid-sixties and shows no sign of flagging.

"If I were a movie," Robert told model Mark Walker, "I'd be *I Am a Camera*."

His model was the character Sally Bowles in Christopher Isherwood's *Goodbye to Berlin* which, adapted as a Broadway play by John Van Druten, became the 1955 Julie Harris film, *I Am a Camera*. Next churned by popular culture into a 1960s Broadway musical, Isherwood's vehicle became *Cabaret*. Robert's Studio 54 friend, Liza Minnelli, won an Oscar for her successful portrayal of divine decadence.

If Sally Bowles's take was good enough to transform Liza into a major star, the take was good enough for Robert.

Provocation and decadence, he figured, could make him a superstar.

"My God!" said British critic Edward Lucie-Smith. "Robert was introduced to me by a psychoanalyst as 'the most polymorphously perverse

person I have ever met in my life.' What a come-on! We hated each other instantly. He knew I knew he had small talents for sale."

Undaunted, Robert plotted how to market himself up from the anonymity of the Pratt brat pack. He created his own luck. He hung on to the more successful Patti Smith when she performed her poetry readings. Then, portentously, he met the godmother of the young underground, Holly Solomon, who was the first gallery owner to promote him in two 1977 exhibits.

He styled his personal image and his social quips. As much as his nascent talent, he honed his wit. When millionaire art maven Sam Wagstaff walked up to the young Robert in 1972 and said, "I'm looking for someone to spoil," Robert didn't drop a beat.

"You've found him," he said.

The favor was in himself and his stars. Astrologically, Robert and Sam were born on the same day twenty-five years apart. November 4. Both Scorpios. Trivia, perhaps, left over from the Age of Aquarius, when the first question asked was "What's your sign?" Not so trivial to discover other Scorpios: Pablo Picasso, Claude Monet, Rock Hudson, and Katharine Hepburn. Even before the Reagan White House sought out astrologers, Robert milked astrology (the pentacle) as much as Catholic theology (the crucifix) and fascism (the guns, knives, swastikas), always trying to assert his free will against all the forces of philosophic determinism.

He gathered symbolism where he found it.

From the Wagstaff merge came "The Mapplethorpe."

As bold as Robert was publicly, personally he was quite shy. At exhibition openings, the ingratiating public Robert could barely conceal the boyish Robert, who nervously fondled Kool cigarettes, champagne glasses, or beer bottles whose labels he peeled off with his fingernails.

His contradictions endeared him. He worked even his insecurities into an appealing sell.

According to photographer Miles Everett, Robert barely tolerated the gallery fans who assailed him, fawning, "Oh Mr. Mapplethorpe, OH Mr. Mapplethorpe, OH MR. MAYYYPLETHORPE!"

At openings, he impersonated James Dean mixed with a lot of The Doors' lead poet/singer, Jim Morrison, whose look Robert had, somewhat by physical resemblance, more by affectation. His public persona hypnotized eager patrons. He could turn it on and turn it off like a method actor.

Susan Strasberg once said that she and her friend Marilyn Monroe were walking down Fifth Avenue and no one noticed them.

Marilyn, who was studying at Lee Strasberg's Actors Studio, said to Susan, "Do you want to see me do *her*?"

The private Norma Jean, standing on the street, adjusted her posture, her walk, and her face.

Suddenly, she was mobbed.

Robert was similarly facile at creating on-cue "The Mapplethorpe."

He stood, enigmatically silent, among the chattering classes at openings, fielding small talk, double-talking, hoping someone interesting might pop up, saying one thing to a person, and then bolting for a taxi where he said quite explosively the opposite. Robert was instantly judgmental. Most people dissatisfied him because they fell short of their potential as perceived by him.

"So why do you do it?" I asked.

"The secret"—he spoke very precisely—"is to kiss their ass until they end up kissing mine with a check."

Robert, for all his sex-and-society playboy wildlife, was as much an artist-workaholic as he was a careerist totally absorbed with concept, design, technique, and subject matter. It all came together in inspired fusion when he stepped behind his camera, totally focused, to create moments perfect.

"His real thrill," according to painter-photographer George Dureau, "was the kill, the sale."

2
I ABSORB YOU IN THE NAME OF THE FATHER, THE SON, AND THE HOLY GHOST

Robert Mapplethorpe's high profile as a singular talent, as an American original, made him seem at first devoid of influences. In fact, Robert was an excellent student who absorbed the history of photography, reviving and refreshing existing work with his own personal sensibility.

Robert's images are original enough, but many of his photographs carry the influence of other photographers' work. No artist creates *ex*

nihilo, from nothing. Robert's personal character becomes more interesting when his work reveals that even The Mapplethorpe was, like Tennyson, a part of all that he had met.

Robert had the gift of creative absorption.

Many of Robert's photographs reveal their source material in cultural myth, in religion, in art, in sex. Joseph Campbell would have approved Robert's apperceptive mass approach to the history of culture. His scholarship was sometimes homage, sometimes satire, but never outright pillage. He reshot the content, with his own pictorialist style, of sculpture, painting, and literature as well as antique and contemporary photographers.

His camera eye took in everything.

His pleasantly derivative work references the Bible, Baudelaire, Beardsley, Rimbaud, George Platt Lynes, and George Dureau, but all reimaged through the identifiable Mapplethorpe Spin—that confrontational edge to render his sources more controversial and commercial.

Always fascinated by Catholicism and the crucifixion of Christ, which he openly copied in the exaggerated arm extension of his *Self Portrait, 1975*, Robert flipped a spin on the blasphemy of the Decadents, those Beardsleyan provocateurs of Art Nouveau. Anything they could do, he would do.

Gustave Moreau, himself quoting Delacroix, set the pattern for Félicien Rops, who illustrated *Les Sataniques*. Robert's very early crucifixion and torture of a penis, Number 14, *Untitled, 1978*, owes a direct debt to Rops, who, in the previous century, showed phallic images crucified, as well as a penis itself crucified for the masturbatory pleasure of Mary Magdalene.

Robert, as a collector of historic photography, was well aware of the work of F. Holland Day, the photographer who dieted himself down to emaciation to play the Christus in his own 1898 self-portrait hanging on the cross, *Crucifixion*.

Mapplethorpe was also a collector of the work of his friend Joel-Peter Witkin, whose 1982 crucifixion photograph, *Penitente*, Robert greatly admired.

David Fahey, owner with Randee Klein of Fahey Klein Gallery in Los Angeles, is the authorial force behind *Masters of Starlight*, the definitive book on Hollywood glamour photography that grew out of an article Fahey wrote when he was a contributing editor to *Interview* magazine. *American Photographer* magazine, January 1994, named the genial Fahey among "The

100 Most Important People in Photography." An early champion of Herb Ritts, Fahey represents Mary Ellen Mark and Bruce Weber. Fahey defends Robert's borrowings: "All artists learn from one another, and borrow, consciously or unconsciously. This shared consciousness of particular artists working at a particular time in a particular culture is not at all plagiarism."

Studying the independent Robert's work for derivation simply makes him all that more interesting. His originality is not demeaned because he had sources.

Warhol was the biggest proponent of borrowing.

Flipped 180 degrees, Robert was also the source-influence for many other photographers. "The student," Whitman wrote, "who most honors the teacher is the student who outstrips the teacher."

Sam Wagstaff was the first noted curator to collect historic photography; he gifted Robert with thousands of original prints. In addition to an enormous amount of "anonymous" fine-art antique photography, Robert pored over Edward Weston's vegetables, Cecil Beaton's fashion studies, Julia Margaret Cameron's portraits, the African-American work by George Dureau and Miles Everett, and male physique work by Eadweard Muybridge, Baron Wilhelm von Gloeden, Fred Holland Day, George Platt Lynes, and Leni Riefenstahl.

Robert, incidentally, sold most of his antique photography collection in 1982, when his need for cash intersected the going rate of market demand.

Robert was ravenous to learn everything, digest what he wanted, and dump the rest.

A parallel metaphor is Robert's interest in sexual scatology. Mapplethorpe photographs of this "last taboo" will take years to surface. Private prints exist, even if the negatives have been destroyed. The Vatican's art collection is rumored to have more than one "forbidden" Mapplethorpe. Far nastier than his leather work, the scatological shots have about as much chance of being identified as did the Grand Duchess Anastasia.

More than one *derrière* photograph deliberately suggests his literal interest in through-put. He asked me to find him a well-built scatologist, someone really into the specific scene, whom he could shoot.

I introduced Robert to Jerry Paderski, lover of Thom Morrison, the Scatology King of San Francisco. At a modest hotel near Powell and Market streets in San Francisco, Robert shot, face occluded by back and shoulders, this famous scatman's butt confronting the camera.

The confrontation quotes Robert's whip up his own ass, but with Jerry, straddling the porcelein toilet ass backwards, ready to deliver his dark communion.

A dirty jockstrap frames the buttocks.

The result was fashion photography that would do print ads for "facial quality" toilet tissue proud.

Rear nudes, which have long been socially acceptable, were made very shocking by Robert, especially when one knows the existence of the scatological photographs. One surviving, particularly literal photograph depicts a set of buttocks straddling a man's shaved head: the anus and the mouth in covert connection.

Mention also might be made of the Mapplethorpe portrait of hyper-masculine author Norman Mailer, who, besides his literary success and antiestablishment antics, appealed to Mapplethorpe because Mailer (the omniscient novelist of *The Naked and the Dead*; the participatory New Journalist of *The Armies of the Night*) had dared to dump scatologically as public metaphor against the U.S. war in Vietnam.

Bob Mizer, whose *Physique Pictorial* magazine influenced Robert, photographed young men since World War II at his Athletic Model Guild Studio in Los Angeles. Mizer, in January 1970, reacted to the full nudity allowed only the year before in print in the U.S. mails. Mizer, who died in 1992, was a civil libertarian who editorialized in his magazine: "How Dirty Can Pictures Get?"

No more nudity can be shown than is now available, unless we consider split beaver and anus shots. When does a picture become anatomically instructive instead of sensual? In trying to outdo their competitors, many photographers in both the girl and boy fields have had their subjects pull protective flesh out of the way to graphically and minutely display the mucous membrane areas of the vagina and anus.

After virgin eyes overcome the initial shock to such intimate revelations, one can settle down to study the intricate anatomical detail formerly only available in expensive medical textbooks. If the pornographer fails to stimulate us sensually, at least he is providing intellectual stimulation. But soon the public will tire of such medical views. Many people who bought the much touted book, *The Phallus*, which contains page after page of penises at

full 8.5 × 11 page size, found themselves bored after the first
dozen pages.

At the very time pioneer Mizer was writing, Robert, age twenty-four,
was leafing through the pages of *Physique Pictorial*, studying what shock
might be. In fact, he was quite pleased when I managed an interview with
the usually reclusive Mizer in 1981. Robert Mapplethorpe venerated Bob
Mizer as an elder statesman.

Robert was facile at chimerically absorbing the photography of others,
putting the spin of the design into his version, which, more than theirs,
spoke directly to the taste of the specific avant-garde New York market
whose commercial values he courted in the 1970s and 1980s.

"Robert played to his audience," George Dureau said.

Some photographers and critics, not as kind as David Fahey, are
beginning to assess Robert's appropriation of images as some kind of grand
larceny. Hardly. Robert was competitive, but not that aggressive. Certainly,
he posed in a self-portrait as a gangster, but he was too moral in character
and too talented in his own right to copy others. I witnessed his act inside
out. He liked one-upping his peers. He enjoyed the performance art of
carrying his Hasselblad like a six-shooter, but that was merely the affecta-
tion of a rising young star acting the part of the fastest *nouvelle* gun in town.

By the seventies, paparazzi and hitmen came to share the name
"shooters." Would-be assassin Sara Jane Moore, crowded in with media
photographers, took a shot at President Ford in San Francisco. Ex–New
York photographer, Harvey Milk, who had emigrated to San Francisco to
open a camera shop, was elected as a city supervisor. He was shot to death
in his City Hall office in November 1978.

John Lennon was gunned down in 1980 (the night of the afternoon
Annie Leibovitz shot the duo of the naked Lennon curled fetally onto his
reclining wife/muse). Later, Robert shot Yoko Ono alone, the world's
second-most-famous widow-by-gun.

Her photograph in *Some Women* almost closes the circle.

Robert's ultimate cultural-terrorist comment on the deadly equation
of guns and cameras as assault weapons in an age of terrorists is his cerebral
1982 *Self Portrait* of the photographer as a leather-coated hitman holding a
machine gun in front of a pentacle star.

Robert anticipated Madonna and her photographer, Steven Meisel, in
his facile self-image changes. Evoking the Bogart-Belmondo gangster

mystique, dragged up in a Gestapo-like raincoat, Robert, in this stylized autoshot, also lays claim to the famous Symbionese Liberation Army photo-poster of Citizen Kane's granddaughter, Patty Hearst, as the urban guerrilla, Tonya.

The pentacle, of course, symbolizes his interest in the occult and is matched in symbolic shock in other "secret" S&M photographs by his purposeful use of a Nazi swastika as a back-drop as a naked obese Jewish man is tortured and humiliated by men in full leather.

Jamie Wyeth's 1971 painting of a blond leatherman inspired Robert as much by subject as by Wyeth's pedigree.

"Anything he can do, I can do better."

Robert may have been a hold-up artist, holding up other photographers' work to see how he might make it his own, but he never, ever, not even in his misinterpreted consensual-action leather photographs, condoned violence, which S&M is not.

In fact, the S&M photography, film, and videography of the period are more literally graphic than any of his sanitized single frames. His leathersex photographs relate to the actual leather genre the way staid lobby posters relate only obliquely to the movie.

The leather scene in the seventies was so wild that Robert's work looks like still-life studies when compared with such classic period films as *Erotic Hands* (three-way handballing), *Sebastiane* (Derek Jarman's S&M version of the homoerotic martyrdom of St. Sebastian; a British film, dialogue in Latin, with English subtitles), Wakefield Poole's *Bijou* and *Moving*, and Dave Masur's Skulls of Akron *Fisting Ballet*, which was shot at the Mine Shaft in New York.

Robert deliberately tried to clean the leather scene up to acceptability to push his avant-garde following. He thought the genre legitimate. In fact, he envied director/porn star Fred Halsted, whose films *Sextool* and *L.A. Plays Itself* (with the S&M and fisting sequences intact) were purchased for the permanent collection at the Museum of Modern Art.

Halsted was top star in the stable of featured guest writers when I began editing *Drummer* in 1977.

Halsted was the S&M Leather King of the West Coast.

Halsted had a drop-dead handsome face, a rugged muscular build, an iconic penis, and an Original Case of LA Attitude.

Halsted didn't care that the editor of *Drummer* wanted him to write a feature profile on Robert. Halsted was not at all interested in meeting the

New Yorker who was, according to Halsted, "a nobody on the make, an opportunist."

Halsted was one of the first strict arbiters of masculine-identified homosexual taste.

Halsted, an A-list star of the Los Angeles leather scene, wrote erotica, made films, sold drugs, hustled torture-sex for money, starred in porn films, used the word *nigger* erotically, and published his own magazine titled *Package: Fred Halsted's Journal of Men, Fact, and Opinion*, which often featured black bodybuilders. He also owned the LA bar called "Halsted's." His staff photographer was the pre-Mapplethorpe Robert Opel. Halsted's blond lover, business partner, and co-star, Joey Yale, died of AIDS in 1988. Fred Halsted, himself HIV-positive, committed suicide in Los Angeles in 1990.

Halsted, a founding father of the leather culture, dismissed Mapplethorpe in the same way Mapplethorpe dismissed those who were of no use to him. I learned early on never to mention Fred Halsted to Mapplethorpe or Robert Mapplethorpe to Halsted.

Robert, envying Halsted, would have shot Halstedian moving images of S&M, but the leather scene was too active for him to control it the way he needed to exert directorial control.

Robert could not sell the gristly reality of leather.

The reality of leather would be too radical.

He had to formalize leather to sell it.

Once the leatherstream saw Mapplethorpe's perceivedly exploitationist take, they, following Halsted's lead, by 1982, turned on him.

Robert, coincidentally with the onset of AIDS in society, abandoned any real walk on the wild side. He had earlier decided to smarten up his leather take to make his foray into leathersex more commercial. He left the faces and personae of whole men behind, settling for the still life of *Finger Inserted in Penis*, and *The Fist*. He further gentrified leather in the photograph of Lyle Heeter and Brian Ridley posed in leather and chains, stylized in their chic Manhattan apartment as if they were a noble couple in an eighteenth-century portrait.

Robert was as incapable of shooting action pictures as was Warhol, whose infamous *Blow Job* (1963) was no more than one sixteen-minute take of the face and shoulders of a piece of rough trade leaning against a wall.

Between 1979 and 1980, Robert was the "official" Mine Shaft photographer. Wally Wallace asked Robert to shoot a party at the club. Robert

worked dutifully but he was unable to shoot in the paparazzi style required so he hid or destroyed the party negatives. Robert, in an uncontrolled environment, could not shoot from the hip. In October 1979, he shot David O'Brien, that year's Mr. Mine Shaft, at the bootblack's stand where inferiors shined the shoes and worshipped the boots of superiors. Actually, the missing "Mapplethorpes" of the Mine Shaft Period as well as the Scatology Period should be of as much interest to historians and critics as the officially released Mapplethorpe photographs.

Robert wisely stayed with the Genre of Masochism that suited his talents. His ultra-Catholic moral vision of the big picture of the human condition empowered him to stretch his aesthetic vision in the small picture of his viewfinder. He was not violent or evil. He had actually a sweet personality. He was intellectually curious by nature. Violence and evil interested him the way they interest theologians, psychiatrists, and sociologists.

Catholicism had made him a "scholar" of good and evil. He was a dualist who saw that bad things happen to good people. This causes problems to viewers who see only one-half the photograph that contains within its literal self a reciprocal mirror. Never lose sight of the mirrors that Robert designed into the elegant frames of his early photographs: the viewers of those photographs see themselves caught in the single frame of the mirror set amidst the photographs.

BANG! YOU'RE DEAD!

The internal evidence for reading a Mapplethorpe is all in each frame. Silent as he was, he made his images speak volumes. Art achieves meaning two ways: by what the artist puts into it and through what the viewer brings to it.

Robert's images, because they are so literal, are often perceived as endorsements of the subject, when, in fact, the single frames are actually also potent question marks asking, "Have you thought about *this*?"

His aesthetic assault was provocation to thought. Same as his sexual seductions. "What if we did *this*?"

The photographer, whom everyone claims to understand, was a journeyman/pilgrim whom few knew. For one so verbally shy, Robert left open the nuances of his inner self to those who knew how to read his personality and his intellect. Everyone who knew Robert has a different take on the person, the man, the artist they knew. Robert carefully kept his confidants separate.

Robert's art must be read with that same empathy. So subtle is his art,

that when it is good, it's the best kind of art: the art that, as much as it is *ars gratia artis*, presents subliminal truths about the human condition to people in denial about those truths.

Reality changes with time as one's perceptions change. One day a person discovers he *can* read Shakespeare, and that becomes his reality. Shakespeare has always been there, but the reader couldn't accept the artist as part of his reality until his perceptions matured to a point where he could appreciate him.

Robert was what he termed a "prolapsed" Catholic, much encouraged by the coven of ex-Catholics at Warhol's Factory.

"You know what a prolapsed Catholic is?" he asked. "It's when, after a night of great sex, your asshole and your soul both fall out on the side-walk."

A survivor of Catholicism, he arrived in Manhattan from Long Island, knowing that "if he could make it there, he could make it anywhere." He became, long before Tama Janowitz, a slave of New York.

He was intense about his ambition, but he acted cool about his escalating talent. He was improving in visible stages, like a flower going from bud to bloom in time-lapse jumps. He was not vain. He was not temperamental so much as petulant. He was extremely controlling of himself and others, always with the motive of creating public mystique while sometimes inviting real personal intimacy.

"Robert would never talk about his craft," George Dureau said.

Photographer Joel-Peter Witkin, who chatted often with Robert, said, "He should have written about what he was doing. A monograph, at least."

Robert hated writing. He was virtually dyslexic. To compensate, he took on writers as friends. In fact, he worshipped writers: Patti Smith, Jim Morrison, Ed White, Joan Didion, William Burroughs, and Nick Bienes, who appears in a famous Mapplethorpe photograph with a tattooed forehead.

Bienes wrote best-selling Jackie Collins–style novels—*Sins*, *Love-makers*, and *Dazzle*—under the pseudonym Judith Gould. At least one was made into a successful television mini-series. I witnessed Robert salivating at Bienes's New York apartment, which was decorated like a subway car: industrial-rubber flooring, light-rail-vehicle lighting, and video monitors, like windows, recessed into *faux* steel walls, gray carpeting, track lighting, mini-blinds.

Often silent among the talkers, he was a canny artist in the business of art. He merchandised what he could get away with, what he could pass off, what he could redefine as avant/underground/fashion quality in those early days. He was in pursuit of his own career. He knew fame's value. He knew its price. Nothing, not even his personal shyness, stood in the way of his sales pitch.

He was no Picasso famous for constantly doodling on napkins and tablecloths, but he was a prodigious producer of product. In his lifetime, he shot thousands of photographs. He virtually "extorted" money from some of his famous clients, so says the 1989 BBC video, insisting his subjects be shot by him at his going rate. Leather friends he cadged for free in exchange for drugs, and, often, a print of themselves.

He licensed his work for greeting cards. He created more than twenty exhibition catalogs and books. Ultimately, he achieved the pinnacle of American success: he was incorporated. He protected his art as product by initiating the Robert Mapplethorpe Foundation, Inc. Not an unusual move for artists.

Robert needed someone to take charge of his studio, as he had no head for the details of business: filings, bookings, billings, cataloging, and archival protection. His Bond Street apartment was an intellectual mess. One afternoon, I found his kitchen table on fire from one of his cigarettes. We stomped the fire out, and he threw everything away, Con Edison bills included, without even looking at what he discarded. In the eighties, the foundation reportedly discovered he had saved few letters, travel dates, or other records from the seventies.

He was smart to hire art-and-business-wise managers.

A multi-million-dollar empire is not easy for a working artist to run. Robert was no mogul. After his death, magazine mail-order advertisements offered an edition of collectible "dinner" plates printed with his signature calla lily. T-shirts are sold in museum shops along with posters and greeting cards. His photographs appear on refrigerator magnets manufactured in places where copyright means nothing.

For the sexually liberated consumer, designer sheets and pillow cases of *Man in a Polyester Suit* may likely be licensed by popular demand to better stores everywhere.

"Robert ran himself," George Dureau said, "like a department store."

Robert had American values. He was Sammy Glick turned into Jay Gatsby. "This whole market-driven impulse," Edward Lucie-Smith said,

"to turn Robert into a saint parallels the impulse to canonize Warhol. In my view, this is all bullshit. Robert and Andy were both climbers, and those who facilitated their progress are now trying to justify, not the dead, but *themselves!*"

Robert knew how to read a market. In an age of sound and video bites, when people were famous simply because they were famous, when *arrivistes* were applauded for their gall, he assertively generated his own mystique: a heady mix of personality, money machine, sex, drugs, and some truly fine art.

Robert was always on the make to widen his market.

But he kept his photographs central.

Take notice of the furniture and jewelry, the collages and frames, that he designed. Start with the photographs. Consider his printing processes on paper, platinum, and textiles. Look at his frames, which received more critical attention at first than the Mapplethorpe photographs they enhanced.

Robert's inspiration for "important" framing derived as much from his early interest in collage as it did from David Fahey's famous frames that predated the Mapplethorpe frames in New York.

Robert envisioned his photographs hanging in rooms of a certain style. He might even, as Cecil Beaton had, have moved into costume and set design for stage and film. Add a decade to his life and see Robert Mapplethorpe, an auteur director of videos and movies.

By 1977, he was director-videographer of poet-singer Patti Smith. At the last, he was directing and shooting exquisite art video footage of Lisa Lyon, for whom he acted as coach for her "Next Wave of American Women" muscle-and-art nude posing at Laforet Museum Harajuku, Japan, in March/April 1984.

Only two Mapplethorpe photographs of Lisa appear in the Laforet catalog. Most of the photography was by Kishin Shinoyama. An additional two photographs each were provided by Marcus Leatherdale and Helmut Newton.

Robert did not like sharing pages, or exhibits. In 1979, Edward De Celle said, "Robert was scheduled to do a show, 'Trade Off,' with Lynn Davis and Peter Hujar. He refused to participate unless Hujar was dropped. He got his way. He did not trade off."

Robert was child of the mixed-media sixties and seventies. He was protégé of Warhol, who spanned photography, painting, underground filmmaking, and designer rock shows. Andy produced, what to me in 1965

was very hip, *The Exploding Plastic Inevitable,* a touring multimedia happening that featured Nico, Lou Reed, and the Velvet Underground. That was cue enough for Robert to work with Patti, shooting her in stills and video and creating her record covers.

In 1987, "The Mapplethorpe" appeared, for pay and publicity, in a magazine print ad selling Rose's lime juice for Schweppes, Inc.

How odd, in a print ad for lime juice, to discern the self-assured, handsome Robert who was beloved—one time for a long time—when we were chronologically correct and passionately in sync, Robert was loved because he was "Roberto, *caro* Roberto," because he was sensitive and wild and so very talented, glib, and seductive.

"I'm besieged," Manhattan collector Joseph Vasta explained, "by acquaintances jumping on the sex-and-photography bandwagon. They misunderstand. Mapplethorpe was about fine art first, and about sex second."

Making love with Robert was always uncommon erotic sport, and his openness, purposefully displayed to me as his then current court chronicler, afforded opportunity to witness something of his creative process: how he practiced and played with mirrors—and partners' eyes—to pull together, in this case, the image that he was rehearsing for his self-portraits.

More than once, he honored me, as he also entertained other intimate friends, as his test market.

The snap of Catholicism, art, and fetish focused us, for three years, as two of a kind. For us, each separately, the notorious Mine Shaft, the Everhard, the Slot, and other back rooms and baths of late-night desire were anonymous playgrounds we both enjoyed, but found fruitless when we patronized them together, because each was so judgmental about the tricks the other cruised.

The best of those tandem nights was watching Robert work the after-hours bars, the endless corridors of the baths, keeping his marketing priorities straight, looking for models first, and partners second.

"I feel like a vampire," Robert said. "I am a vampire."

He photographed Lisa Lyon with vampire fangs in 1986.

Those nightspots, in New York, plus The Gauntlet Bar and the Manspace bath in LA, and The Brig and The Ambush bars in San Francisco, where he also auditioned talent at baths such as The Slot, The Handball Express, and The Hothouse, were, for Robert, gliding like Gide, Genet, de Sade, Sacher-Masoch, and everyone's favorite, French philosopher Michel Foucault, through the nightblooming scenarios of sophisti-

cated sensualists, the *source* of both his Rimbaud leathersex and Baudelaire flowersex photographs.

Threeways were never a consideration.

When alone *à deux*, at his place in Manhattan or mine in California, where calla lilies filled the yard with splendid bloom, we cavorted most personally, away from the pleasure gardens of anonymity, away from the lens of personality, tripping twisted tricks of the soul only Catholic boys seek to discover if what works sexually as mortal sin might work aesthetically as immortal art.

Danger here lies in revealing too much privacy.

Most often in the conjuring bed, his "there" had a "there there," often enhanced by his baggies of white powders he always kept next to his black cowboy boots with the pointed toes.

Sometimes, however, this man who was always in control of his recreational drugs was physically present in the sheets, while the artist in him had taken the off-ramp to Alpha Centauri.

Robert luckily always made round-trips.

Sometimes, his real persona drifted from the room, leaving behind the curious mix of photographer as model, spinning from within some fantasy image he wanted me, the writer and editor, to critique with erotic, aesthetic, and potential marketing response.

"You're from Peoria," he said to me. "Tell me what you think. If it plays in Peoria, it will play anywhere."

I reminded him I had fled Peoria the way he fled Long Island. For the same reasons.

There was no stopping his enthusiasms. His bed was not so much casting couch as it was rehearsal hall. Many of his photographs remind me of our nights together when I sometimes felt more like an audience of one than a sex partner.

Robert in heat was a cast of thousands.

His self-portraits reveal his pursuit of *The Hero with a Thousand Faces*.

Robert learned to give face and attitude from Warhol.

Working as a staff photographer for Andy's *Interview* magazine, Robert bonded with Warhol in mutual admiration. At Warhol's knee, he learned the brevity of fame and the tricks of commercial marketing.

Andy taught Robert a thing or two about chasing money and celebrity. Warhol, more cynical about his art than Robert ever was about his, often induced other artists into creating his paintings, prints, and films,

which he then signed as his own. This Tom Sawyer–fence attitude toward authenticity was accepted, not as a scam, but as yet another artful Warhol quirk of eccentric genius.

To Robert, Andy's take on authenticity justified—in a kind of retro-spin—Robert's own habit of reprising other artists' work to give it the Mapplethorpe treatment, because they hadn't fully formalized their style. What he meant was he could make the material more commercial.

Robert received no substantial cash from Warhol for his work in *Interview*. He traded his photographs for Andy's endorsement. Never underestimate the power of the "gay mafia." Gallery owners, magazine editors, and the insular Manhattan art crowd were delighted by Robert's person, his credentials, and, most importantly, his obvious talent. And not without reason.

Robert's early work in collage and photography displays had virtually the same power as the mature Robert. Vasta said he was stunned by the early date (1969) of two brilliant collage box sculptures by Robert, one of which sold at Sotheby's in 1990 for $22,000.

Amusing, ingratiating, always climbing, Robert catered to the Famous Who Were Famous for Being Famous by giving them the opportunity to do something famous, by appointment, with the famous photographer consecrated by High Priest Warhol.

Nouvelle photographie.

Co-conspirators, the FBF's ran to his studio, where fame could collide in the nuclear accelerator of personality. Candy Darling, the Warhol superstar whom Robert shot in 1973, once complained to Robert that it was so dreadfully boring and difficult to find something famous to do everyday.

Life in Manhattan, to the boy from Long Island, was a dream come true, and a game, which he won long before he died, because his purpose was to make art, gain celebrity, and make money.

On cue, he could play Puck, Hamlet, or Faust.

3
BLIND PARENTS RAISE INVISIBLE CHILD

Shock was Robert's medium in the shocking seventies: the shock of burning bras, the shock of abortion, the shock of sexual liberation, the

shock of losing Vietnam, the shock of terrorist Olympics, the shock of Watergate, the shock of Americans hostage in Iran, the cumulative culture shock that led to the aftershocks in the eighties' shock of AIDS, Iran-Contra, the Republican deficit, the destruction of the middle class, the meltdown of the nuclear family, the epidemic of drugs, the homeless, the savings-and-loan scandals, the blasphemy of television evangelists, the rise of shock-rock music, shock-trash television, and shocking U.S. policies in the Mideast.

Every item in this litany is more obscene than any Mapplethorpe snapshot ever.

To be noticed, Robert responded in kind.

He had to shock the shell-shocked.

Shock was all that commanded attention.

Julian Beck and Judith Malina's Theater of Assault, based on Artaud's Theater of Cruelty, responded to the age of lies and liars on stage. Ken Russell directed shockingly beautiful sexual biographies of artists and musicians and clergy on screen. Tennessee Williams said, "We must yell 'Fire!' in the burning straw-house of the world." Flannery O'Connor wrote in defense of her shocking gothic-grotesque stories: To the almost deaf you have to shout. "To the almost blind, you have to paint in very large letters."

Ezra Pound put it right: "Artists are the antennae of the race."

Robert was no more shocking than his times.

In fact, no one really noticed he was all that shocking until his controversial photographs were more than a decade old.

When the style changed, politicians, with no more ability at art interpretation than literal fundamentalism, could not comprehend the metaphor that art is to literal life. It's good art, when its uncomfortable revelations tweak our personal and cultural psyches out of comfortable states of denial and reveal dysfunction.

Unless they are propagandists, evangelists, or entertainers, artists tell the truth. Essentially, with subversive neo-classicism, Robert sexualized death.

If he couldn't find personal passion, he could mix eros and thanatos intellectually in his work. Love and death catch people's attention.

When an artist equates love with death, two taboos are broken.

When that artist himself begins dying of an erotically transmitted disease, the themes he always played become more insistent.

Robert's work was not pornographic. Robert's work is all about love and death.

He had no answers. He had only increasingly intelligent questions. That was his assault on society.

When Mapplethorpe became a political issue, everyone discussed sex. (That was good.) What they really feared in his work was his cold intimations of their own mortality. (That was scary.)

In an age of plague, with AIDS spreading unchecked and indiscriminately through the world's population, Robert gave face to death.

Robert instinctively tripped the circuits of the exact American psyche that Ernest Becker so brilliantly diagnosed in *The Denial of Death* (1976).

Part of the joke was on Robert. At first, he was a tease, a bubble dancer, a stripper of psychosexual clothes. It was fun to be naughty. He had little idea at the start that his camera was Pandora's box. The career that started as a lark to make money elicited from critics and connoisseurs a reaction more serious than Robert ever intended to achieve.

The camera, that stealer of souls, that all-seeing Third Eye, revealed to him a shocking existential vision.

David Hershkovits, in his introduction to the 1987 Japanese edition of *Robert Mapplethorpe*, from Parco publishing, gets it: "Careful and reverent, he humbles himself before the subject and allows it to be."

"A poem," Robert Frost had said, "need not mean but only be."

Robert, indeed, as Witkin hoped, bowed to the power of his medium.

What began as fun turned into philosophy.

Sort of.

The proof lies in his self-portraits. Lay them out in succession from the laughing boy to the dying *éminence grise*.

In his final autobiographical self-portrait, Robert changed the sharp focus on his face in his earlier autopix to a soft focus. In his *ave atque vale*, (hail and farewell) the skull-cane pulls the focus. And Robert's beloved, ravaged face drifts away from the camera like the ghost, the spirit of an ancient Irish story teller.

As with the occult, one can't fool around with art and not eventually get into deep shit. Especially when the art, turned confrontational, questions middle-class fundamentalist perceptions, not just of eros and thanatos, not just of nudity and violence, not just of gender and race and class, but of the human condition.

Photography changed Robert. Its discipline pulled his intellectual

focus together. Film developed his interior life. Always the expansion of one life expands the culture in which it is lived. Robert expanded responsibly: morally, aesthetically, and commercially.

The mature Robert kept mastery of his early glib gifts for superficial glamour even as he introduced more serious material. He came to grips with himself as a person who was an artist. At the beginning, he had no notion that he would transcend himself and master the perfect moment.

The perfect moment of a single frame cancels time.

BLIND MAN'S BLUFF

Mark Walker, in the drawling southern way he talked, showed how significant Robert had been to him during the years when Mark was blind. He spoke the way the blind speak, even after he had regained his sight, illustrating by remembered insight how aesthetic his life had been with Robert in New Orleans.

For eight years, having been sighted until early adulthood, Mark Walker suffered from hereditary retinitis pigmentosa, which made him blind to everything but big blobs of color. An artist himself, Walker, a glassblower, had been, like Robert, sculptural and three-dimensional. Adult blindness depressed him. He wanted to continue working in the arts. That seemed impossible until the supper party, where through the auspices of New Orleans painter-photographer George Dureau and Robert met Mark. Mark had a long, leggy, swimmer's body, much like Robert's, but his hair was blond and his eyes blue.

"I've been described as very like Pan," Mark said.

"You resemble Robert," I said. "He photographed himself as Pan more than once."

"There were facial qualities that I have that he had, especially in the one self-portrait: he's in white face with a skull. Our bone structure, very prominent cheekbones, was similar."

Robert, ever on the lookout for faces that reflected his own, saw that resemblance in Mark when they met. Dureau and Mapplethorpe both knew Mark was desperately broke, but Mark would not take any loans.

Robert, who considered blindness worse than death, suggested that Mark pose as an artist's model. "You can be involved with art and earn a living. You look great," Robert said.

Mark replied, "You don't know what it's like to look into the mirror and not be able to see yourself. Robert began describing me in a way no

one else could. I related to what he told me about myself. He became my mirror."

"He gave you a verbal photograph of yourself," I said.

"Yes. He could say just one or two words and we would connect."

"He was a man of few words."

"The physical part of blindness, figuring where things are, is the easy part. Even movement, for me, was easy as dancing. The weirdest part of blindness is personal communication. Robert somehow broke through my sightlessness. He was like a light. In my mind, I referred to him as my knight in shining black armor."

"He was your seeing-eye photographer."

"You know how people play with movie titles?"

"What movie was Robert?"

"He called himself, *I Am a Camera.*"

"Perfect."

In his collage photograph *Cowboy, 1970*, Robert pasted a cutout of his left eye (the eye *sinister*) completely over the obscured face of the naked cowboy with gun.

"Robert really was my seeing-eye. He was very poetic and romantic. He was personal. He was always explaining visual things to me, wherever we were, in the street, in a coffee shop, in a gallery. One of the things he liked about me was that I didn't react to him the way other people did."

"You didn't fawn on his talent."

"He was my friend. I am not unfamiliar with artists. Before my blindness, I was curator at the New Orleans Historical Collection. I know the difference between a private person and a public person."

"Robert liked that."

"When I went blind, I stopped going to art shows. I stopped going out. I stopped having sex. Because of Robert, I started all that back up. At art openings, people who knew I was coming with him were sure to have something I could touch. Robert was a teacher. He described the art to me."

"His words let you almost see it?"

"Yes. What is really interesting now that I can see again is looking back over old catalogs of shows. His descriptions were so exact. I have many good friends who helped me during that time, both emotionally and visually. The thing about Robert, during all the censorship publicity, is that nobody has mentioned that he was really wonderful."

"The art became bigger than the artist and the censorship became louder than the art."

"His art was very personal. At least with me. The first photograph he shot was very relaxed and playful. He said, 'Don't get caught up in being a blind boy.' He eased me with grace into it. He said, 'There are professional models making six hundred dollars an hour who are not as good as you.' "

"He wasn't patronizing you."

"Quite the opposite. He was an artistic relief for me. A few years before, I had been sculpting in Italy, studying in Murano, an island near Venice, and the way Robert talked to me, I suddenly flashed on my own perceptions of Michelangelo. Robert gave me confidence. He said, 'You can project any quality you want because you really have to see it in your mind's eye. You have an advantage. You can't be distracted by other people's looking.' He talked very much about self-image, and meditation, and conserving my energy. He focused me. It was nothing I had not heard before, but he made it relate to the here and now and made things seem timeless."

"He coached you into perfect moments of transcendence: the universal, the past, the present, the future vision."

"He made me able to glide into forty-five-minute poses. He made it possible for me to go on to work with George Dureau at the New Orleans Academy of Fine Arts, and with several sketch and drawing groups doing studio modeling for figure drawing and portraiture. I was back in the arts and I was supporting myself."

"So Robert found a vocation for you."

"I didn't get caught up in being a blind boy."

Mark saw Robert on three trips to New Orleans from 1980 to 1982. After one of those trips, in January 1981, Robert talked to me of their affair with a kind of passion. As if he were fucking someone whose total vision he could be. Robert took Mark, celibate for more than three years, into his arms. The relief was wonderful. Because AIDS was alarmingly new, Mark had suffered some discrimination from people who thought his blindness was related to the CMV virus. At the school for the blind, he underwent more than twenty AIDS blood tests.

"I didn't know what they were looking for. Then it hit me. They think I have AIDS—which at that time was called GRID."

(Acquired immune deficiency syndrome, AIDS, before it was named, was called GRID: gay-related immune deficiency.)

"Robert had none of this prejudicial fear about you?"

"No. Not at all."

"Everyone was so frightened then."

"Robert gave me the confidence to have leathersex again, to do bondage again, to go out and play publicly."

"He tied you up?"

"Yes. I like to play mutually. Robert and I would fight for the top. That added excitement. I had always been good at tying knots, but, not being able to see, had given all that up. He grounded me with rope the way he had freed me with visual descriptions."

Robert punned on human vision photographing Mark blind and blindfolded. He had a point to make about cultural blindness to art.

Mark said, "Because I was as much a top as Robert, I told him what I told other players. If you like bondage, and if you want to hang around with me, then you have to go out into the streets blindfolded. Just as Robert shared his sight with me, I introduced him to my sightlessness. He was fascinated by the concept. He really got off on it."

Imagine Robert Mapplethorpe in black leather, blindfolded, being led by a blind man, who moved as gracefully as a ballet dancer, through the French Quarter, eating in coffee shops, his mind's eye excited by the denial of sight. In the humid surround of New Orleans, Robert's other senses, subordinate to his dominant vision, were enriching his experience to a multisensual take that later layered into his visual work.

"Robert liked my guiding him back to my apartment. I had to lead him up through the main house, out onto a balcony, and across a balustrade to my living room and bedroom, and then down to my leather playroom on the ground floor. He really got off that my place had once been the slave quarters."

"In what way did he express that?"

"He talked about the energy of the place. He was very sensitive to alternative energies. He imagined what vibrations were stored in the rooms. He talked about slavery."

"Historical enslavement of blacks?"

"Yes. Morally, he couldn't approve of it, but psychologically he was fascinated so that he made connections between historical slavery and contemporary self-bondage through self-censorship. He was very class conscious."

Mapplethorpe, like Wagstaff, like most people when scratched, favored his own gene bank.

"Robert was a sexual magician," I said.

"He was a kind of conjure man," Mark replied.

"You role-played together?"

"We did mutual light bondage, tying ourselves together, making animal sounds, trying to break free of one another."

"He liked the descent to that animality as if he was deconstructing what it was to be human."

"Yes. Animal sounds," Mark said, "very guttural. I had a very understanding S&M dyke landlady who was impressed by him and George Dureau. Their fame, I mean, and that I knew them, and brought Robert to her house. Actually, she helped me hang a sling in the playroom. I already had trapeze rigging, because my regular boyfriend at the time worked for the circus. He was an acrobat, but he wasn't around very much."

"Robert loved acrobats."

"A most wonderful night we were doing animal sounds. Did I tell you he was most always blindfolded when we played? We were surrounded by all this circus equipment and we centered down onto one little piece of leather and one little piece of rope. We kept wrapping it around each other's hands, so one or the other of us couldn't touch or see. He said he had never really enjoyed that with anyone else."

"Robert often licked my eyes," I said. "Almost as if he were anointing my vision. Your blindness and my sight were two sides of his investigation into human vision."

"Robert made S&M very personal. He gave us the freedom to experiment."

"In those slave quarters, was Robert fascinated in any way you remember about blacks?"

"That fascination I lacked, because I knew a lot of the blacks George Dureau was into. I didn't trust them. I must explain that while I was blind, I was mugged three times by black guys on the street, usually someone into drugs."

"Perhaps you were being mugged by drugs and poverty personified by people who just happened to be black," I said.

"I'd like to think so. Even though I'm a southerner, I've always been for liberation and equal rights, much more so than the average liberal, but, being blind, that was a hard one for me."

"Now that you can see, what are your feelings about Robert's photo-graphs of you?"

"They're wonderful. At least the ones I've seen. There's one in his *X Portfolio*. He shot some duos of me with Diana Dexter and also with Wally Sherwood that I haven't seen."

"There's a great deal of Mapplethorpe work that has not surfaced. Some people claim he was very tight in handing out photographs, but many of the people he shot have one or two," I said.

"There must be a large body of his work out there."

"Certainly. Stuff that no museum or even the Mapplethorpe Founda-tion has seen."

"He shot Cynthia Slater many times."

"She died, you know. I have many of her unpublished stories which she sent me."

"I'm sorry. She was a wonderful lady."

Cynthia Slater was one of the few women in the seventies allowed in as a regular at Steve McEachern's Catacombs, a private handballing palace he had constructed in the basement of his Victorian on Twenty-first Street in San Francisco. She was one of those lusty women who remained a woman even when she was one of the boys. She was one of the original founders of the omnisexual S&M club, The Janus Society. At an early Janus meeting, we sat in a circle, each one of us pledged to confess that one element we found necessary to make a sex scene perfect. She and I both said, "Pain," and we embraced. Later, in an affairette with my brother, a Vietnam vet, she played "Downed American Fly-Boy" games, until she didn't, until the night she invited my brother out to a stylish supper and told him it was over. Edward De Celle, whose San Francisco gallery first championed Robert, has two of the Slater photographs, which he finds mercilessly harsh.

"Cynthia," Mark said, "was good friends with Diana Dexter. Both of them were quite wonderful in helping me adjust to adult blindness."

"Sometimes we don't have to depend on the kindness of strangers."

"Not with such friends. Robert photographed Dex in New York and again in 1978 at a party in Sausalito where somebody had an elaborate dungeon and playroom."

"Robert shot quite a few photographs as a result of that night," I said.

"Weren't a lot of those in the *X Portfolio*?"

"The title of the *X Portfolio* came from that party."

"Robert had a lot of connections that I don't know much about."

"He thrived on keeping his big circle of friends secret. He was as much social director as film director. He was very secretive about whom he knew," I said, then added, "How did you feel being shot by him with a woman?"

"With Diana Dexter? Fine. Dex was the only woman I've ever posed with. We went to high school together. She worked for the Ford Agency. She was like a very young Liz Taylor. She's dead now."

"At least her photographs remain. I'm sorry you lost her."

"I'll never forget at one point during the shoot, I was lying on my back. Dex had on these severe stiletto-spiked heels, boots, really, that came up about mid-thigh. Robert told her to put the ball of her foot on my forehead. I was in complete leather, with one leg out straight and the other bent up. Robert pictured me trying to lick up to the insole of her spiked heel."

"That was a very intense photograph."

"Believe it or not, Robert marketed it to *Le Figaro* in Paris for a Thom McCann shoe ad."

"Mapplethorpe was a drummer."

"Our shoot was really relaxed and childlike. Dex and I felt innocent playing in front of Robert. He was not judgmental of the act before the camera. What he wanted was for us to be ourselves while he found the look, the angle, and the balance. He wanted balance without symmetry. If I had one hand with the forefinger closed, he wanted all the fingers on the other hand spread. He was my mirror. He wanted every fine detail with elegance."

"When did you last communicate with Robert?"

"The year before he got really sick. Nineteen eighty-three. Nineteen eighty-four."

"Did you write or send tapes?"

"At that time it was Braille or tapes. Mainly, we talked at night."

"That's how we finished up, late at night, on the phone, at long-distance."

In 1983, Mark Walker moved to a twenty-two-room Victorian in San Francisco, where he co-published *New Sex Magazine*, an erotic post-AIDS journal.

"Robert let me see my real self," Mark said. "I was blind, but I could see."

WHITE ART, BLACK MEN
RACISM IS ESSENTIALLY SEX

Race fascinated Robert Mapplethorpe as much as sex and more than gender.

The only self-portrait that even the shocking Mapplethorpe could never exhibit was himself made up in black face.

In 1979, Robert sat bolt upright, startled erotically, by William Friedkin's searing screenplay, *Cruising*, which captured precisely the dangers and excitement of leathersex in the New York nightlife that was Robert's milieu.

Thirty minutes into the controversial film, star Al Pacino resists—because he is an undercover cop—interrogation by cops who do not know his identity.

Suddenly, a door opens.

A huge black man strides tall into the room.

He is built like a linebacker.

He wears only cowboy boots, cowboy hat, and a white jockstrap. He backhands Pacino, sending him flying across the room.

Wordlessly, he exits.

"What the shit was that?" Pacino asks.

Robert knew.

Epiphany!

Friedkin shocked him to a new crystalline vision: the erotic power of the black male.

Illuminated by that seminal moment, Robert dared confront his curiosity about masculinity and about race. Earlier, in 1976, Robert told Boyd MacDonald in the premier underground erotic magazine *The Manhattan Review of Unnatural Acts*, also called *Straight to Hell*, that his favorite movie

was *Mandingo*. Based on Kyle Onstott's Falconhurst series, the movie presented blacks as serious sex objects of white desire. This was a fresh spin on the pop stereotype of black men as sexual predators hunting white women.

At a grind house on Market Street in San Francisco, in 1978, before video rentals shut down twelfth-run theaters where patrons' feet stick to the floor, Robert, who was very selective about the rare movie he saw, insisted we go together to see *Mandingo*.

"We've both already seen it," I said.

"We need to see it together."

Gone With the Wind had avoided the issue of black men by desexing all blacks into Mammies and Toms.

Mandingo exploited the libidinous attraction of the white plantation lady, Susan George, to the handsomely built black slave, Ken Norton.

Critics hated *Mandingo*. Liberal whites were embarrassed. Some blacks loved it. *Mandingo* was a pop morality play of white sexual lust that ends in racial violence, which is always sexual violence.

Mandingo popularly reflects the honest sexual attitude of the Sexualizing Seventies toward race relations. In pop culture, no black woman has yet become a sex icon to mainstream America. But plenty of black men have long had romantic or athletic sex appeal that sells tickets at the box office and at the stadium: Poitier, Belafonte, Ali, Johnny Mathis, Billy Dee Williams, Ken Norton, and Magic Johnson.

Robert's sex-race curiosity found instant gratification in *Mandingo*. Only sexually was Robert multicultural. He liked the street-chic crowd in the Market Street theater: mostly young, male blacks in Afro haircuts, dashikis, and blue wool watch caps. The culturally participatory crowd, raised on interactive religion, were eating, smoking, talking, shouting at the screen with more spontaneity than staid white culture—including the with-it white crowds acting out the Saturday midnight ritual screenings of *The Rocky Horror Picture Show*.

Up to the 1980s, twenty-four-hour grind movie theaters gave homes to the homeless. They were street people's entertainment and shelter. (This particular Market Street theater was torn down and rebuilt as another link in the consumer chain of The Gap.)

The audience knew *Mandingo* by heart. They yelled hip responses at the screen. When the blonde actress Susan George called the boxing champion Ken Norton to her four-poster, she was slathering lust. He was

black pride: heroically muscular body stripped to the waist; wearing only a pair of soft white cotton pants. He stood, back to the camera, as she crawled across the bed, reached up, pulled the drawstring knot of his pants—a very long drawstring that, as she pulled it, caused his white cotton pants to slide ever so slowly down his beautiful black butt.

The crowd grew increasingly Uh-HUH at the wantonness of this rich white lady. As Ken Norton's butt appeared, and Susan dived down under the drawstring, a black male voice in the audience shouted out with full-soul inflection: "Howl-leeeee-wooooood!"

Robert and I, leering at the scene, and even more at the crowd's cheering response, squeezed hands together under the arm of the theater seat.

"See what I mean?" he said.

Robert found in *Mandingo* a certain pop culture confidence to proceed into sex and race.

Wally Wallace was founding owner of the after-hours orgy club, the Mine Shaft. The orgy club was to male sex and drugs what CBGB was to punk music and drugs and what Studio 54 was to celebrity schmoozing and drugs.* The three clubs' name lists overlapped. Not everyone went to CBGB or Studio 54, but sooner or later everyone came to the Mine Shaft, where sex, not status, ruled.

The Mine Shaft was located on the West Side of Manhattan, at 835 Washington Street. Its Joe-Sent-Me entrance swung open between the multiple sides of raw beef hanging from hooks over the loading dock, where men in bloody white coats tossed carcasses in the wee hours of the morning. It opened in October 1976 and was closed on November 7, 1985, by the New York City Department of Health.

The action was leathersex.

The clientele was leathermen, laced with celebrities out slumming. One night, Robert, quite thrilled, said he had seen Mick Jagger turned away at the door, not because he was Mick Jagger, which counted for nothing once inside, but because he was with a woman. (Women, disguised as men, often made it into the Mine Shaft. In fact, more than one woman, aided in disguise by her escort Mapplethorpe, spent a splendid night of active orality and fisting at the Mine Shaft.)

* Wally Wallace opened the Mine Shaft in 1976. Hilly Kristal founded CBGB in 1973 and opened to punk and new wavers in 1974; Camille O'Grady and Patti Smith both appeared at CBGB. Steve Rubell and Ian Schrager opened the Studio 54 disco in spring 1977.

Robert asked Wally, the source of all New York sexual information, about, in Robert's term, "nigger" bars.

"I told him about the black bars," Wally said, "but he was scared. He kept after me, so I took him there myself. I'd never seen Bob so nervous. He had shot a few black men previously, but they had been gay black men, some of them professional models. I knew Bob. He wanted the danger of the real thing."

Wally Wallace is one of the few people ever to call Robert Mapplethorpe "Bob."

Diffidently moving into his "*Mandingo* Period," shooting rugged black men, Robert wrote me, "I'm still into Niggers. I even have a button on my leather jacket that spells it out when I hit the bars. It seems to attract them."

Attract them, he did.

Robert pushed the then accepted taste of race, which is a category of sex, by exposing the body of the nude black male, which is twice as verboten as the nude white male.

He worked with a double edge.

He could invest his art with a certain ambiguity that often made viewers feel that maybe they were the butt of some smartass joke.

"If you flinch, you lose." Double-dare spin was the prime secret of his success.

For instance: he could make polite nudes seem somehow buck naked.

He blurred the line between the received conventions of art and the sexual frontiers of art. In his technique, he used classic values. He invoked formalist style. He used beauty, and art for art's sake, to tweak the received taste of what was beautiful and what was art.

Robert, first famous as a collector and then as a photographer, was not particularly dedicated to inscribing the African cultural contribution into the white history of art.

He wanted to sell photographs to his target market, the radical chic, who had attended Leonard Bernstein's fund-raising party for the Black Panthers in 1970. Agnès Varda, a filmic equivalent of Cartier-Bresson, had made her films, *Black Panthers* and *Lion's Love* (1969), back to back. *Lion's Love* starred Warhol superstar Viva, the authors of *Hair*, Gerome Ragni and James Rado, and filmmaker Shirley Clarke.

By 1970, many photographers merchandised the collision of white beauty and white sex. Few, if any, artists presented images of blacks. Warhol

approached the subject in his 1964 silkscreen *Race Riot*, which Robert eventually folded into his personal art collection.

The seventies were Robert's time for his secret, sexual exploration of black men. Leathersex had led to the leather photographs. "Nigger sex" led to the black photographs that debuted in the eighties. Blacks had crossed over the same way gays crossed over. Race and sex: blacks and gays. To the mix, Robert carried camera and a checkbook.

The blackening of white America happened in sync with the queening of straight America.

Seventies alternative pop culture blew out the jams. Mainstream America was never to be the same again, despite the Republican regency, southern politicians, and fundamental religionists seeking a restoration of the old, white, and straight patriarchy.

In 1977, pop icon Warren Beatty was dating Iman, one of the most beautiful of the black women beginning to appear in the world of fashion photography that Robert covered for *Vogue*, Italian *Vogue*, and *Vogue France*.

Black women in fashion introduced a new elegance.

Black men in photography remained problematic.

Images of black males began to cross over only in the work of male photographers shooting for gay erotic publications interested in sporadic novelty picture spreads on astounding genital size.

The male frontal nude would not exist were it not for gay photographers and the gay audience.

Despite Lorena Bobbitt's cutting her way into nineties folklore, straight women generally are interested in the whole man, not his penis. Straight men generally do not want to see any penis because all penises invite comparison.

Photographer Jim French, in his Colt Studio work, is basically the only gay photographer balancing fine art with fine erotica. French is, arguably, one of the most consistent if not one of the best American photographers of males in this century. He knows the art of public taste, popular culture, and successful commerce. One day, an exhibition called "Jim French and Robert Mapplethorpe" will be revealing.

French and Mapplethorpe shared at least one model, the exquisite blond bodybuilder, Roger Koch, known in Colt films and the underground videos of Christopher Rage as "Frank Vickers." For French, Frank wore leather. For Mapplethorpe, Roger wore mesh stockings. On his

deathbed, Roger told me, "I have nothing good to say about Robert Mapplethorpe." Robert was difficult. For friends and models.

Mapplethorpe models, black and white, were often recruited from the ambitious world of erotic video. They often resurfaced on adult screens advertising that they, "live on stage," had once been a "Mapplethorpe Model."

French's work with blacks is far less threatening than Robert's. Mr. America, French's black superstar, Chris Dickerson, does not disturb the viewer the way that Mapplethorpe's photograph *Michael Spencer, 1983* turns a rugged black man in white thermal underpants into raw sexual power.★

Robert picked up on the seventies' West Coast "porno" success with black men. He admired photographers Jim French and Calvin Anderson, and artists Tom of Finland and Bill (The Hun) Schmeling. As a collector with Wagstaff, Robert was also well aware of New Orleans's painter-photographer George Dureau's nude studies of black males. Robert sensed an untapped Manhattan market for this new subject matter: black males.

He took race and sex up from the trend-setting gay subculture and mainlined it into the gold veins of Manhattan.

Almost ten years of personal sexual and racial experimentation passed from Robert's initial "plantation" fetish for black men, whom he wanted as sex slaves, to the publicly "corrected" aesthetic of his *Black Book* in 1986. He realized he could market only race, not racism.

Conventional wisdom in the politically correct eighties, when Robert shot the majority of his black men, levitated Robert above seventies "blaxploitation" movies. No one objected when Lili Tomlin darkened her face to play a black man on stage and screen. In 1993, the PC (Politically Correct) crowd freaked out when Ted Danson put on black face to entertain his then intimate, Whoopi Goldberg, who as a black woman had to defend Danson and herself in the media for their consensual sex-and-race humor at the New York Friars' Club, which holds nothing sacred.

Meanwhile, African culture, having entered white politics, began to inscribe its image into the apartheid of the art of photography.

Robert's timing was astute.

In 1982, the Harlem Exhibition Space, in New York, included him in

★ Mr. America, Colt Studios model Chris Dickerson, commissioned an inter-racial drawing from Bill Schmeling, "The Hun," in 1984.

the group show "The Black Male Image." In 1984, Robert's *Ken Moody, Stern Magazine* dramatized a nude black male "selling" a woman's shoe with a tangible edge of high-fashion fetish. In 1986, Robert triumphed with the lyric mandingo *pas de deux* of *Thomas and Dovanna*. In June 1988, *Harper's* designed its cover around his photograph, *Robert Sherman and Ken Moody*, white and black, both bald and in profile, to illustrate Shelby White's lead feature, "I'm Black, You're White, Who's Innocent? Race and Power in an Age of Shame."

Talk about *spin!*

Robert, whitebread from Queens, no matter what his motivation, had crossed the racial barrier as a hero. He broke apartheid in photography the same way apartheid in South Africa was broken: economic sanctions.

Robert's new goods sold, but not without some controversy.

Gay culture has always required an explanation of Mapplethorpe, because gay culture's obsession with politics, which, way more than AIDS, keeps it from truly mainstreaming itself, envies and can't comprehend a famous queer who was about as politically correct as Eva Perón.

Gay culture, wanting explanation of Mapplethorpe, has fingered me as his friend, his lover, his publisher, his biographer, and his "widow," when in reality I am only one of his friends, one of his lovers, one of his publishers, one of his biographers, and one of his "widows."

In the eighties, the gay group called "Black Men and White Men Together" had debated Mapplethorpe's point of view. So had the Avatar Leather Organization in Los Angeles, on June 27, 1990, to whom I presented a lecture on Robert Mapplethorpe coincident with Nelson Mandela's first visit to Southern California.

Previously, the first OutWrite Conference was held Saturday and Sunday, March 3 and 4, 1990, at the Cathedral Hill Hotel with Allen Ginsberg as keynote speaker. Mark Hemry had videotaped a panel I was supposed to address on the subject "Censorship of Gay and Lesbian Art in the Age of Helms and Mapplethorpe." The subject could not be addressed because a PC brawl erupted between some gay men and some lesbian separatist feminists. Hemry captured it for posterity with his video camera. The Zapruder-like footage exists in gay pop culture archives.

In the aftermath, in the lobby of the hotel, some gay black men, hot on the topic of my panel, accused Robert's work of exploiting race. Lesbian black women deemed him acceptable, because he at least made black people visible.

Robert, fascinated by black leather against white skin, felt black skin was exotic as black leather.

He fetishized both.

Los Angeles erotic-art photographer Mikal Bales expressed his own feeling of what his gay kinsman Robert felt when a white boy looks at blacks. Bales's Zeus Studios often features muscular black men in bondage, not as slaves, but as captured hypermasculine heroes.

"In 1967, when I was in the Peace Corps in Nigeria," Bales said, "I was the only white. Everyone around me was black. It shocked my eye when I would reach out my arm and see my white hand against the others' black skin. I felt outlandish. Literally strange to myself. At first, their blackness made them all look the same to my white eye. Soon I could discern the difference. I was astounded at their individual and collective beauty, which white media had effectively, and so mistakenly, censored from my eye and consciousness. This was not Bojangles or Superfly. These were people."

That had been my own experience in the summer of 1961, when, as a Catholic seminarian, tutored by Saul Alinsky, I was engaged as a social worker by The Woodlawn Organization (TWO), knocking door-to-door in tenements, explaining to rural blacks fresh to Chicago's South Side, Sixty-third and Cottage Grove, what urban resources were available where.

Robert teased me of being racially chic before it was fashionable. He questioned my religious motives. Did I find blacks sexually attractive? He said he guessed it was all right for me to be carried bodily by the Chicago police out of Mayor Daley's office. He confessed he'd never do that, not even with Martin Luther King leading the sit-in.

"You never wanted to fuck them?" Robert said.

I was a seminarian, a very young seminarian. At the time, sex wasn't something that I did. Sex was something I kept people from doing.

"Oh, Jack!" Robert laughed and laughed. "You missed the opportunity of a lifetime."

Robert related to athletic blacks who were genitally endowed, in order to marry the threat of race with the threat of sex. He was, in his adopted "European" way, picking up on Leni Riefenstahl. They had met in Manhattan. She had shot both the perfect moments of bodies in her 1936 *Olympic Games*, as well as the mystique of blacks. (Riefenstahl's 1935 *Triumph of the Will* is the most powerful propaganda film of the twentieth

century.) The never-ending racial controversy over Riefenstahl anticipated the moral furor over Mapplethorpe.

Robert's cannily mixed race and sex is evidenced in his *Bob Love, 1979, Philip, 1980, Man in Polyester Suit, 1980*, the white oral-sexing of the black in *Marty and Hank, 1982*, the phallic equation of calla lilies in *Dennis Speight, 1983* and *Thomas, 1986* with Thomas's *Navel, 1986*. (Thomas's navel is shaped to suggest a second set of male genitalia.)

Robert's dismissal of white endowment is the very early photograph of the white leatherman, *Mark Stevens (Mr. 10½), 1976*, who was the Caucasian exception, not the rule.

Robert Mapplethorpe was a size queen.

What man isn't? (If not for penis, for breasts.)

Robert ritualized black men for sex. He was like Holden Caulfield who thought he was not a man until he had made it with a black woman. In a sense, because the black photographs buzz a running subtext to the leather photographs, white-southern senator Jesse Helms may have had no more quarrel than a bad case of sex-race penis envy.

Racism is essentially sexual fear.

Robert enjoyed confronting his white patrons, especially women, with photographs of black men and black penises. He played "chicken" with clients. "If you don't like this photograph," Robert implied, "you're not as avant-garde as you think. You don't belong in this gallery."

He capered through dialogue: "Black guys are hung bigger, except for the ones who date white chicks."

Robert used sex to audition models: leathermen and black men. As scary as S&M leather was, blacks were more so when Robert objectified blackness into a mix of sexual threat and aesthetic beauty.

Again: the blackening of America and the queening of America.

Mapplethorpe's black photographs are chic advertisements of miscegenation. He dramatized black men as desirable sex partners to a nation that for three centuries had lived in sexual fear of black men. His mandingos make his white men look like wimps. His blacks are fuckers.

If ever Robert shot truly sexy photographs, look not at the drama-queen sexuality of his leather period, nor at his below-freezing nude females. Attention must be paid to his black men.

His 1976 "white" celebrity portrait of bodybuilder Arnold Schwarzenegger is cold statuary compared with the heat of his 1986 "black" celebrity portraits of Joe Morris kneeling over a barbell and Terry Long

sweating in a shoulder-shrug cropped so tight that his facial expression might be interpreted as orgasmic and the composition of head and neck as phallic.

It was perfect marketing in the AIDS eighties, where sex equaled death. AIDS was too popular a drama for him to be excluded. He made choices. In his life and in his art. In his own psyche, Robert changed from archetypal young faun to archetypal dying man reaching for universal immortality.

Robert courted love and death, sex and danger, in the faces and bodies of black men. That's what he paid for when he picked a black man off the street. He chose the same kind of "upscale nigger" for a model as he chose for an "uppity nigger" sex partner.

He wanted a black man made as compliant by money as he was defiant because of the money.

He wanted "niggers" he could buy for his racy sex games in his bed and in his studio.

He wanted them compliant enough to take direction.

He wanted them defiant enough to require him to be either their "massa" in his bed or their director in his studio.

Defiance keeps models from being mere objects, because a defiant person exerts a personality, an energy that defies the camera's inherent objectification. That's why Robert "entered" his work with hired black models with more vigor than he "assayed" his leathersex work.

The black models surrendered with a conditional edge.

Robert was artist enough to know he had to move his art on to black men, the way Tennessee Williams, tired of blond meat, had moved on to dark in *Suddenly Last Summer*. In the seventies, the decade of black music, black magic, Black Power, Black Panthers, and the Symbionese Liberation Army, black males' inherent defiance was Robert's way of realigning hot spin on the cold axis of his formal work. In the Warhol-connected Broadway musical, *Hair*, Robert had heard the song sung by both men and women: "Black boys are delicious. Chocolate-flavored treats. . . ."

Robert recognized his main aesthetic flaw: by sheer force of "Being Mapplethorpe," he turned models into objects.

By sheer force of his earlier vocation to sculpture, he turned people to stone. He assaulted the individuality of the human persona with his camera. He poured cold beauty on mortal flesh. He couldn't even leave a

leaf alone. He was always the sculptor, always the transcendentalist, always the symbolist.

Every "lily-white" portrait he ever created is summed up in his quintessential sculpture-photograph, *Apollo 1988*, which he approved specifically for the cover of *Robert Mapplethorpe*. The book's occasion was his virtually terminal exhibition at the Whitney Museum in 1988.

Robert, the dying Catholic iconographer, rubbed the cold marble profile with his hand and wet its lips with his breath.

The "sweat" on the marble face is a tricky take, a self-photograph preciously objectified. As if the statue has life. As if Mapplethorpe will soon be cold as memorial stone on a knight's sarcophagus.

Apollo 1988 is an autobiographical photograph of the finger grease of Robert's touch and the condensation of Robert's breath.

It is perfect valedictory, frozen in the perfect moment.

Robert clobbered anyone and everyone. He used money, fame, drugs, or whatever he needed to exert his will. Life was easy. Everyone was caving in to Mapplethorpe. How could he create a "perfect moment" without resistance? By the early eighties, Robert was disdainful of everything and everyone, because whatever Mapplethorpe wanted Mapplethorpe got. He wanted people to resist him.

"You are a petulant bastard," I told him.

My resistance to him added longevity to our relationship.

People wonder how intimate friends withstood Mapplethorpe's hubris. If his character was flawed, his flaw was the caliber of Greek drama. His wanton arrogance required wanton insolence.

The naughty white boy wanted someone to be as insolent to him as he was to the world.

He hoped blacks would deliver insolent heat to his frigid work, and animate his art with "soul."

He hoped someday he would meet his own powerful Cinque, who would radicalize his work the way Cinque, the black leader of the Symbionese Liberation Army, had changed kidnapped heiress Patty Hearst into a gun-toting bank robber demanding cash from moneyed people cowed into submission. He even shot an advertisement for himself as white gangster with machine gun.

He hoped to find a black man who would change his life in a black way as Sam Wagstaff had changed his life in a white way. He chased black men.

"I have no shame," he said. He hoped in the perfect moment of sex to find the perfect moment of death.

He hoped someday a black would kill him.

When it came to real sex, Robert didn't have a clue about leather, fisting, or fetish sex. He sometimes seemed like a scared heterosexual posing as a homosexual, putting on his alternate sexuality the way he pulled on his leather pants.

One of the most handsome of his black models, Joe Simmons, went on to make erotic gangbang videos in New York for late director Christopher Rage. Simmons then took his solo performance-art act out nationally to the gay theaters: "LIVE ON STAGE! MAPPLETHORPE MODEL! JOE SIMMONS!" His priapic onanism on stage caused onanism in the SRO audiences.

His black work, not his leather, is the closest Robert comes to fulfilling his reputation as an erotic photographer. Sex in Mapplethorpe's world is never procreational. Sex is always recreational.

In American popular culture, Robert is a high-toned NY-Gershwin version of the race culture Hollywood ground out in movies from the 1930s through the 1950s to cash in on the sex appeal of actresses like the black Marilyn Monroe, Dorothy Dandridge. The pop culture taste for underground race and sex is as old as Cain's being called black.

Technically, in lighting, black skin presented Mapplethorpe a photographic challenge different from white skin. Also, because blacks are only sporadically visible in the history of photography, Robert could not fall back and reshoot historical photographs of blacks as interpreted by earlier photographers.

Photography's brief history began, really, less than a decade before the American Civil War. In 1840, the camera took from eight to twenty hours to shoot one single frame. By 1850, a single exposure was two minutes or less. Photography, like the novel, was a luxurious art seemingly destined for the idle rich. No one early on suspected everyone would become a photographer shooting mass images in mass culture.

The imprint of black men and black women in the art of photography is as model, not as photographer. White photographers who shot the occasional black included: Louise Dahl-Wolfe, fashion photographer for *Vogue*, who also shot calla lilies; Edward Weston who shot one black female; and Eikoh Hosoe, Tokyo 1977, who shot strikingly pre-Mapplethorpe black-and-white duos.

Painter-photographer George Dureau was prime tutor to Mapplethorpe.

The second most influential photographer was Miles Everett, who had three distinct virtues Robert loved: the elderly Everett, who lived in Los Angeles, was unexhibited, unpublished, and unknown in New York City.

As really the first collectors of photography, Mapplethorpe and Wagstaff created a market for the contemporary photograph by initiating a craze for the historical photographs they bought inexpensively. With antique photography they had found, at last, a genre the ubiquitous Andy Warhol had not staked out.

Without many "race" photographs to reference, Robert educated himself in the art of shooting blacks by studying work he could find, and by visiting photographers such as the famous Dureau in New Orleans and the unfamous Everett in Los Angeles.

Robert, as lucky as he was absorbent of other photographers' work, met the over-eighty shooter, Miles Everett, at a private Los Angeles exhibition for gays in the late seventies.

Robert was yet a neophyte, lusting after blacks.

Miles, a white man, an octogenerian, was a veteran.

Blacks photographing blacks was then virtually uncharted, exotic territory for white culture. *Playboy* displayed its first black Playmate, Jennifer Jackson, in March 1965. *Ebony* magazine, a black *Life* magazine look-alike, had flourished since 1945, but rarely crossed over to white culture. Ralph Ginzburg's counterculture *Avant Garde* magazine, which flourished briefly to very hip white acclaim, published a cover and a spread on black photographer Hugh Bell's female models, "Bell's Belles," in the May 1970 issue.

The feature was introduced with a cropped waist-high nude shot of the black male photographer. No other men were shown.

Bell's black women were presented nonexploitatively, nude, in full-body shots, but with genitalia masked with hands and flowers. Frontal nudity in mainstream media was only just becoming legal. Ginzburg had already suffered court trials and censorship with his *Eros* magazine.

As artsy as Ginzburg's *Avant Garde* was, it offered a beginning access to the pop culture literature of the black body, even as it bowed, like historical litmus, to the sexual fears of black beauty.

In 1974, photographer George Butler and writer Charles Gaines

collaborated on the wildly popular book *Pumping Iron: The Art and Sport of Bodybuilding*. Physique posing quickly moved out of sleazy gyms directly into the showbiz mainstream.

Butler's photographs emphasized two things: Arnold Schwarzenegger and black musclemen.

Robert hated bodybuilding the way he hated blacks: he couldn't get enough.

By 1976, Robert, appreciating the sculpture of muscle, had shot Schwarzenegger on his way to co-creating the first female bodybuilder, Lisa Lyon, and to shooting my then lover, bodybuilding champion Jim Enger, who modeled his own muscle and look on the drop-dead gorgeous 1967 Mr. America, Jim Haislip.

Robert coveted Butler's photographs of black bodybuilders like Serge Nubret, Leon Brown, and Gordon Babb, displayed next to antique photographs of strongmen, including 1951 Mr. Universe, the black Montosh Roy, who posed for fantasy photographs, not nude, but suggestive of the "Young Physique" magazines Robert had come out on in the adult bookstores on Forty-second Street.

Bodybuilding's sudden popularity seemed sexy. Robert watched how display of the "Object Body" as "Object Physique" brought phallic bodies up from the underground magazines that he had already used in his earliest collage work: *Leatherman II 1970* and *Model Parade 1972*.★

Traditionally, the words *artists and models* were code for *johns and whores/hustlers*.

To legitimize itself from this stigma, bodybuilding often referenced classic statuary. Gaines's pop-seminal *Pumping Iron* called bodybuilders "living sculpture."

A point was made that in biblical myth, God is portrayed as a sculptor

★ So in tune were we even before we met that I had in my own collection the 1968 magazine *King's Leather Men*, from Calafran Enterprises, Inc., San Francisco. I had bought it in 1969 on Forty-second Street. The warning inside the cover typifies the moral climate of the time and the "purpose" of these underground magazines: "*King's Leather Men* is produced to provide a collection of photo reference studies to be used by the Artist and Art Student in his studies of anatomy and the posing of the model. While it is always preferable to use a live model, photographs can provide an invaluable reference when a professional model cannot be obtained. Those desiring erotic or prurient material are warned that such is not to be found in this product, nor is it our intention to provide material of such a nature. . . . Beware of cheap copies and duplicates of our work, which cannot compare in quality and detail."

to such a degree that God maintained copyright in the Third Commandment, which warned against sculpting images not in God's likeness.

Bodybuilders Frank Zane, Ed Corney, and Arnold Schwarzenegger have all explained themselves in terms of classical sculpture as they offered their bodies up as photo ops.

Charles Gaines said in his lecture at the Whitney: "Physique posing is a kinetic art. . . . Posing is the presentation; the physique is the object being presented." This, of course, fit in with the formal direction sculptor Mapplethorpe was heading.

Bodybuilding, among other sports, gave blacks another athletic venue. But bodybuilding is not an objective sport like basketball, in which the ball either goes through the hoop or not.

Bodybuilding is rather a subjective sport that has historically always been judged in terms of classical size, look, and myth.

On Wednesday, February 25, 1976, Schwarzenegger appeared live, as a performance artist, posing, one night only, at the Whitney Museum of American Art. Presenting Schwarzenegger with the bodybuilders Frank Zane and Ed Corney were *Pumping Iron* authors, Charles Gaines and George Butler.

They were all "Exhibit A" for the panelists debating a kind of pop culture wrestling chautauqua of "Mind versus Body." The panel included professors of fine arts from NYU, of English and comparative literature from Richmond College, and of the Art Department at Rutgers. They were all male and made legitimate by the gender of the assertive moderator, Vicki Goldberg.

That night at the Whitney was historical for itself and for its directly quoted reference of the night nearly 170 years before when Lord Elgin brought the Parthenon marbles to London.

"In June 1808," Goldberg said, "the famous prizefighter Gregson was induced to stand naked in the museum and pose for two hours in various attitudes so that his anatomy could be compared with that of the statues."

Intellectual sex—Mapplethorpe's favorite kind—has always been deliciously prurient.

At the Whitney that night, Schwarzenegger and Ed Corney and Frank Zane posed on a revolving platform. The SRO crowd went wild. The scene was a gladiator-slave show "straight" out of a Fellini coliseum in ancient, decadent Rome.

Candice Bergen, shooting photos for the NBC *Today* show, made her

way through the thronged artists, fashion models, and jet-set rich for whom Mapplethorpe was licking his chops.

As the symposium concluded, Robert worked his way to the green room, where the musclemen were holding court and signing autographs. He invited them to pose for him at his Bond Street studio. Schwarzenegger, the most self-promoting of the three, recognized a kindred soul in Robert Mapplethorpe. Robert, the sculptor, was the first contemporary fine art photographer to explore bodybuilding's *objet d'art* aspirations to classical sculpture.

Also, that night at the Whitney was filmed by George Butler's movie crew for the film *Pumping Iron*.

No one yet could acknowledge directly that humans are essentially voyeurs.

Bodybuilders go beyond the well-proportioned nudes of art history into the aggressive naked superheroes of mass media.★

The lost war in Vietnam required a home-front reinforcement of American masculinity. If the United States had not been losing the unpopular Vietnam War right at the popular rise of feminism, feminism would not likely so quickly have gotten its leg up on men.

In a country where biggest is best, bodybuilding, maybe as compensation for a war lost and for women marching, became the next pop cult attraction. Women and men, both coached by the sexual politics of the open seventies, had to adjust their post-Victorian ambivalence to a new erotic icon. As women grew more powerful, men grew bigger. Why deny that bodybuilders stuff 220 pounds of male into two-ounce posing briefs!

These pumped and articulated pioneers introduced the virtually nude male with the pop art message: "Straight women love bodybuilders and straight men want to be like bodybuilders."

Straight society was at sixes and sevens about such aggressive masculine behavior. Psychologists speculated: "Is the goal of steroids to create a thousand-pound bodybuilder?"

★ Schwarzenegger's career, no matter what he is personally, is symbolic of the kind of classically overwrought sculpture that becomes the superhero, the *übermensch*, who is a larger-than-life statement of national virility, much like Mussolini's fascistically homoerotic statues commissioned for the Foro Italico. The "lost war" of Schwarzenegger's Austrian past has always provided a kind of romantic subtext. I photographed Arnold Schwarzenegger in paparazzi shots from the hip in May 1970 at the Venice Beach muscle pit. Actually, Arnold walked into my 35-mm color shots of the strawberry-blond bodybuilder Ken Waller.

On the other hand, the unexpected male aggression of gay liberation, newborn at the Greenwich Village Stonewall Rebellion in 1969, welcomed the heroic iconography of bodybuilders with open arms. Bodybuilding, like the male frontal nude, would not exist were it not for gay photographers and the gay audience.

Finally, out of the closet came male sex objects as delightfully exaggerated as any Hollywood female sex object.

Gay liberation was not invented to be politically correct.

Gay liberation was invented to party without getting arrested.

The way black liberation was spontaneously invented to get a seat on a bus without getting arrested by fascists.

In that first decade of gay liberation, bodybuilders (no matter what their personal sexuality) became sex objects. The openly gay gym was invented. This gay-driven rise of bodybuilding elevated black men as well as white men to erotically perceived media status.

In 1976, screenwriter Sylvester Stallone set the Hollywood craze for bodybuilding in the first *Rocky*, which proved in cash the worldwide race interest in a muscular white man (Stallone) and muscular black man (Carl Weathers) fighting nearly naked in a ring. Stallone's success paved the way for screenwriter John Milius's *Conan the Barbarian*: bodybuilder Schwarzenegger and voice-builder James Earl Jones parry white and black themes by never referencing race in a medium that is essentially visual.

Before bodybuilding, photographs of blacks were of the historical and anthropological kind. The *National Geographic* provided many a white boy's fantasy material directly about breasts and indirectly about blacks, until the *Geographic* updated its policy away from objectifying native cultures and turned instead to environmental concerns.

Robert, not yet nationally known, was creating self-conscious New York art when fate introduced him to the West Coast photographer Miles Everett. Miles fascinated Robert, because Miles, during his long career, had never bothered to stage an exhibit in a gallery.

Robert was stunned by Miles's avoidance of fame.

"I had never thought of fame as a requirement for life," Miles said. "Bill Schmeling, the painter, introduced me to Robert. Bill also knew Lizard, who was Robert's friend."

Robert knew Lizard better than Miles realized. The handsome Lizard was a star who was famous for his leathersex in clubs. He was one of the intimates Robert tried to appropriate to himself.

We were all longtime friends together and singly in the communal seventies.

And then Robert would ride in and try to divide and conquer the posse of friends, many of whom did not appreciate the famous "Mapplethorpe ego trip."

Robert had already purchased a drawing by Bill Schmeling, known as "The Hun." Schmeling's specialty is black men in leather and sports gear, usually depicted in an extremely orgiastic fantasy prison in the American South called "Shadynook," where whites and blacks both speak in Stepin Fetchit English that has been criticized as "extremely racist," not by blacks, but by some whites.

"Robert," Bill Schmeling said, "bought the original drawing from me for four hundred dollars. He raced on, pumping me about how I created 'blackness' in my work. I think he was trying to divine how to transpose my drawing technique to his photography of blacks. He was so intense and insistent, I told him everything I could think of about capturing 'soul.'

"Finally, Robert asked me the oddest question. 'Why don't you draw more dominant black men as sexual tops?' I do so most of the time. In fact, the drawing he bought depicted a very dominant black top in full leather. *More dominant*? How far did he want to go?"

Exactly! Robert's search to crack the black aesthetic had landed him in the right group. Schmeling's longtime companion is a black man.

"I met Robert," Miles said, "in the late seventies in Hollywood. I went to a Mapplethorpe exhibit. Some show. Some gallery. I had seen a few of his pictures, and had heard of him through Jim Yaeger, who photographed blacks in Chicago, and through Craig Anderson in San Francisco."

Craig Anderson, aka "Calvin" Anderson, was a photographer specializing in erotic studies of black men. He was yet another photographer, like Mapplethorpe, who solicited my writing:

"July 12, 1983. Hi Jack. [Here's] my latest catalog. Maybe we should collaborate on a book of Black kink for Winston [Leyland, publisher of Gay Sunshine Press]. A sure winner!—Calvin Craig."

His studio, Sierra Domino, flourished with a small-format magazine-catalog featuring full-color and black-and-white erotic studies reveling in muscular nude young blacks. Using "Calvin Anderson," a more black-sounding name, Craig often hosted lavish parties at his Pacific Heights Victorian so his photography patrons might mingle with the talent. He was not, as were so many other erotic photographers, running a black brothel.

Too bad. At a Sierra Domino Christmas party in 1981, shopping for Mapplethorpe models, I had to discipline myself so beautiful were the men, especially Anderson's premier model, Jon X, who was in training for the Mr. America physique contest. In his own way, he was the equal of Jim French's Chris Dickerson, who was one of the very few black models ever featured by Colt Studios. Afterward, I introduced Robert Mapplethorpe to Craig Anderson, who was shy of Robert's intent. He thought Robert was too crass, too commercial, and that Robert would require sex with the models, which would add fuel to the black prostitution charges.

To squelch the "black brothel" accusations, Anderson, in the *Sierra-Domino Newsletter* (December 1981), wrote: "It has come to our attention that there are several agencies in New York advertising 'Mandingo Men' and 'Top Sierra Domino Models.' While men of Sierra Domino may work at the agencies in question, Sierra Domino is in no way associated with the companies."

Anderson, after running an article on the interracial group, was accused of "exploiting" blacks on one hand, and acting as an "Uncle Tom" on the other. "It appears to us," he wrote, "that a disservice is done to 'blackness' and the black race whenever the term 'exploit' comes up when someone is paid *fairly* for his blackness. Should Cheryl Tiegs feel 'exploited' for blonde hair?"

When race mixes with sex, strange inquiries arise.

These questions, all whites, even Mapplethorpe, working with black models, are asked, because of American pop culture's "plantation mentality" about any and all relation between white and black.

To avoid such confrontation, especially because his work with blacks was so personal, Miles Everett never sought public recognition.

For Miles, it was enough that other artists, graphic and photographic, found his work through underground networking. Besides, Miles worked for the federal government with a top-security clearance.

Miles photographed his first black man in 1931. He was a track and field athlete. "We had to be very clandestine," Miles said. "I admired the guy. I had never seen anything like him. So I spent two years finding out what he was all about. His body stunned me."

"So," I said, "you shot this series of him in nude track poses?"

"We could have both gone to jail."

"For any number of reasons from nudity, to photography, to race. You

were ahead of your time. You were doing photography and they were lynching."

"I've always had to be clandestine. I had to sneak into government darkrooms, my negatives carefully folded. The prints I always washed at night. Oh, Jesus, I think of those days. I've lived through almost a whole century of censorship. But those limits caused me to create my work in my special way." Miles smiled. "There'll never be another me."

"Not even Mapplethorpe?"

"Not even Mapplethorpe."

"How did Robert," I asked, "react to your clandestine work that first night he came to your home?"

"After we met at the gallery, we went to Bill Schmeling's so Robert could see his drawings. It was a Saturday night, and it was early, so we stopped off at a tea party thrown by the group called Black Men and White Men Together. Then I brought him home here where I've lived for fifty-one years.

"I never understood Robert, then or now. He was extremely nervous. He kept telephoning some guy he said he was having a hell of a time with. He smoked continually. He stayed till one o'clock, but wouldn't let me drive him back. He wanted to take a taxi. He was very intense. He rifled through my work, and, let me tell you, he pulled out my best stuff."

"He took photographs with him that very night?"

"Maybe twelve or fifteen. A sizable bunch. I suppose they're in his estate now. When *20/20* or *60 Minutes* showed Robert's work during the censorship controversy, goddamnit, five or six of those pictures were mine, not his. My friends caught the mix-up, too. I've had five heart attacks and about three strokes. That mix-up nearly gave me another one. But I really don't care. Friends of Mapplethorpe think that a lot of my work is better than Robert's."

"Did Robert buy your photographs?"

"Him? Pay? It was a barter, an exchange. Many photographers trade pictures no one else sees. He sent me a picture of Marty. He insured it for five thousand dollars. Marty was one of my models before Robert shot him. I think Robert's picture of Marty is very crude and vulgar, but Marty likes it."

"What makes you think it's crude and vulgar?"

"He's got a hard dick, holding it right up so you can see it. I think that's disgusting. Robert could have done better than that."

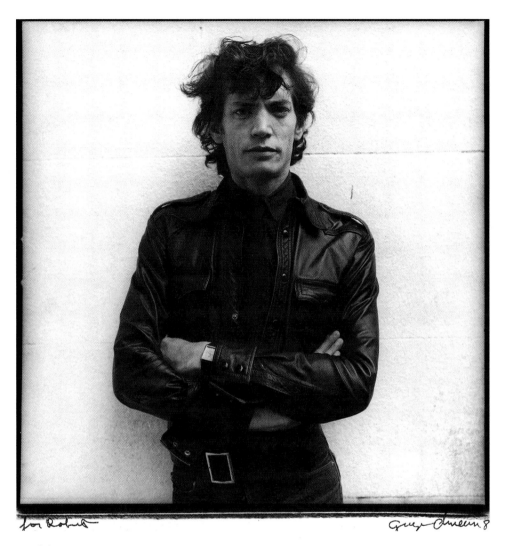

for Robert George Dureau 8

When they got together, Mapplethorpe and George Dureau would shoot dozens of pictures of each other. This is one of Mapplethorpe's favorite portraits, which Dureau shot in New Orleans in 1983.

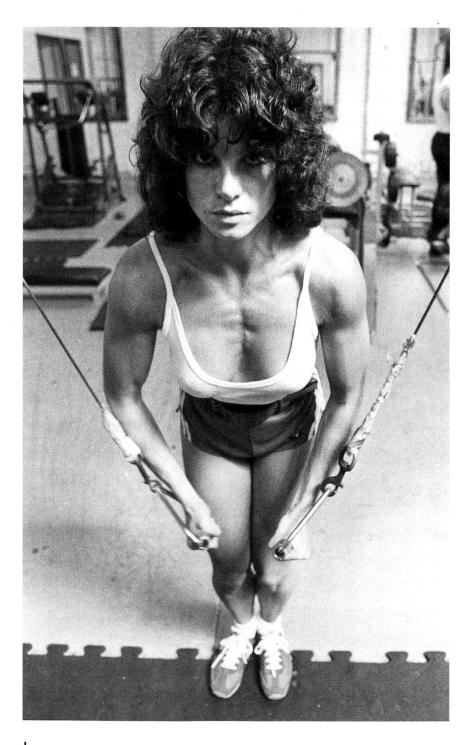

Lisa Lyon working out at Gold's Gym in Santa Monica, CA, in 1979. The UCLA grad won the World Woman's Body Building championship. She later became Mapplethorpe's favorite model. (AP/Wide World Photos).

Attending a Mapplethorpe exhibit at the De Celle Gallery, San Francisco, March 25, 1980: (L–R) Jack Fritscher, bodybuilder Jim Enger, Greg Day, Lisa Lyon, and Robert Mapplethorpe. (Photo by Rink).

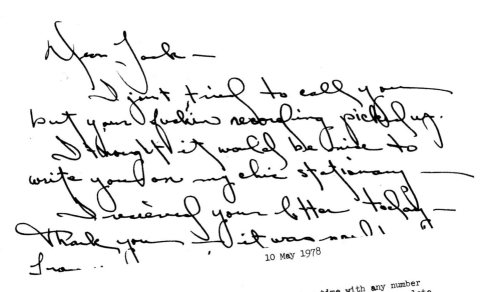

Dear Jack —

I didn't find to call you
but your fuckin recording pick up.
I thought it would be nice to
write you on my chic stationary —
I recieved your letter today —
Thank you — it was nice.
Ira ..

10 May 1978

Caro Roberto,

Hanging in a holding pattern since you. Having an okay time with any number of numbers. Wishing some of these good times were with you. Sitting very late at night in the Brasserie at the Fairmont eating Pancakes Oscar and watching strange tribal rituals of disco proms conducted by the rich children of richer parents in Burlingame: thinking how you would have fit into my observation catbird seat. Very like a more mixed One Fifth. Saw Travesties at ACT. Lived a few more. Ate brownies in the second row of the orchestra. Went home.

... from some women
... days ago who said she heard
I was doing a book —

... want:
patterns, it has stuck in mine. Somebody else out here has caused me to hit hard the first syllable of wonderful. Sometimes being a Gemini can be a fucking bore. Everything becomes fodder for the mill. Everything is eclectically mine. Ah well, it works for the writing, and more than that I cannot ask. Haven't gotten back to Nita the Jewish dyke person yet. Must do that. Sorry you're not coming out. But for sure later in the summer or early fall. You must, as I must, work out the creative, expressive side of our beings and not just drug-and-fuck it away. It's too precious and ultimately valuable to let a lack of internal discipline cause us to be great in unthankful beds around the world while our talents suffer because we starve those who want, and want to buy, what we have to create. Take care, my good friend. I love you with all my head.

Jack

Though Mapplethorpe dreaded writing, he corresponded with the author frequently during their relationship. This is a section of his letter written April 20, 1977, and a Fritscher letter to "Caro Roberto."

Mapplethorpe and Fritscher were bi-coastal lovers in a decade when gay men lived on airplanes, flying the New York–San Francisco–Los Angeles–Amsterdam–London circuit. (Photo by Jack Fritscher).

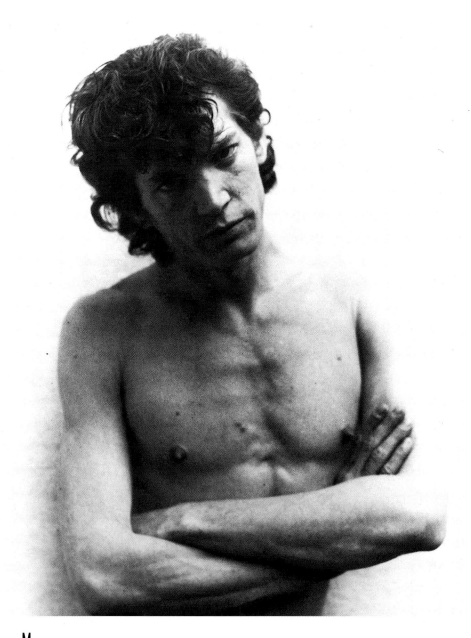

Mapplethorpe in a somber mood, captured by the camera of artist George Dureau, which he titled *Robert Shirtless*. Dureau teased him about not enjoying the world-famous New Orleans food.

Jack Fritscher's self-portrait, taken in 1979, which reveals the author's own penchant for bodybuilding. Even after Fritscher broke off their relationship, Mapplethorpe still sought out the author's counsel.

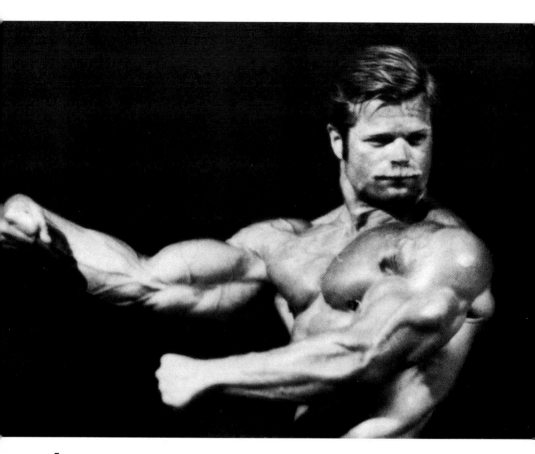

Fritscher's ex-lover Mapplethorpe wanted to shoot new lover Jim Enger, above. When Enger refused to sign a release, Mapplethorpe cropped off Enger's head and turned the photo into a postcard. (Photo by Jack Fritscher).

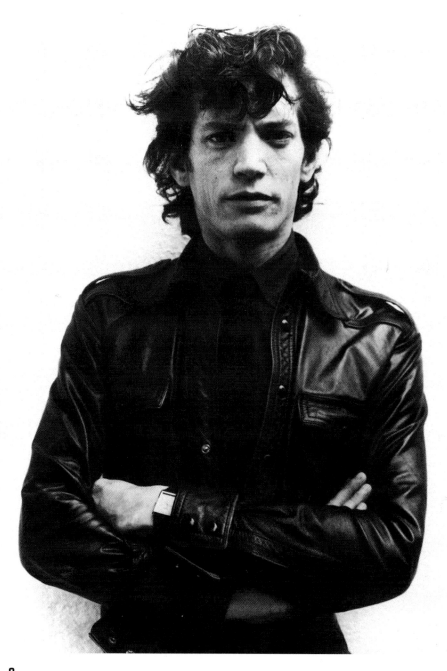

George Dureau's portrait of Mapplethorpe in a serious mood in New Orleans, 1983. Mapplethorpe acquired many of Dureau's photos for his famous collection, particularly his work with black models.

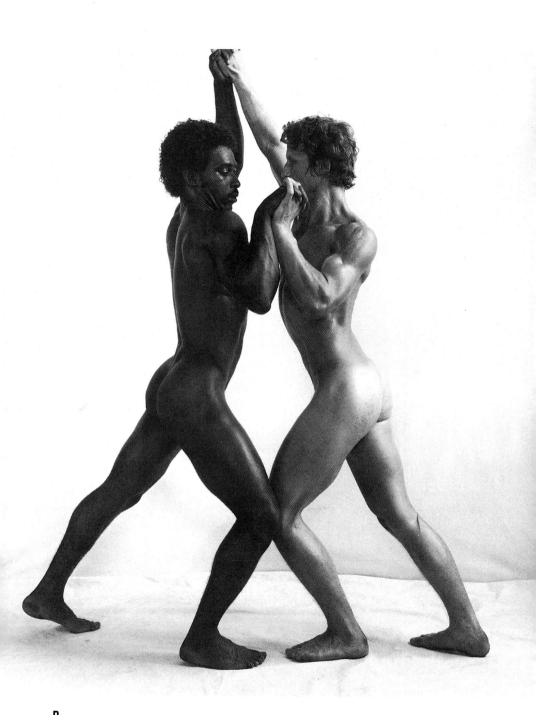

Dureau likes to set his models in poses reminiscent of ancient Greek and Roman statuary. Here are two symmetrical models, Thompson and Brown, taking on the geometric stance of two men in mortal combat.

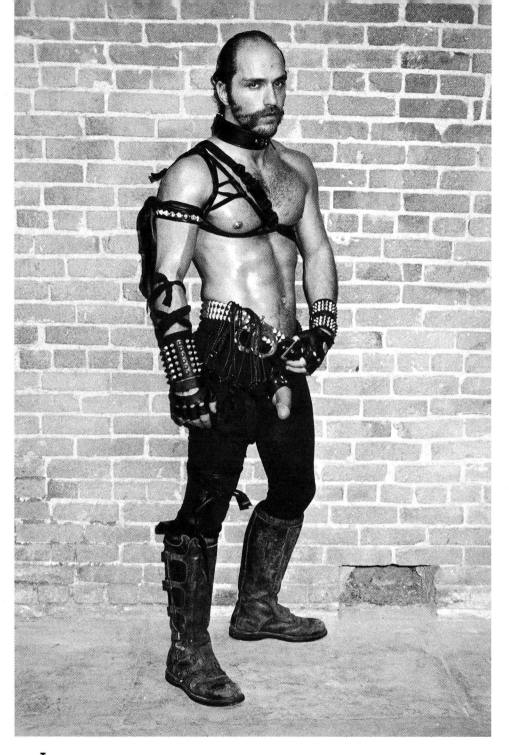

The famous stage and screen porn star, J. D. Slater, attracted a great deal of public notoriety. He was a friend of both Fritscher and Mapplethorpe. (Photograph by Mikal Bales).

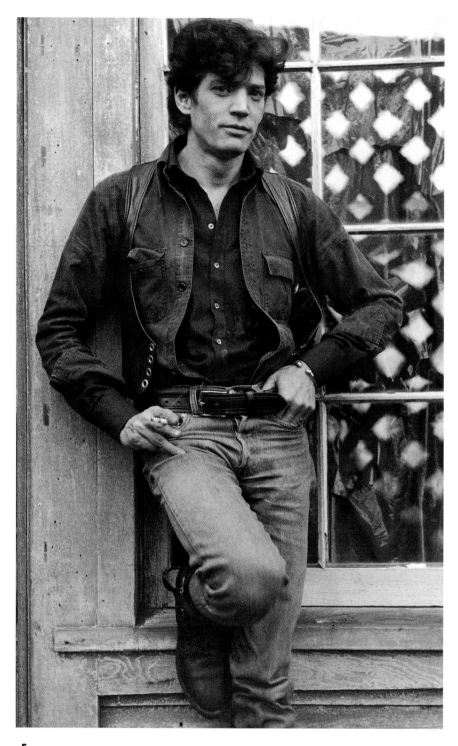

Early Mark Thompson photograph of Mapplethorpe with his perennial cigarette. Mapplethorpe was always certain he would enter the who's who of photography along with greats Scavullo, Dureau, and Warhol.

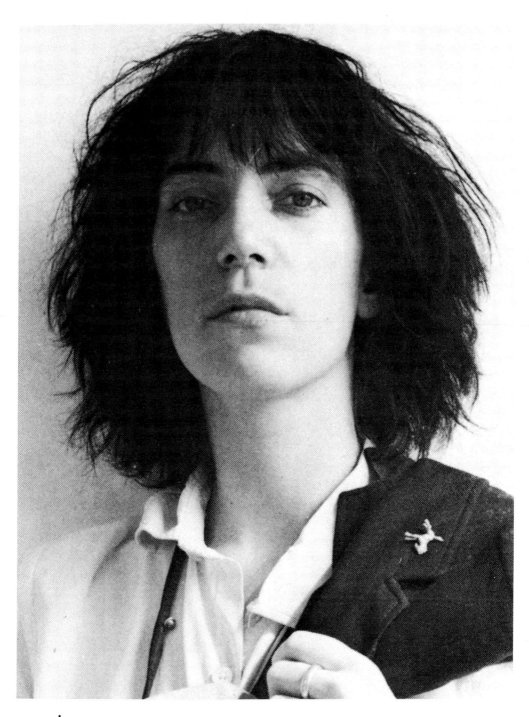

A 1977 photo of Patti Smith, Mapplethorpe's schoolmate at Parsons in Manhattan. She became his roommate and model, while gaining fame as a poet/singer and hard-rock bandleader. (AP/Wide World Photo).

Gunnar Robinson's *Kiss of Death, 1982* caused politically correct gays to censor leatherstream gays in a way that infuriated Mapplethorpe. (Jim Wigler Photo © Raw Graphics)

CAMILLE O'GRADY

Fey—Way Productions
1287 Howard Street
San Francisco, CA 94103
(415) 626-1000

Publicity shot for Fey Way Gallery features singer/poet Camille O'Grady. She was present when two muggers shot Fey Way owner Robert Opel. She later vanished from the San Francisco scene. (Photo by Larry Hunt).

Certificate P 079

I, the undersigned, hereby certify that I hold the office of ...
City Registrar of the City of Boston and I certify the following facts appear on the records of Births, Marriages and Deaths kept in said City as required by law.

The Commonwealth of Massachusetts
STANDARD CERTIFICATE OF DEATH
REGISTRY OF VITAL RECORDS AND STATISTICS

REGISTERED NUMBER: 001787

DATE OF DEATH: March 9, 1989

DECEDENT
NAME: Robert Michael Mapplethorpe
SEX: Male
PLACE OF DEATH: Boston
COUNTY OF DEATH: Suffolk
HOSPITAL OR OTHER INSTITUTION: New England Deaconess Hospital
Inpatient
SOCIAL SECURITY NUMBER: 085-36-4698
RACE: White
DATE OF BIRTH: Nov. 4, 1946
AGE: 42
BIRTHPLACE: Floral Park, N.Y.
EDUCATION: Unknown
MARRIED, NEVER MARRIED: NeverMarried
USUAL OCCUPATION: Self-employed
KIND OF BUSINESS OR INDUSTRY: Photography
RESIDENCE: 35 West 23rd. St. New York, New York
ZIP CODE: 10010
FATHER-FULL NAME: Harry Mapplethrope
STATE OF BIRTH: N.Y.
MOTHER-NAME: Joan (GIVEN) Maxey (MAIDEN)
STATE OF BIRTH: N.Y.

INFORMANT
NAME: Edward Mapplethrope
MAILING ADDRESS: 24 Bond St. New York, N.Y.
RELATIONSHIP: Brother

DISPOSITION
METHOD OF DISPOSITION: Cremation
FUNERAL SERVICE LICENSEE: Otto F. Kucera 6076
PLACE OF DISPOSITION: Forest Hills Crematory
LOCATION: Boston, Ma.
DATE OF DISPOSITION: Mar. 10, 1989
NAME AND ADDRESS OF FACILITY: J.S. Waterman & Sons 495 Commonwealth Ave. Boston, Ma.

PART I
RESPIRATORY FAILURE — MINUTES
OVERWHELMING PNEUMONIA — DAYS
ACQUIRED IMMUNE DEFICIENCY STATE — YEARS

PART II
UPPER GASTROINTESTINAL BLEEDING

WAS AUTOPSY PERFORMED? NO

WAS CASE REFERRED TO MED EXAM? NO
MANNER OF DEATH: NATURAL

CERTIFIER
DATE SIGNED: MARCH 9, 1989
HOUR OF DEATH: 6:10 A
JEROME GROOPMAN, MD.
MICHAEL T WONG,MD, 185 PILGRIM ROAD, BOSTON,MA. 02215
LICENSE NO: 88-91534

WAS THERE AN H: NO

RECEIVED IN THE CITY/TOWN OF: BOSTON
DATE OF RECORD: MAR 10 1989

I further hereby certify that by annexation, the Records of the following-named cities and towns are in the custody of the City Registrar of Boston:—

X1063

WITNESS my hand and the SEAL of the CITY REGISTRAR

on this Day of A.D. 19.........

MAR 14 1900

Judith A. McCarthy
City Registrar

By Chapter 314 of the Acts of 1892, "the certificates or attestations of the Assistant City Registrars shall have the same force and effect as that of the City Registrar."

Death certificate of Robert Michael Mapplethorpe, 42, who died of AIDS at the New England Deaconess Hospital in Boston on March 9, 1989. He left his estate to the charitable Mapplethorpe Foundation.

"You think Robert was too assaultive in his work?"

"Yes. I have most of his books and they are a little too gross. Erection is going too far. I don't mind the picture with the little girl. That's nothing."

"So it's one thing to be nude and another thing to be hard?"

"Years ago, because I've always developed my own film, I shot erections, but I realized they distracted from the beautiful bodies. In the seventies, when I was in my fifties, I shot many beautiful nudes out in the vastness of nature. I love Death Valley. The High Sierras."

"You shot bodyscapes in the context of landscape."

"Yes, artscapes. George Mavety, the publisher, recently looked at my work for his nude magazines, but he said it wasn't as pornographic as he would like it."

(The Mavety Media Group in New York publishes several gay magazines: *Torso, Honcho, Playguy, Mandate,* and *Inches* and has featured my work but none by Mapplethorpe.)

"Erotic art is not necessarily pornographic," I said. "Even when erect. I know George Mavety's work. He honestly paid you a compliment."

"What is strange is that the Mapplethorpe photographs that caused so much controversy here were exhibited in Japan where they're much more conservative and there was no problem."

"Robert liked to absorb other photographers' images, change them, make them his own. Did he borrow from you?"

"I shouldn't say this, but I'm ancient enough to say anything." Miles positively twinkled. "I do feel in some of his later pictures, where he shot black men against a black background—hat came from my work. Before, he had used gray, not black on black. He saw in my work a certain beauty that he liked and duplicated. His lighting is much the same as mine. We were looking for the same thing: the features of the body, the muscles, the contours of the skin. He got it just as I got it. We both understood the art of photographing blacks."

"When did you last see Robert?"

"We mostly talked on the phone."

"That's how he disappeared from most of us. On the phone."

"I saw him last about 1984. Around that time, maybe earlier, he flew to Los Angeles to shoot the ballet. He was too exhausted to come see me. I never saw his name associated with the ballet pictures that were published, but I've never seen such beautiful work in my life. Frankly, I don't think anyone has done any work like his: so polished, so finished."

"So you judge his work will be appreciated in years to come?"

"Oh, yes. He's like Von Gloeden. A hundred years from now, people will look back and say, 'Jesus Christ, this guy was good.' "

"What distinguishes your work with blacks from Robert's?"

"My work is no longer nude, and I photograph them in motion. On television sports, it all comes together. I remember Rafer Johnson, and then Ben Johnson in Seoul. I saw immediately on television the beauty of the black man in athletic motion."

"Which takes you full circle to the black athlete you photographed in 1931."

"Yes. I was supposed to have a shooting session today with a young man who's about six-foot-six and weighs about one hundred twenty pounds. He's a dancer. He's beautiful. He's like a snake."

"After sixty years, you're still shooting."

"Age takes its toll, but there's always another shoot."

"That's what's so tragic about Robert dying so young," I said. "So what do you think of Robert's black studies?"

"Beautiful. Spectacular. I like the studied way he places the body parts to form shadows. I particularly like one chunky man he photographed. From Massachusetts. Robert didn't know he had a brother here in California. I photographed him."

"In your style, not of classical stasis, but in motion."

"I have them hop, dance, jump rope."

"You catch them in actual movement, whereas Robert was static in his takes, perhaps because he started his art studies in sculpture."

"I think his still life is the key to his work. He had a static eye, whereas mine is all dynamic. Not that he couldn't cross over to movement, as he did so beautifully with the ballet."

"Robert shot the dancer Gregory Hines in motion."

"I'd like to see that."

"It's quite wonderful."

"I see everything in motion. Beauty in motion. My background is electrical engineering: elemental nature in motion. From the first, my pictures were all in motion. Those black men in motion from 1931 were among my best pictures. Unfortunately, most of them have been sold. I have the negatives, of course, but, oh, God, I don't have the energy to go into the darkroom to do anything. I would like to find a company that really knows how to handle negatives."

"Robert spent little time in the darkroom."

"Toward the end, Ansel Adams left the darkroom. He found a printer who did better work than he himself did. By the way, did I mention that Edward Weston photographed a black girl? Just one. That always surprised me: Edward Weston doing one colored girl."

"Have you encountered much prejudice as a white man shooting black men?"

"Fifty years ago, I might have been shot down quite severely, but at the time, I didn't realize photography galleries existed. I never shot to be famous. I would have been instantly removed from government service. I'm content to be unknown. All I wanted was a picture of an individual. I wanted to find out what a black man looked like."

"When did America first become aware of the black body?"

"Some photos exist from the 1900s. Robert certainly stirred up interest. That may be another of his legacies."

"Perhaps the time has come to exhibit your work."

"Actually, I do exhibit. Clandestinely. My work is shown in black high schools around the country. It's motivational. To show black students photography is something they can look at and, hopefully, shoot themselves."

"That would be wonderful," I said. "Something for the NEA to fund: black kids photographing inside black life, photographing life!"

Miles beamed. "We've had very good luck with my shows."

"Have you shown at white high schools?"

"No. Black high schools. All black. I'm not black yet. I'm certainly getting that way."

"So you are a closet exhibitor: high schools, private showings to other artists and friends."

"Not closeted. Clandestine. I think we live in a wonderful age. We see these photographs now, but we won't see them a hundred years from now."

"What do you mean?"

"Photography is one hundred fifty years old, and I think it has another twenty-five years before some new medium of recording will replace it. All the good photographers of this time should see to it that their work is secured, so that people in the future can enjoy them, no matter what storage and retrieval system will be then available."

"Have you ever shot white males?"

"I tried once. It came out so bad I tore it up and threw it away. You can't get the muscular definition from a white man that you can from a black."

"Has it to do with the lighting?"

"No. The white body is different from the black body. Whites have a subcutaneous layer of fat that masks the muscles. Blacks don't have that. When a black fellow flexes his arm, you can see every muscle. That was the first thing I detected. The black body has beautiful muscles you simply can't see in the white fellows."

"Miles," I asked, "do you think in your life you have found truth with the camera?"

"Momentarily. That's all. Just for the moment."

"Some truth."

"Yes, a moment's truth."

"Put all together, your photographs contain much truth."

"Unlike Robert, I don't care what happens to my work. I give up in despair. My grandfather came across the Dakotas. He was attacked by Indians. My other grandfather came from Scotland around the Horn. I've enjoyed my life. That's more important than fame."

Miles projected a distinct attitude that he thought Mapplethorpe might have shot himself in the foot while the foot was in his mouth.

"Do you think," I asked, "that Robert finally realized that, too? That fame, too much publicity, too much public life, can kill the soul, the private person?"

"Who knows? When he was at the gallery where we met, I noticed he was very uncomfortable among all the asses standing around drinking wine and smoking, shouting, 'Oh, Mr. Mapplethorpe! Oh, Mr. MAPPLETHORPE! OH, MR. MAPPLETHORPE!' That 'Mr. Mapplethorpe' thing wore him down. I saw it that first night. For me, it was right to be the hidden one."

"You lived your life. You created your art. You created a heritage of images of blacks who would otherwise be invisible."

"The pages of my life have gotten to the end of my book."

"You did what you wanted."

"As I hope did Robert."

In 1993, rumors circulated fingering blacks as the race most likely to spread AIDS.

As sex and race, always combined, intermixed once more, tempers on both sides generated more heat than light.

In my own life experience, I know that my friends who died first had sex almost exclusively with young blacks.

If black society has as much unsafe sex as white, and has more intra-venous drug use than white, then this observation is racist only if one says blackness itself causes AIDS.

Blackness does not cause AIDS any more than homosexuality itself causes AIDS.

A virus causes AIDS.

After Robert's death, a public service "commercial" warning about the losses caused by AIDS appeared on television. It showed several faces. Prominent among them were the white photographer Robert Map-plethorpe, and the black TV journalist Max Robinson.

Robert was hardly a saintly AIDS Poster Boy.

Underlying his controversial sex photography lurks his more disturb-ing theme of race.

Mapplethorpe wanted a black to kill him in what can only be inter-preted as some weird parody of a possible future.

Robert's personal racism is nothing compared with the genetic racism bred into every race.

When the politically correct are swept away by the racially correct, the global village will deconstruct to the social turmoil of an emerging Third World country.

Who will look at photographs then?

MAPPLETHORPE MENTOR: GEORGE DUREAU

"The camera is just a mindless lunatic."
—*George Dureau*

N *ew Orleans.* In March, 1991, I met with George Dureau who had photographed Mapplethorpe who photographed Dureau. That was not the whole story. Much like the Antonioni film, *Blow-Up,* the single frames which the two dueling photographers shot of one another contain the eerie kind of plot and character so expected by northerners descending into the French Quarter where, because they are northerners, they suspect that something beyond the appearance may, in fact, be the reality.

Mark Thomas Hemry and I had flown into New Orleans with video equipment to shoot George, barefoot and quippy, brushing his final strokes on a huge painting he was completing for the "The War Show" at the New Orleans Contemporary Arts Center. In the news media, the Gulf War had finally eclipsed the ongoing NEA controversy over Robert Mapplethorpe who had been dead for twenty-four months.

"I can never remember birthdays and anniversaries," George said. He stood on his canvas that cascaded down the wall. At the top, a tank charged out of the painting; on the floor, George painted in Persian carpets on the canvas where he knelt. "This 'War' show is not anti-war," George said. "It's simply about war. Although my painting certainly dramatizes the current war."

"Distracting, isn't it," I said, "having another war to protest while we are busy protesting censorship of art?"

Dureau's enormous studio is large enough to contain his huge paintings, his photographs, his sketches, his collection of other artists, his household treasures, and his ebullient self.

From his wrought-iron balcony aerie, Dureau holds down one corner of Dauphine Street. Music from the sidewalks in the Quarter, the beat from car radios roaring past, the far-off barking of dogs, the voices calling out to each other, sometimes wailing up to Dureau's studio, where, no mean Blanche du Bois, George provides the kindness strangers always depend on.

Dureau's home is a gallery set fit for Tennessee Williams's drama. Photography books about artists and New Orleans homes so frequently show his bed and board in their pages he has had to turn down requests to shoot. The magazines beg for no more than one or two shots, but the dramatic texture of Dureau's digs has the art directors begging for more.

By comparison, our double shoot of Dureau on two afternoons was easy. After hanging George's canvas at the Contemporary Arts Center where the work draped from the thirty-foot ceiling to the floor so viewers could actually walk across the carpet patterns George had created at the foot of the work, we returned with Jonathan Webb to find George in the midst of washed greens, cooling pasta, and boiling pots of shrimp. He cooks as expansively as he paints. Robert Mapplethorpe loved visiting Dureau, but not for the food. Robert was made quite anorexic by drugs; his main interest was in Dureau's latest ideas. Mapplethorpe was a collector of Dureau's photographs and a closet student.

"We have wonderful food and wonderful restaurants in this town," George said, "but Robert always turned up his nose at food and the art of food."

"Actually," I said, "Robert should have eaten the food he photographed. He'd be alive today."

"His 'precious' grapes? I don't think so. All Robert wanted was an egg done his certain way and a Coca-Cola."

Dureau sat for his video close-up on his balcony. Afternoon became evening as George, a true raconteur, thoroughly engaged our video camera. His lighting was brilliant in the twilight. We had nearly ninety minutes on tape. The sky had moved in, cracking with lightning, whipping the breeze up around the many jungle plants on his balcony. When the rain began, we scuttled our setup at table, yanked our documentary cassette to safety, and carried lights, cameras, and tripods back inside, stepping through the huge openings of the ten ten-foot-fall, floor-to-ceiling guillotine windows.

"Nawalins has great special effects," George drawled broadly.

Two days later, Mark Hemry set up our video in Dureau's studio, where we filmed George at work shooting the classically muscled black model, Glen Thompson.

<div align="center">★ ★ ★</div>

IN THE DOCUMENTARY VIDEO FOOTAGE:

The rainy season of an early spring tinkles on the roof. Dureau's lighting of Thompson on the set lights the video. The effect is stunning. Thompson's body glows incandescent.

Around the heroic-looking model, already dripping with sweat and shining in the pinpoint flood lamps, the rest of the studio is dark as night in the overcast afternoon.

George directs the model with voice and touch. His gentleness makes his longtime house-model Thompson generous in holding the physically strenuous Dureau poses.

From another room, the scent of cut flowers mixes with the damp wool of jackets worn in from the rain after lunch.

"Glen, drop your head and move your arms to your right. . . . Can you please bend your left leg . . . That's it . . . Hold it. . . ."

Dureau shoots carefully, never clicking his shutter until the model and the light transcend the actual moment and turn, we felt it, into the perfect moment every artist feels, when Dureau rose up in the darkness to make his shot, to condense time and space and into one single frame.

Long silences as Thompson holds steady while Dureau continues to ponder the human sculpture. Distant thunder rumbles over the occasional voice rising up from the Quarter. Dureau directs like Balanchine. No wonder Mapplethorpe worshipped at the altar of Dureau.

Recorded on our documentary videotape, the perfect moments of creative silence followed by creative explosions calibrate the rhythms of Dureau's masterful genius. Finally, George himself turns to our color monitor and directs his first-ever video segment.

The moment is historic.

Dureau, the painter and photographer, touches videography.

The technological future meets the classical past.

No one need ever wonder at the secrets of a Dureau shoot.

Finally, we turn the studio lights down.

An amazing blue light shafts down on the set.

Our video camera, monitored in beautiful strobe effect, catches Dureau on screen positioning Thompson the way a dancer moves a lover.

Silence.

Thunder.

Rain.

The far-off dogs.

Robert.

I lament video was not available the earlier times I watched him shoot his photographs.

"Robert Mapplethorpe saw some of my photographs at the Robert Miller Gallery," George Dureau said. "He fell in love with a couple of them. He wrote and asked could he buy one."

"How many did he buy over the years?"

"More than thirty. He came around here a good bit. New Orleans fascinated him, but he behaved very differently from me."

I knew Robert liked the open sensuality of New Orleans. He was an artist from a cold clime come down to warm his hands.

"Robert and Sam were collecting every photograph they could find," said Dureau. "Robert was distilling them all into what he wanted his work to look like.

"My classicism resembles early periods of Greek and Italian art where the form is still identifying itself and there is still a struggle with the content. Because Robert was so derivative, studying photographs instead of studying art, he is the soul of neo-classicism.

"I must say I never thought about what my photographs would look like. I came to the camera to document my family of ragamuffins. When critics compared me to gay photographers like Holland Day, I had no idea about 'gay' photography. I love Walker Evans and Dorothea Lange who shot during the Depression. I thought if you 'worried' over art, your photographs would end up looking like *Vogue* magazine."

"You have a reputation in Europe that you are Mapplethorpe's secret mentor."

"Robert certainly never came to me to learn anything."

"Robert's absorbency factor was great. He wasn't a plagiarist so much as a Great White Hunter out stalking ideas."

"You've got the 'Great White Hunter' right." George said. "Of course, Robert borrowed, and borrowed, especially when he could appropriate the form but not the content. He sometimes stole form from my photographs, but he deleted my content, my solicitousness, and that subtraction, of course, reduced the risk that his theft would be immediately identified."

George Dureau's voice rolls with New Orleans charm. He has that quality of storytelling so particular to southerners, like Faulkner, Eudora Welty, and Tennessee Williams, who once lived around the corner; they can take so long to get from here to there in a story because there is so much in between the *here* and the *there* that is too intricately colorful and meaningful to omit.

Dureau is languorous, witty, and ripe. He mixes art and sex and food and human relationships together the way he mixes paints on his palette, splurging them across his canvases, with such vigor that he recently hit himself in the face with a brush. There's southern passion in the man who drew in the cold Robert from a colder Manhattan. The difference between them is the heat of passion. Dureau was a painter before he was a photographer and he remained both. Robert had studied sculpture before he was given a camera.

Their common interest is the black male.

"Robert and I," George said, "could hardly be more fundamentally different."

"Yet there are similarities."

"But different sensibilities. Robert and I started photographing about the same time. Perhaps our photographs of black men, where some people see similarity, is where we were most divergent.

"My photographs look like my paintings and drawings. I'm very much a humanist. I'm very involved with the people I shoot. My photographs are family pictures. Very sentimental. Sam Wagstaff couldn't abide that. He never for one moment would have tolerated Robert shooting people with my compassion, because compassion was highly inappropriate for the market Sam had in mind for Robert's career. Wagstaff was a real fascist. He despised minorities—not that anybody has to love them; they piss me off sometimes, too—but he really hated the whole idea of anyone making beautiful statements about the poor. I remember Sam looking at a large selection of my photographs. He just kept staring at me as if to say, you must be crazy to like these people: lovely, handsome, young men, poor

whites and blacks, oftentimes with missing limbs. My photographs say quite clearly that I like everybody I photograph."

"You certainly don't exploit your subjects. Your work is not a sideshow of freakiness. In fact, your photographs are erotic. Robert's aren't."

"Robert, at Sam's insistence, cleaned my work up for New York, where I once lived for nine months in the sixties before returning to New Orleans."

"Why?"

"So I could remain human."

"You both are regionalist photographers. Robert could thrive in New York, though he wanted to live in San Francisco, but he denied himself that, because New York was the art marketplace. What do you mean, he cleaned up your photographs?"

"He used some of the aesthetics of my kind of good, old-fashioned posing that I had developed over twenty or thirty years of painting and dance training, but he stylized it into an art-for-art's-sake kind of art which suited him and his chic clientele. His clients were not usually compassionate. There was a coldness about his work, either because Robert was cold, or his audience was. He always used to smile and give a 'Ooh, how could you do it?' look."

"When we met in 1979, I took two or three really lovely ones of him, and, later, in 1985, when he was not well."

"Robert had a beautiful face," I said. "He narrated the whole story of his own life in his series of self-portraits."

"So you could have taught him a trick or two," I said.

"You must understand Robert and me in the late seventies. In those days, I had a big house right outside the French Quarter. Now I live in the French Quarter. We went out together, drinking, cruising, comparing notes. We shared quite a bit of the same taste in whom we liked, but we had little similarity in our sexual roles.

"Robert had that sweet, come-hither, baby-sister look. I'm an old-fashioned Greco-Roman patriarch queer, not a flip-flop queer. I'm the dominant male about the house. I have gorgeous young men who work for me. My house is a kind of genteel colony of the underclass, but I'm Big Daddy always.

"Robert's behavior was more modern gay, which is so altogether different from me. Robert didn't understand that old-fashioned queers are different from liberated modern queers."

"In what way?" I asked.

"Involvement. Caring. Robert would pay four hundred to five hundred dollars to get a young man to drop his pants in front of the camera. That was it. Shoot, pay, gone. It seems so time-efficient and cost-efficient."

"Robert was moving fast. He was one of those people who knows his life will be short, so he has to act quickly to accomplish what he is about. I wrote him as early as 1979 and told him he would not live a long life. I always thought him capable of suicide at the proper moment."

"What made you think that?" said George.

"We had a very empathic relationship. You live in New Orleans. You should understand."

"Maybe that explains his one-shot quick take. I'm not like that."

"You have a different sort of wild reputation."

"Even when I was drinking, my wildness was the tenderness I afford my models. They are my children. Robert, at the time, was always scraping for money. He asked me how I could get them to pose so cheap. I said, you can get them cheap if you don't mind having them for life. My models are all people I'm involved with, letting them stay with me, 'doing' for them. I've always seduced people because I loved them and then I would have them to dinner to paint from or to draw from. To photograph or to fuck. Robert didn't understand New Orleans economics. If I paid them a hundred dollars to pose for me, they'd be back the next day anyway to get money to pay their momma's water bill. I could have paid them a thousand dollars, and they'd still be back. New Orleans isn't New York. You can't shoot them and leave them. There's always two or three standing at my door."

Dureau reminds one of Tennessee Williams's *Suddenly Last Summer*, but he is no exploitative Sebastian Venable. He is more like a Father Flanagan, although he says sometimes when he's not Big Daddy, he's Brick in *Cat on a Hot Tin Roof*. Actually, in one of his self-portraits, a painting, he is a Doppelgänger of Richard Locke, one of the most popular gay film stars of the seventies.

"When I was thirty-five in the sixties, when we all had long hair, I looked in the mirror and realized I had attained the age of my fantasies. Oh my God! I suddenly became the daddy, the pursuer instead of the pursued one, and I must say it's the best thing that ever happened to me."

"When you and Robert went out, were you loaded?" I said.

"Robert always had to make pit stops. I didn't have to. I did smoke into the sixties and seventies. I used to be quite alcoholic, but I've never related

to the drugs Robert used. He had a different mentality. His drugs of choice hooked up very well with his vision of what people could do for him as opposed to my Big Daddy come-on of what I'm going to do for them. I see people as somebody I might adopt, or do for for a while, while Robert never looked beyond what's this one going to do for me tonight. His was a very modern-day, gay, and, I suppose, legitimate behavior for the seventies and early eighties. I'm an old-style queer, not a contemporary gay man. I think the new style is tied together with drugs and immediate gratification.

"I must tell you about my best time with Robert. We had an absolutely splendid time cruising through the cold of Mardi Gras. Canal Street, the main drag, was mobbed. We played a cruising game like we were gunners in a war bomber.

"I'd say, 'Look at three o'clock: tall, skinny, tan.' He'd say, 'Look at nine o'clock: mean, black, dangerous, sexy.' That's what we shared the most mutual joy in, the hunt. He'd talk me into going into a black gay bar, and they'd recognize me and be all over me to shoot them. Robert would find someone he thought fabulous-looking, and I'd drop him home with them, but often as not, afterward, he'd say, 'Oh, they weren't any good. They didn't do the right thing.'

"I thought him petulant. He liked what he saw, but often their performance never came up to New York standards. In the bars, he'd stand in the corner and scowl at people, then say something. He acted the same way in a New Orleans bar as he would in a New York bar, looking petulant. I don't do that. I ask them about their wife and kids."

"Did Robert ask them what kind of drugs they liked?"

"I suppose he offered them drugs, because he didn't have enough confidence in his own charm. Drugs are the cheap and easy way."

"What is your take on Robert's wearing a button that said, 'Nigger'?"

"That was a real problem with him, that nigger thing. I'd set him up with someone I knew, and the next morning I'd ask, 'How was he?'

" 'Not too good,' Robert said.

" 'Not too good? Why not?'

" 'Well, he didn't want to do anything.'

" 'I can't believe he didn't want to do anything.'

" 'He wouldn't say,' Robert said, 'I'm your nigger.'

"I'd go, *Huuuh?* I've been accused of being a colonialist, accused of keeping slaves, despite my cordial behavior with my darlings. And I'd say to

Robert, 'He wouldn't say, "I'm your nigger"?' Isn't there an alternate, like, 'Oh my darling, I love you'?

"Robert would say, 'No! Why couldn't he say, "I'm your nigger"? I say to them, 'I'm your cocksucker.'

"Well, do I have to explain why it's hard to say that? The problem was on his side. He wanted a scenario that was very set, inflexible. I mean that some person had to open his mouth and say, 'I'm your nigger.' Robert could have just thought that part as a fantasy in his head.

"There's that picture of his, the one with the big black dick hanging out of the polyester suit. Robert had major plans for that one. He thought that was going to be some big lifelong affair.

"One time, he said, 'I wish I could find a smart one.'

"I said, 'What do you mean, a smart one?'

"He said, 'You know, I'd like to find one as good-looking as Bryant Gumbel.'

"I said, 'Why?'

"He said, 'I want one that has a brain of his own.'

" 'Why? So he doesn't hang on to you?'

" 'Yes.'

" 'But, Robert,' I said, 'if there was a black man that was brilliant and beautiful and had a successful business, why would he want to go into a corner and say, "I'm your nigger" to someone like you?'

"That was probably the New Yorker in him talking."

"Oh, God, was it! He was hooked on New York. He said I was living a sweeter, warmer life than he was. A couple times, he came down to spend a couple months, but it never worked. He'd stay a week or two. He'd love it. But he couldn't stay off the phone. He was always doing business."

"The kill for the Great White Hunter was the sale."

"Whenever he'd arrive, he'd ask to see my latest work. He always wanted to see if I had any new niggers.

"He'd complain, 'I haven't photographed any nigger in six months.'

" 'Then what are you doing?' I'd ask.

" 'Oh, I photographed some horses and some ads for Cardin.'

" 'But haven't you done something you enjoy?'

" 'No,' Robert said.

"What a price! First you're famous, then you have to beat yourself up to be more famous. Frankly, there's just desserts there," said George.

"What do you mean?"

"Robert was so famous his fame shit all over him, and not just over him, over me as well, because people got such a load of Mapplethorpe, it's hard for them to understand my work. What he did doesn't have anything to do with me.

"His famous style laid a wet blanket on every other photographer. My pictures, because they're about being human and romantic (compared to his by formalists), look less pure, because they're not as stylized, or as abstract as his. My photographs are more concerned with the person in them than in formal classic stylization. My models look at you, embarrass you, make you feel guilty and uncomfortable.

"Robert's controversial photographs caused a different kind of discomfort, more abstract," I said.

"Melody Davis wrote an essay about Robert and me in her book published at Temple, called *The Male Nude in Contemporary Photography*. One of my photos is the cover. She wrote that Robert's pictures belonged in the speculative concept of art, like the nude over the bar in the western saloon. It's put up for men to speculate on and use it in their heads as they will. My photographs do the opposite. They look at the viewer. The viewer becomes the viewed.

"Very few of Robert's blacks look at you except in a funny, sexy way. There's a photograph he did straight out of me, the very first picture of mine he took from. The model's name was Oscar. He had a recently scarred face and big bulging eyes."

"You said you weren't his mentor."

"You have to understand, because of the circles Robert operated in, particularly in Europe where people knew my work, that I heard from people come back from some university in Belgium or from Paris who'd say, 'Well, everyone over there knows that you were Mapplethorpe's master. Everyone knows he had this master in New Orleans whom he would visit like a pilgrim.' "

"Then he learned some things from you."

"Let me tell you about my assistant, Jonathan. Robert always thought Jonathan too quiet and vegetarianish, and Jonathan always thought he wasn't sophisticated enough for Robert's company. The truth is, Jonathan is no fool. Robert knew that and wanted to keep his distance.

"Jonathan, one time, said, 'I know you luuv to wrestle with Robert. You always have a good time together. But can't we hide some of your pictures, because you know you'll see his version of them in print

if you leave them sitting out on the table. You'll lose more than you'll gain.'

"It was the kiss of death when Robert would buy something of mine. It was like he was paying a token price for what he was going to do with that picture. Put it in the Big Time! It was funny, because he would drain the soul out of it, that big slice of soul I created out of my personal experience, and not exactly for public consumption."

"You opened your house to him and showed him your work. You sold him photographs. You were friends. What is all this?"

"New Orleans."

"You know I'm going to quote you."

"Let me read it back afterward."

"In the best sense of context."

"I do get a little like Long John Silver when I get really mean."

"Everyone has his or her own Mapplethorpe."

"I don't mind saying wild things that are the way I see them."

"Why did you let him in your house?"

"Where I live in the French Quarter is the most wonderful house. It's an 1840 house with guillotine windows, but a hundred years ago, it was gutted and made into a warehouse. So it has a Queen Anne front and a Mary Ann behind. There's a roofed one-hundred-twenty-foot balcony that wraps around the corner of the block. It's the biggest and best balcony in the city. That's why I moved here. The front is laced with ironwork and inside there are no walls. At one time, it would have driven me crazy, because I love details of architecture, but I learned from the last house that you can go crazy from beautiful architecture."

"Maybe *Architectural Digest* makes queens crazy."

"I have rooms that are fifty-five feet long. Two big warehouse rooms that are fifty-five by thirty. My paintings and drawings always want to be looked at from fifty feet away. I draw very big and bold. My contours are strong."

"But why did you let Robert in?" I asked.

"His studio on Bond Street was so tiny. My God. What a terrible way to have to live when you're rich. It was so grim and grungy with a hole for a room and kitchen with a half-eaten can of tuna."

"That studio was the real Robert. That showplace apartment that is shown in the BBC documentary was not him."

"I let him in because he needed a sense of home and studio and

warmth and love and romance. I find it delicious to show and sell things out of my home instead of at a gallery. It's kind of a bother, but you can really communicate with the person who's worrying through trying to buy the best picture that suits them. I wanted Robert, who was suffering from all too much business, to have a sense of all that."

"You don't mind letting a Trojan Horse into your house?"

"Let's say Robert did 'departures' from me. There were two pictures. One is of Dave Kopay, the football player, sitting side-saddle, nude, with his knees up on a platform. The other was a black boy sitting the same way, but with his dick and balls hanging out the bottom. Robert put these together to make his photograph of a black boy sitting on a pedestal."

"The photographs of Ajitto," I said.

"He also did a 'departure' on Oscar, the black with the pockmarked face. That was the first one he bought. He put his 'departure' on the cover of his *Black Book*. Every time Jonathan would see one of Robert's 'departures,' he'd say, 'Oh, he really must have loved that one of yours.' Robert had that picture of Oscar hanging in the hall right next to his bedroom when he was dying," said George.

"Imitation is a sign of influence."

"Robert never photographed a black before he met me. That's why he bought the first one. He asked me how I did it, and, like a fool, I told him. He said, 'I can't believe how you can get them to look like that for you.'"

Robert owned almost forty photographs by Dureau.

Said George, "Robert bought some of my very earliest work. Nineteen seventy-two. I used a sixty-five-dollar, eleven-year-old two-and-a-quarter Mamiyaflex camera. I photographed three years without a light meter. I learned from the start how to photograph black people, because you frequently have a bleed-out background by the time you've exposed the black or brown person. I addressed the situation tenderly. Robert couldn't be bothered. I thought his using strobes and lighting up the whole thing in that magazine style was too MGM. I don't do that, because I don't want to scare my darlings, or my tricks, to death. I told him what I told you: I made love to them while I shot them. I play with people a lot. I downright seduce them. I grease them with heavy Vaseline. I got that from my kickboxer friends. Robert got it from me, but he never understood the greasing as a comforting seduction. My pictures of blacks, and whites, are actually foreplay, the act itself, or afterplay. Did Robert ever do that?"

"Perhaps that's why his photographs are so cold, so intellectual, so

unemotional, so unerotic," I said. "But, then, he was a commercial photographer. I can't imagine him stroking his socialite princesses and actresses. He was working in a different genre with his commercial assignments. Perhaps that element of commerce is what makes his blacks so different from yours. So much else seems the same by derivation."

"I must tell you, one day, Robert and I photographed each other," said George. "I posed with a model up against huge, battered columns. It was my idea. He wasn't very manipulative. I suspect he was more directorial with people who were important to him. He didn't fuck with me and I didn't with him. Maybe it was because we knew too much about the same thing. We didn't want to expose everything about ourselves. We weren't in the least attracted, but were fascinated by how different our approaches were to art. As it was, quite by accident, Robert and I used the same camera and the same paper and the same film and all that causes some similarity, which is coincidence more than a 'departure.' "

I said, "I notice your influence on Robert in certain photographs, especially one of his model, Thomas, who is posed, full-length, nude, torso arched back, his face so far back he's faceless, and it's in his presentation of arms that Robert references you. Thomas's arms are raised up around his head and disappear at the elbows. He also virtually amputated the arms of another★ model. I wouldn't have thought much about this 'amputee' stylization if your work did not exist. Actually, that pose is a classic physique contest pose I used in a series of "Self-Portraits 1979.""

"Many of my models are deformed, by birth or by accident. Some are just drop-dead gorgeous. People seem to respond with affection to physically impaired people. Some respond foolishly. Sam Wagstaff was one of them. My models are people who are beautiful and sexy and the fact that there's a stump where an arm or a leg should be doesn't mar their sexiness or their beauty. You don't say, 'Well, let's throw out this little Roman sculpture because it's partly broken,' " said George sarcastically.

"Perhaps people respond to your work because you make literal, in

★ A prime example of Mapplethorpe's referencing Dureau's amputee stylization is his photograph of a black model, *Ken Moody, 1983*. In the Schirmer/Mosel edition of Mapplethorpe's *Ten by Ten*, Photograph 56, Robert displays Ken Moody back to the camera, in a way that causes Moody's arms to look amputated. Robert's reference, quoting race and gender and pose from Dureau, also references ancient classical statues whose perfect forms ancient vandals broke from their perfect moment.

your pictures, the parts that are missing. You confront them with the notion that we all have parts missing in ourselves."

"My work elicits much affection."

"Robert's doesn't," I replied.

"Of course not. He was always a classical formalist. Some of my work is classical and the sense of form dominates the subject, as Robert's always does. Mostly, my work is romantic in the sense that the subject is so important that it almost always goes off balance, because it just has to, because I can't bend this model around anymore, I can't tell his story formally because I make contact with the person coming out of him."

"Robert often stepped in and did your ironing," I commented.

"Exactly. He cleaned up my work to make them respectable for respectable queers with money," said George.

"Gay photography, at least in the magazines, certainly shies away from deformity, except the deformity of big cocks. Ordinary people rarely appear. They take a backseat to super, heroic, built, and media-handsome men. At least some gallery shows, and some photography books, are beginning to break that taste by showing persons who are living with AIDS."

"That's what I mean when I say Robert's art speculates others," said George. "His models are meant to be looked at. He pushed them all into a sort of calendar-boy pose that, even when they're looking menacingly at you, you're saying, 'Oh, that's Robert's Mr. December.' "

"You mean his work looks commercial, as if the photograph is trying to sell itself as a product to mainstream money," I said.

"I know it! He makes his models look too available, whereas mine look like something dragged in off the street, which they were. His were dragged off the street, too, but he presented them in a way that every good faggot will know what this means. With mine, every good faggot doesn't know what this means. He was very commercial. He used to ask me, 'George, how do you live off this? Who's going to buy these things?' That was his big worry."

"It sounds like you assault a social consciousness."

"And he assaulted checkbooks. It's true. I'm so comfortable dealing with handicapped people. I have lots of intellectual, sophisticated handicapped friends, some who are lawyers for the disadvantaged, and they invite me over to discuss sex, because I'm the only normal person they know who knows about having sex with handicapped people. One time I almost died when, in this group of handicapped people talking about sex, I had taken a friend and his wife, neither of whom was handicapped. There was a girl with no arms,

and all this couple wanted to talk about was what it would feel like to put their arms around a girl with no arms."

"That sounds like a scene from Todd Browning's *Freaks*, where the 'normal' woman, surrounded socially by the physically impaired, realizes that in that group, she is the freak," I said.

"Exactly. 'Now you're one of us.' I love to watch people making decisions about my photographs. That's why I prefer to sell them out of my own home. Robert loved the thrill of the sale in a different way. The thrill of the sale became the thrill of adulation. When he shot a scary picture, he saw it in the eyes of the beholders, rich people who would have to buy it, look at it, swallow it, live with it on their rich walls. I look at my pictures from the point of view of the people I photograph. I get all nervous they may not like their pictures. If there's one that's rude or shocking, I worry they won't like me anymore. Robert never understood any of that."

"At first, I hated the solo portraits he did of me. He didn't care. He liked the photograph and said he was revealing the scary side of me. The shots he took of the two of us together I like much more."

George looked at me closely and said, "Are you black?"

"I think I'm white. I resemble my family, but I'm so dark they've told me for as long as I can remember that I was switched in the hospital with Baby Mounds."

"Who's Baby Mounds?"

"He was the son of a black band leader my parents often danced to. My dark complexion and kinky hair have always bemused them. They saw Baby Mounds the last time when he was three, playing drums in his father's band. It's a long-standing family joke. Especially in the summer, when I tan with iodine and baby oil. I'm sometimes asked if I'm part black. I always say I'm an octoroon. No one knows what that means anymore."

"Are you handicapped?"

"No. I'm homosexual."

"You're worse than Robert."

"We were two of a kind for a while."

"Because you knew Robert, you must be shocking. Your novel is shocking," said George.

"Robert was very helpful while I was writing it."

"People were talking about it the other night."

"It's about the seventies, and nothing is more shocking in the nineties than the seventies," I told him.

"It's strange fate that Robert became more famous and more shocking after he died."

"He left us to enjoy the circus."

"Nothing would have made him happier than to be the ultimate scandalous person," said George. "I was always a bit fascinated by his slightly repulsive taste in clothing and demeanor. All that leather-wear made him look like a boy groupie with a band. He tried to dress 'dangerous.' He used dangerous, bad-boy fashions to substitute for dick size as motorcyclists and ghetto gangsta's do."

"I remember him looking at my photographs, which are entirely too enlightened and instructive and noble. I could see him thinking, 'How can I do this and make it unacceptable?' Aloud, he'd say, 'Don't you want to make some cocksucking pictures?' I said, 'I have one here.' A sort of tough-looking guy who always wanted me to photograph him sucking my dick—which was hysterical. 'Is that what you mean, Robert?' And he'd go, 'Aaah! You don't even want to talk about art. You're just being nasty. I want to tell you about art.' He was really possessed with how he could make a picture shocking."

"What do you think will happen to Robert's reputation in the future?"

"I think it will drop, because he shot his wad. There's not a lot more to say or think about his work. He had his glory on earth. He shoved it down everybody's throat. He was very good at editing and figuring out what was most bombastic and best. He did so much cropping and editing, that without him, the single frames aren't much good. Robert wasn't saying enough to make his pictures live on. His work is too derivative of others. Many Mapplethorpes are just George Platt Lynes. Robert, for all his creativity, seemed to have lifted everything. He wasn't comfortable with just the object or the person in front of his camera. He had to frame it in terms of an historical style. Maybe I'm wrong, but there always seems to be reference in his work."

"Is this Dureau the painter, or Dureau the photographer, speaking?"

"People ask me: Is photography really as good as painting? As a painter, I have to say, no, it ain't. Photography is an editorial art. It's not a creative art in the sense that painting and drawing are—in which you start with nothing. The camera will give you too much, so all you have to do is shut it up. The camera is just a mindless lunatic. More precisely the camera is an *idiot savant*. No direction. No brain. But it remembers *everything*!"

1982: EXCLUSIVE PROPHESY!
MAPPLETHORPE ON CENSORSHIP!

"We will have Fascism in America, but we will call it
Americanism."

—*John Dos Passos*

B y the summer of 1982, Robert Mapplethorpe had already felt the sting
of censorship. Within the homosexual community, he found censor-
ship of his work and the work of other photographers not only intoler-
able, but inexcusable.

When photographer Jim Wigler's "Black Leather Death" show was
hung at the very popular bar, The Eagle, in San Francisco, Robert was
furious when queenstream gays pulled the Wigler exhibit down from the
walls of The Eagle.

He empathized with Wigler because that summer Mapplethorpe was
already experiencing problems of censorship as he entered his high period
of international gallery, museum, and book presentations.

Robert confided that he expected some resistance to his leatherstream
photographs from artstream straights, but he never expected it from within
his own gay fraternity.

Robert was infuriated by judgments of his work when the judgments
were not aesthetic, but were "moral" or "politically correct."

He foresaw that the censorship of Wigler was virtually the same as
censorship of his own work.

That summer of 1982 was strained and anxious.

Gay politics had produced a *faux*-Nazi group who ruled pontifically
about what was or was not politically correct.

The trashing of the Wigler exhibition was their Kristallnacht: very like

the unexpected night Hitler's Brown Shirts attacked Jewish shops all across a surprised Germany.

The irony to Robert and to me was that gay liberation was supposed to set people free.

He resented this new level of repression: gay art censored by gay politics.

To him, it was a maddening irony.

Four years before, at San Francisco's Fey Way Gallery, before Robert Opel was murdered, the gay crowd had adored Mapplethorpe.

He did not like the fickle turn of the queenstream against the masculine-identified leatherstream. In addition, that summer of '82 marked the end of the liberation celebration of the seventies. Ugly whispers had turned to uglier talk and the talk was fanned by the media.

Gay men were sick and dying from an unnamed plague. Before acquired immune deficiency syndrome was called AIDS, it was singled out as gay-related immune deficiency (GRID). That summer of 1982, the nameless dread was dubbed, simply, gay cancer. People were beginning to be scared sexless. Death, unrecognized previously by gay men, was the stuff of novels, movies, and photographers like Wigler and Mapplethorpe.

Denial of death, of course, ran rampant. And no one denied it more than Mapplethorpe. He had resisted me on health matters since 1979, and he was not about to cave in "because a few faggots had sex with aliens."

That summer, a sunami of a sea change surged through the tidal basins of gay pop culture in New York and San Francisco. A real, palpable fear of death led to the censoring of actual sex acts into what would later be called "safe sex." As physical sex was circumscribed, so was the expression of sex in art.

What shifted so quickly on the fault line in San Francisco on a physical level shifted even faster on the aesthetic.

If AIDS had never appeared, Robert Mapplethorpe, Jim Wigler, and the entirety of the gay arts and politics movements would never have suffered censorship in bars, galleries, or the U.S. Congress.

Who knows to what heights of acceptance gay liberation, born at Stonewall, June 27, 1969, would have reached in art and politics by century's end, had a virus, conveniently biblical, not spread a plague that fundamentalists exploited for their own ends?

Robert, always encouraged me to write about him and about what

interested him, because he himself was no writer. He insisted that I defend Jim Wigler in print because he was seeing yet another alter ego in Wigler.

I had been writing about censorship for years. Robert never asked a writer, not even Patti Smith or Eddie White, to write without trying to manipulate. Mapplethorpe's sudden interest in censorship seemed self-absorbed, but it was one of the only times he ever really flexed himself inside a social problem.

Actually, that summer of 1982, seven years before he died, Robert gave some clue as to how he would have handled the posthumous trial of his work in Cincinnati.

Never forget: (1) that exhibition and famous trial occurred *after* Mapplethorpe died; and (2) Mapplethorpe himself *never ever* received a penny from the National Endowment for the Arts.

In 1982, I was editing for Michael Redman, a straight publisher, a tabloid I created for him called *The California Action Guide*. Redman, successful with his straight Bay Area tabloid, *The Pleasure Guide*, thought he might enter the fray of gay publishing by presenting a homomasculine editorial view alternate to the queenstream of the *Advocate*, the feminist take of the *Sentinel*, and the lesbianarama of the *Bay Area Reporter*.

The straight Redman was more courageous than gay publishers who had caved in without a fight to feministic gay men driven by radical lesbians demanding that gay male culture correct its course politically.

Redman welcomed my controversial Mapplethorpe-inspired piece on the censorship of photographic art in the once-united gay community.

In the August 1982 *California Action Guide*, I presented Robert's thoughts combined with mine, using five of Wigler's black-and-white photographs as Exhibit A.

Robert was expert at damage control.

He knew the fight against censorship would raise tempers. It was safer for him to fight censorship using the photographs of Jim Wigler, because any backlash would hit the beleaguered Wigler, not Mapplethorpe. Robert the publicity hound deplored anything that would hurt his sales.

I had to juggle the needs, agenda, and egos of both Wigler and Mapplethorpe.

Before the article was printed, I read it over the phone to Robert, who allowed his name to be mentioned only once, as a kind of internal signature.

This was the way he had me front for him from the beginning of our relationship. Every artist, to remain beloved by the public, and not to seem temperamental, needs agents of various kinds to front for him. As a writer, I have always enjoyed championing individual rights. In light of the global fame, controversy, and trial that happened after Robert died and was unavailable for comment, I am thankful that I had been able to engage him on the subject of censorship. Did anyone else?

If he was using me, he could use me till he used me up, because we were lovers and then friends, and he gave me as good as he got.

My feature defending Jim Wigler was called "Take It to the Limit One More Time." That title, like the title of my novel, *Some Dance to Remember*, came from the Eagles' album *Hotel California*.

The Eagles were, to my mind and Robert's, the group that best articulated California's 1970s life-in-the-fast-lane style.

Anyway, next to the "Take It" title in bold print, I laid in a very aggressive photograph of Gunnar Robinson in full leather, holding in his black-gloved hand a long knife. I intended the article to be as aggressive as the photographs of both Wigler and Mapplethorpe.

The text itself wound around photographs of Robinson holding the point of the knife against the belly of a man wearing a black leather jacket and hood, and tied with rope to a fence in a deserted place.

Robinson's gloved hand pushed on the man's throat, forcing his head back and his belly out very vulnerably.

The other three photographs were execution poses: Robinson using a gun pointed at the bound and hooded man.

The hood made the victim seem very universal.

These purposely *True Detective* magazine type tableaux of a leatherman killing another leatherman were provocative: many gay men were victims of killers from their own kind during the seventies.

William Friedkin caught the fear quite accurately in his virtual documentary, *Cruising*.

Wigler has indicated that while these photographs could be considered an homage to Friedkin, they are more truly inspired by real gay fears and fantasies.

No one in the straightstream should be surprised that Terminal-Sex, Death-Talk, Snuff-Trip FANTASIES provide continuing Erotic

Edge to a subculture whose very lives have historically always been threatened.

"Kill the fags!"

When heard often enough, that phrase causes counterphobic behavior: a person acts out in psychodrama the things he fears most.

Robert, himself always fascinated by the erotic connection between love and death, related to Wigler's photographs on both sexual and aesthetic levels. Mapplethorpe very much approved of Wigler's work, despite its level of literal melodrama.

Actually, Robert enjoyed Wigler's work with leathersex the same way he liked *Mandingo*'s take on interracial sex.

Robert seemed in his appreciation of Wigler a bit like Cocteau's getting off sexually on Ken Russell. But, then, Robert was a New Yorker through and through, and Wigler was Californian.

Robert always gave us all that slightly superior East Coast edge, as if we others were living on the American frontier.

Robert knew how to push people's buttons.

I pushed his back.

That's why we liked each other.

I could tell him no, enough, or yes.

So when Robert was leery about my printing one of his leathersex photographs with my Wigler article, I called him chicken.

Instead of a Mapplethorpe shot, I printed a full-page photograph by his New York rival, Arthur Tress, which I titled *Industrial Sex*.

The Tress image exhibits a man, blindfolded and gagged, sitting naked in a deconstructing factory amidst gauges, electric wires, and a big Bulova clock reading 3:45.

By the time I sat down to write "Take It to the Limit," the voice every writer hears in his head was a duet led by Robert Mapplethorpe.

A decade after the article appeared, the fight over Wigler was an uncanny foreshadowing of the Great Mapplethorpe Controversy in Cincinnati.

The "politically correct" queens of San Francisco behaved not unlike Jesse Helms and the Mapplethorpe prosecution.

THE CALIFORNIA ACTION GUIDE
AUGUST 1982

Take It to the Limit One More Time!
Cutting Through the "Politically Correct" Bullshit
About Wigler and Robinson's Consensual S&M
As New-Wave Performance Art-gasm . . .
By Jack Fritscher

Enough of the queenly bullshit about the art of photographer Jim Wigler and his partner/model Gunnar Robinson! Righteous editorials in local "politically correct" gay rags have, indeed, gasped at the masculinist Wigler-Robinson images recently shown at The Eagle Bar, South of Market. It's not The Eagle's fault that some of their patrons have naugahyde minds under their leather caps. The Eagle was at first daring enough to exhibit the Wigler photographs. Too bad The Eagle knuckled under to the screaming minority who demanded that the "offensive" photographs be taken down.

Something is afoot in San Francisco that smacks of censorship by "Naugahyde Nazis" who figure that just because they take it up the ass they automatically qualify as critics of what's art and what's not. Have you ever met a know-it-all queen who didn't have a critique to dish out about "absolutely everything"?

VICTOR/VICTORIA VS. WIGLER/ROBINSON

Pauline Kael, in her May 3, 1982, *New Yorker* review of *Victor/Victoria*, found the movie rather repugnant: it pretended to be a broad-minded howl, but in fact was an insulting piece reaffirming standard middle-class sexual clichés. Kael finds it difficult to believe that homosexuals, who during the years we were despised, and developed for ourselves the

compensatory myth that we had better taste than anyone else, could fall for so bad a film. Homosexual enthusiasm for *Victor/Victoria* by itself "should help debunk that myth": that being gay automatically makes a man a critic.

The lady's right: we've got a lot to learn about the essential differences between art and morality, between homosexuality and homomasculinity, and especially between escapist entertainment that leaves your values alone and the intensity of art that changes you and your values by its mere existence.

SOCIETY'S OUTLAWS AND THE AVANT-GARDE

Homosexuals have traditionally been society's outlaws and the art world's avant-garde. What's happened to that wonderful, daring sensibility? Has the art of our subculture succumbed, the way the Marxists, etc. would have it, to the service of politics? MGM's logo, *Ars gratia artis*, art for art's sake, says it all: art is superior to politics and religion, and any bending of art to pump for politics or morality is a betrayal of art. Art is apolitical and amoral. Now that we are no longer outlaws, and that "gay is good," have we become so upscale middle-class that we begin to censor the S&M part of our subculture the way straights would censor our whole subculture (if they had their druthers, and if they could)?

Why must we prove to anyone that we're good little homosexuals?

Homosexuals used to experience shame. Now shame has shifted over to pride, if not outright, outrageous vanity. The shame, Kael says, was a snare; the vanity can be, too. And damned if it doesn't snap its petulant little wrist here at Jim Wigler's photographs, which depict real, valid, male sexuality boldly interpreted both through Robinson's docu-role and Wigler's aesthetic vision.

WIGLER'S STUDIO AIN'T CALLED RAW GRAPHICS FOR NOTHIN'

In the 1980's, the world lives on the dark side of the moon: nuclear annihilation, urban terror, and "gay" cancer, wherein the word *gay* is enunciated by the media to sound like we invented it and are getting our just biblical desserts. The media also specifies distinctly "homosexual murders," but never uses the term *heterosexual murders*. Like it or not, we'll always be in a class by ourselves. "They" know we are. And we should be smart enough to stay distinct, making our "fine" distinctions a contribution to the wider society that seems capable of only obvious distinctions.

If homosexuality does not give us a freewheeling, parallax view on life, then we're failed faggots, for whom our sexual distinction is nothing more than genital calisthenics. We are set aside from the society at large for reasons more than sexual. For centuries, the philosophers, warriors, and artists who have shaped the "straight" world's history and tried to direct its stodgy mind-set have almost all been in our camp!

We will never be, and should never want to be, assimilated, except insofar as our human rights are concerned, into the homogenized vanilla of middle-class America. If we do, then we are lost, and they are more lost without us. No one knows what causes the gift of homosexuality. I suggest, in a Fundamentalist Nation, where people have Jesus whispering personally in their ears all the time, that we tell them that homosexuality is a vocation, a divine calling to a particular kind of life—no matter how you define "divine." Its rites and rituals, including especially the catharsis of S&M, are to be protected and nurtured, as all religions in America are.

Our rights include our specific right to be different. We are, in essence, philosophically, definitive existentialists running contrary to the sentimentalized sexual/parental morality of the American middle class. Naturally, if a homosexual does not understand that our different mode of body-sex inspires a different mode of head thought, then he's not going to be capable of understanding the Wigler-Robinson aesthetic statement.

GUNNAR THE BARBARIAN

A homosexual trying to pose in the drag of middle-class values is a traitor to homomasculinity, which is as barbarically primitive as it is tenderly pure in its consensual code of things masculine. The art of homomasculinity, which is homosexuality theorized and put into practice on a man-to-man level, becomes increasingly difficult in an increasingly feminist society.

It is the very virtue of the Wigler photography that angers and frightens brainwashed feminist men. The Wigler view is too butch.

The word *virtue* comes from the Latin *vir*, the masculine noun for *man*. Homomasculinism's specific virtue is the same virtue as the Wigler photographs: a manly daring to exhibit the existential vision of eros and thanatos, of love and death, in ways politically correct feminists haven't the balls to acknowledge.

As long as there is a feminist movement, which ironically creates that contradiction in terms, a feminist man, then we need a masculinist movement, with statements like Wigler's, until the day when there are not feminists and masculinists, but only humanists.

Let model Gunnar Robinson murder his "victim." Beauty, unlike morality, which is relative, is absolute. Murder, which is usually immoral, can still be performed as an aesthetic act to be judged by the rules of art: is the ritual, actual murder beautifully executed or not?

One thinks of the pure performance art of the suicide of leatherman-writer, Yukio Mishima. The Japanese film *In the Realm of the Senses*, with full Oriental rather than Occidental sensibility, tackles murder as a beautiful act of artful, ritualized passionate love. Pasolini's *Salo*, an artistic film that soared beyond conventional morality, received the same queenly drubbing as the Wigler photographs. Few perceived Pasolini's powerful death images as a metaphor of fundamentalist fascism. Instead, their literal minds watched the screen and they ran to the exits with their shit coming between them and their Calvins.

DEAFENED BY DISCO AND BLIND IN THE DARK

Flannery O'Connor defended her southern gothic grotesque vision of the world in this way: "To the almost deaf, you have to shout; and to the almost blind, you have to write in very large letters." Under the din of disco and The Eagle's low lights, the fact that Wigler succeeded in getting a rise out of his audience is proof positive that his raw graphics are more art than jerkoff entertainment.

Entertainment photography, such as the sentimentalized work of Colt Studios, has a definite and pleasing place in our subculture. And precisely because of the sugary finesse of Colt's Barbizon–*Gentleman's Quarterly*–muscle mag subjects and airbrushed style, we must also look at our subculture's other, darker side to bring in the balance. Wigler's daring advent has received much the same reception as the first showings of Robert Mapplethorpe's evil leather photography, or the first critical reactions to the gritty masculinist pointillism of the incomparable artist Rex.

Artists, because they *are* what avant-garde *means*, are always ahead of their times. Wigler, in the eighties, clues us in that the riotous nineties are almost here. Artists are the Road Warriors of tomorrow today.

Entertainment photography, say, fashion entertainment *à la* Bruce Weber, is a valid, but cozy-safe experience. Entertainment reinforces our values, makes us feel good about the way we are and the way our world is. Nothing wrong with that; but it's limited and limiting. Art, on the other hand, disturbs us from smug ideas about ourselves and others. Entertainment reinforces who we are. Art challenges who we are and what we might become. Entertainment makes us more of the same. Art changes us. But when people are afraid of change (and that is most of us most of the time; and death is the Big Change), we kick and scream and try to censor the alternate vision thrust upon us when we would rather not acknowledge or accept its truth, but remain rather supposedly safe as we are. Entertainment plays to the superficial self. Art surprises the self by peeling back the layers of the deeper soul.

Our seers are also our soothsayers. Our photographers tell us their truths. What Wigler sees in his visions he speaks in his photographs.

LOVE AND DEATH AND THE WHOLE DAMNED THING

Art is love and death and the whole damned thing. The murderer in me has wanted to kill my lover in the heat of blissful passion, so that in the mix of eros and thanatos, we could transcend out of finite time together forever. The murderer in me has also wanted to kill my lover out of jealousy. The first is a grand, operatic, passionate motive. The second, cheap and petty. There, in premeditated print, it's said. But haven't all of us committed little murders in our hearts? Haven't we all enjoyed, at least as spectators, voyeurs, connoisseurs, the sports and the adventures that put life at risk of death? We don't like to acknowledge the outlaw, disobedient, unbridled side of ourselves. We don't like to live on the existential cutting edge of truth when we can retreat, like young colts, into sentimentalized romanticism. We pretend we're Butch and Sundance, when we're really Frankie and Johnny.

We don't like to be reminded of our own mortality. We live our lives spending and getting, only to be reminded by a larger-than-life character like Tennessee Williams's Big Daddy in *Cat on a Hot Tin Roof*, who says, "We traipse around buying up everything in the hope that by chance we'll buy eternal life." The denial of death causes a great deal of dysfunction when it comes to confronting art that is about mortality. Resurrection is what makes Christianity such a big corporate franchise.

Wigler, in the best tradition of "The Artist as Seer," is leading us into forbidden territory: levels of passion we know exist, but don't want to acknowledge, because mommie dearest always forbade the wire hangers of stylized S&M ritual. This is not to say that the Wigler-Robinson entente is a pair of murderers. They may not, as individual, private persons, even agree with any of this. The point is that an artist's work also exists, really and viscerally, independent of the artist. Art is a mirror. Art means as much, or as little, as the viewer or reader is able to absorb. At any rate, Wigler keeps his fine art photography, raw as the stylized subject matter may be, far from cheap-shot sensationalism. Only the fundamentalist, retrosensitive, literal mind could object to his artfulness. His "look" is one of ritualized confrontation with the concept of death-as-orgasm, *le petit morte* of French existentialism.

DEATH AS A HARD-ON

Sexual activity has two sides to it: flavors of attraction and flavors of repulsion, flavors of hard and soft, love and aggression, personal and impersonal, anima and animus. There is the same reciprocity with mortality. Does not denial heighten feeling and curiosity? Does not the inevitability of death heighten the excitement of the stakes of the daily game? Is there a person alive who isn't deeply curious about what dying will be for him? Is there a man alive who would not like his dying full of excitement?

Is there a man out there who really wouldn't like a date with Gunnar Robinson?

Wilhelm Reich pointed out that the culmination of sexual excitement peaking in orgasm is a way of getting out of ourselves and into the universe. Orgasm, like art, takes us from the world of the known into the world of the unknown, experiencing our unboundedness for a brief time (even though tied in heavy bondage), giving us a hint of what our dying might be.

When we have orgasmic experiences, we are saying, "I let go. I give. I risk. I die. I melt. I become one. I go to the cosmos. I surrender for a few moments to the unknown." Too many people have learned not to say, "I love you" or "I wish I could die" or "I feel this love as a melting into the universe, like dying."

When was the last time you crawled out of bed on all fours, exhausted with lovemaking, saying to yourself, "I could die happy right now." Orgasm of this kind is obviously different from garden-variety ejaculation.

CENSORS EXPOSE THEIR OWN INNERMOST HEARTS

Wigler and Robinson dare to bare themselves, at least in their personae as artists, with their strong images of orgasmic love and death. Liberation has let them learn to know how to feel it, to say it, to communicate to us in the photographs the very essence of orgasmic bonding between homo-masculine men, for whom sex is not play, but is rite and right. For this, they should be censored by the very retrograde, politically correct, gay fundamentalist minds who need to receive the message of their artful point the most?

Censors, if the truth be known, should be very careful what they censor. Censorship is a very self-revealing thing. People always tend to censor in others the thing that in their secret heart-of-hearts they fear is the real truth of their hidden selves that they think nobody knows. After Anita Bryant came out so strongly against homosexuality, was it ironic or what that a few years later she divorced her husband allegedly because he was gay? Was the lady seeking to control in society what she could not control at home?

Once a man is not afraid to confront his own self, he can recognize the aesthetic, human, amoral validity of the artist's images. He also begins to understand that a man can deal, not dysfunctionally, with an essential passion—such as his literal curiosity and fear of eros and thanatos—only after he has fulfilled that journey, that fantasy, that rite of passage on some psychologically authentic level, such as is triggered by a grab-ass photo that knocks him out at The Eagle Bar.

Wigler should be congratulated for opening one of the last closet doors. The Eagle Bar, perhaps, should not listen to the laddies who protest a bit too much.

Robert liked the article, but the experience of intramural censorship soured him on the gay community and its ignorance of art. He was getting enough grief from straight gallery owners and publishers who wanted him to clean up his act.

"Besides," Robert said, "gays never buy art anyway. All they want is something pretty or something nasty to jerk off to."

For all the controversy over Robert Mapplethorpe's media recognition as an erotic artist, I doubt if anyone has ever really masturbated to a Mapplethorpe photograph.

1978: PASOLINI'S LAST PICTURE SHOW
TOWARD AN UNDERSTANDING OF THE FILM *SALO*

L et's cut through all the queenly bullshit about *Salo*, the last and most controversial vision of Pier Paolo Pasolini. If you're alive and gay, you waited two years for the U.S. release of this film. Now that you've seen *Salo*, how do you handle its scenes in your own head and explain them to unkinky gays? Especially since *Salo*'s explicit scenes, at first viewing, seem so directly tied to the S&M lifestyle. You can't laugh *Salo* off like *Pink Flamingo*'s outrageous Divine eating shit. *Salo* is no joke.

TWO KINDS OF CINEMA

Make a distinction: movies and films. You go to a *movie* to escape life's tension. You go to a *film* to intensify life. You go to a movie for entertainment. You go to a film for intensified input. Some guys short-circuit when

The author's review-essay first appeared in *Drummer* magazine, May 1978.★

★ Anita Bryant crusaded her brand of Florida Christianity against homosexuality in the political arena and wound up losing her commercial endorsement of orange juice as well as her recording career. Bryant and her Proposition 6 are examples of the kind of wonderful damage gay pressure can do to bigots.

Avowed heterosexual Ed Davis was the chief of police in Los Angeles. Davis raided gay bars, baths, and gay publishing houses, including *Drummer* magazine. Performance artist Robert Opel streaked the Academy Awards live and was arrested by Davis at a City Council meeting for indecent exposure when Opel protested the legislating away of Los Angeles's nude beaches.

Comedian Richard Pryor made derogatory remarks about homosexuals at the Universal Amphitheater, saying he had tried *gay* sex and didn't like it. A public outcry damned him. Pryor and I come from the same home town and my response to him was, "I remember why you didn't like it, because you weren't any good at it, you were so loaded on drugs."

they pay admission for a movie only to find out what's on screen is more than they bargained for: a film.

Before you approach the box office, read reviews and listen to word-of-mouth to determine if the feature showing is a movie or a film. Then figure out if you're in a movie-mood for entertainment, or in a film-mood for intensity. Since most reviewers are confused by trying to judge movies by film criteria, and films by GP-movie standards, you basically pay your money, take your chances, and wind up as your own best movie/film critic.

With an entertainment-movie, you get pretty much the sound of music that you bargained for. With the intensity of a film, you can bet you'll be yanked into some artful spaces you never expected to go. When you leave a movie, you exit much the same as when you entered. When you leave a film, you exit changed by an experience that really opened your eyes and your mind.

SALO IS A FILM

Poor Pasolini: more misunderstood dead than alive. He filmed clues to his murderers' identity. His murderers are our attempted murders. His clue is *Salo* itself: a film about the Bryants and Briggs and Pryors (whose grandmother's name is Bryant). Pasolini's *Salo* is a cautionary film, a warning flag. He is frankly blunt about his message. For him, there is no pentimento in *Salo*. No regret. No change of heart or mind. Certain murder, he cautions, lies in wait.

Salo is a dark film shot in a narrow space.

SALO IS ABOUT AMERICAN GAYS TODAY

There are two kinds of S&M: ritual and real. Ritual S&M men go to see *Salo* hoping that Pasolini has made a gay porno-fantasy movie as innocuously entertaining and ritualistic as *Born to Raise Hell*. Instead, Pasolini, although a fan of ritual-macho S&M, in *Salo* presents a film of real S&M. (And often disappointingly straight at that!) Ritual S&M is Black Leather

Therapy acted out for mental health with mutual consent. Real S&M is the evil stuff of a Hitler born again in a Bryant, Briggs, or Davis. Real S&M is fascism. Chances are that American gays in the coming eighties are in for a fantastically fascistic bad time. Good-bye glitter, and hello Anne Frank.

CABARET TO *JULIA*

Films find fascism fashionable. *Cabaret* insightfully showed the easy seduction by fascism when the handsome blond Nordic boy sang "Tomorrow Belongs to Me." This sequence detailed fascism's bandwagon seduction as face after face joined his rousing song. Director Fosse's own filmic power seduced the American audience right into the spirit of the sunny beer garden song, so that in movie houses everywhere, audiences were shocked to find themselves so suddenly, so easily sucked into the thrill of what began as a gloriously innocent song and built to an impassioned fascist anthem.

Julia more gently shows dramatist Lillian Hellman (Jane Fonda) rescuing liberal Europeans from pre–World War II fascism, which eventually murders Julia herself (Vanessa Redgrave). Less delicately than *Cabaret* and *Julia*, the films of young Spanish director Fernando Arrabal (*Viva la Muerte* [1974] and *Guernica* [1976]) portray the grotesquely real S&M of Franco's fascism under which Arrabal and the current generation of young Spaniards grew up: gay men shot up the ass with pistols because they were gay, his own father buried to the neck in sand so his head could be used by four horsemen as a polo ball, a woman shitting on a male prisoner's face. These are strong images meant to stir up strong audience reaction by a filmmaker. A moviemaker, on the other hand, like Ken Russell, rolls Ann-Margret around in chocolate in *Tommy*, and this movie brand of pretend-shit the fainthearted think is "just wonderful camp."

SOME GUY WON'T FACE TRUTH

So what has fascism to do with gay Americans in 1978? John Dos Passos warned, "We will have Fascism in America, but we will call it Americanism." Bigots from Bryant to Briggs are Americanists. Americanists do what fascists did. Hitler burned books and censored radio. Germans were not allowed to see what they wanted to see nor say what they wanted to say. Americanist/fascists always want other people, their victims, in tied-up situations.

Pasolini dared demonstrate this by literally tying up *Salo*'s victims, by literally gouging the eye (to symbolize you may not see what you wish), by cutting out the tongue (to symbolize you are not free to speak your opinion), by scalping the head (to symbolize you may not use your head according to your own thoughts), by forcing one couple to make love on command (to symbolize you may not fuck except as ordered), by shooting an interracial pair of lovers (to symbolize you must not only procreate with your own kind, but you must also have passion for nothing but the Movement). And always, fascism makes you eat its shit.

THE WIZARD OF OZ MEETS MUSSOLINI

Salo offers strong images to strengthen the viewer. Pasolini was so aware of the horrors of his third section, "Circle of Blood," that he softened the images by distancing the audience from the bloody action with a telephoto lens that gauzed out the edges. Sometimes assault is the only way to raise consciousness.

Throughout *Salo*, which is not salacious, Pasolini artfully staged his cautionary political warning at a gut level. *Salo*'s images are contrived to get your attention. *Salo*'s message is to hold your interest. *Salo* is a political film in the antifascist tradition of Pontecorvo's *Battle of Algiers* and Costa-Gavras's *Z* and *State of Siege*.

And despite his serious message, Pasolini has the sense of humor to add the comic relief of those silly women dragged up like Glinda the Good Witch, coming down the Hello-Dolly staircases, telling their naughty, campy tales. But, he implies, behind their fashion lurks fascism.

WHATEVER HAPPENED TO MGM MUSICALS?

Lots of gay men don't like real things. They hide in fantasy and ritual. They prefer life in a gay ghetto. They need nobody to cover their eyes and ears. On their own, they ostrichlike refuse to look or listen farther than their cocks can shoot. They miss Pasolini's value of using gay vision in a twisted straight world.

Pier Paolo's images are strong. His message is clear: FASCISM IS COMING OUT OF ITS CLOSET, TOO. His film won't let us ignore it. He shakes us so bodily we want to turn away our faces from the screen. We may not emotionally like what we see; but, understanding his visionary point of view, we can intelligently distinguish and explain how what he films is not about our ritual S&M, but about a real political-moral reality that, like something dreadful, this way comes.

GET THE PICTURE?

In defense of her own bizarre short stories' strong images, Flannery O'Connor wrote about people who have eyes and see not and ears and hear not.

Pasolini's death cry, *Salo*, shouts very large.

TAKE 20

RISKING THE MAPPLETHORPE CURSE
MURDER, MODELS, AND HETEROPHOBIA

Supreme Court Justice Potter Stewart's Eyeball Test of Pornography: "I know it when I see it."

It's not fair to judge 1970s art by 1990s relative standards.

"FAMED PHOTOGRAPHER'S PORNO PIX FOUND IN DUMPSTER!"

I always knew Robert would come to this. The *National Enquirer* wants him. So does the *Globe*. Warhol promised fifteen minutes of stardom. Robert manages to leverage another month. Patti Smith could write a new song: "Tabloid Fay-yame." Tennessee Williams said, "The *National Enquirer* is the only real literature being written in America."

The media besieged the San Rafael, California, attorney's office after three Mapplethorpe photographs were found, trashed in a Dumpster, and were placed in protective custody. At the time vintage Mapplethorpe sold for $10,000.

The lucky finder would become the keeper after 120 days of Sodom if no one proved ownership.

Tina Summerlin, then executive director of the Mapplethorpe Foundation, believed, after examining a fax of the photos, that the signature was Robert's.

Andy and Robert would have loved fax. A whole new medium since they died. Fax mutation itself has become art.★

★ As early as 1979, Marilyn McCray edited *Electrowork*, a catalog for a groundbreaking exhibition of Xerox art for the International Museum of Photography at the George Eastman House, Rochester, New York, featuring images by Carioca, Buster Cleveland, Willyum Rowe, et al. Before Warhol, Ansel Adams, Minor White, and others worked with Polaroid Land photography.

FABOU PHOTOG
ROBERT MAPPLETHORPE
Presents
"Photographs in a Dumpster"
Concept by Irony
Sired by Andy Warhol
From a Wish and a Prayer by Senator Jesse Helms
San Rafael, Marin County, California
Engagement Limited by Marin Dumpster Pickup
Air-Filter Amyl-Nitrite Feather Masks
by San Francisco Sculptor Edward Parente

The photographs, all signed, are dated 1977, exactly the period when Robert first came to the West Coast. His piss photograph, *Jim, Sausalito, 1977,* was one of many he shot in the Bay Area.

Marin was Robert's kind of place: conspicuous decadent wealth.

I drove him in my Toyota Landcruiser to the Marin Headlands to look back over the Golden Gate Bridge at the picture-postcard view of San Francisco that is the ultimate Bay Area photo-op cliché.

Robert did not drive. He was a New Yorker. Taxis were his medium even in Los Angeles, where photographer Miles Everett warned him of the expense. He liked being driven. I liked driving him. The faster I drove, the more excited he became as we scouted isolated locations for outdoor shoots where he was not likely to be disturbed.

The abandoned World War II concrete bunkers on the coastal Marin Headlands fed his Leather Ninja fantasy: old concrete, rusted rebar, industrial ladders, steel hooks, romantic ruins of a warrior civilization.

I thought the bunkers, with the loss of Vietnam only two years old, an ideal set for men in military, leather, and prison gear. My lover David Sparrow and I had photographed David Wycoff as a soldier, and supper-club pianist John Trowbridge as a prisoner, for separate *Drummer* covers and spreads. The bunkers are only a stone's throw from San Quentin.

Robert read the ruins of the fortifications as a West Coast opportunity. Ruins, ancient and modern, are staples of male photography from Von Gloeden on through the genre of male physique magazines sired by the Canadian-born, Venice Beach–based Weider brothers, whose muscle-magazine empire created Arnold Schwarzenegger.

Schwarzenegger's cross-over rise through pop culture included, almost

simultaneously with Mapplethorpe's 1976 photograph, a shot, seated, very pumped, on the February 1977 cover of the very gay *After Dark* magazine, which was at its zenith. The issue became imminently collectible for the famous frontal nude shot of Schwarzenegger on page 41.

The Marin bunkers inspired Robert. The ruins gave him a chance to show up New York photographer Arthur Tress, who also worked out of the Robert Samuels Gallery.

To Robert Mapplethorpe, Arthur Tress was a competitor.* Tress had created an erotic series of naked men dramatized as sex martyrs, sado-masochistically posed as victims of erotic violence in abandoned industrial ruins of factories and wharves.

Robert was amused by my "Meditations on Tress under Stress" in *Drummer* (fourth anniversary issue, June 1979). My texts were short parables, each erotic mantra matched to a photograph of a Tress perfect moment.

Extrapolating from my published work with Tress, Robert spun plans for me to write erotic meditations for his photographs. He wanted us to do a book together. The working title was *Rimshots: Inside the Fetish Factor.* At that time, he had nothing much published and he was in heat to produce a coffee-table book.

Robert thrived on layering his take in on top of other photographers' visions. It's what film directors call a "quote."

"He'd look at my photographs," George Dureau said, "devouring them, discussing ways of making my rather romantic approach nasty, searching for the shock value."

Robert was an incurable eclectic, honing an edge, which was his special gift, on every image he saw.

"I have discovered a shameless piece of visual plagiarism on the part of Mr. Mapplethorpe," Edward Lucie-Smith faxed on May 17, 1991. "In 1977, at a moment when S&M was almost mainstream fashion in New York, a book, titled *Hard Corps*, was published: text by Michael Grumley; photographs by Ed Gallucci. One or two of the Gallucci pictures are very

* Robert once demanded that photographer Peter Hujar be removed from an up-coming exhibit. If not, Mapplethorpe would withdraw. Mapplethorpe won. He thought buyers, instead of buying a Mapplethorpe might buy a Hujar. He did not demand that Lynn Davis, a female photographer in the same show, withdraw. Perhaps he did not regard women as competition. Lynn Davis eventually became a board member of the Mapplethorpe Foundation.

obvious sources for those of leathermen in rather twee settings which Robert repeated a year or two later. It is very clear he saw the book."

The specific Gallucci picture shows leather-film porn star Fernando, sitting in full leather in his "twee" apartment in 1977. Robert quoted Gallucci in his 1979 at-home portrait, *Brian Ridley and Lyle Heeter*. Both men wear full leather. Brian, chained, sits in the designer apartment with Lyle standing, holding the chain.

Heeter, like so many others met separately, was a friend to both Robert and me. Fernando, another trick, was last seen as an "atmosphere extra" in William Friedkin's movie *Cruising*, which used actual leathermen as set decorations. Our smoke-and-mirrors worlds of art and sex were populated by many of the same people.

My interest in leathermen was to find their specific sex trip, play it, and write New Journalism feature articles about it. Robert likewise probed their fetish interests to photograph their posed image.

We were co-conspirators harvesting men.

From San Francisco, I wrote to him in New York:

21 March 1979
Dear Robert,

Licks upon your Opening! As Emerson said to Whitman, "I greet you at the beginning of a great career." As with all "overnight" sensations, you've worked long and hard to hang socialites next to sensualists, princesses next to pissers, and flowers next to fetishes. For a satyr who hasn't had but this current incarnation since about the sixth century B.C., you've adapted stunning-well to the technology of putting out-of-focus people and more out-of-focus kinks into energy frames filtered through your lens. You do okay for a kid from across the river. . . .

Enough.

I miss you, and really do, in a special way, love you.
 —Jack

"You know what movie you are?" I said to Robert in our constant Movie Game.

"What?"

"*A Dandy in Aspic.*"

Actually, he found sex difficult unless he posed the tableau. Sex for Robert was a single frame.

It's a risky career move to adapt and reinterpret living photographers and succeed in creating a fresh tension that makes the reinvention seem so startlingly original that the derivation is forgotten.

Robert dared comparison.

He climbed up on the shoulders of giants to get a better view.

Robert loved risk. In his life. In his art.

Pressing danger, he made his life a series of "perfect" moments.

Perfect for him.

Robert was the center of his own gravity.

His instincts were as keen as his intellect.

The Marin Headlands presented a challenge this studio photographer could not resist.

Robert, like most sexual warriors, had stories to tell. The militarism of the bunkers set him chattering about his stint in the elite Pershing Rifles reserve unit in college. He told the story with some slightly self-deprecating humor that he had once been rather gung-ho before he came to his senses about the Vietnam War. Personal survival, not politics, motivated his pacifism. He managed to avoid the draft in the sixties until he was too old in 1972. His work, despite a couple of severely aesthetic shots of a tattered flag (*American Flag, 1977*) and a battleship (*The Coral Sea, 1983*), both taken well after the fall of Saigon, contains no real internal evidence of a political consciousness disturbed by war.

Robert never gave up his fascination with guns. His camera truly was his assault weapon. He really was a shooter. He knew how facilely Freudian he was. Because he was homosexual, he shot adoring frigid photographs of some females he would have fucked if he had been heterosexual.

Some women were his trophies.

Because of cultural tensions, homosexuality, naturally diverted from heterosexuality, often creates art.

He liked shooting women.

He liked shooting blacks.

He liked shooting gays.

Robert was a Great White Hunter.

At the Headlands, Robert, a creature of the night, looked up at the Pacific sun as if it were a key flood lamp he could control.

Where better than outdoors in sunny California to shoot forbidden

leather, usually seen only at night in sex clubs or in urban aboriginals' dungeon playrooms?

Conventional gay wisdom: The best gay sex is public sex.

Robert risked being caught in the act of shooting leathersex on federal land. The tension of the public act of creation added to the innate sexual tension of forbidden leather.

At his February 1978 exhibit at Norfolk's Chrysler Museum, Robert displayed several Headlands shots. He had returned to the bunkers with his leather model, "Jim," who was a San Francisco opera singer. "Jim" brought along his leather toy box. The photograph, *Jim, Sausalito, 1977,* features the model crouched at an iron ladder, stripped to the waist, defaced, wearing a black leather hood.

"I'm obsessed," Robert told William Ruehlmann, "with coming up with a vision nobody else has had before. My personality is with the portrait as much as the person I'm shooting. It's somehow fifty-fifty. The result is the projection of some kind of sensuality. 'Jim' would be considered perverted in Norfolk, but he's no more perverted than most of the people I know."

This early exhibit also featured some of the very photographs that a dozen years later caused headlines: specifically, naked children. No one in the seventies objected. Robert's exhibition was so successful that the Chrysler Museum director, Mario Amaya, established a permanent gallery for photography, which, until the mid-seventies, had been an orphan among the fine arts.

Never underestimate networking. Orson Welles cautioned: "You can be a live wire, but without connections, you're dead."

Mario Amaya, whom I had known since 1967, long before Robert had invented himself, was a British art critic and intimate of Warhol's Factory. He was the first gallery director to enshrine Mapplethorpe. On June 3, 1968, when feminist Valerie Solanas shot Andy, she also shot Mario in the hip. Mario died of AIDS in London, June 29, 1986.

Robert and I finally met in March 1977.

On February 24, 1978, Thomas Albright reviewed a Weegee/Mapplethorpe exhibit at the Simon Lowinsky Gallery in the *San Francisco Chronicle*: "Realism, Romanticism and Leather."

> It would be hard to imagine two more sharply opposed groups
> of pictures, both falling under the broad umbrella of "straight

photography," than the displays by Weegee and Robert Mapplethorpe. . . .

Weegee—aka Arthur Felig—was, of course, the celebrated New York news photographer whose starkly immediate, harshly illuminated views of the undersides—more often tough and seamy—of city life were compiled in one of the most memorable photography books of the late 40s, *Naked City.*

In later years, Weegee ventured into more experimental techniques, but the exhibition contains only one of this interesting, if often gimmicky work—the familiar 1960 "Marilyn Monroe," in which the face is distorted to a focal point in a grotesquely twisted pout. The bulk of the collection consists of work dating from throughout the 40s—straightforward, blunt, generally nocturnal scenes, spotted in the violent glare of the old-fashioned flash bulb: of a bloodied body on a sidewalk in Hell's Kitchen; a "16 Year Old Boy Who Strangled a Four Year Old"; a dowdy frump observing poshly decked out arrivals at a concert. . . .

It is tempting to see Weegee's mordant realism—or what passes for such, for "realism" in photography, as elsewhere, is principally a matter of convention—as an anticipation of Diane Arbus. . . .

Weegee's photographs lack the obsessive feeling of Arbus. . . . They bear the inimitable stamp of their time and place. . . .

Mapplethorpe is a distinguished collector of photography, specializing in quite respectable work from the 19th century, some of which is now on display at the University Art Museum in Berkeley. His own photography is, one might say, something of a contrast.

Mapplethorpe's primary subject is heavy-leather, hardcore S-M—men in wet suits, bulging crotches, here and there a fully exposed genital (Lowinsky says he edited out some of the heavier imagery, which is scheduled to be shown next month at 80 Langton Street). These images are interspersed with somewhat more neutral ones, such as a nude shot of Patti Smith, and, oddly enough, close-ups of flowers. Given the context, these take on a curious Fleur de Mal quality although one suspects that, seen by themselves, they would scarcely command a second's attention.

In fact, subject matter aside, Mapplethorpe's photography is pedestrianly conventional: rigidly posed, crisply focused, somewhat melodramatically illuminated in the cliché style one might

find in the commercial photography of the slick glamor magazine. The message is the message. It is, at any rate, consistent—in contrast to the naturalism of Weegee's work, with nowhere an unfalse note. But then artificiality is of the essence of decadence, which is really just another form of conspicuous consumption.

When author Brett Easton Ellis's editor removed Weegee's name from the controversial 1991 manuscript of *American Psycho*, which was to words that some people judged Mapplethorpe was to images, he left the name of photographer Annie Leibovitz and photographer Cindy Sherman on *American Psycho*'s endless yuppie consumer lists. How odd that Ellis, in 1991, did not include Mapplethorpe in his celeb name-dropping novel.

After all, the Mapplethorpe-Helms controversy was everywhere, even on the lips of leggy Mary Hart on *Entertainment Tonight*.

Terrence McNally's 1990 Broadway play, *Lisbon Traviata*, made certain to dress its opera-queen set with a Mapplethorpe calla lily, which oversaw actor Richard (John-Boy Walton) Thomas begging to be fucked before the subsequent murder. Set designer, Philipp Jung, knew the potency of stage action under the photograph, the symbol, the hex sign of the Mapplethorpe *fleur de mal*.

In June 1994, Paul Rudnick's *The Naked Truth*, perceived as the "Mapplethorpe comedy," opened at the WPA Theater in New York's Chelsea replacing Yoko Ono's musical *New York Rock*. Rudnick, the author of *Jeffrey*, *I Hate Hamlet*, and of the screenplay for his dead-on movie title, *Addams Family Values*, is this *fin de pop*'s wild Oscar. His loosely Mapplethorpean *The Naked Truth* romped gleefully across an ambitious SoHo photographer, some rich white women, museums, a black penis, censorship of photographs, lesbians, Republicans, sexual identity, and moral crusaders. Rudnick hoisted *Naked* off "Literal Mapplethorpe" into "Legendary Mapplethorpe," slicing with a rapier to a comic cut of an ambitious "Mapplethorpe's" life among the chic and censorious. Rudnick-niks know that Rudnick's alter-ego, his side-quip, Libby Gelman-Waxner, is Rudnick himself, who promises there always comes a day when finally we laugh at everything and everyone who was once so serious.

But in the early unfunny years before the Final Distinguished Robert Mapplethorpe of *Self Portrait, 1986* could say, "The calla lilies are in bloom," he was just another kid from the Styx.

He had boosted porno, at five cents a photograph and ten cents a

"physique" mag, out of Forty-second Street bookstore bins. He had codged drugs, sex, leather, superstars, and ideas from the underground movies of Warhol and Anger. He condensed whole feature-length films into single-frame elegance. His love of multiple images was especially apparent early in his career, 1973, when he photographed, in separate multiples, Patti Smith, Candy Darling (the Warhol superstar who died of cancer in 1974), and himself naked as a sculpted baby draped with a net on black leather sheets.

He loved the fresh iconography of whips, chains, leather, guns, and fists.

Featured with the *Chronicle* Albright review was a Mapplethorpe photograph of leatherman Larry Hunt, seated on a Mission bench, fully clothed, wearing heavy logger boots laced up to the knees, which were spread wide.

The reaction in the San Francisco leather world was immense. Robert was an instant hero for uncloseting the unshown.

The single photograph, *Larry, NYC,* was a mass-media hit.

Robert in one take opened up leather and transformed the personable Larry Hunt into a fifteen-minute media star in a decade in a city where everyone wanted to be a star.

Few leathermen suspected that their obscurity, which had been their deep-night sanctuary, would be turned into chic images that would open their uniquely male world to prying eyes.

Robert found the private doors of New York and San Francisco leather playrooms opened to him. He found it easier to scout the Village and the South of Market bars, to seduce men he found interesting, to explain who he was, what he was doing, and why their cooperation with him was to their advantage.

If art is the perfect marriage of form and matter, then Mapplethorpe's formal medium, the camera, needed the edgy material of men who at night lived the lives of martyrs, saints, and soldiers.

Robert played the avatar, the incarnation, a sadist who was a masochist, who was a sadist.

His camera became a literal fetish object as he cast his spell through the camera. His fetish vision became a ritual men sought.

Vested in animal hides, disciplined in sacred and profane rites of torture, blood, fists, and waste, men offered Robert the material he found he needed to make himself immortal.

It was the seventies.

There were enough drugs around to make anything possible.

Mapplethorpe was a welcomed seducer who practiced his wiles. When first in San Francisco, he was so eager for approval that one night, when we were out together, he entered The Ambush Bar, despite my advice not to, in full leather.

"Oh, Jack," he always clucked at me when I knew something he thought he knew better.

He was startled by the "patented" Ambush plaid-shirt-and-work-boot construction look. Immediately, he exited, taxied back, and returned to The Ambush half-geared-up in a dark blue wool shirt.

So specific were the various gay bars to the male look, by which they distinguished themselves, that a man traveling city to city, bar to bar, had to ask the locals what to wear where. In Los Angeles, Robert was amazed to see men stand in parking lots outside bars, with the trunks of their cars open, changing from one look to another as they changed bars.

"It's very LA," I said.

Robert understood the important semiotics of male codes of dress, and he dressed to kill. He cruised, not for sexual encounters, but for models. He was his own best talent scout, and he hit on everyone I knew or could provide him. He roamed the bars looking for character actors to cast in his ambitious photographs.

Leathersex in the seventies was the last taboo to stomp out of the closet. Its entrance was made grand by Mapplethorpe.

Mainstream homosexuality, represented by the EST-ian *Advocate*, has mostly held leather in low esteem, because mainstream gays confuse the whips and chains of ritual psychodrama with real violence.

Robert, always running against the mainstream, both straight and gay, glamorized leather precisely because of its perceived menace.

Recall the fashion statement the leathered Brando made in *The Wild One*, terrorizing a town where parents ran to lock up their daughters.

Robert's take on leather was they'd better also lock up their sons.

Kenneth Anger's 1964 underground movie, *Scorpio Rising*, Warhol's *Bike Boy*, and the sixties' Hollywood arsenal of biker movies culminating in 1969's culture-shaking *Easy Rider* had turned Robert into a motorsexual homocycle.

Robert was a canny fashion photographer, creating fashion by cruising the streets and bars where fashion happens first.

From the leather bars and the movies, Robert texturized leather peerlessly in his photographs of chaps, vests, gloves, jackets, hoods.

In essence, he sensualized and sexualized the male taste for things male.

He even made straight men look differently at men.

Robert, in the final analysis, spotlighted a primal masculinity contrapuntal to the seventies' emerging feminist consciousness.

That alone was enough to demonize him.

His campy *Self Portrait, 1985* featured two very self-conscious horns popping devilishly from his head in direct spin on the hair-haloed "Christus" aura of his early seventies self-Polaroids. His infamous *Self Portrait, 1978*, with goatee and whip protruding scatologically from his anus, was his self-anointing as Pan/Satan in one of photography's most twisted and twisting frames.

He was already a long way from doing windows for F.A.O. Schwarz toys.

His new toys were sex toys for big boys.

His take on leather seduced people.

He made viewers rethink the received taste, the taste they had been told was correct but was no longer in the exploding pop culture.

At Studio 54, which opened in spring 1977, fashion, drugs, art, sex, and politics all mixed with leather.

At Amaya's Chrysler Museum in Norfolk, in 1978, leathersex began to look chic, interesting, kinky.

He brought the subtext of risky leather to the glossy surface of his photographs, where the forbidden, the feared, and the truly dangerous were held up for observation by some and worshipped by many.

Robert shocked totems and rocked taboos.

He was the boy at summer camp who at night around the fire told the scariest stories he swore were true.

He played nerve endings like the stabbing, screeching "E! E! E!" violin string on the soundtrack of the shower scene in *Psycho*.

If some straight people and nonleather gays thought his work lurid, he calculated his high-tabloid take to make them seem like philistine rubes.

To leather cognoscenti, Robert's imaging work was not alarming. Quite the opposite.

Robert presented a sanitized version, made perfect, classic, and pretty, of some very heavy-duty unsanitized night games.

San Francisco photographer Greg Day said, "Robert made exciting sex look stuffy and boring."

Day is essentially accurate. Robert's classic approach deletes the sweaty essence of erotic athletics. His leather images are squeaky clean compared with the work of other leather photographers, especially the early seventies gay cinematographers: Wakefield Poole's *Bijou*; Fred Halsted's *Sex Garage* and *L.A. Plays Itself*, which are in the MOMA collection; the Gage Brothers' trilogy, *Kansas City Trucking Company, El Paso Wrecking Corp.*, and *L.A. Tool and Die*; and the fisting classic, *Erotic Hands*, that was busted by the Los Angeles Police Department.

In addition, Derek Jarman and Lindsay Kemp's 1976 erotic-religious film, *Sebastiane*—the only movie with dialogue in Latin—exhibited images of Catholic martyrdom, urine, implied scatology, and lusty bodies that enthralled Robert.

Sebastiane, directed by Derek Jarman, whom Robert made his mortal enemy, served as paradigm for Robert that everything that arouses can converge.

Kemp and Jarman, in the seventies, tweaked polymorphous perversity and androgyny on screen and on stage. Kemp's play *Flowers*, backed by David Bowie in his Ziggy Stardust period, introduced New York to a camp spin on Jean Genet's *Our Lady of the Flowers* when it opened at the Biltmore Theater, October 7, 1974. Kemp's *Flowers*, a hit in London, frightened New York patrons right out the door of the Biltmore and closed in less than three weeks.★

Robert was twenty years old and rubbing Manhattan shoulders with Kemp, who pontificated that "theater should shock, frighten, and astonish." Kemp, a mad overwrought genius, also staged an androgynous Off-Broadway adaptation of Oscar Wilde's *Salome*. "*Salome*," he said, between appearances in Ken Russell films *Savage Messiah* and *Wicker Man*, "is my remake of *Sunset Boulevard*."

Kemp was Robert's kind of avant–agent provocateur. They were

★ Nearly twenty years later, *Genet* (the first biography of Jean Genet who died three years before Mapplethorpe on April 15, 1986) was completed in 1993 by Ed White. White's *Genet* was reviewed by Patti Smith in *Details* magazine, November 1993, which also featured a photograph by Lynn Davis, a board member of the Mapplethorpe Foundation. *Details* in 1990 featured photographs of celebrities shot by Robert's brother, Ed Maxey Mapplethorpe. Such small degrees of separation!

operatives in the same scene. They wanted art to frighten the horses; anything less was entertainment, safe art.

For all his high-press-coverage excess, Kemp was extremely disciplined, a quality Robert admired. The derivative Kemp, like Mapplethorpe, same as all artists, was "accused of stealing ideas from numerous sources, but . . ." he maintained, "that he uses such references as songs and character descriptions as mere props to help the audience identify with elements in his own personality." And, Kemp said, "I only steal from the best."

Mapplethorpe listened because Robert had an agenda. He was cleaning up the leather scene for chic consumption.

Barely more provocative than other gay photographers of the seventies, he gained notoriety because he, unlike his confreres, refused to stay in the gay ghetto.

"Fuck them all," he said. "I hate faggots."

He was not a self-hating homosexual. He meant he hated the dead-ending stereotype of the urban gay man driven by politics and living in the gay ghetto. He was ahead of his time.

At the OutWrite Conference for Gay and Lesbian Writers held in San Francisco, April 1991, guest speaker Edward Albee was booed when he told his parochial audience they should break out of the small gay presses and head for major American mainstream publishing houses.

Robert, a dozen years before, had headed out to the American mainstream.

The result was that the gay mainstream never really paid him any attention. He was a twofold traitor to the received image of the sweater-and-camp queenstream: he was leather and he mixed with straight people with money. So the gay press ignored him.

Robert hardly cared. He hated what passed for the gay press. Not until twenty-one months after his death, after a dozen straight publications had put a very newsworthy, Helms-attacked Mapplethorpe on their covers, did the *Advocate*, the most widely circulated national gay newsmagazine, finally acknowledge him on its cover.

Robert made the cover only because of the staunch insistence of the *Advocate*'s progressive editor, Mark Thompson, himself an interviewer of the early Mapplethorpe. Thompson broke the gay ban on Mapplethorpe.

Robert was named the *Advocate* "Man of the Year, 1990," sharing half the cover with "The Woman of the Year."

Despite Thompson's desire to feature Robert's autophotograph with the whip up his buns, the *Advocate* powers insisted on *Self Portrait, 1980*, the "cosmetics ad" autopic of Robert in androgynous drag makeup to reinforce the readership of queens.

Even so, in came the letters objecting to the choice of Mapplethorpe.

The word on the street about him became reactionary. He was even rumored to be a spy on gay liberation for the federal government.

Whispers about "the Mapplethorpe curse" were making the rounds. It made as much sense as "the curse of the *Time* magazine cover," or the curse of getting involved with the Kennedys.

The talk of the Mapplethorpe curse steeped Robert's reputation. Being homosexual in America was dangerous enough.

Being Mapplethorped was almost a masochistic tempting of fate. The folk-rep curse seemed to have some superstitious truth, but the rumor interested Robert only because it made him seem dangerous. He liked any kind of publicity.

He was very aware that in San Francisco, shades of *Cruising*, several murdered leathermen had been last seen in the S&M bars South of Market. For a period in 1978–1979 (coincidentally, the time of Robert's first spending time in San Francisco), a canny murderer cruised the bars where leathermen, surrendering to play S&M games, got themselves into what Tennessee Williams called, in *Night of the Iguana*, "tied up situations."

S&M bondage is based on trust. Judgment of trust can be impaired by lust and drugs. Bodies turned up like photographs in Dumpsters South of Market.

Leather and murder were on the public mind.

Robert's glamorization of aggression and submission was a deliberate mindfuck exploiting the fear. Robert wanted his work to be awesome and his audience awestruck.

Critics and curators could talk of the classic beauty of his flowers and his celebrities. To them, Mapplethorpe, with his inexplicable leathersex period, put a curse on his own career.

In truth, Robert's deliberately designed leathersex photographs made his career.

Robert attracted violence.

I had never seen anyone shot until I was walking with Robert in Manhattan and a young gay man was wounded in a whirlwind of violence in front of 2 Charlton Street.

I had never seen thugs beat up a shopkeeper before that afternoon when Robert and I and Jack McNenny were nearly killed in McNenny's Greenwich Village florist shop.

The once much-bandied-about "Mapplethorpe Curse" may be high-concept folklore, but Robert truly was a vortex.

In 1989, a voice on the telephone identifying himself as Dean Kuipers, who said he was a reporter on *Spin* magazine, called to ask about the rumor that Mapplethorpe had a competing photographer murdered.

The new "facts" of the old story unfolded during talks with other people. The gossip came replete with the phone number of a prison warden who could give permission to speak to a convict who had decided to confess that he and two accomplices had been hired by Mapplethorpe to break into a certain unnamed photographer's studio, steal his negatives, and ruin his shows. The photographer interrupted the burglary and was killed, because he accused the burglars of working for that son of a bitch Mapplethorpe.

This story is a pop culture "Urban Folk Tale," like the babysitter who gets stuck to the toilet seat or the lady on a bus with a cockroach in her beehive, like the poodle in the microwave. Each storyteller knows some-one who knows someone who was "really there."

Maybe jealousy of the Mapplethorpe money, talent, and success moti-vated scandalous talk.

As a memoirist, I'd loved the Mapplethorpe Murder story. As a friend, I drop into absolute denial because I gave up hearing confessions years ago. I can't, don't, and won't deal with any Mapplethorpe-caused death other than his own.

Robert never ever caused violence. Disaster simply followed in his wake. The way he probed at life with his sharp intellect, skinning back what most dare not look at, much less question, made me leave him more than once. To continue with that line of hyperreasoning could only lead to trouble, and never wanting to argue with him, I deferred to him, or exited.

"You're dirty," he'd say, trying to probe a confession from within the dark confines of my soul.

Over and over.

"You're dirty."

Not even lust is as seductive as reason.

Robert could talk almost anybody into anything.

Very few ever said no to him. But I did. Several times.

Then, when he launched into seductive hyperreason, even when it meant everything to him, I said no at last.

On the list of names Robert gave out, as he lay dying, I am, besides Patti Smith, the only one from the seventies who is still alive or locatable. We who created the sybaritic seventies all suffer some survivor's guilt. We seek catharsis trying to explain that decade's primal experimentation and innocence to those who missed the party they wrongly blame for causing AIDS.

There are drugs and sex and rock 'n' roll.

There are male bondings more complex than any plot.

But there are no lies.

There is only the truth that is stranger than fiction.

Larry Hunt became victim of the Mapplethorpe karma.

After Larry posed for Robert, he moved to Fallbrook, south of Los Angeles, to live with Steven Darrow in 1980.

Darrow was a blond bodybuilder, a sweet man, much into leather. Photographers and magazine audiences loved his clean-cut American looks.

By the late seventies, he was a star model for svelte-masculine-art photographer Jim French's Colt Studios. Photographer Mikal Bales of Zeus Studios shot fine art studies and heroic-bondage photos of Darrow, who modeled under the leather name Cord Brigs. Both photographers read his good looks as extremely vulnerable. He was often featured in submissive leather bondage. In 1981, Darrow became, in a straight Bay Area physique contest, a triumphant Mr. San Francisco.

Larry Hunt, whom I had photographed on a Satyrs' Motorcycle Run in the summer of 1978, when I was editor of *Drummer*, also favored bondage. Hunt was a famous leather craftsman and photographer of personalities like the doomed Ropert Opel and Camille O'Grady.

The union of Darrow and Hunt was the marriage of two stars who very much interested Robert.

By winter 1981–1982, one of the stars was missing.

Larry Hunt had driven off in his Jeep to a leather bar in LA on a Saturday night. Sunday, when he failed to come home, Steven began the search. Larry's Jeep was found undisturbed in the bar parking lot.

The Mapplethorpe model had disappeared.

In pursuit of the story as much as of Steven Darrow, I drove to

Fallbrook. I have two attractions. One is for blond bodybuilders. The other is for demimonde detective work.

The escapades of Mapplethorpe friends, models, and patrons reflect very much in their stories the interior story of Robert Mapplethorpe.

I have been keeping journals since I was fourteen.

Robert was interested in my Fallbrook expedition. He was concerned about Larry and he was interested in my chatting up Steven Darrow for a shoot. While Larry was missing, Steven had taken up with popular photographer's model Gunnar Robinson, with whom Robert also wanted me to discuss a Mapplethorpe shoot. He hoped to photograph a series of leather duos with the two blonds.

At Fallbrook, I found Steven alone in his house snugged away in an old apple orchard. The walls, inside and out, had been stripped for remodeling. Bare wood studs held up the roof. Wrapped Cristo-like, the house, where the walls had been, was swathed in long horizontal sheets of opaque gray plastic. A naked lightbulb dangling from a yellow construction cord was the only light. All the furniture was in place. The situation was mysterious, and proved quite romantic, because, much to Robert's chagrin, Gunnar Robinson had changed his name to Chance Something and disappeared, leaving me alone with Steve.

If there are only twelve people in the world, I was falling through mirrors: name changes, disappearances. "Is it me?" I asked Robert.

"This stuff always happens," he said.

"Not to me, it doesn't," I said.

"To me, it does."

Then he said he thought it was "cute" that Steven and I were alone together "playing Muscle God in Bondage." I think he was being snide that I had broken off with the other bodybuilder champ, Jim Enger, whom Robert had photographed. Robert felt left out that something sexual had happened between Darrow and me when nothing of his duo-blond leathersex shoot could happen.

Robert always became frustrated and irritable when things he planned did not go his way, as they hadn't with Jim Enger.

In his mind's eye, he had already created the *pas de deux* of Darrow and Robinson. He felt betrayed by them, and by me, for not closing the deal over which I had no control.

"You can't force people to model," I said.

He changed the subject. "What kind of name is *Chance* when your name is already *Gunnar*?" Robert asked.

"I don't think *Gunnar* was a real name either."

Shortly after our brief affairette, Steven called. Someone had found a jawbone in Griffith Park.

It was first and last news of Larry Hunt.

Until, perhaps, the Dumpster photographs surfaced in Marin.

One of them was inscribed, "For Larry," and signed and dated "Robert Mapplethorpe, 1977."

Could it be the missing clue in Larry Hunt's unsolved murder? How many Larrys in the Bay Area did Robert know in 1977?

Robert ultimately disliked the California bar talk of the "Mapplethorpe Curse," because to him, those quips represented the curse of the queening of the gay mainstream who would not accept his leather portrayals.

He was not alone.

Director William Friedkin, hot off the gay comedy *The Boys in the Band*, and *The French Connection* and *The Exorcist*, was at this same time cursed by queenstream activists who disrupted his New York location filming of *Cruising*. In 1991, the cast and crew of *Basic Instinct*, on location in San Francisco, was besieged similarly. The objection to Friedkin was the same as to Mapplethorpe: mainstream homosexuals, by and large fairly much the sweater set of female-identified homosexual men, feared how straight society might perceive homosexuals after seeing a film about leather and murder.

So much for "in your face" gaystream confrontation of straight society: it's okay for drag queens to flounce down the street in gay pride parades and to wear dresses on TV talk shows, but it's not permitted for leatherstream gays to be the subject of a Hollywood movie. Such bashing of male-identified homosexuals fit in perfectly with the extreme feminist agenda of professional "victims" who need oppressors. The takeover of the once gay-male publishing industry by lesbians and that most moronic of oxymorons, feminist gay men, set out to brainwash queenstreamers.

Urban queers exhibit a heterophobia equal to redneck fundamentalist homophobia.

The urban queenstream has so demonized anything male and straight that queens have become, despite their sexual preference for men, self-hating men.

The curse became censorship.

Friedkin capitulated. A little.

More than Mapplethorpe ever did.

Cruising was completed, and, despite the "politically correct" changes, gave the best "cinéma vérité" take on the real seventies leather subculture of masculine-identified men ever seen in a commercial Hollywood film.

Anyone wanting to know the texture of all-male leather nightlife in the seventies will witness in *Cruising* the pop-sex world that Mapplethorpe cleaned up for museum consumption.

Available on video, the film can be scanned slowly, the VCR put on PAUSE, and surviving denizens of that wonderfully decadent decade can recognize the faces of once-familiar friends and famous "Sex Stars of the NY Night" whom Friedkin hired as atmosphere extras.

Cruising is a virtual documentary of a night in the life of Robert Mapplethorpe.

Gay critics generally trashed *Cruising*. But most gay critics lack credentials as critics. Many are opinionists who often abuse the occasion of their review to spout their own agenda. Amazingly, Robert, alive, never received a really bad review from straight critics.

The gays avoided comment.

"I'm beyond them," Robert said.

"Of course, you are," Robert Opel said. "Critics in the gay press are lucky if they've finished high school. They're desperate to break into publishing. They're young. All they know is that if they trash cleverly, they'll get published."

Robert, now the wealthy artist, raised the ire of underpaid publishers and writers. The average gay reviewer gets paid from $15 to $30 per article, if that, and may be published regularly if he's bitchy enough, and politically correct enough for (a) the Separatist Lesbian Publisher, or (b) the Marxist-Feminist-Queen Male Publisher.

Gay reviewing is, perhaps, no more corrupt than straight.

If reviews are good, chances are friends are reviewing friends as in the notorious mutual masturbation of that Manhattan clique called "The Violet Quill." The whole process of reviewing art in the gay and lesbian press is, almost without exception, invalid on grounds of aesthetic incompetence and lack of critical training. The consequent hurt to reviewed artists, straight and gay, is enormous.

Robert protected himself with his "Fuck 'em" attitude.

He wished gay publishing had been otherwise, because coverage might have meant more sales.

The gay press was the primary cause in Robert's exiting the gay ghetto as fast as he could.

"Actually," Robert asked, "what is it about me?"

"It's not about you," I said.

"Then what's it about?"

"It's about the heart of darkness."

"That's about me," he said. "I show them pretty images of death, which is the opposite of the youth they idolize."

I quoted to him a poem written in Berlin in the 1890s. Literally translated, it said, "Just because you take it up the ass doesn't make you a critic."

By 1982, the queening of the "politically correct" gay press twisted into censorship as full-blown as AIDS.

Self-appointed gays began to censor gay art.

As mentioned, San Francisco's Eagle Bar, in the remaining seventies spirit of leather psychodrama, hung a Jim Wigler photo exhibit featuring Gunnar Robinson and an unidentified model. Wigler displayed leather images of Gunnar Robinson posed aggressively with gun and knife pointed at a leather-hooded bound victim in the woods.

The San Francisco natives were not pleased.

I called Robert in New York. He was shocked.

He figured censorship of Wigler, a photographer whom Robert respected because he had imitated Robert, could mean gay censorship of Mapplethorpe.

After several days of pressure, The Eagle took down the Wigler exhibit. It was an act of gays censoring gays. Robert and I talked cross-continent long and late. He thought The Eagle was wrong to bow to gay censorship. He was genuinely threatened.

"Why should our kind turn on ourselves?"

Robert, who was not a self-hating, homophobic homosexual, did not understand the weird need to censor alternative-sex images, simply because some strange gay cancer was driving the gay world to new heights of hysteria.

He thought photographs of gay death could be interpreted as gay martyrdom the same way that the Catholic Church depicts gory icon scenes from *The Martyrology* for contemplation of what people suffer for their beliefs and way of being.

His concept was right. His timing was wrong. AIDS deaths had the gay community in a screaming panic.

Denial of death became a mind-set that could not withstand the Mapplethorpe brush-off or the Wigler mindfuck.

Robert thought it unwise to enter the Wigler censorship fray directly. For once, he wanted no attention centered on himself. That's when he asked me to defend him by defending Wigler.

"How?" I asked.

"In print. Write something."

"Why do I have to do all the dirty work?"

"Because you're dirty, Jack, and I love you madly."

Of course, it needed to be done; I wrote the feature, even though, by then, Robert was well into the little series of betrayals that happens when friendship turns to use.

There was AIDS, but there was no specific curse, other than ignorance, on Mapplethorpe.

In America, where education does not include art literacy or even media literacy, all art, even broadcast television, is cursed.

Should all artists immediately admit cause-and-effect responsibility for the world situation and the disintegration of the American family?

Obviously, artists, sexually harassing politicians, pedophiliac priests, and incestuous fathers are subverting Christian civilization.

Each and every artist is guilty of the decline and fall of American morals in the new world order.

In the Mapplethorpe seventies, pop art and punk art became performance art.

In San Francisco, an artist husband and his artist wife slapped each other repeatedly before an appreciative audience. How is this different from, or the same as, *Who's Afraid of Virginia Woolf?*

In Rio, a performance artist asked the audience to link arms with him in a darkened room; then he stuck his finger in a light socket.

In Venice, California, Chris Burden, the most famous performance artist of the seventies, earned his MFA by spending a cramped weekend locked naked inside a fifty-cent locker in the LA bus station. Burden also had himself shot in the arm for a museum audience. Just a flesh wound. He also was bolted to the floor of a gallery, neck and wrists and ankles, next to an exposed electrical cord. Nearby, a bucket of water stood available for any playful art lover who wished to end at least Chris Burden's part in the art

movement. Burden finally had himself crucified with nails through the hands to the top of a running Volkswagen parked in a gallery.

This was the art world Mapplethorpe had for peers and competition.

It's not fair to judge 1970s art by 1990s relative standards.

Art, despite the stained-glass school of perverting art into the service of morality, has nothing to do with morality.

Art in its pure state, *ars gratia artis*, is neither moral nor immoral.

Art transcends morality.

Try and explain that to a fundamentalist who thinks art belongs to morality the way the state belongs to the church.

Art is, by essence, simply amoral.

Art has nothing to do with relative moralities as such.

This frees art into universality.

Art stays open-endedly the same in essence, while morality itself is relative, changing from age to age, culture to culture, class to class, of every topic from contraception to abortion to capital punishment.

The richness of art as a concept, despite the impoverishment of even wannabe artists who try to milk it for all its worth, surprisingly always maintains.

No matter how outrageous, controversial, or dangerous.

Art is supposed to be scary.

Otherwise it's entertainment.

In the 1970s a New York artist persuaded two street gangs to hold a rumble inside the Museum of Modern Art. Without warning, the gangs turned on the swell audience and beat and robbed them.

"What started out as a minor piece developed into a major work, an experience that forever altered the consciousness of that audience," said the artist.

No shit!

That's why *West Side Story* is entertainment, not art.

Actually, Mapplethorpe was quite tame by art standards of the seventies.

In the late eighties, his seventies work was caught in the wrong place at the wrong time by the wrong people who were reacting post-AIDS to a pre-AIDS decade of liberation.

Politicians and preachers love to incite the simple villagers with torches to storm the castle where lives "the evil monster," the only man in town with any sense, books, and art.

The Dumpsters, ordered up like tumbrels by the Babbitts/Bryants/Falwells/Helmses/Buchanans/Wildmons et al., will always be waiting, because "Art as a High Concept" excludes people who lack the education or feeling to understand it.

What human beings do not understand scares them in their cause-and-effect cosmogonies.

What scares their sense of status quo order they label as sinful Satan's work.

What Adam and Eve achieved through biting into the beautiful apple, no one seems to remember, was *knowledge*.

If art is the disobedience of absolutes to create knowledge, then art's a sin only to those whose interior lives are slavishly surrendered in obedience to an outside authority who can control them because, lacking knowledge, they are stupid.

Aaaaa! Not that secular humanism stuff again!

Only through demagoguery did *art* and *family* become antithetical buzzwords rallying followers as armed, dangerous, and divided as the friends and foes of *Roe v. Wade* (1973).

> "American illiteracy includes not only the inability to read words, but also the inability to read images: photographs, movies, and video."
> —Jack Fritscher, *Television Today*, Claretian Press, Chicago 1972

At this end of the twentieth century, Americans in the United States seem to be a dysfunctional population suffering the high anxiety of denial of everything that has gone wrong in the social contract.

African writer Chinua Achebe was right: Things fall apart.

Visionary artists pique traditional morality.

The nuclear family has gone into meltdown.

Parents run away from home.

Breeders who abandon children expect Big Brother as babysitter to censor music/movies/television/books ad nauseam until even the censor must be censored ad absurdum.

Illiteracy becomes a Pyrrhic victory.

Illiteracy has function as the ultimate censorship.

Those who can't read words, images, or numbers can't be influenced by the literate conspiracy of artists.

Rampant illiteracy misreads words, images, numbers, and science. (For example: See fundamentalist Bible studies or most gay or lesbian periodicals.)

Petulant illiteracy trivializes everything to defend its vanity. Has ever a truly literate person accused someone of being "book smart" as if books were bad.

Semantics change. *Liberal* becomes bad. *Conservative* becomes good. *Family* twists to a buzzword to endorse self-serving agenda. Exactly when families no longer exist, the word *family* is ironically co-opted by theme parks and politicians and enters the empty rhetoric of "truth, justice, and the American way."

Patriotism masquerades as nationalism at the very dawning of the Global Village made instantly possible by the rise of CNN and the collapse of Communism, which Lenin predicted.

Artists contributed to that collapse.

Playwright Valclav Havel became first president of post-Communist Czechoslovakia.

In America, art gets little respect.

Too bad Robert Mapplethorpe couldn't have been shooting pictures in the Oval Office in October 1989 when broadcast news showed President Bush staring open-mouthed at his TV set at the surprise fall of the Berlin Wall. Bush was caught in an imperfect moment that Robert could have made perfect.

The Western world changed progressively toward individual freedom while the United States crept out from under the twelve-year Republican regency that petulantly circumscribed freedom of expression.

The 1990 censorship of Mapplethorpe was mere presage of the heavy-duty 1991 censorship of the free press during Operation Desert Storm.

Or *multiculturalism*.

Faster digital information, by video and computer and satellite, allows little time for analysis of the information, which, often as not, is purposeful dis-information.

How does a Mapplethorpe photograph, televised live by satellite for ten seconds, differ from a Mapplethorpe photograph exhibited for a month in a museum?

Race, gender, abortion, sex, death as euthanasia and capital punishment, environmental and educational and health care issues, even art, all

torqued up into movements, question both traditional and progressive values with little or no philosophical reflection.

Political campaigns and presidential scandals have become as positive as an AIDS test that the national morality is sick.

Drugs and guns in the classroom are as scary as prayer in the classroom.

Twenty-second news bites terrorize reflective thinking.

Automobiles with carphones, fax, computers, and photocopying machines on board are not complete without an automatic alarm system whose panic button can be pushed during a carjacking.

The concept that a single national language unites a country is a joke as standard English verges on collapse. Bilingual education rarely means French or Italian. Bilingual education simply leads to illiteracy in two languages.

The melting pot has turned into the Tower of Babel.

No wonder American artists have turned outrageous.

Artists cry out against the dehumanization of technology, which they prove is a needless dehumanization by the very way they incorporate new technology into their humanist art.

The Constitution guarantees equal rights, but the demands of the disparate groups are increasingly demands for respect.

The Constitution does not guarantee respect.

Respect must be earned.

Dysfunction rules families, ethnic and cultural and political activist groups.

Denial of dysfunction causes anxiety and stress from living a lie.

The emotional debt is greater than the national deficit.

Call 911!

Maybe art, that act of trying to make order out of chaos, is the only thing left as a healing therapy in the insane asylum of a society mad with dysfunction and denial.

Robert Mapplethorpe grew up and blossomed during the dysfunction that was Vietnam, during the lies of Watergate, finally during the performance-art Reagan presidency that perfected denial of AIDS, the homeless, and the deficit.

Mapplethorpe as artist labored through an age of liars to peel back through strong images his vision and version of social, moral, and aesthetic truth.

He used the traditional metaphors artists have always used: that

striking combination of beauty and terror that grabs the guts and won't let go.

Robert was the very model of a modern major artist.

His story is the history of making beautiful art to show the terrifying truth reflecting and refuting dysfunction, denial, and mendacity.

For all his personal ambition, Robert was some kind of Diogenes carrying the lantern of his camera looking for an honest human.

For the sins of his country, its morality and popular culture, Robert Mapplethorpe, for more than fifteen minutes, suffered an all-American crucifixion as old as the Scopes monkey trial and the Salem witch trials.

The curse on Mapplethorpe was that the war of values, the New American Civil War, is a constitutional debate about separation of church and state, as well as a protectionist debate about diversity, about homosexual culture's constitutional integration into heterosexual culture, and about women's equal rights.

If Mapplethorpe hadn't been a rip-roaring queer, there would have been no trial in Cincinnati where homosexuality itself, not photography, was the issue.

His documentary portraits of masculine sex threatened a culture terrified of penetration and penis.

"The Mapplethorpe Curse" is the curse on all artists, intellectuals, visionaries, and shamans in a breeder society obsessing on its seedlings.

Breeders, a subset of otherwise acceptable heterosexuals, curse society with censorship.

When their seed goes bad, breeders, denying their parental responsibility, need to blame the media, the museums, and the Mapplethorpes.

The breeding of brats caused the banning of Mapplethorpe.

Breeders are not only art-threatening.

Breeders' overpopulation is the cause of the worldwide ecological disaster. Procreation causes pollution. But breeders' vanity, racism, patriotism, or religiosity causes them to reproduce themselves needlessly.

When overweight and overwrought actresses go begging in television infomercials for money for starving children who should never have been conceived, it's unutterably High Camp. It may be cruel, heartless, and relatively immoral, but critically, hey, it's weird.

Asking for money for planned-birth education that prevents global suicide-by-overpopulation is not Camp.

Children do require food and prudent protection, but is it necessary to restrict adult freedoms and pleasures to the extent that movie producer Dean Blagg could not show in his 1994 coming-attractions trailer for *Six Degrees of Separation* a brief shot of the naked Adam in Michelangelo's Sistine Chapel ceiling?

Censorious breeders should not only get a grip, they should be made to get a parenting license before they procreate.

Actually, and this is not facetious, the world should get down on its knees and thank homosexuals and lesbians for not breeding and for inventing sex that is recreational, not procreational, and for making the world "pretty" by design, music, poetry, all those things that the great homosexual Tennessee Williams's drag-heroine Blanche du Bois said, "Separate us from the beasts."

Any memoir of Mapplethorpe, what he did and what happened to him, lacks validity without accompanying memoir of the culture debate that his strange tribe of homosexuals had about the strange tribe of heterosexuals.

Some heterosexuals think homosexuality is strange.

Most homosexuals think heterosexuality is too bizarre for words, but they tolerate it anyway.

Heterophobia remains as rampant as homophobia.

Can these pop culture issues be debated?

Or what?

The alternative is all too often the Ultimate American Review: "Shut the fuck up! Or you're fuckin' gonna make me have to fuckin' shoot you with my motherfuckin' gun!"

MAPPLECHRIST SUPERSTAR

Artists are the people among us who realize creation didn't stop on the sixth day.

—*Joel-Peter Witkin*

J oel-Peter Witkin is a painter and photographer living and working in Albuquerque, New Mexico, and is often perceived to be more clinical and brutal than Mapplethorpe. Witkin however, while controversial, is one of the world's most highly regarded fine art photographers, and a subtle gentleman who four times has been awarded grants from the National Endowment for the Arts. Witkin, who is heterosexual, offers a kind of pacific mysticism that is very understanding of Mapplethorpe's Catholic battle between his two demanding masters, heterosexuality and homosexuality.

Witkin's work sometimes seems directly descended from Darwin's use of photography in *L'Expression des Emotion Chez l'Homme et les Animaux, In L'Expression,* Darwin studied wild facial expressions induced by electrical charges on faces. Darwin's work was photographed by Duchenne. Such historic reference offers some idea of how controversial Witkin himself is in some circles because of his aesthetic but unnerving work with cadavers.

Witkin, almost always more shocking than Mapplethorpe, benefits from exposition of the brief history of photography. The camera from the first attracted some over-the-top visionaries. Witkin suggests dramatic descent from the French photographer Émile Bayard, whose outstanding collection of 750 studio photographs of men, women, and children presents a striking artistic document of the human form. Presented in *The Esthetic Nude,* these images—shot between 1902 and 1907—present, according to historian Joe Vasta, a vision unique to the previous turn of the century. Bayard's dramatic-fantasy characters encouraged to varying degrees the work of Mapplethorpe and Witkin. Bayard created fantasy

characters: human torsos montaged to papier-mâché horses; heroic women pulling a chariot; sea sirens on oversized shells.

Robert Mapplethorpe owned at least seven of Joel-Peter Witkin's extraordinary photographs. One features female body builder Lisa Lyon as a bearded Hercules. Another shows the American mystic Fakir Musafar, the "Mandan," ritually hanging from hooks in his pectorals. Musafar is the inspiration for *Modern Primitives*, which popularized much of the nineties' ritual body piercing.

Mapplethorpe's most outrageous Witkin photograph is *Le Baiser*. Shot in 1982, *Le Baiser* (*The Kiss*) created such an uproar that the negative was destroyed in 1983. In the field of the circa fifteen-by-fifteen-inch photograph, Witkin places the left profile and the right profile of the same severed head in the pose of the kiss of death.

Robert owned print number seven of the truncated run of fifteen.

"I just spent two days at White Sands in the desert photographing this beautiful girl from San Francisco," said Joel-Peter Witkin, who was exhausted but exhilarated.

"We buried her in the sand up to her neck. What we shot was great, but art and fate sometimes conspire in the most extraordinary ways. We suddenly found ourselves surrounded by a group of French-Italian directors and actors. Our model was so beautiful, they insisted, really insisted, we borrow one of their horses and continue our shoot. I could not say no to the opportunity, gifted to me, to photograph such a beautiful woman on such a beautiful horse. I could not say no, not in the desert."

The altered alpha-level state of the artist is often equivalent to religious mysticism. Robert titillated the public by playing with the darker side of Catholicism, but he always came back to his calla lilies, making Easter flowers his symbol of resurrection. He was always such a shocker. He claimed his flowers were not ordinary flowers. They were, he said, "New York flowers." He so wanted to be bad, he wanted his flowers to be Baudelaire's flowers of evil.

"Robert was very, very talented," Joel added. "I regret that much of what we talked about over many suppers was less than mystical. I think his ultimate redemption came about through his veracity, because of how he addressed life. His vision was honest. As for his homosexuality, people, no matter how sexually experimental, always come back to that sexual *thing* which makes them feel whole and true and sane."

"Many people regret Robert's leathersex period. They wish those photographs would go away."

Something very powerful lies in the leathersex pictures. Robert cut their photographic paper with a razor's edge. That edginess makes people uneasy, even those who regard themselves as progressive.

The secret to Robert Mapplethorpe is not in his flowers, not in his figures, not in his faces. The secret is not sex.

The secret is transcendence of the mortal body.

The secret, quintessential Mapplethorpe can be divined by study and examination of conscience looking at his leather work.

In the leathersex photographs, Robert presented what serious artists for generations have sought: a combination of beauty and terror that reveals human alternatives, that strips the denial from the human condition, exposing what humans are capable of when fully turned free of institutionalized cant so they can reach levels of mysticism and godliness.

The year I met Robert, I was introduced to an "incident photographer," a recently freed ex-con from San Quentin whose job in prison had been to photograph "incidents."

The incidents were all murder.

As soon as the body hit the cellblock floor, the incident photographer shot the corpse, grisly, bloody, rictus beginning on the face. He caught that first moment of human truth that terrifies humans: the look of the face that was alive only seconds before.

Robert, like the incident photographer, caught the perfect graphic moments when flesh, transcending itself through itself, in often terrifying sexual gymnastics, uses bodily excrescences and *Kama Sutra* chakra fist-massage as the means to the end of achieving a mystic state.

The Mapplethorpe of the seventies must be understood in the context of his times. His accurate historical images must not be overlaid with latter-day attitudes about sex and drugs, which were both different in the golden age of personal liberation and self-actualization.

Robert was no X-rated porn mogul filming slight variations on the missionary position. Robert, riding high on the seventies' sexual style with slick grace, puts leathersex in your face as an acid shock treatment to demonstrate that the body is the way to physical, emotional, philosophical, and theological ecstasy.

Unlike the incident photographer, whose reportage eight-by-tens had been printed from smuggled negatives he had stolen when released,

Robert's work found exhibition in the media of education: galleries, museums, and books. My regret is that I could find no gallery or publisher who would touch the work of the incident photographer, now lost in time, because the truth of his work would have given perspective to Robert's take on the wilding state of humanity. They would have made an ideal dual exhibit in a society that does not censor the true that is beyond the acceptable truth.

"*My* regret," Joel said, "is that for years I wanted to photograph Robert before he died. I never did it. I don't know whether it was because of his condition, or his not wanting to be photographed by anyone else. I was going to make a trip to New York, photograph him, and make ten prints and give the estate eight."

"That was very generous."

"But he died. If I could question him now, I'd ask, 'Did you make a trade-off between what you wanted to do and what you did?' I read once that 'what you give to the poor is what you take with you at death.' I don't know what he took with him at death."

"He took a life dedicated to art," I said. "He left beauty behind. Also a lot of money for AIDS research. He was a saint of his kind. One of those saints who plays at being bad, so he could have a really terrific deathbed conversion. Like St. Augustine."

"His work, so prolific and strong, amazed me. Too often the work destroys the artist. What vision Robert accomplished was what he gave, and maybe that's enough redemption. I really believe that. If I had to make the choice between any living person and my work, or between a person and my spirituality, I'd go for spirituality."

"You have a son," I said. "You seem much like Abraham, willing to sacrifice Isaac for spiritual obedience."

"My work, or anybody's work, will not accede to everlasting life. With Robert, I can only hope that in a peaceful way, he did complete his cycle, but I have my doubts."

"Robert," I said, "was more tormented than peaceful, at least the years he and I were close. He had a very multiplex vision of himself and what he thought friends close to him should be. Sam usually caved in to Robert. At the last, I didn't."

"Sam gave me my first major show," Joel said. "I saw Robert's show at the Whitney. I'd never seen any of his shows before. His images were wonderful, but the show was hung terribly. Too much of a mix-up of too

many things. Earlier, when Robert and I showed together at the Sam Hardison Gallery in New York, I remember very blatant Mapplethorpe photographs: a blow job. He wasn't mysterious then, mostly basically masturbatory, more okay than aesthetic. I thought he needed to be edited more."

Robert had a young boy's eagerness.

Sometimes, in the early days in San Francisco, I thought it was about getting cash. He was always broke. He seemed always speeding to exhibit almost everything he shot as if in hope that if he pleased enough people, he'd have enough money.

He was very much an art hustler, much like one of those hustlers who needs to turn a trick every hour, not just for the cash, but to prove he's a stud.

When he came knocking on my door, I had, at that time, more money and notoriety than he, and I was seven years his senior.

I liked his dash so much, the money for taxis and brunch I never held against him, because his obvious talent made me feel like an art patron. My house filled up with photographs and proof sheets that he left carelessly about.

"I release nothing," Joel said, "unless I know I can't do it better. Work is an expression of deepest love and mystery and graciousness explaining why people continue to make art and find themselves through art."

"Once artists mature."

"I have to ask more questions of myself about Robert," Joel said. "I'm being honest. Honesty is all I know. Too few artists go honestly into themselves. Robert's careerism and commercialism, that some people fault, was not a failure of honesty so much as it was a survival factor in an age of the cult of personality."

"Thank his mentor Warhol."

"Robert, despite all that, really put his soul on the line, not so much in his advertising work, but in the way his personal aesthetic constantly connected to his sense of self-discovery. When he died, the censorship question seemed to me a cowardly thing: trouncing a dead queer. How can anyone know what he had in his heart? Not that he was a saint."

"I think," I said, "Robert was a retro-saint killed by a retro-virus. Robert flourished in an age of retro-truth. In the seventies, lying became a high art form. Lies about Vietnam. Lies about Watergate. All the lies that led to the eighties' lies of Iran-Contra and the savings and loans. Robert

shot the rich and powerful. He was in advertising. He dined at homes elegant in media and politics. He knew he was shooting lies for liars in denial about their lying."

"That's a very good point," Joel said.

"He wanted to photograph liars, because everything in life to him, from Catholicism to militarism, seemed like a lie. He was court photographer to the liars. Maybe that's why the leather photographs seem so shocking. They reveal truth. Truth, not lies, has shocked us since the seventies. We've fallen through the looking glass, and Robert tried to correct our vision through his lens. These are inverted times."

"If I were a woman," Joel said, "right now my work would be lauded. Cindy Sherman is a photographer. She's lauded. She's good, but she's in, because women right now are in."

"I know. I was disinvited from the Gay Games Art Festival in Vancouver—after I had been invited, because, I was told, swear to God, over the phone that I didn't fit their quota because I wasn't a French-speaking lesbian."

"Life now is like purgatory. I fear for the future of my son. Did Robert receive the last rites of the Church?"

"I don't know. If he did, he did it as an insurance policy."

Robert's last days at Deaconess Hospital in 1989, when he was no longer in control, are shrouded in mystery. Does anyone know what the dying really want?

"I wonder about Robert," Joel said. "That's why I asked about the last rites. We've all chatted with him. We've all read about him. But at death, what's more important: what art you hung on your walls, or what you made of your life? Everybody has to decide what his or her truth is.

"If you're slammed up against a wall with a knife at your throat, and someone says, 'In one second, buddy, tell me what your life is about,' the assault may bring out the truth.

"Was Robert trying to serve two masters? A cock is not going to give you last rites. Money is not going to give you last rites.

"I think Robert handled the major challenge of his reality in a loving, compassionate, spiritual way. He pulled the knife away from his throat, and took a stab, a reasonable stab, at visualizing not the lies of the seventies or even the excess of the eighties, but at his own primordial heroism.

"Robert was a primordial hero.

"Sometimes I'm asked to speak when someone dies. I say that art, the

work of art, is a form of prayer and what a person makes of himself, through himself, is what he is and what he is to be judged by.

"Robert's work had context, yet there's this multi-billion-dollar edge of the business of art. There is too much art being produced for no reason other than to meet commercial schedules, and it suffers because it's being produced too fast to keep up with the fast-moving art market.

"The context of art is the human condition.

"Losing context is a dangerous thing. Artists sell themselves out, going for name and money. Cindy Sherman's early photographs had context. Her early work glowed with the reasons she created it. In the current art market, she seems to have less context. No one wants context. It's as though she has to play to an audience of empty milk bottles. Artists should become more human, not less, as a result of working with art. I hope that's what happened to Robert.

"His vision may have been a bit ahead of his times. Five or ten years from now, the take on his work will be quite different.

"In this so-called postmodernist age, Robert was a rebel. He dealt with people in flesh and spirit. These are traditional concerns we can't escape no matter how postmodern we are. I pick up art magazines and they are increasingly empty and completely inane. This minimalist thing is a passing stage that can't pass too quickly.

"When everything controversial about Robert settles down, and when time's relationship of social factors gives better perspective, the worth of his work will be seen more clearly.

"The future is on his side.

"His work was not excessive at all compared to his times.

"He wasn't the Bad Boy he played. He was his own best person."

"As Emerson would have written," I said, "Mapplethorpe achieved the Mapplethorpeness of being Mapplethorpe."

"That is his redemption. If he tried to know himself, to the degree he succeeded, he lived a life of purification and growth."

"Light and purification. That's essentially an artist's life, isn't it?"

"That's every person's life," Joel said. "Artists are different because they're hanging by their short-hairs. Artists are the people among us who realize creation didn't stop on the sixth day. It continues in people of sensibility and vulnerability who risk everything as the tuning fork of a particular society, or as the mirror image of the time they live in."

"Artists scare people," I said.

"True artists do."

"Robert tried to shock and scare people, but he needed someone to scare him, too. That's why the white boy, Wally Wallace told me, turned to shooting blacks. Robert was afraid of blacks. He met his personal fear head on and characteristically worked through the public fear in his photographs. He knew pictures of blacks could add another level of terror to his shocking work. Not just blacks. But naked blacks. He played with race, its exotic beauty, its sexual threat."

"I guess Robert and I both would be considered decadents."

"But not exploitation artists," I said.

"No. With Robert's blacks, or with my women, both groups much open to discussion of exploitation, there is a beauty of the work, no matter how gross or dangerous it may seem, as long as the compulsion the artist has to display his obsessions uses the flesh, not as pornography, or maybe even as pornography, to show the beauty of the flesh which is the incarnation of the spirit. That's what people don't understand. Sensuality is not carnality."

"Flesh captures the attention, but the spirituality holds the interest," I said. "Christ became flesh to illustrate spirituality. Look at the mess he created mixing the two. People still argue if he was man or god."

"Society needs to sophisticate its symbolic literacy," Joel said, "so people can see what is on the surface, and then proceed through interpeting the surface to what the surface symbolizes. Not all art is meant for everyone. Robert, I think, worked so hard to make his spiritual point that he misprojected and people got locked into the literal elements of the photographs and never saw the symbolism."

Is Robert very like Andrès Serrano, who also broke the accepted trance and told the brutal truth? Serrano's *Piss Christ* altered forever the pastel version most Christians hold of what really happened on the way to Golgotha, the *Via Dolorosa* of the human condition.

The suffering and death of Christ, human, but very male, are an iconographic image that Robert, his homosensuality pressed through institutional Catholicism, found at the center of his most religious work, his leather photographs.

The crucifixion obsessed him.

The icon of crucifixion shows up not only in his arrangement of photographs in groups but also in self-portraits.

In some autophotographs, he is a pagan satyr.

In others, he is the Christus himself.

In the first gift he gave me, a very young Robert (*Self Portrait, 1975*) throws his arm across the field of the photograph, as if his arm is laid out for crucifixion. Except for his arm, and bearded face, and a bit of his right nipple, the photograph is empty.

He signed it "To Jack. . . . Robert '78".

Robert used this grinning photo as the cover for the poster-sized program for his show, titled, "Robert Mapplethorpe," at *La Remise du Parc* in Paris June 15 to July 13, and September 5 to 20, 1978.★

That kind of laughing honesty about his open ambiguity is one of his greatest talents.

"From the start," Joel said, "every year, as an iconographer, there was always something I would make that would have reference to the Christ. It's not uncommon among western artists, Robert included."

"You made a twelve-by-fifteen-foot crucifixion sculpture."

"Ah! It's been shown in about thirteen museums in Spain, where they appreciate that sort of art. It almost sold in León, but the price was too high."

"Perhaps you didn't want to sell it. I have my own series of crucifixion photographs. How does one put a price on art?"

"Right now, it's in a storage unit. A kind of white elephant. But that doesn't matter. The passion to create it is greater than the need to peddle it. I made it not for the sake of selling it, but for the opportunity to use my skills and the materials to transcend through."

"To break on through to the other side," as Jim Morrison sang.

Robert idolized Morrison.

The only possession, besides my soul, that Robert ever asked me for was a large black-on-silver print of Morrison. It was a limited edition that I found on Eighth Avenue in New York in 1967.

I never gave it to him, no matter how much he begged.

I think I was just disciplining him, knowing how much he wanted it, and how he always got everything he wanted.

Thank God, I never gave it to him. Christie's would have auctioned it off. AIDS has taught me never to lend anybody anything without a

★ Robert's self-portrait, also shot in 1975, but *Untitled*, featured a blur of his face over his own frame-filling feet, the soles of which are shown wrapped in a sheet. This Mapplethorpe angle is essentially a view from the foot of the cross of Christ.

written receipt; I've lost things that were sucked up by greedy straight families.

Besides, it was good for Robert's character, and mine, and for our relationship, not to let Robert have everything his own way.

We got on famously because I often said no to him, and the secret to handling the wild Mapplethorpe was in saying no.

The word *no* thrilled him. He saw it as a challenge to continue badgering until the person said yes.

That's what stoked his professional ambition even after he was rich and famous. He wanted the whole world to say yes to his every photograph.

Every no, every rejection, was a small, delicious, lubricious crucifix-ion, pinning him down, so he could think up ways to outfox the naysayer and resurrect himself, turning no's into hallelujah choruses of yes!

Theologically, Robert, same as all lapsed Catholics, had his psyche wired by Catholicism. Theologically, really more than even symbolically, Robert wanted the *alter Christus* status of the crucified god.

Real nails through his talented hands would have made him happy.

Who's to say that the crucifixion of AIDS, his final torture, might not have been self-induced.

AIDS: the artist half in love with death. Or, maybe, the real motiva-tion, AIDS: the perfect suicide.

AIDS: the perfect way out of a controversial career that he may have suspected had run its course.

Stranger suicides have been devised.

In the self-photographs, the maker of icons becomes himself an icon.

Making way for the next single frame of his next existence.

Ask Shirley MacLaine.

"Mysticism and art," Joel said, "are virtual synonyms."

"A woman who lives near me," I said, "has written a New Age book called *Ordinary People as Monks and Mystics*. She talks as do you about transcending through one's work. If it's true of ordinary people, then is it more true of artists?"

"Transcendence brings clarity," Joel said. "Robert may have burned up, not burned out, with clarity. Clarity, doing the work, is the artist's nourishment. Robert wanted his work to be venerated. I don't. My work expresses a soul in progress. That's all. The only direct connection between Robert and me is that he always dealt with the beautiful. I don't. I intentionally deal with the strange, the exotic, the horrible. I recently

created a piece about the difference between a severed hand and a flower. We have all kinds of flowers all over the house, and they're very beautiful. I appreciate them, but I am not obsessed by them."

"Robert preferred cut flowers," I said. "Cut, they were already dying. Cut, they stood as metaphor of human life, which is cut from the mortal start. Their beauty was perfect for the moment. He had limited time to work before they wilted. Their beauty was brief."

"Yet his career wasn't. Even if he had run out of things to say, he couldn't have coasted another twenty years without really being dedicated."

"What was his dedication? It was more than money and fame."

"His dedication," Joel said, "was his personal torment, his anguish that was never totally resolved. The homoerotic aspect of his humanity."

"Was his homosexuality a stumbling block to him?"

"I think it was his driving force."

"You mean because he chose not to follow the biological human urge to procreate literally, he chose, instead, to create aesthetically?"

"That may be."

"Robert was not dysfunctional. He never let homosexuality become his excuse for not joining the world. He contributed more than his share to the common good of the wider world."

"There are degrees of dysfunction," Joel said.

"Without those degrees, there would be no artists. Can a normal person, whatever that is, be an artist?"

"Dysfunction happens in all walks of life," Joel said. "Robert was gloriously productive. Yet, I think his homosexuality could have been a stumbling block to him. Sexuality itself is a stumbling block no matter one's sexual preference."

"I'd prefer to say that normal society is the stumbling block to sexuality," I said.

"In Robert's case, he was given the off-center homoerotic edge as a personal, artistic problem to be worked out in a predominantly heterosexual society."

"He carried his cross well."

"As a minority in a pluralistic society, he dealt with homoeroticism in the most honest, beautiful, spiritual way he could. I think that's his importance."

"I think that's cause for artistic sainthood."

"You mentioned ordinary people as monks and mystics."

"Your mention of the missing limb," I said, "reminds me of George Dureau's photographs of men with missing limbs. With your interest in what the norm would call deformity, and Robert's interest in perfection, do you think that homosexuality was his deformity that caused him to try so hard to shock the heterosexual take on life by insisting there were alternative takes on human existence?"

"I'm not going to say no, but, yes, that was his basic struggle. He saw two masters: homosexuality and heterosexuality. This unresolved, perhaps unresolvable, conflict is the essence of his aesthetic."

"In his personal life," I said, "he was stressed by his attraction to men and his attraction to women."

"But in his work . . ."

"And in that work is where the internal evidence of his outsider's eye, his outsider's psyche is absolute . . ."

". . . Robert, stumbling and carrying his homosensitivity," Joel said, "brought a psychological balance, a giving over, bringing out the best qualities of women and men. He looked for the best in them as he did in himself. His desire was to make the best image possible even in his subterranean world of leather, where, what in reality can be quite rough, he refined with elegance. I don't refine my work. Robert couldn't get away from making an image beautiful.

"His personal carousing may have been legendary, but what we know for sure is what we see published. There lies the evidence. His photographs are the highest expression of how he saw life and reconciled life's alternative plurality. And he did it for public consumption."

"Then he was a teacher, like Socrates, a teacher who was thought decadent."

"Robert's mysticism is not decadent," Joel said. "A label like 'decadent' says more about ineptitude. Many photographers are inept, because the camera is such an easy instrument of instant gratification. Everyone thinks he's a photographer these days."

"Robert, although he feigned even more ennui than he really felt, was never boring. His photographs are very crisp and alert."

"Exactly. Even his commercial portraits of celebrities, although most of them are probably barracudas in life, he presented beautifully. He had to relate to them, get around some human flaws, and artfully dodge the ugly truth into photographic beauty."

"Robert exerted power over his models," I said. "He rather overpowered them, even while he brought their beauty to the fore."

"Robert, I must say," Joel said, "is a modernist. Postmodernism is an admission that modernism has failed. Unlike postmodernists, Robert was dedicated to the romanticism of finding himself as opposed to pursuing a career through sheer aesthetics. That's what makes him real, as opposed to people whose goal is to make money through the multi-million-dollar art exhibit. He made a lot of money and he inherited even more, but the amount of work he created, even when he was sick, when he could have quit, shows it was, ultimately, not the money, but the work, the spiritual quest."

"So he succeeded."

"Except for one thing. He didn't articulate what he was doing."

"The photographs speak for themselves."

"He should have done more than give interviews," Joel said. "Robert himself should have written about his work."

"He couldn't write very well. That's why he ran around with writers."

"He was a frustrated writer," Joel said.

"The camera was easier."

"It disappointed me that he never wrote a book," Joel said. "Robert should have written at least a monograph, because a person should, at one point in his career, make a kind of manifesto. Just to clarify all the other writing about him, so he, not Susan Sontag, or you, or any critic or biographer, can have the last word."

"Perhaps we're back to the Seven Last Words of Christ," I said.

"I want inside other artists' mysticism. That happens when the work itself resonates in a dialogue. It's not so much the actual photograph. It's a resonance from the spirit of the artist to the spirit of the viewer. Sure, the art object exists on its own. But wouldn't it be wonderful if Robert had been verbal about his work? We know of his dedication, his discipline, his love, his vulnerability, even of the way he tried to reassure the world through his art, but all of this, all of his work, all the critiques are not enough."

"They're clues."

"More than clues, I want to read something Robert wrote about his lesser self and his higher self."

"Clues are all he left. Mapplethorpe left us in mystery. He asked me to write for him, about him," I said. "At the time, he didn't tell me it would turn out to be a detective story."

"Robert went out, as I do, into life's darknesses. It takes courage not to be totally seduced by the dark. It takes courage to come back in, unconfounded by the darkness. Without the dark side of the soul, there is no saint."

"Robert's life is much like Conrad's *Heart of Darkness*."

"Robert's life is very much like Thomas Merton's *Seven Storey Mountain*," Joel said. "As an artist, he went out into the dark and came back with the best of what he saw in humanity and in himself. He was rare. It's very hard to render emotions through a camera. Robert was a bright light, throwing light on aspects of mortality that society usually denies. He caught emotion.

"Last night, being awakened at ten o'clock out in the desert at Alamogordo, I said to myself, *If I die now, I'd be happy*. From his work, Robert must have felt that. Every artist does when he stands back and looks at something he's made, and on the most honest, no-bullshit level, realizes he's transcended his own physicality and has tapped into something of the spirit, and he looks at it and thinks, *My God! How did I do that?*"

INDEX